Synagogues

Synag

Leyla Uluhanli
Foreword by Judy Glickman Lauder
General Editor Jai Alison Imbrey

ogues

Marvels of Judaism

RIZZOLI
NEW YORK

New York · Paris · London · Milan

General Editor's Note

This volume covers synagogues from their earliest appearance to the present. Many Jewish houses of worship have long and complicated histories with records that have been either lost or obscured by time. To help us appreciate their richness and diversity, a team of scholars has been assembled from around the world. Our collective goal is to present these extraordinary synagogues to a general audience. However, the wealth of fine examples has constrained us to select only a small fraction of the synagogues that have enriched and sustained the lives of Jewish communities over the millennia. We have limited our selections to synagogues of the major diasporas: in the Middle East; western, central, and eastern Europe; India; North and South America; Russia; and the Caucasus. Included are both active and inactive synagogues in their many iterations to show the evolving arc of faith and dispersal of Jewish communities. Some are now museums.

In keeping with the practice of international scholars of Judaism, the dates of buildings, historic events, and personages follow the Gregorian calendar (expressed here as BCE and CE), rather than the Jewish calendar. In listing dates, we use CE only when needed for clarity. Note that the founding dates of certain synagogues may be different from their consecrations. Many older synagogues have been destroyed, renovated, substantially rebuilt, or moved; hence the original buildings may no longer exist, though their memory is preserved in the structures. For these reasons, our essayists have often elected to use dates that reflect the dedication of new adaptations and refer to the dates of earlier incarnations only when necessary. Numerous synagogues have multiple names, some of which have changed through time. We generally refer to the synagogues by their most common appellation and sometimes use the English and Hebrew equivalents.

Many words in this text are transliterations of Hebrew and Yiddish dialects. With the assistance of a linguistic scholar, we have selected the most common spellings for transliterated terms. For the most part, we have drawn on Merriam-Webster's New World College Dictionary and Encyclopaedia Judaica for their orthography. Some diacritical marks have been omitted.

—JI

Contents

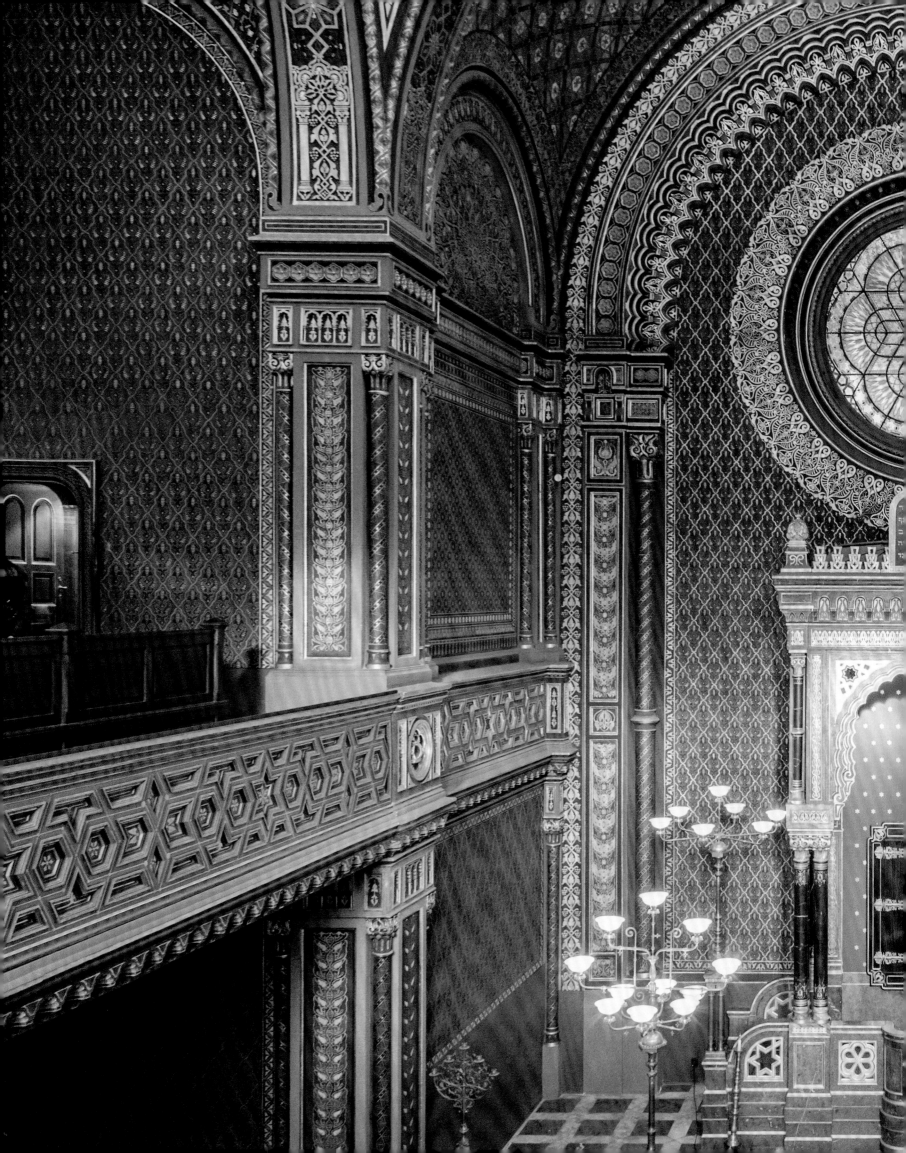

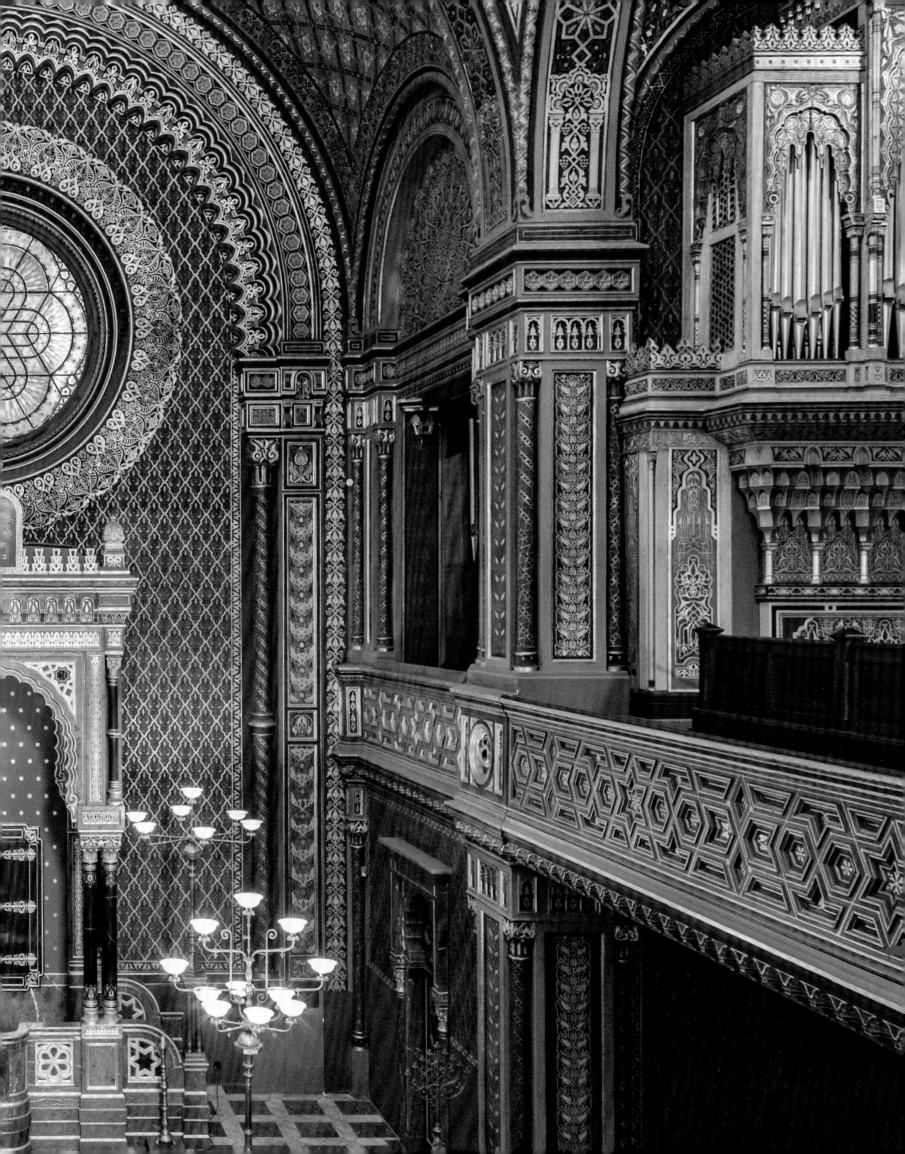

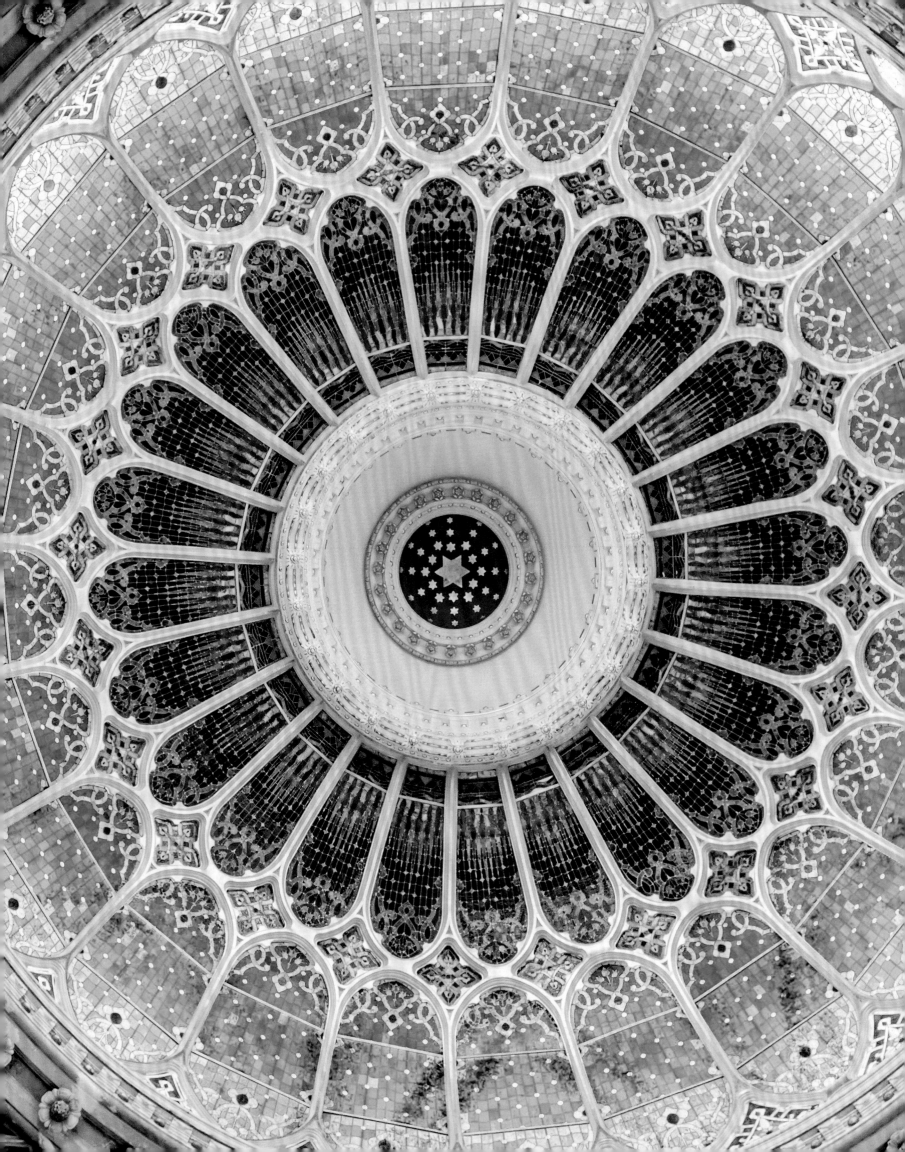

A Beautiful Journey

Judy Glickman Lauder

In these pages, you will discover glorious synagogues—ancient and contemporary, majestic and modest. They stand in great capitals and small villages, in cityscapes and deserts; they soar amid mountains and rise along seashores. And within each structure, you will encounter an energy, a spirit, something touched by the living God.

In these synagogues, you may also find the key to Judaism's incredible survival. Our ancestors built their first sanctuary in the wilderness, creating a home where God's presence could be made manifest. Several centuries later, King Solomon dedicated the Holy Temple in Jerusalem with a psalm composed by his father, King David: "Lift up your heads, O gates, and be lifted up, O ancient doors, that the Lord of Hosts may enter." With the destruction of the Temple came the Jewish exile, the scattering, the diaspora. Jews built consecrated sanctuaries wherever they lived. But over time, these structures ceased to be merely sanctuaries and became synagogues, literally houses of gathering, houses infused with the essence of God and the presence of community; houses alive with prayer and celebration, study and contemplation, lament and comfort, praise and thanksgiving—so uniquely holy that the sage Abba Binyamin proclaimed, "One's prayer is heard [fully] only in a synagogue" (Babylonian Talmud, Berachot 6a).

As a photographer, traveler, and someone deeply interested in my Jewish heritage, I have been drawn to synagogues wherever I find myself and have personally visited many of the beautiful sanctuaries brought to life in this volume. Each of these historic buildings has been hallowed by spiritual journeys, communal prayers, meditations, and songs; by candles kindled, Torah portions chanted, rituals enacted, and milestones marked.

One can simply feel their spirituality: sometimes in a place as small as an early immigrant synagogue in Maine—a shaft of light illuminating a single prayer shawl draped on an empty pew or a sacred book, awaiting the next prayer service. I photographed an entire intergenerational family who had traveled from Israel to their large homeland synagogue in Sofia, Bulgaria, to recite Kaddish in memory of their many relations lost in the Holocaust. Sadly, I have also witnessed the absence of synagogues, including those destroyed during the Holocaust, as well as former synagogues that are now museums, movie theaters, and cultural centers, denoting the loss of so many vibrant Jewish communities—gone to the ghettos, the killing squads, the extermination camps.

Make me a sanctuary, and I will dwell among them.

> Exodus 25:8

In this passage, God instructs Moses to build a place of holiness not only as a dwelling for God but also as a place where God will dwell in us. It is with the spiritual union of a community that a building becomes a synagogue. And in the resonant words of writer Mindy Radler Glickman:

Like a mezuzah, which contains holiness, the Shema,
And like our bodies, which house our soul,
The synagogue is the vessel,
which envelops the Jewish community's soul.
A synagogue is a place where souls gather.
When ten come together forming a minyan,
God hears our communal prayers.
It takes a community to build a sanctuary—
Together people make holiness.

Spirit of a People Through Time

Leyla Uluhanli

*In days to come the mountain of the Lord's house shall be established as the highest of the mountains
. . . all the nations shall stream to it.*

Isaiah 2:2

Welcome to the second in Rizzoli's series on treasures from the world of sacred architecture. With these beautiful volumes, I wish to share my passion for some of the great houses of worship across time and culture. My hope is to show how these buildings of different faiths reflect the powerful inner lives and spirits of their creators.

With the help of an amazing group of Judaic scholars, artists, thinkers, and architects, my eyes have been opened to the extraordinary depth and range of Jewish synagogues around the world. Every architectural detail I studied has given me fresh insight into the spiritual character of its makers.

I had the good fortune to be born and raised in Azerbaijan, where I experienced Jewish life and culture firsthand. Few know that since the fifth century BCE, many Jews have lived peacefully there with the local people of this region. A number of Jewish settlers came to Azerbaijan to escape persecution from the kings of Babylon and later from the Persian Empire. Subsequently, a productive partnership developed between these communities and the Khanate of Khazar, which lasted for more than a thousand years. In my native Baku, I discovered how the neighborhood synagogues drew freely on ancient Persian and Near Eastern architecture, as well as Islamic and Christian art forms. Today, it is this rich shared history that inspired me as a designer and architect to create this book.

In my research, I have journeyed back four thousand years— through ancient Egypt, Assyria, Babylon, Persia, Greece, and Rome, to name just a few of the early civilizations that have contributed to the synagogue's diverse architecture. But for me, it's the Great Synagogue of Rome, built over a century ago, that encapsulates the essence of the synagogue and its transformation over time.

Jews have lived in Rome since the second century BCE and are seen as one of the oldest surviving Jewish communities outside of the Middle East. In this time, entire empires and cultures vanished, and modern civilization as we know it was born. How did the Jews of Rome manage to endure? From roughly 1555 to 1870, Roman Jews were largely confined to the crowded ghetto in the Rione Sant'Angelo and faced numerous bouts of persecution. Still, many not only persevered but also thrived as an intellectual and financial force. Following Italy's unification in 1870 and in celebration of the ghetto's emancipation, the community decided to build a single monumental synagogue, soon known as the Tempio Maggiore. Its design draws on an array of styles, fusing neoclassical architecture with Assyrian, Babylonian, and Baroque elements, and even aspects of the fashionable art nouveau. Its immense square dome, unlike any in Rome, rises majestically along the Tiber. Inside, above the square drum, the vault culminates in a burst of color, reminiscent of the *khoshen*, a mysterious garment of the biblical high priesthood with its twelve colorful stones evoking the Twelve Tribes of Israel.

By 1986, the Jewish community had become such an integral part of the city that Pope John Paul II paid an official visit to the temple, declaring, "This is the first time that the Church of Christ discovers a bond with Judaism by delving into its mystery. The Jewish religion is not 'extrinsic' to us, but in a certain way is 'intrinsic' to our own religion."

For me, the Great Synagogue of Rome is a visual metaphor for the Jewish spirit as well as for a way of thinking: Its tenacious roots combine with a vibrant embrace of modernity and a willingness to adapt and learn. Maybe this is one of the many secrets of Judaism's phenomenal history, its creative energy, and its ability to survive.

Below, clockwise from left:
The Tempio Maggiore in Rome (1904), which blends Assyrian-Babylonian, Egyptian, and particularly Greek and Roman architectural styles, stands as a remarkable testimony to one of the oldest Jewish communities outside of the Holy Land.

The impressive Torah ark, with multiple menorahs similar to the one on the Arch of Titus (see page 18), illuminates the Tablets of the Law. This view shows the openwork bronze grille surrounding the women's gallery; the unique square vault and oculus are the brainchild of Roman architect Osvaldo Armanni. Colossal columns frame a second-floor ceiling with floral decoration.

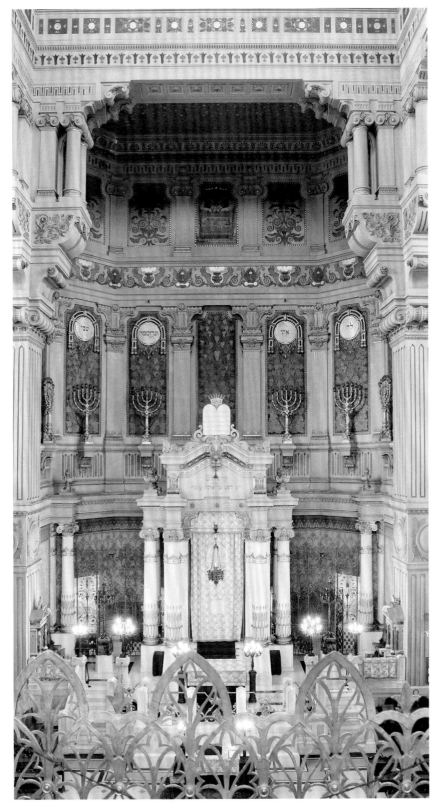

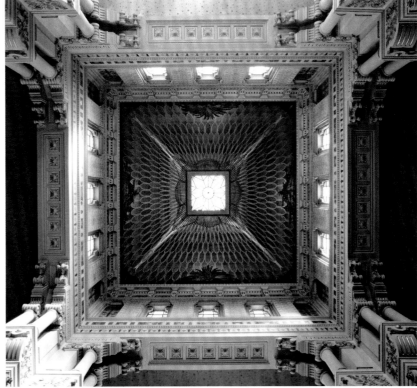

The Synagogue: An Organic Space Across Time and Geography

Aaron W. Hughes

Jews have undergone much over the past several millennia. They have been forcefully removed from their homes and they have subsequently built new ones. They have been persecuted and they have been accepted. They have been imagined and portrayed as the enemy par excellence, and they have been patrons of their communities. If their long history without a national homeland has been unique among other peoples, their desire for a home in the places they have found themselves, along with their hope for the communities that they have built, is as normal as it is praiseworthy. Throughout their long history, Jews have done what all religious communities have done: They have struggled in the face of adversity and rejoiced in celebration. Between these two poles, they have lived their lives in a manner that they consider to be reflective of their special relationship to God.

In a volume meant to showcase the multifaceted splendors of Jewish houses of worship, it might be worthwhile to ask a fundamental question: Who exactly are the Jews? And, perhaps just as importantly, what differentiates them from their neighbors? To answer these and related questions it is necessary to travel back through time and space to show how a small group of nomadic people transformed their beliefs into a major religion that helped change the shape of world history.

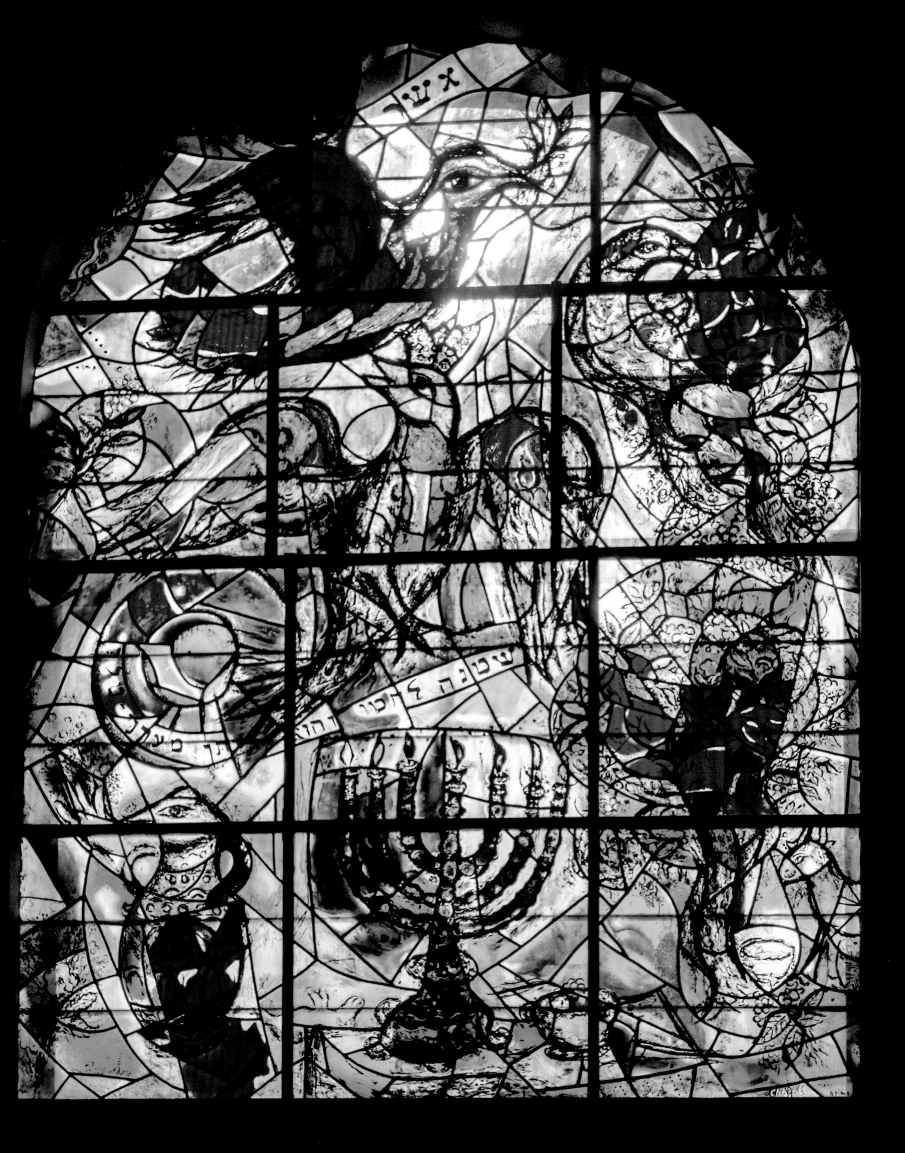

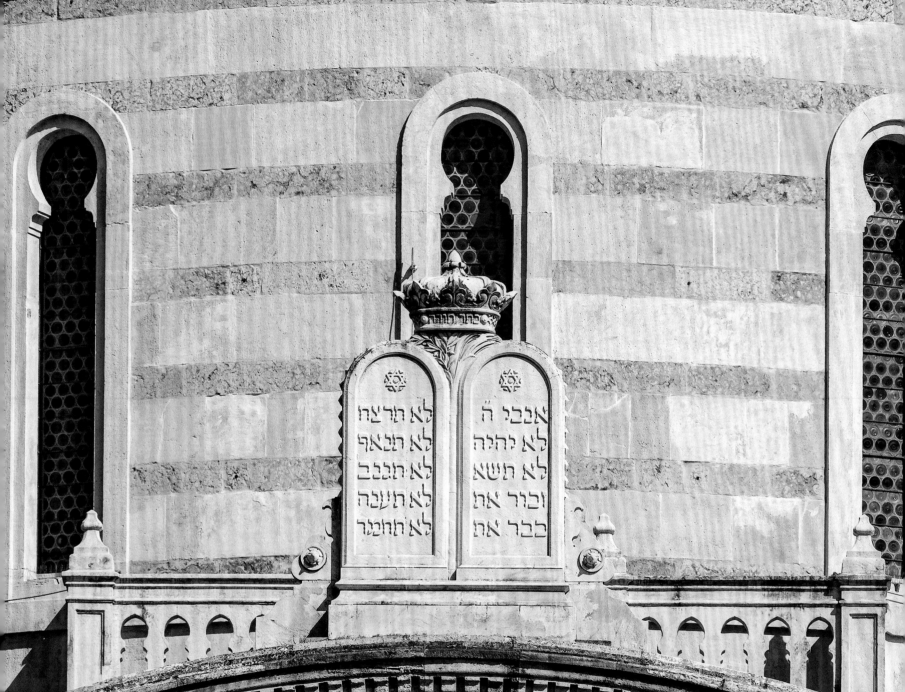

The Jews: A Brief History

The Book of Genesis reminds us that what emerged as Judaism initially began as a promise between God and Abraham. This promise, as it came to be understood through the generations of subsequent centuries, actualized Jews as a distinct ethnic and religious group in the Middle East during the second millennium BCE, in the part of the Levant called Canaan, which became known as the Land of Israel.

In this land, Jews have gathered, been dispersed, and returned with the hope of further understanding the exact contours of that initial promise. It is this triangulation of peoplehood, land, and God that finds itself archived at the heart of the Hebrew Bible, and which has found further expression and elaboration in virtually all of the textual and architectural monuments that Jews then created for themselves.

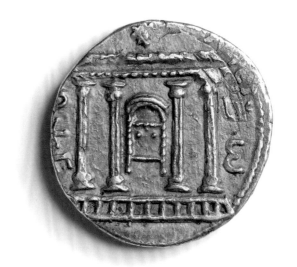

According to the basic narratives supplied by Jewish scriptures, the Jews trace their lineage back to the patriarchs Abraham, Isaac, and Jacob and their wives, the so-called matriarchs: Sarah, Rebecca, Leah, and Rachel. From Jacob are descended the Twelve Tribes, familiar to all readers of Genesis. After famine in the land, and the forced migration to Egypt, it was the lawgiver Moses who led the Children of Israel, the ancestors of today's Jews, out of Pharaoh's house of bondage, and it was Moses, along with his assistant, Joshua, who initiated the process of return to the Land of Israel. This promise of return has functioned as a thread holding together much of Jewish history.

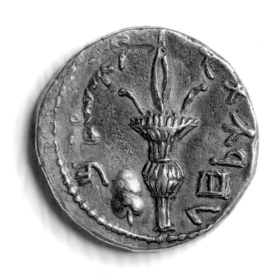

What binds this narrative further is the idea of the covenant, in which God promises the Jews land and protection in return for their devotion. It is this idea of inseparability that functions as the spirit guiding Judaism. Jews are required to uphold the commandments (*mitzvah*) in return for divine favor and sustenance. From a traditional religious perspective, but certainly not from a secular or historical one, all of Jewish history can be understood based on this relationship to the covenant. When good things happen to Israel, it is on account of devotion to and performance of the commandments, just as when bad things happen, it is on account of ignoring the

commandments. Whether or not any of this can be proved by the archaeological or historical record is not important. What is significant is that the basic narrative just recounted has produced a national story—and just as importantly an ethos—whereby the ancient Israelites and subsequent Jews have understood themselves. The light offered by this narrative has illumined all the paths that Jews have traversed. Indeed, it is this covenant that permitted Jews to distinguish themselves from their neighbors. The covenant was what was ultimately responsible for the monotheistic impulse to worship one God— the God of Israel—to the exclusion of other deities. Within this context, it is worth noting that one of the Ten Commandments instructs Jews not to make graven images: "Thou shalt not make unto thee any graven image, or any likeness of anything that is in heaven above, or that is in the earth beneath, or that is in the water under the earth" (Exodus 20:4). While this is usually interpreted to mean that Jews cannot worship images of God, in terms of Jewish art, it means that representational images of God and humans are often avoided. Though, as it will be clear in some of the photos throughout this book, such strictures have not always been strictly followed, perhaps most famously at Dura-Europos (see Chapter One, page 39).

The construction of a temple in Jerusalem—promised to David but ultimately built by his son Solomon—now became the epicenter of religious life. With this building, the religion of the ancient Israelites was no longer something that could be performed in one of numerous shrines, but instead became centralized in one place and in one city. It was the Temple that became the locus of the divine presence on earth. According to the book of Kings, the main chamber of the Temple was carved with "engravings of cherubim, palm trees, and open flowers, in the inner and outer rooms. The floor of the house he overlaid with gold, in the inner and outer rooms" (Kings 6:29–30).

The priests (cohenim) mediated between Israel and God in the confines of the Temple, performing sacrifices and ensuring religious and political order in the kingdom. There, the priests also carried out offerings in the morning and afternoon, in addition to special offerings on the Sabbath and Jewish holidays. Levites recited psalms at appropriate moments during the offerings, including the Psalm of the Day, and special psalms for important sacrifices, the new month, and other occasions. Yet, as anyone familiar with Judaism will know, there is no longer a Temple that stands in Jerusalem. This first, Temple was completely destroyed by Nebuchadnezzar II, the Babylonian king, in 586 BCE. This ushered in the Babylonian Exile among Israel's elite, and the subsequent return to Israel under the aegis of Cyrus, the king of Persia. The Temple was rebuilt, now called the Second Temple, on the same spot in the year 516 BCE. The Book of Ezra, among others, describes how the Second Temple included many of the original vessels of gold that had been taken by the Babylonians (Ezra 5:13–14), thereby ensuring continuity with the past. It was Herod (r. 37–4 BCE) who began extensive additions to the Temple, to make it a fitting and elaborate home for the God of Israel in the burgeoning Roman Empire. He extended it on three sides, adding a pool of moving water, a royal stoa, and a new interior temple called the Golden Temple. Though it was not complete until after he died, this massive and rich building inspired future ideas of Jewish architecture.

This Second Temple was also destroyed, and this time for good, by the Romans in 70 CE. What remains of the Temple today is a segment of the retaining wall that, commissioned during the reign of Herod, is known as the Western Wall (or, alternatively, as the Wailing Wall).

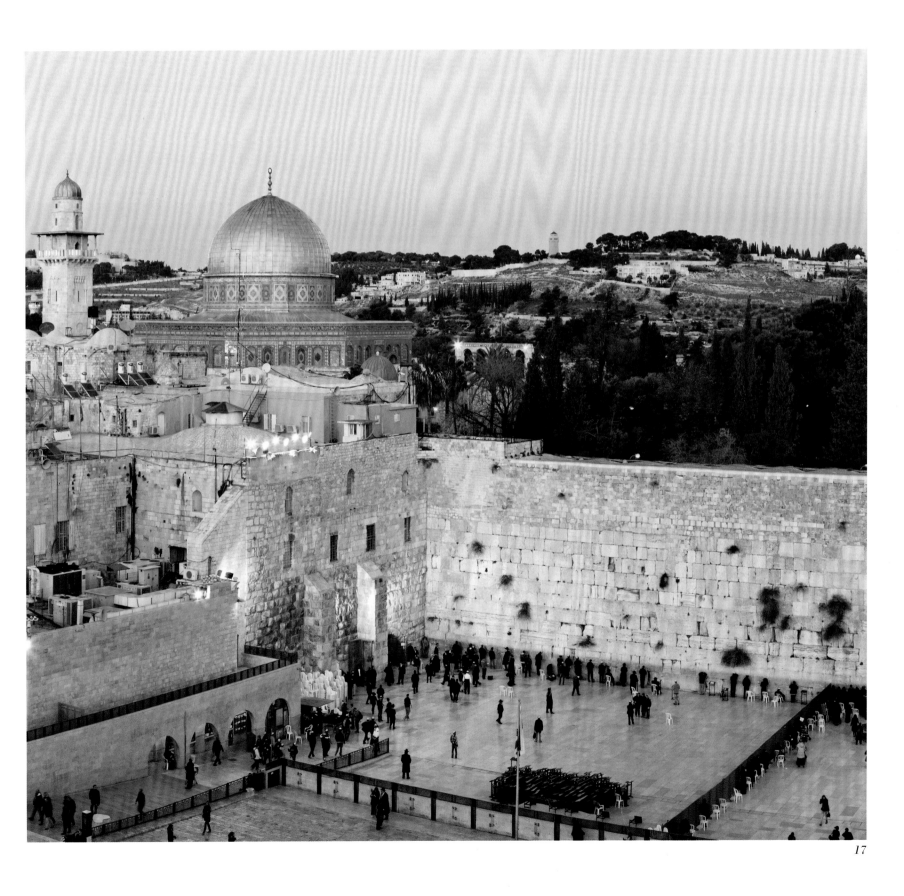

Below: The Western Wall, known by Christians as the Wailing Wall, is part of the external parapet of Herod's Temple in Jerusalem.

Top: In this relief from the Arch of Titus in the Roman Forum (81 CE), a menorah is carried off in triumph by Roman soldiers upon the destruction of Herod's Temple and Jerusalem by Titus's troops (70 CE).

Bottom, left and right: After the fall of Jerusalem in 70 CE, Jews migrated around the Mediterranean building synagogues in local regional styles such as the Moorish columns in the Joseph ibn Shoshan Synagogue (ca. 1180) or the uniquely decorated carved stone capitals and the horseshoe-cusped windows with mashrabiya *latticework in the Synagogue Don Samuel Halevi Abulafia (1357), both in Toledo, Spain.*

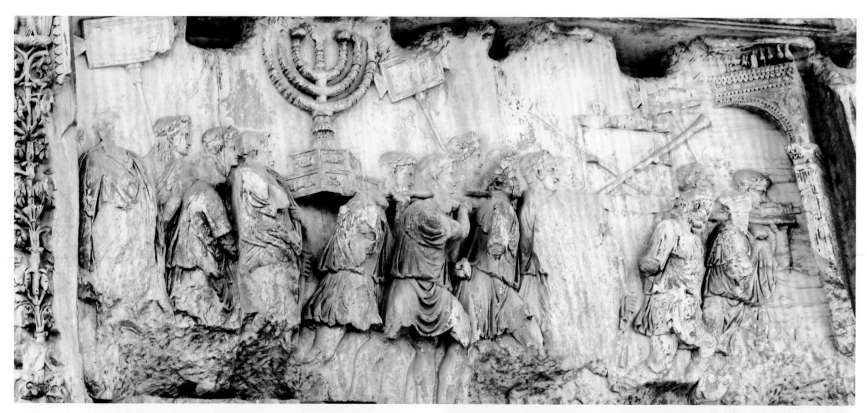

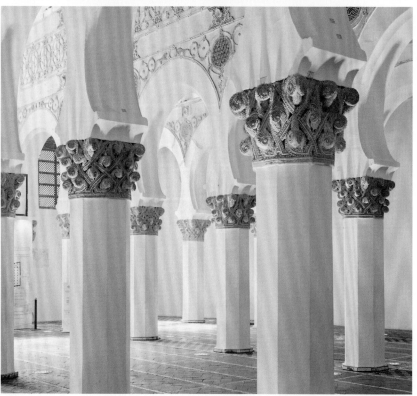

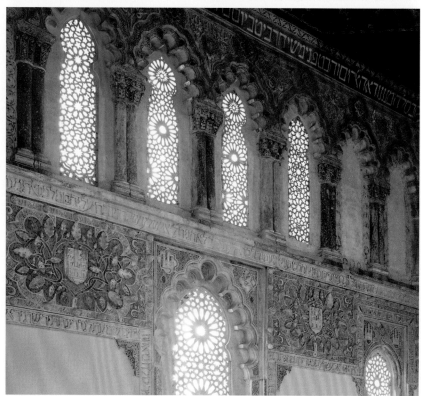

From Temple to Synagogue

The destruction of the Second Temple ushered in massive changes. Jews—and, by extension, Judaism—no longer had a center. With the Temple destroyed, the sacrifices carried out therein naturally came to an end. The priestly caste, as the Temple's defenders, was also largely destroyed by the Roman siege. Judaism in the aftermath of the Temple's destruction faced a bleak future. To survive the destruction of the Temple and those who administered its sacrificial system, Jews needed to develop new ways to be religious. It was out of the ashes of destruction, in other words, that Judaism as a vibrant and non-Temple-based religion evolved.

The leadership vacuum created by this destruction was quickly filled by a new class, the rabbis. It was the rabbis who set the pattern for debate and discussion on religious law and interpretation, who developed elaborate techniques for interpretation of the Torah (known as Midrash), who began collecting and organizing the older oral traditions (in collections such as the Mishnah and the Talmud); who determined how to observe rituals without the Temple (such as conducting a seder and the use of the shofar); and who organized the liturgy.

The result was a Temple-less religion, and the beginnings of what we would today recognize as modern Judaism. Perhaps, most importantly, though, is the fact that the rabbis made Judaism portable. Jews could practice their religion anywhere. One no longer needed a Temple to be religious. The home and the synagogue now replaced the Temple, and the rabbinic teaching and acts of loving-kindness (*gemilut hasadim*) took the place of priestly sacrifice. Though some Jews had lived for centuries outside of the Land of Israel—most famously in places such as Alexandria in modern-day Egypt—all Jews now lived in exile (*galut*). To practice Judaism, one now needed only a book and a quorum of at least ten men (minyan), in addition to various communal services provided by schools, synagogues, butchers, and others to minister to a community. During their time in exile, generations of Jews never gave up the hope of returning to the Holy Land—an aspiration that was only realized in 1948 with the formation of the modern

State of Israel. While many Jews have chosen to live in Israel, many have not. And their houses of worship are found in all those places that Jews live, functioning as testaments to their presence. Over the years, Jews adopted local architecture, had access to excellent masons and craftsmen, and from the nineteenth century until this day, employed well-known architects to create their synagogues.

While the Temple no longer remains, parts of its liturgy still exist in the modern-day practice. The traditional Jewish morning service, especially the part surrounding the Shema prayer, is believed to be unchanged from the daily worship performed in the Temple. In addition, the Amidah prayer, recited in synagogues far and wide, regardless of denomination, replaced the Temple's daily *tamid* offering, and special occasion *musaf* ceremonies replaced additional offerings made on holy days. The Temple continues to be invoked extensively in Orthodoxy, whereas the Conservative movement retains mentions of the Temple and its restoration but removes references to the sacrifices carried out therein. The Reform movement, however, has largely replaced mention of the Temple in Jerusalem with other features that would come to define its movement (such as social justice).

From Jerusalem to Beyond

Jews quickly spread throughout the globe, finding themselves in places far beyond the confines of Jerusalem and the Land of Israel. With no political autonomy of their own, they made their way to places like Muslim Spain (Al-Andalus). Taking up Arabic as their spoken and creative language, Jews now began to write secular poetry, philosophy, works of history, and *belles lettres*. Muslim Spain produced some of the most famous names in Jewish history, such as Abraham ibn Ezra, Judah Halevi, and Moses Maimonides. These Jews, and their descendants who moved to Arab-speaking countries in the aftermath of the expulsion of non-Christians from the newly unified Spain in 1492, are called to this day Sephardim or Sephardi Jews. While the essentials of Judaism are the same for all Jews, Sephardi Jews have slight variations in diet (eating legumes and rice

during Passover), customs (keeping Torah scrolls in cylindrical cases as opposed to velvet covers), rituals (reciting penitential prayers for the forty days prior to Yom Kippur), and so forth. Since synagogues always take on and adapt local architectural structures and motifs, many Sephardi synagogues employ arabesque patterns and columns.

Other Jews made their way to the West, to central and eastern Europe, and are known as Ashkenazi. These Jews also built homes and communities and began to speak the languages of the places they dwelled in, as well as their own hybrid language known as Yiddish. As Jews encountered ideas associated with, in chronological order, medieval Aristotelianism, the Renaissance, and the Enlightenment, they began to rethink Judaism—and the place of Jews in the modern world.

The Ashkenazi community also witnessed forms of anti-Semitism—the hostility to, and prejudice or discrimination against Jews. This would have numerous effects on European Judaism in general and synagogue architecture in particular. We will see, for example, the burning, destruction, abandonment, and concealment of houses of worship. Indeed, there are many countries in Europe where all traces of Jewish presence have been erased on account of anti-Semitism. Yet, if some Jewish communities tried to conceal their worship, others sought to create grand architectural edifices to demonstrate their strength. Though anti-Semitic attacks were responsible for the destruction of Jewish houses of worship, we also see them being rebuilt, and with new additions.

In places like Germany, speeding up to the nineteenth century, most of the current forms of Judaism—Reform, Orthodox, and Conservative—emerged, as various ways to integrate with the contemporary nation-state. At stake in all of these conversations, and in the denominations they produced, was the relationship of the Jews to the commandments. How and to what extent, for example, should they be performed in the modern world?

In other places, such as eastern Europe, Jews, for the most part, remained in their traditional communities and retained the religious and social rhythms that had guided them for centuries. It was here that Haredi, or ultra-Orthodox Judaism, was born.

As the forces of change blew across twentieth-century Europe, Jewish life—traditional, secular, and every shade or gradation in between—gradually began to wane and risked disappearance. This culminated in the horrors of the Shoah, or the Holocaust, which practically brought an end to the Jewish presence in Europe. Jews increasingly settled throughout the world, as the following pages will reveal in beautiful detail, in places such as India, China, the South Pacific, Australia, and of course, the Americas.

Special attention should be paid to the United States of America. It was here that Jewish life entered perhaps one of its richest phases. No longer defined by the anti-Semitism or anti-Judaism of the Old World, Jews increasingly became part of the fabric of American life and culture. If still imperfectly, Jews now entered the mainstream of American social, political, and economic life in ways that were hitherto unknown to them in other parts of the globe.

Everywhere Jews have been, and wherever they have existed and continue to exist, they have left testaments to themselves, their neighbors, and their communities. What follows celebrates Jewish existence and faith in all their timeless beauty and variety.

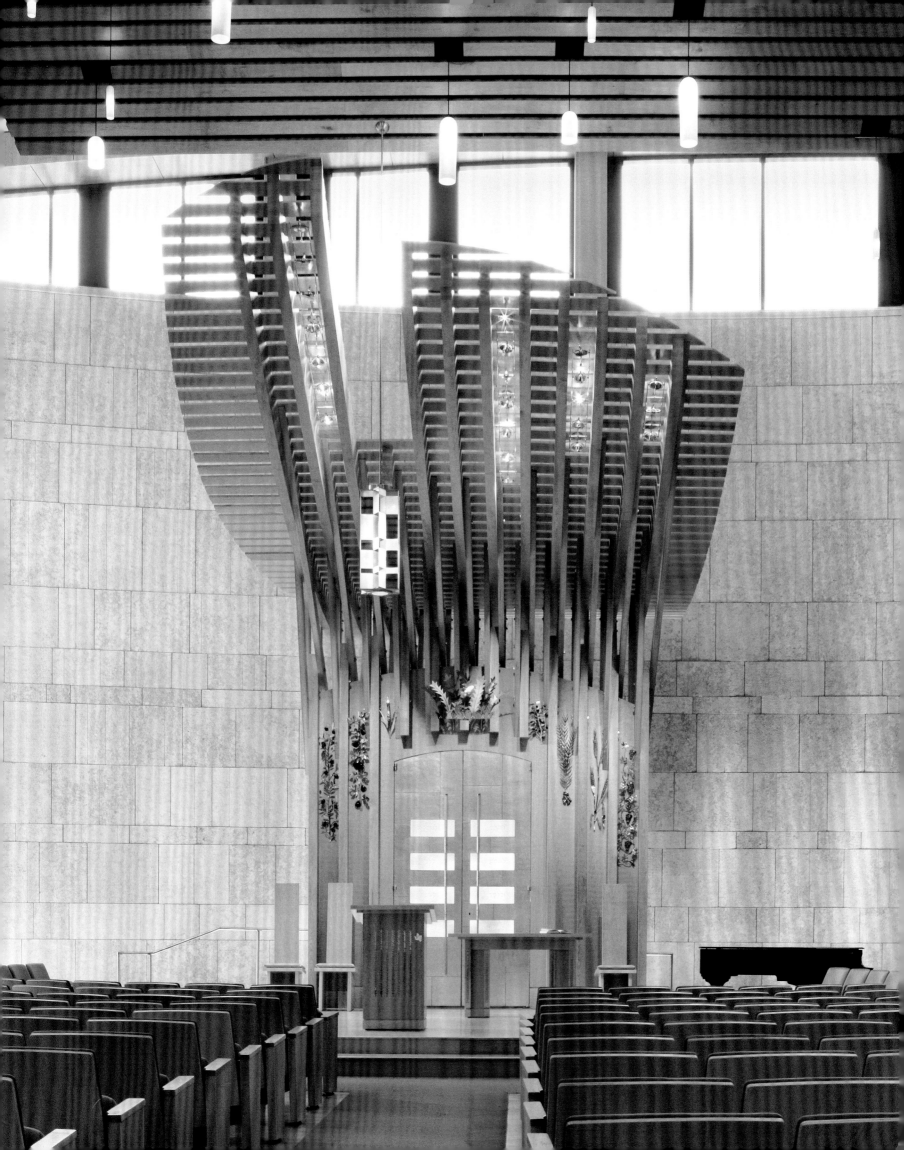

Elements of the Synagogue

Aaron W. Hughes

We find synagogues across the globe, in wonderfully diverse contexts, in all those places where Jews abide or have lived. They can be small and intimate or grandiose and elaborate. No matter the place and no matter the level of majesty behind its vision and construction, the synagogue represents, perhaps more than anything else, the rhythm of the community that resides in its proximity and expresses itself in its light. While the synagogue is certainly a space that is, at least in theory, open to all Jews, regardless of their place of birth or country of residence, we must also acknowledge that each sanctuary is abundant with the particularities and customs of its community.

When all of these particular synagogues are imagined as intimately and intricately connected to one another, and not just as a loose collection of individual and organic structures, however, the beauty and the majesty that define them across time and geographic distance quickly become clear. Viewing them in this manner, one is struck by the sheer architectural and aesthetic magnitude that stretches across the horizon of the Jewish world. From Cape Town to Glasgow, from New York to Shanghai, and virtually every place in between, one finds in these marvels of Judaism something of the spiritual beauty of the tradition beautifully coupled with the resplendence of local artisanal customs.

The synagogue exists on multiple levels. First, and most importantly, it represents the house of God, the place wherein the heavenly and divine presence resides on earth. Secondly, it exists as each community's ledger, the place upon which its celebrations and its tragedies are recorded for future generations. In this, the synagogue has signaled, and continues to signal, spiritual comfort and wishes for material safety for each of its local Jewish communities. Third, and finally, since synagogues are architectural structures and not just religious buildings, they must be studied and appreciated in all of their rich materiality and beauty, whether elaborate or humble. It is at this final stage that we may appreciate the materials used to build the synagogue and the glamour of its adornments—the sheer aesthetic qualities.

It is upon each of these three overlapping levels, then, that we witness—from both local and global perspectives—something of the role and place of the synagogue in Jewish life and practice, and the history of its art and architecture.

A Brief History

Ever since the destruction of the Second Temple in 70 CE, Jews have found themselves dispersed throughout the globe. This diaspora was responsible for the introduction of new cultural forms as Jews increasingly interacted with the local communities in which they found themselves. As the Temple lay in ashes, Jews made their way westward to Sefarad (Spain, North Africa, Turkey, and central and southern Asia) and eastward to Askhkenaz (central and eastern Europe). From such places, they made their way farther—to the New World, to Asia, to the Pacific, and to sub-Saharan Africa.

Most significantly for our story is the fact that since Jews no longer had a Temple, a place wherein priests sacrificed animals and other offerings, they needed to find new ways to be religious. One of the main ways they did this was through Torah study and the devotional reading of religious texts in a communal space. Books thus began to take on as valuable a role as architecture. The performance of a distinct liturgy to commune with the God of Israel now replaced a Temple service predicated on sacrifice.

Judaism was now portable. No longer dependent on a specific place—the Temple Mount in Jerusalem—the religion could be practiced anywhere in the world that Jews found themselves. The synagogue—from the Greek *synagogē*, or "assembly" (hence the Hebrew term *beit ha-knesset*, or "house of assembly")—now took on, in the Temple's absence, a central and defining role in the religious and spiritual lives of Jews. In this, it might be worthwhile to clarify nomenclature: While more liberal denominations (such as Reform and Conservative) refer to their synagogues as temples, observant Jews refuse to do so since they hold out for the rebuilding of the one true Temple in Jerusalem. They instead refer to their synagogues as shuls, or schools.

Clockwise, from top left: Over the centuries, synagogues have adopted a myriad of forms, from this discreet door in the Jewish ghetto in Fez, Morocco (Ibn Danan Synagogue, ca. mid-seventeenth century, restored 1996); to a pastel-colored Dutch colonial building in the Caribbean (Mikvé Israel-Emanuel Synagogue, Willemstad, Curaçao, 1732); to a unique modernist masterpiece in Munich (Ohel Jakob Synagogue, 2006), inspired by the architecture of the Temple of Jerusalem.

Clockwise, from top left: A traditional Star of David and a mezuzah adorn the Abuhav Synagogue entry in Safed, Israel (fifteenth century; restored in the late nineteenth century and again in the 1990s); in accordance with Sephardi practice, the wooden bimah of the Esnoga in Amsterdam (1675) is located opposite the equally precious wooden ark containing the Torah scrolls; the gathered white mechitzah curtains divide the male and female congregants of the Great Synagogue of Bucharest in Romania (1847); the ark of the Grande Synagogue of Paris (1874) houses Torah scrolls crowned with rimmonim ornaments and covered with embroidered mantles.

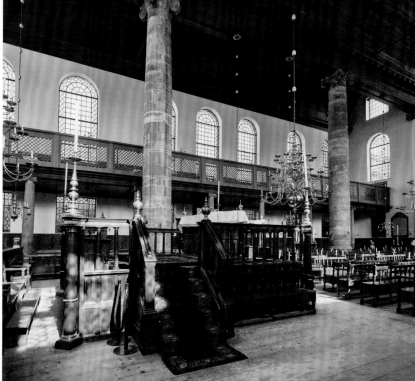

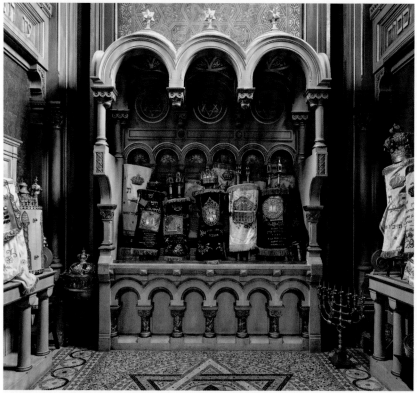

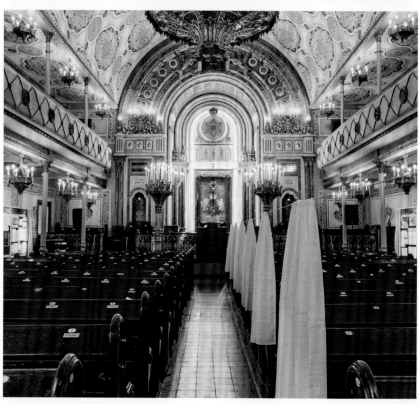

Regardless of the terminology employed and the country in which religious Jews find themselves, the synagogue is at the heart of their daily or weekly rhythm. It functions as the communal space where Jews gather, pray, study, socialize, and celebrate the rites of passage that have sustained them for generations. Though in theory a synagogue is anywhere Jews gather for religious observances, and thus any space can function as such, synagogues, as the present volume shows in glorious detail, are also those elaborate architectural structures that have allowed Jews to express their desire for permanence in particular places. The synagogue, perhaps more than any other institution, symbolizes Jewish existence, in particular the need to create a religious home to take its natural place among the elaborate houses of worship of other religions. While aesthetic styles often reveal the influence of local customs, the space inside remains uniquely Jewish.

Synagogues thus represent the quest for Jewish permanence. They symbolize Jewish belonging in a world in which Jews have most always functioned as a minority. The synagogue, more than any other physical structure, demonstrates safety in the midst of chaos, the place where Jews are able to congregate in a community and communicate with the God who has redeemed them numerous times in the past, from the Exodus to survival after the Holocaust.

The synagogue, which historians date to as early as the Second Temple Period, meaning that it would have coexisted for a time with the Temple, has long existed as the place for prayer and the study of Torah. If the Temple was the place where, among other things, animals were sacrificed to the God of Israel, the synagogue functioned as the place where a different type of leadership, one with expertise in study and the knowledge of traditions, ministered to the community. With the Temple's destruction, however, the synagogue became the place par excellence for Jewish worship. It was the institution that, for all intents and purposes, gave us the Judaism that we have today.

Though Jewish law (Halakhah) maintains that communal Jewish worship can be carried out wherever a minyan, or quorum, of ten Jewish males assembles, it was the synagogue

that would function as the epicenter of Jewish religious life. Though synagogues are uniquely Jewish spaces, there is no set blueprint for what one ought to look like or how it should be constructed. Their architectural shapes and their interior spaces thus reveal considerably rich variety dependent upon country and even region. This is why the following chapters are arranged accordingly, where we see clearly the rich cross-pollination between Jewish religious expression and the local cultures wherein Jews found themselves.

Interior Elements

The synagogue represents a microcosm of the universe. It is the place in which the divine presence as embodied in the Torah scrolls, the symbol of God's communication to Jews, resides. Without the Torah there is no guidance, no path for life, and most importantly, nothing to comment upon or argue with. As the home for Torah scrolls, the synagogue becomes the place where Jews congregate, pray, and socialize. Like the home, it is a place whose walls signify it as uniquely Jewish space.

From the moment one crosses the threshold and touches the mezuzah—the parchment and its case, which sanctify the space as Jewish—one beholds the majesty of the space within. Since, again, there is no set format for what synagogues should look like, no two are exactly alike. They can be as spartan or as glamorous as the community wants them to be. In this respect, the synagogue is not just an architectural structure, but the physical and aesthetic embodiment of the community that constructs it. The synagogue, in other words, represents how the community sees itself and, just as importantly, how it wants to be seen by others.

As one crosses the threshold and properly enters the space within, one sees the manifold ways in which Jews divide up the synagogue's space. While certainly every synagogue possesses a large, often very large, place for public prayer, also known as the main sanctuary, many also contain a myriad of smaller rooms that simultaneously divide and personalize the space within. These can include rooms for study and social halls, in

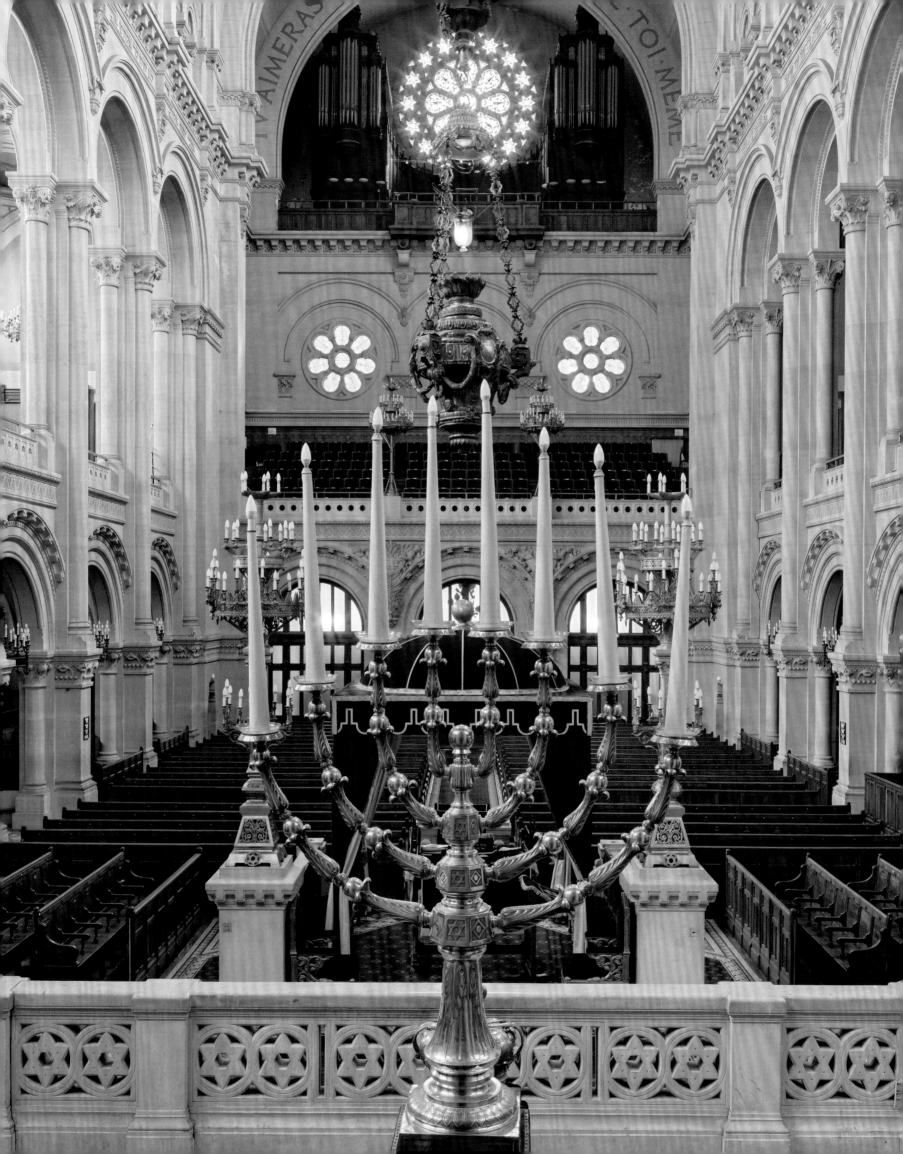

Opposite: Menorahs have decked synagogues since antiquity. This monumental silver example, a gift from Baron Gustave de Rothschild to the Grande Synagogue of Paris, placed before the ark, emphasizes the synagogue's symmetry and grandeur. Despite a fascist bombing in 1941, miraculously, most of the synagogue survived World War II due to the Nazi's policy of protecting Parisian historic sites.

Below, clockwise from top left: Most synagogues today bear a Star of David, often in multiple forms: in stained glass, inscribed with the letters for God in Hebrew from the rose window of the Templo Libertad in Buenos Aires (1932); in a painted stenciled design from the ceiling of the Spanish Synagogue in Prague, interior redecorated in 1882–83; in the crown-glass windows from the Tempio Maggiore Israelitico, in Florence (1882); in gilded bronze in an arch in Temple Emanu-El in New York (1930).

In addition to the older menorah and Tablets of the Law, the star as an emblem of Judaism became particularly popular in the late nineteenth century.

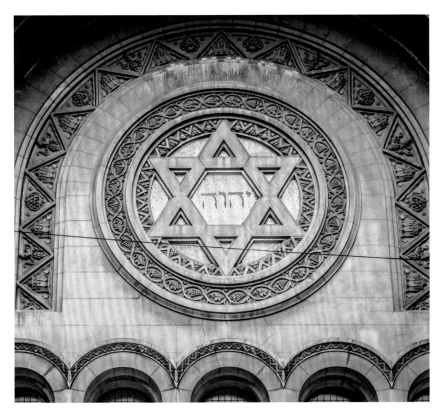

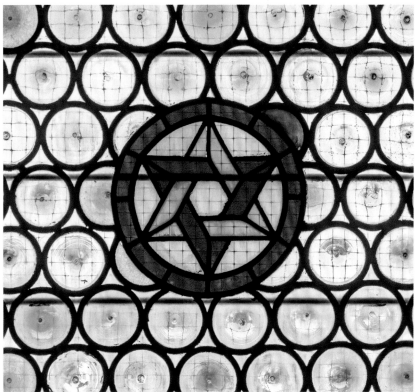

addition to offices for the rabbi and his or, depending on the denomination, her administrative staff. Many synagogues also possess a separate room for Torah study, called a *beit ha-midrash*, or "house of study," or a library of Judaica where congregants can read, study, or take classes.

Returning to the main sanctuary, one finds a bimah, often a raised platform from which portions (*parochet*) of the Torah and *haftarah* (proscribed sections from the prophetic words of the Bible) are read and from which the rabbi offers his sermon (*derash*) on the weekly portion. In Orthodox Judaism, the bimah is frequently located in the center of the synagogue, separate from the ark, where the Torah scrolls that are read on a weekly basis are housed. In other branches of Judaism, it is not uncommon to find the bimah and the ark joined together and located at or near the front of the synagogue. One also finds two flags on the bimah, the Israeli flag and that of the country in which the synagogue is located. This is in addition to various plaques and/or other votive elements that help further commemorate the space within for the community as it has existed across the generations. The synagogue, to reiterate, is not just a space, but, and most importantly, part of the lifeblood that nourished—and indeed continues to nourish—particular Jewish communities across time and geography.

All synagogues also possess a *ner tamid*, a constantly lit light, that either hangs or stands in front of the ark. This light functions as a reminder of the menorah that would have stood in the Temple in Jerusalem, in addition to symbolizing the continuously burning fire that would have existed on the altar, from which burnt offerings would have been made.

Orthodox synagogues also feature a *mechitzah* (partition) that divides the men's section from the women's. Alternatively, such synagogues may include a gallery, an open upper story above an aisle of a nave, reserved for women's seating. In large Reform congregations, however, this upper space tends to be used for overflow seating on the High Holidays, especially the New Year (Rosh Hashanah) and the Day of Atonement (Yom Kippur).

Accounting for Diversity: A Brief Note on Denominations

The Reform movement arose in the early nineteenth century in Germany and made many changes to the traditional look of the synagogue. This was in keeping with Reform leaders' wish to remain Jewish, yet also to show themselves as fully assimilated into German culture.

The first Reform synagogue, which opened in Hamburg in 1811, introduced a number of features designed to make the synagogue appear more like a German Christian house of worship. These included the installation of an organ to accompany the prayers (including on Shabbat, a time when Jewish law forbids the playing of musical instruments); a choir to accompany the hazan; and vestments for the synagogue rabbi to wear. Eventually, Reform synagogues moved the bimah from the center of the synagogue to the front of the sanctuary. It also removed the mechitzah and promoted mixed seating, a practice that the Conservative movement also promotes. Most Conservative synagogues today follow a similar practice.

A synagogue, to conclude, represents an accessible Jewish space. Much more importantly, however, it is the place that tells the story of its community. Those who built the synagogue, those who perished on account of it, and those who dedicated their lives to its upkeep and sustenance are all inscribed or otherwise commemorated in its very walls. The celebration of the community's births and marriages, and the mourning of its deaths, all take place within the sacred space that the synagogue opens up before its congregation. The synagogue, more than anything, is the embodiment of its people. An organic space, it nourishes the community as much as the community nourishes it.

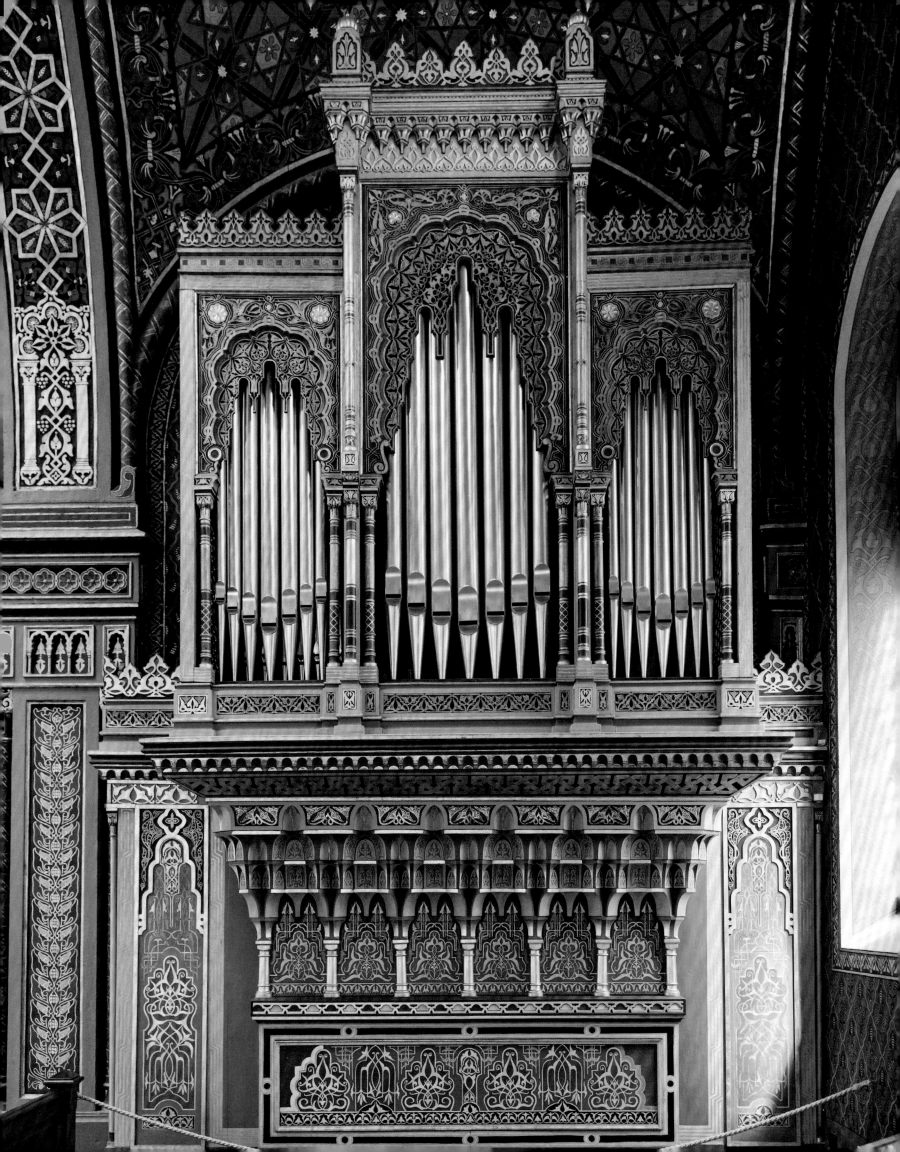

1. Synagogues in the Roman World

Steven Fine

Ancient authors imagined that synagogues had existed since the time of Moses himself—that is, almost forever. Others believed that Abraham had frequented the synagogues of his day, and that after death the righteous spend eternity in heavenly synagogues. The idea that Moses ordained the synagogue as a place where scripture was publicly pronounced and studied by the assembled community of God was so well rooted by the first centuries CE that it became a truism—cited by the historian Flavius Josephus, the New Testament, and the ancient rabbis.

Greek speakers called this place a *sunagogē*—Greek for an assembly or place of assembly. The Hebrew name also reflects its primary function—*beit ha-knesset*, or "house of assembly." Some Greek-speaking communities preferred the word *proseuche*, Greek for a "place of prayer." Synagogues existed throughout the Roman world and among Jews of the Persian east—particularly in Babylonia (modern Iraq) in the south. The spread of synagogues was nourished by a larger trend in Hellenistic and Roman religion that saw the rise of small like-minded communities, sometimes professionally based, and often made up of expatriates, who established cultural and religious associations. These new associations and their houses of worship emerged alongside the great temples that populated the urban landscape.

The First Temple in Jerusalem, the heart of the Jewish universe, was built by King Solomon, destroyed by the Babylonians in 586 BCE, and rebuilt seventy years later. It was completely transformed into one of the most magnificent buildings of the Roman Empire by Herod the Great (beginning 20/19 BCE). Called "the one Temple of both residents and the one God" by Josephus, synagogues served pilgrims to the holy city, and there were synagogues near the Temple Mount. With the destruction by Roman emperor Vespasian of the Temple in Jerusalem in 70 CE, the heart of Jewish life increasingly centered on the synagogue, which became the primary locus of liturgy and community gatherings in subsequent centuries. Over the coming years, synagogues developed as "sacred places" in their own right. Latin-speaking Jews in North Africa called their place of assembly the *sancta synagoga,* while Greek speakers referred to it as *hagios topos*, and Aramaic speakers named it the *atra qedisha.* In all of these languages, the synagogue was a "holy place," developing over time liturgies and architectural forms worthy of this lofty title.

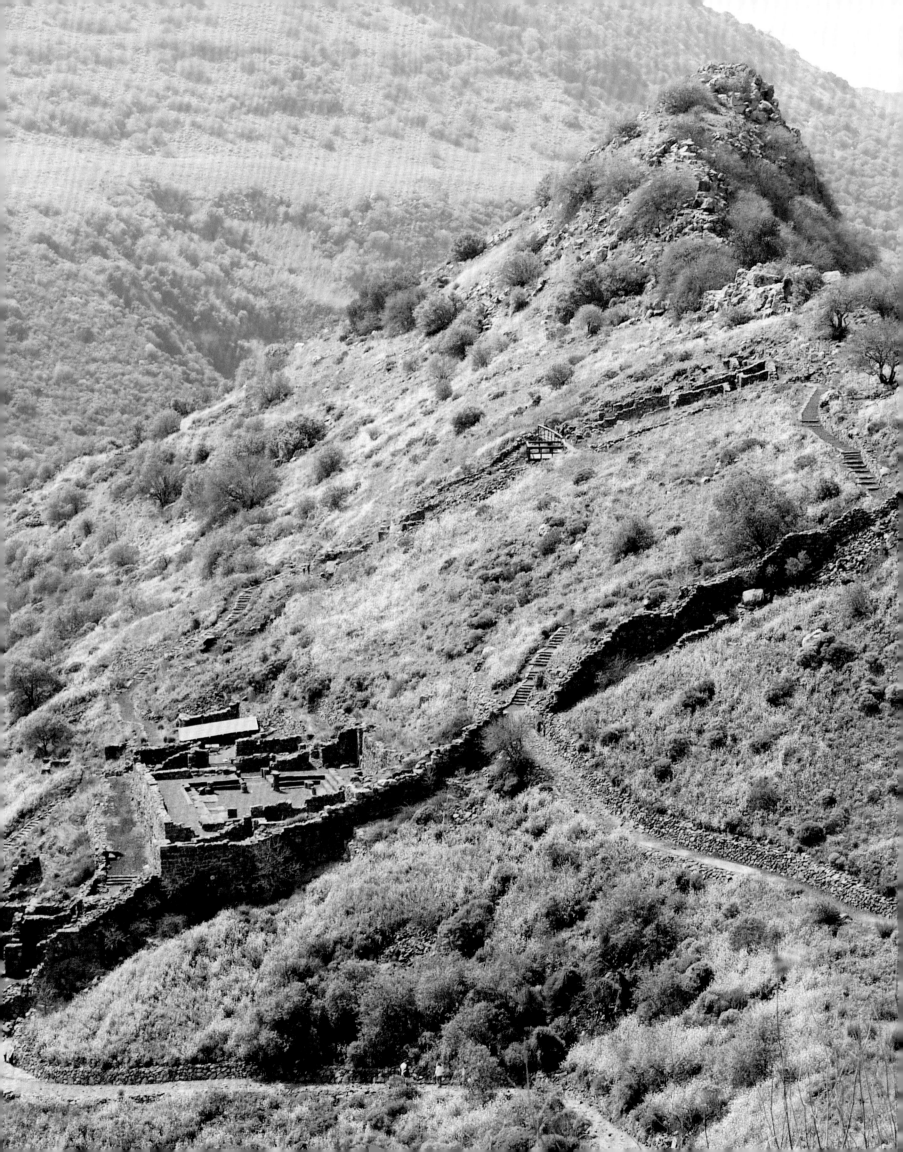

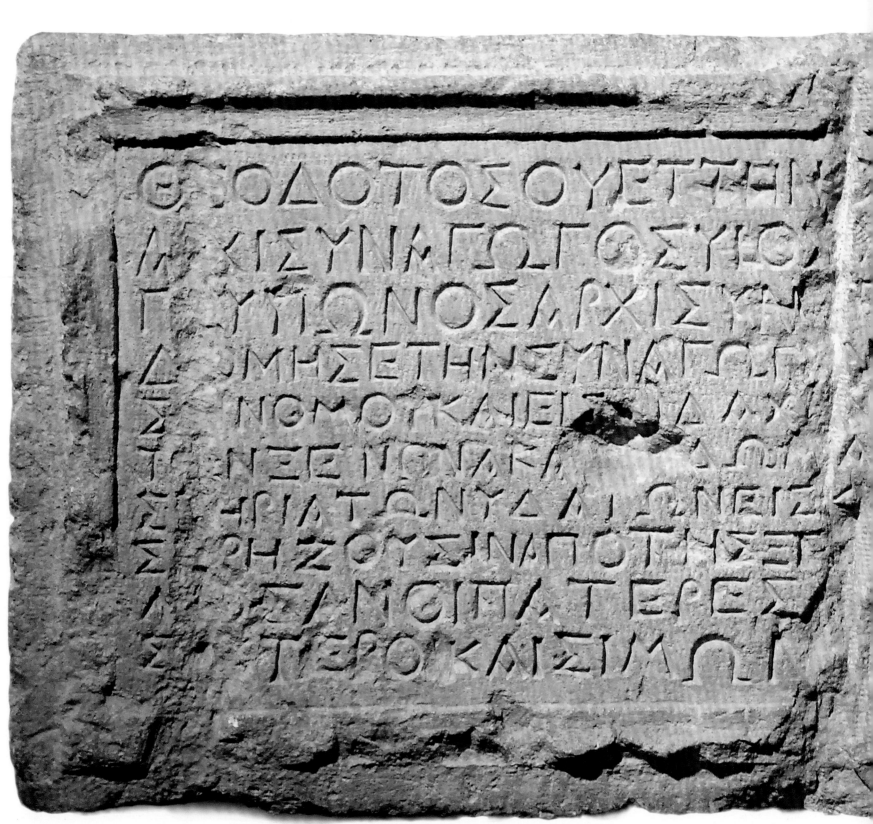

Pages 36–37: Perched high above the Dead Sea, the first-century Masada synagogue, with its facing benches, is similar in design to the Gamla synagogue. It testifies to the fortress's final occupation by the Jewish rebels before their bloody defeat by Roman forces (66–74 CE).

First-Century Synagogues

Synagogue buildings dating to the first century CE were built in Jewish towns across Roman Palestine. The most impressive are the monumental buildings in the city of Gamla in the Golan Heights and Magdala on the northern shore of the Sea of Galilee. The Gamla synagogue was a large public building built on the eastern side of this walled city. Constructed of local basalt that was likely covered with polychrome plaster, the Gamla synagogue followed a rectangular plan (83½ by 56 feet), oriented along a northeast-southeast axis. The main entrance faced west, with an exedra and an open court in front. A ritual bath (mikvah) occupied the right side of the court. Typical of first-century synagogues, the center of the hall was surrounded by stepped benches. A small basin discovered on-site probably served for handwashing. No permanent Torah arks or other liturgical furnishings existed in first-century synagogues. That took a bit more time.

Characteristically, stepped benches were also built around the interior walls facing the center of the Magdala synagogue. The walls featured beautifully colored frescoes of which only fragments remain. At the center of this hall is a unique rectangular footed limestone block of unknown usage, decorated with the image of a menorah on a pedestal and other imagery typical of Jewish art of this period. This menorah is important because it is the only distinctly Jewish symbol to appear in a Second Temple Period synagogue, significantly one drawn directly from Temple imagery.

The Masada synagogue was not originally built as a house of worship. It occupies a rather large 33-foot-square room that was designed as a stable in Herod's remarkable fortress on the Dead Sea. The Jewish rebels of the First Revolt (66–74 CE) transformed this room, adding benches on each wall and a small room on the northwestern wall, within which fragments of the books of Deuteronomy and Ezekiel were discovered. All of the scrolls uncovered on Masada were found in close proximity. The construction of this room on the northwest corner of the synagogue suggests that the liturgy may have been directed to align with Jerusalem. A brightly embroidered cloth wrapping for

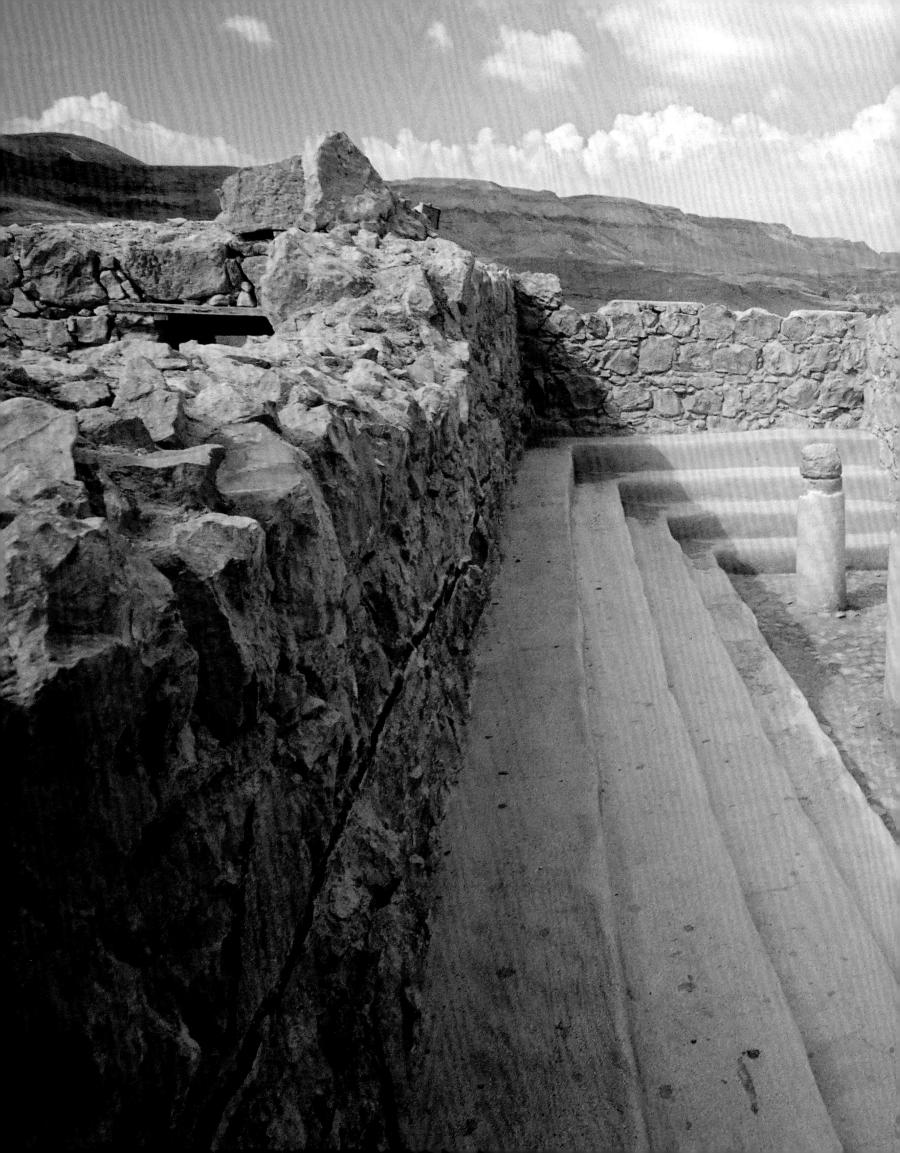

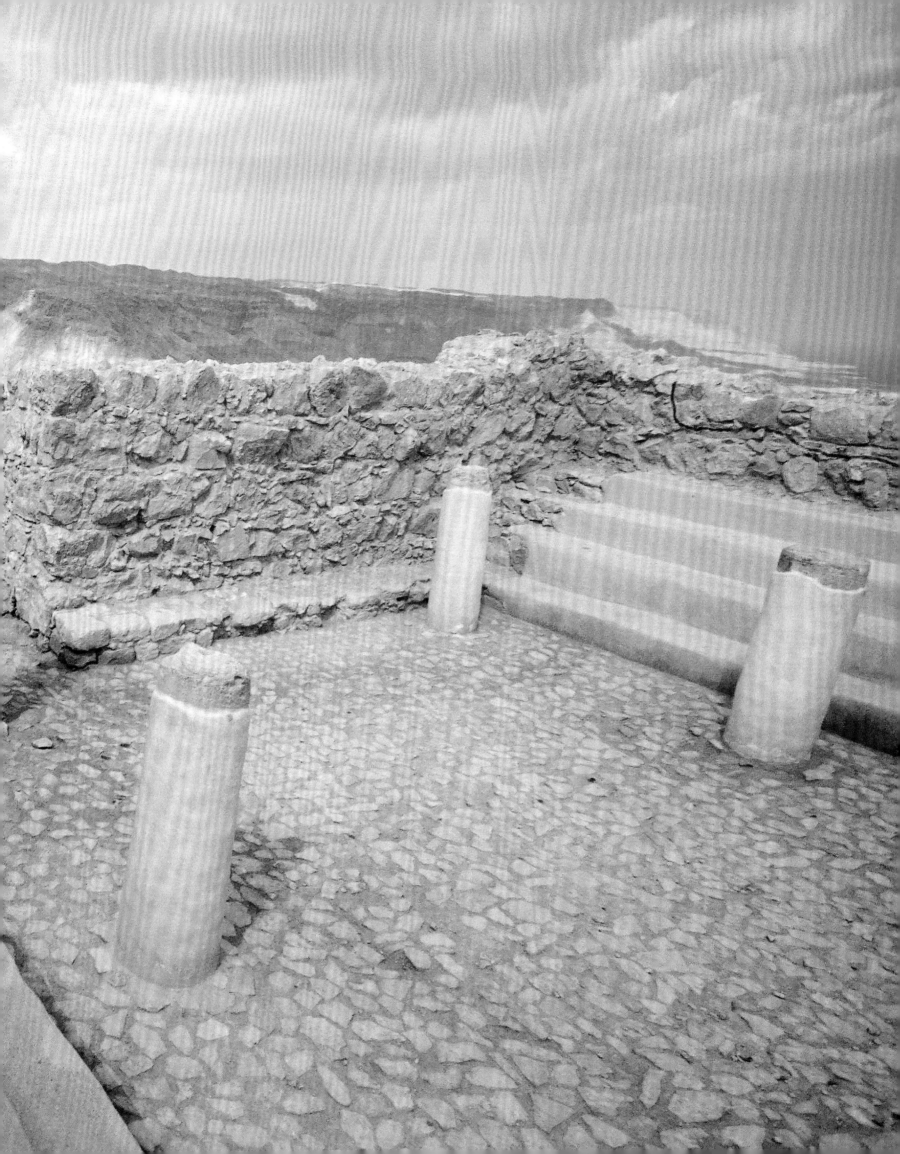

a scroll discovered in situ appears to have added a bit of color to this otherwise stark, improvised synagogue.

A finely carved Greek dedicatory inscription is all that remains of what must have been a Jerusalem synagogue of the first century. It describes some of the activities that took place in synagogues during this period, and the role of their leaders:

"Theodotos, son of Vettenos, priest and synagogue leader, son of a synagogue leader, and grandson of a synagogue leader, built the synagogue for the reading of the Torah (nomos) and teaching of the commandments, and the guest house and the [other] rooms and water installations for the lodging of those who are in need of it from abroad, which his fathers, the elders and Simonides, founded."

The Theodotos inscription memorializes three generations of priestly family leaders within the synagogue. This inscription testifies to the overriding significance of the public reading and interpretation of scripture within synagogues. The synagogue of Theodotos stood on the slope of the Temple Mount. Like the synagogues of "Freedmen" (as they were called) of the Cyrenians, of the Alexandrians, and of those in Cilicia and Asia (Acts 6:9), Theodotos's synagogue undoubtedly served the diaspora communities in Jerusalem, particularly visiting pilgrims. The "water installations" and lodgings point in this direction, as the "purity" of body and soul, achieved through ritual immersion, was a requirement for ascent to the Temple, and may be related to the synagogue itself, as at Gamla.

Synagogues of Late Antiquity

Following the destruction of the Temple, Judaism entered a period of reconstruction and reformulation. As it became clear that the rituals and sacrifices of the Temple would not return quickly, this process intensified. Central to this transition were the rabbis of the Talmud, who flourished in Roman Palestine and Sasanian Babylonia, and served as the literati of these communities. Their writings fill the gap between the Temple destruction and the earliest monumental archaeological

remains during the third century and were written in the Land of Israel well into the early Islamic period (in tandem with the known archaeological record). Early rabbinic sources describe an institution that was endowed with an inherent sanctity of its own, with prayer aligned with a box containing the holy scriptures and onward toward Jerusalem. This did not yet constitute an "ark" reminiscent of the Ark of the Covenant, but a simple tevah, or "movable chest." Early rabbis wrote that, in the best case, synagogues should be built like the Temple on the high point of the town. They were places where a wide range of rituals took place throughout the Jewish year, providing a space for boys and men, and occasionally for women, to study scripture and tradition. This period also witnessed the development of a related institution, the beit ha-midrash, study house, which functioned similarly to synagogues for the rabbis and their students. Whether as "house synagogues" or public buildings, synagogues played increasingly vital roles in the communities in which they were established.

Synagogues of the third century through the eighth provided essential services on a local level, reflecting the styles and cadence of their immediate environments. Visitors would instantly recognize the synagogue, thanks to its large permanent Torah shrine, extensive seating for members, dedicatory inscriptions, and visual references to scripture and the Temple—particularly the menorah. At least 150 synagogues are known from literary and archaeological sources to have existed in Israel during late antiquity, and the same number from the Roman and Sasanian diasporas. Many were called "holy places" in their dedicatory inscriptions. Indeed, they were treated as such by Roman law through much of this period until the Christian empire slowly reduced the status of synagogues and legitimized their despoilment and seizure.

Monumental synagogues began to reappear during the third century, most dramatically at Dura-Europos on the Euphrates in Syria. The Dura-Europos synagogue originally served as a private house procured by the community near the western wall of the city. This complex was transformed over time,

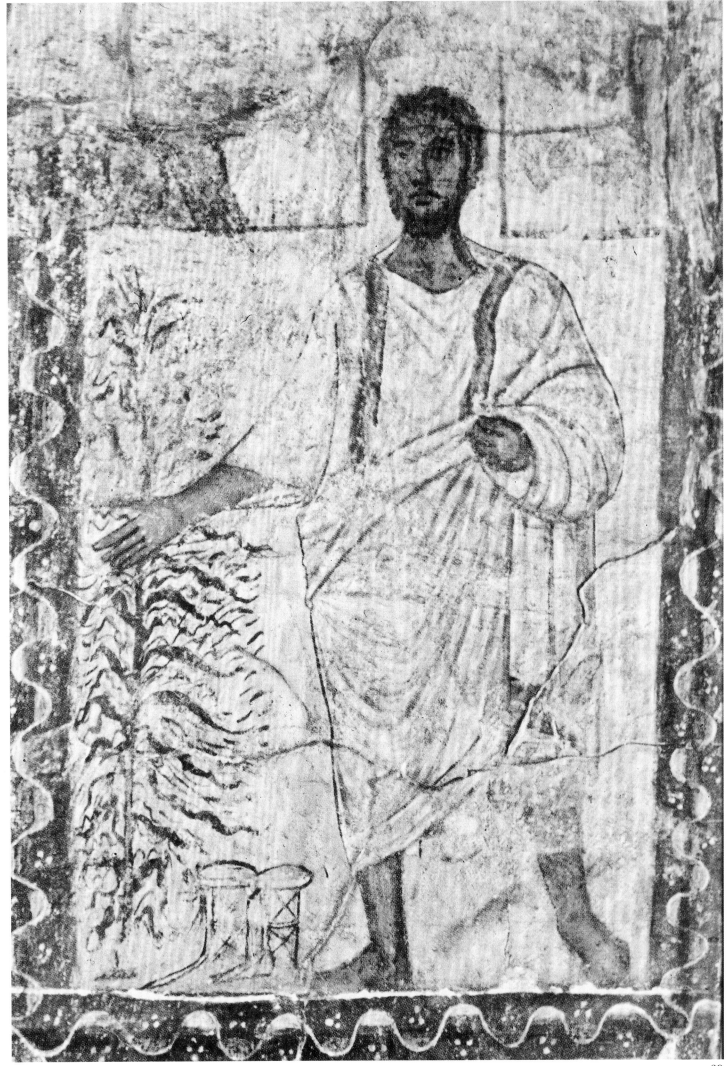

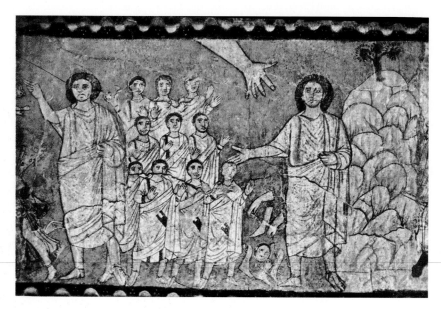

Below, top: This fragment depicts Ezekiel's prophecy of the Dry Bones on the Dura-Europos synagogue's eastern wall, now at the National Museum of Damascus. God is represented by a giant hand. The wall paintings appear to be related to Jewish interpretations of the Bible, which are called Midrash.

Below, bottom: A brilliantly colored mosaic panel representing Samson Slaying the Philistines from the synagogue at Wadi el-Hamam in Palestine (fourth century).

Opposite: The main entry to the majestic basilica-shaped Kefar Baram synagogue in Upper Galilee (late fourth to sixth centuries). The Syrian-style arch over the principal portal, adorned with grapevines, reflects late Roman architecture of this period. Such classical elements have served as a source of inspiration for many modern synagogues.

preserved only thanks to its burial within the defenses of Dura against Sasanian forces who destroyed the city around 256 CE. At the center of the synagogue complex, a meeting room measuring 14 by 25 feet featured benches on all four sides. Remarkably, the walls were covered with biblical scenes read through the lenses of Jewish folk tradition (*Aggadot*) and known to us mainly from rabbinic literature.

Sixty percent are preserved and now housed in the National Museum of Damascus. These include the Discovery of Moses by the Daughter of Pharaoh, the Crossing of the Red Sea, the Tribes of Israel Encamped around the Tabernacle, Elijah on Mount Carmel, the Ark of the Covenant in the Land of the Philistines, Ezekiel's Vision of the Dry Bones, and Mordecai and Esther before King Ahasveros. At the center of the western Jerusalem–aligned wall is a large, permanent Torah shrine—called the "House of the Ark" in an inscription, marking the first time the term "ark" is known from archaeological sources (though it was used by the rabbis about the same time). Nearby, archaeologists discovered a Hebrew liturgical parchment that is closely related to rabbinic prayer formulas and so gives us a sense of the kinds of Hebrew prayers that the faithful pronounced here. Visitors piously wrote graffiti in Aramaic, Greek, and Persian on the paintings. These help identify many of the scenes and provide us with a window into the inner religious life of the synagogue.

Archaeologists were astonished by the discovery of this brightly painted synagogue. One of the odder modern academic truisms has it that Judaism is an aniconic religion, completely averse to art. In fact, Jewish culture was never averse to "art," but only to imagery that Jews have construed as idolatrous and thus illicit—a standard that was viewed more strictly or loosely in each period and locale. The Dura-Europos synagogue is the most visible and well-known example of Jewish art in late antiquity. Near the same time, a public building in Tiberias that may have been a synagogue was decorated with wall paintings. A leading rabbi of his day, Yohanan son of Nafha was informed of this innovation and "did not interfere."

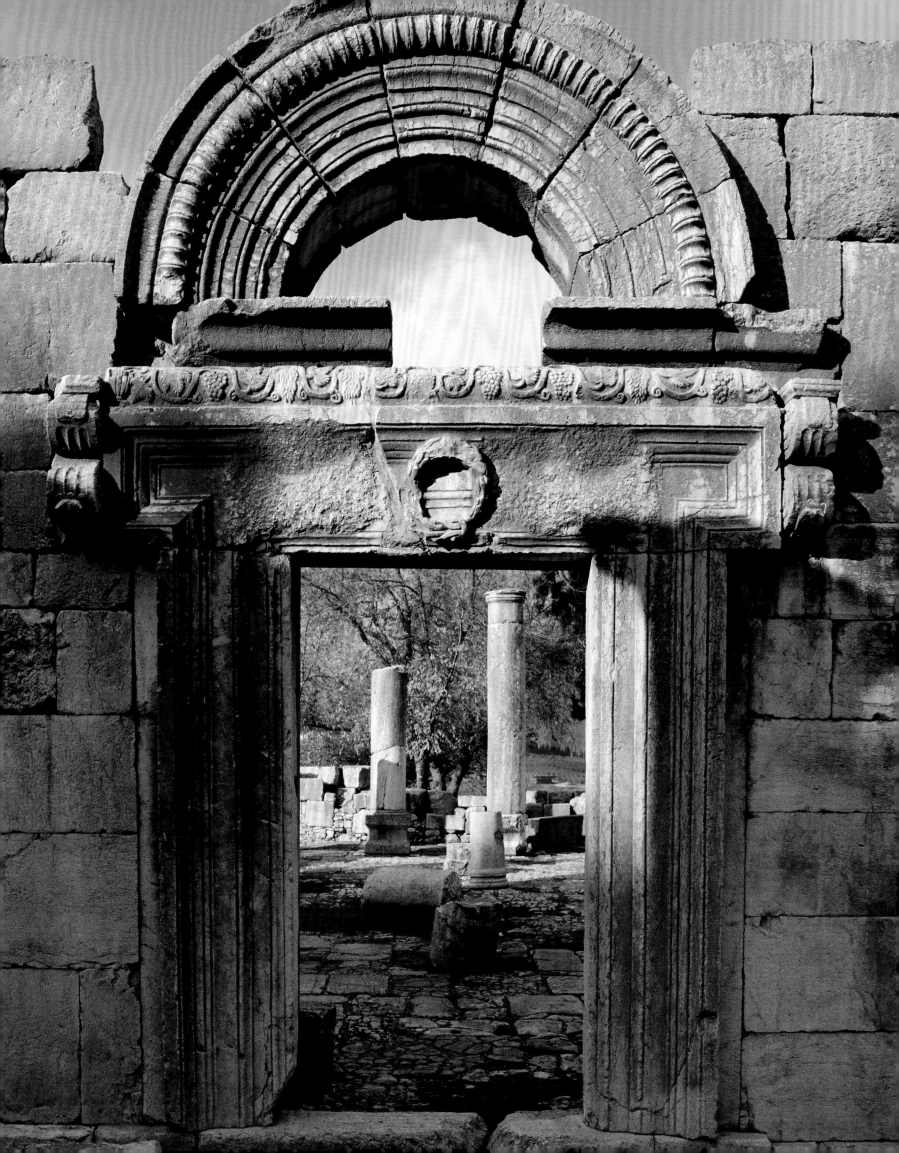

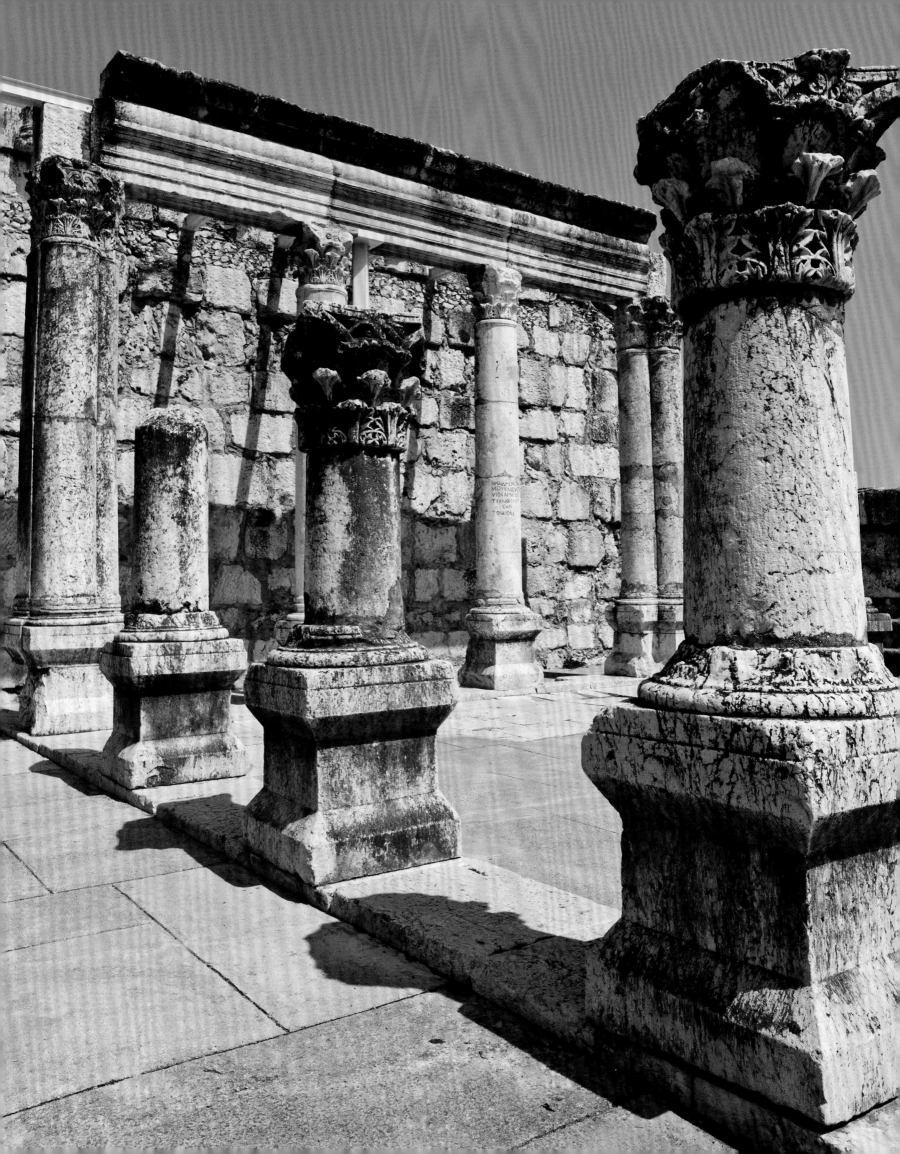

The fourth century through sixth witnessed an efflorescence of synagogue construction—not only in Israel but also throughout the Roman world. The synagogue at Wadi el-Hamam, northwest of the Sea of Galilee, is the first synagogue indisputably dated to the fourth century. Built in a basilical form, this building showcases an elaborate mosaic pavement, which contains scenes such as the Tower of Babel and the Crossing of the Red Sea as well as Samson Slaying a Philistine. The late fourth century through the sixth saw the wide adoption of the basilica form—typically a rectangular building with double colonnades and often a semicircular apse. "Galilean-type" basilicas, exemplified by the well-preserved synagogues of Capernaum on the northern shore of the Galilee and of Kefar Baram in the Upper Galilee, are related to the narrow gable churches of nearby Syria. As in these churches, the congregation entered the synagogue through three portals on the southern wall that gave access to the nave and two side aisles. There were benches on the sides and back wall, and sometimes a Torah shrine between the portals on the southern wall. This form continued through the sixth century in the recently reconstructed synagogue at Umm al-Qanatir in the Golan Heights and in the synagogues of Chorazim in the Galilee.

The synagogue at Hammath Tiberias dates from around 400 CE and served an urban elite community. A large Torah ark functioned as the focal point on the southern wall. Its well-executed carpet mosaic is composed of three principal panels directed toward the ark. The upper panel closest to the ark depicts the image of an ark flanked by lit seven-branched menorahs, thus mirroring the actual furnishings of the synagogue. The central panel features the zodiac with Helios, the sun god—a standard way to portray the sun at this time (while other synagogue floors represent both the zodiac and the labors of the Jewish lunar-solar calendar). The last panel bears an inscription flanked by two rampant lions. An Aramaic inscription in the western side aisle of the synagogue provides a means to understand how the ancients perceived the synagogue: "May there be peace on all who give charity and in the future will give charity in this holy place, *amen amen selah*

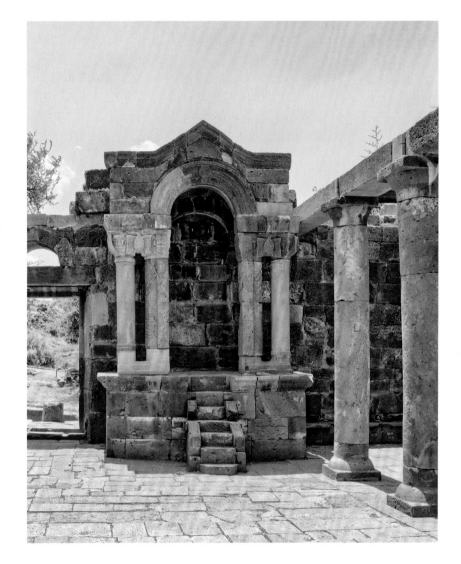

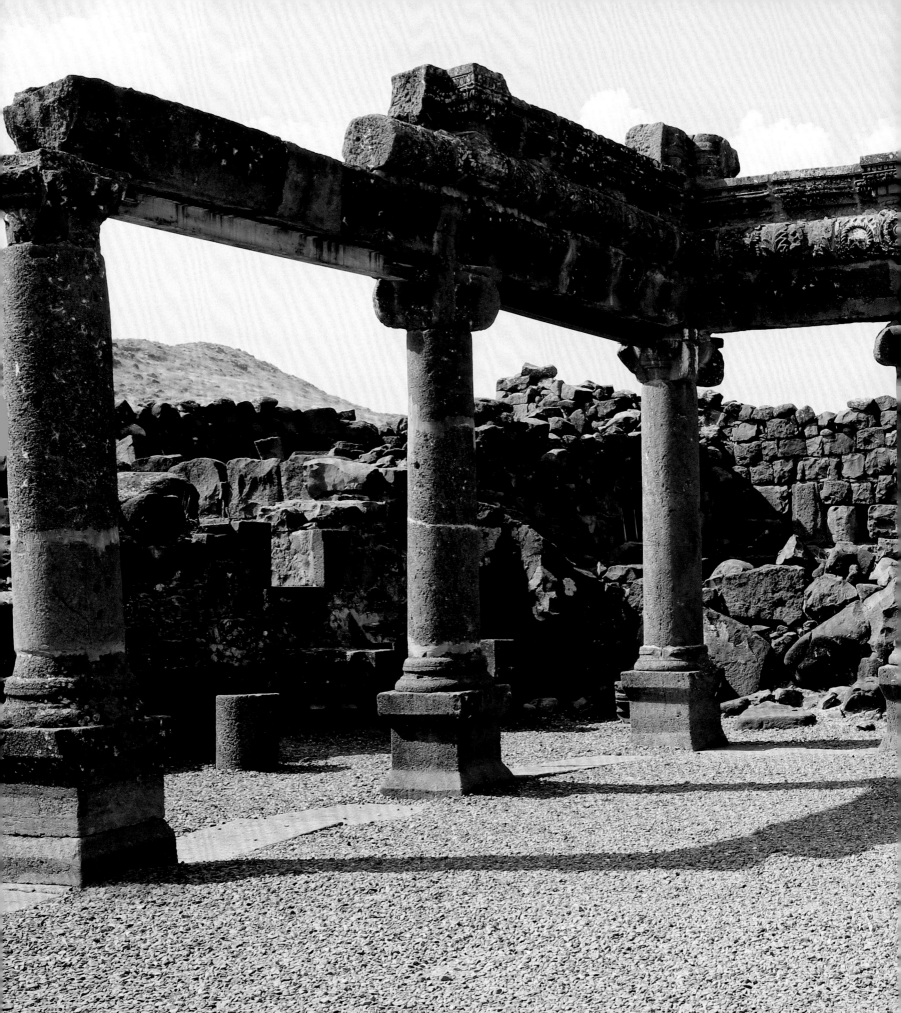

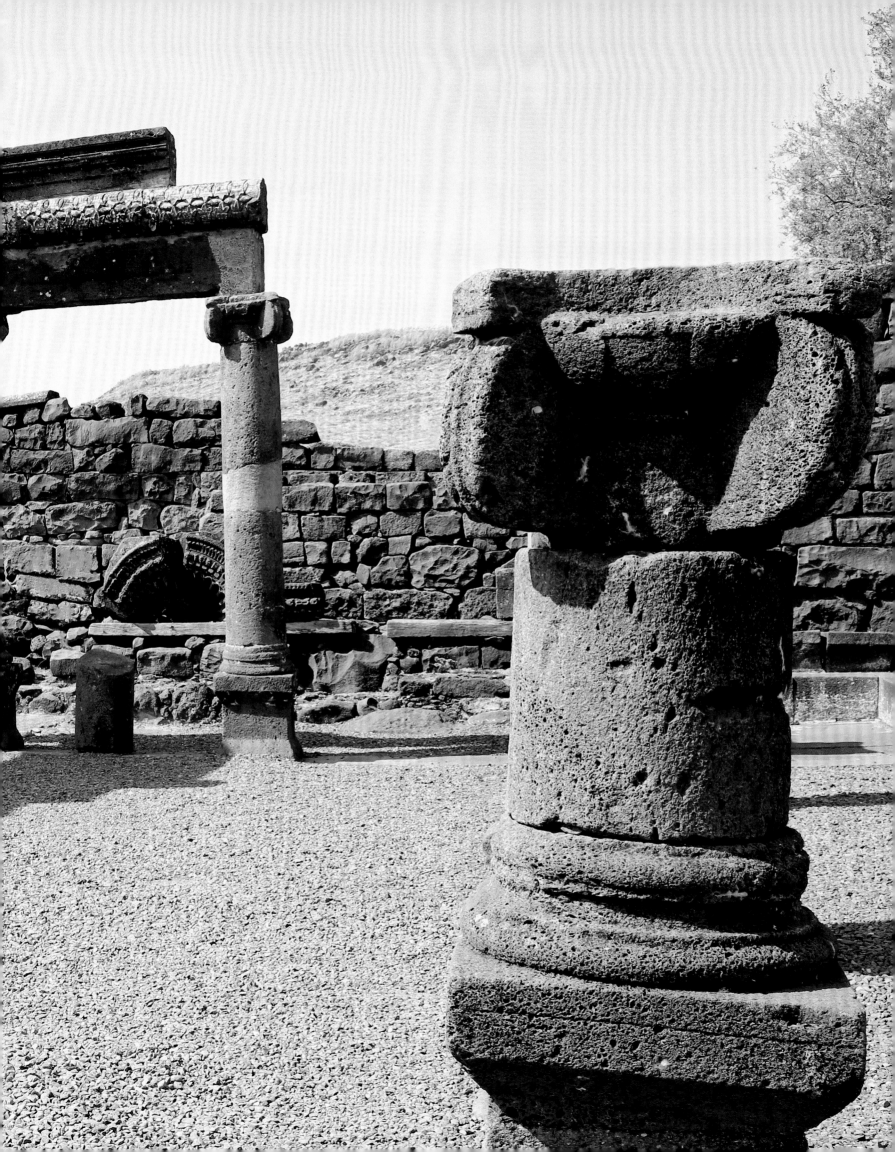

Below, top and bottom left: This fifth-century polychrome mosaic from the Hammath Tiberias in Israel is the first known example in synagogue decoration of the adoption of the zodiac with personifications of the seasons. At the center, Helios rides the heavens on a chariot drawn by four horses. To the south, two lit menorahs flank a Torah shrine. Greek and Aramaic inscriptions designate the synagogue as a "holy place."

Top right: The sixth-century mosaic from the Beit Alpha synagogue in Israel also features a zodiac theme. This time, the central panel accompanied by a scene depicting the Binding of Isaac (not shown here).

Bottom right: This mosaic from the Ein Gedi synagogue in Israel (sixth century) is characterized by animal, vegetal, and geometric motifs with no figural representation.

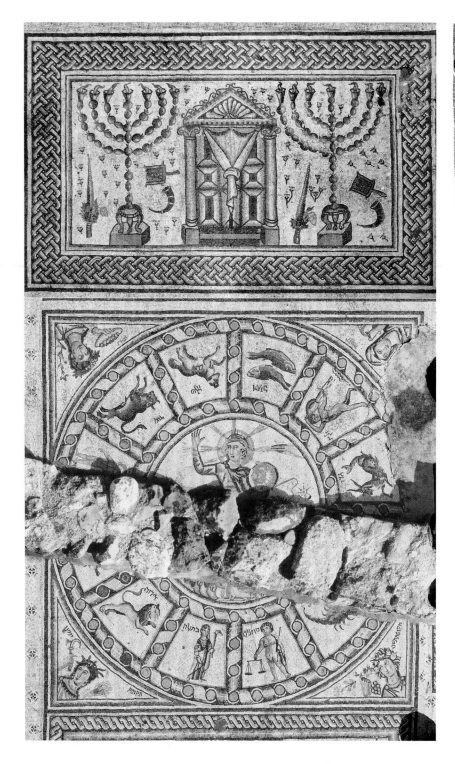

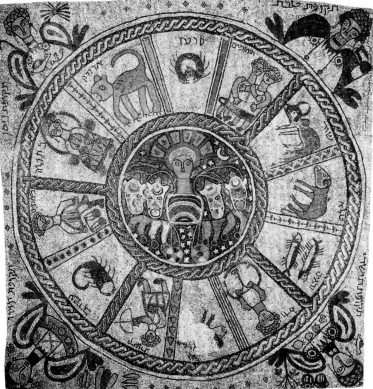

amen." At the northern side of the mosaic, there is a list of the donors in Greek, including "Severus, student of the Illustrious Patriarch."

The Beit Alpha synagogue near Beit Shean belongs to a rural tradition of the basilica with an apse containing the Torah shrine that was set off from the nave by a low fence. The floor mosaic is similarly divided into three panels, though it is far more rustic than that of Hammath Tiberias. Closest to the Torah shrine is a panel much like that at Hammath Tiberias containing the image of a Torah ark, its gable flanked by birds, lit menorahs, and rampant lions. The central panel contains the zodiac and, near the entrance to the synagogue, the image of the Binding of Isaac. Biblical themes with clear liturgical overtones appear in other synagogues, including David Playing His Harp and Daniel in the Lion's Den, with his arms lifted in prayer, imagery reminiscent of the Tabernacle and its rituals. Other themes include the Crossing of the Red Sea, the Tower of Babel, and Jonah and the Whale. Uniquely, the sixth-century synagogue at Rehov housed a twenty-nine-line Hebrew inscription detailing rabbinic agricultural practice. Closest to the main door of the Beit Alpha synagogue, a final panel commemorates in Greek the proud artisans of this mosaic: Marianos and his son Haninah. It is likely that the artisans were Jewish; note that the same team created the mosaic in a nearby Samaritan synagogue.

We know little of how the walls of Palestinian synagogues were decorated, other than that they were painted, thanks to small fragments of painted plaster discovered in numerous buildings. In the Rehov synagogue, an exquisite wreath enclosing a dedicatory inscription was depicted in earth tones on white plaster, together with liturgical and legal texts, a menorah, and various geometric and floral patterns. Typically, artists painted bas-reliefs in bright colors, highlighting scenes with numerous animals, people at their labors, and even Medusa. Remains of gilding were found on screen fragments in the Gaza synagogue.

In other synagogues, communities used nonfigurative representation, such as the mosaic at Ein Gedi, which includes birds, menorahs, and inscriptions—one of which lists the signs of the zodiac and the months of the Jewish year. The inscriptions here are particularly evocative, threatening anyone "who reveals the secret of the city to the gentiles" with divine wrath. A wooden screen encloses the Torah niche area. Near the niche, archaeologists discovered a small brass menorah, a brass chalice, and the burned remains of the Book of Leviticus, which has recently been unrolled digitally. With the rise of Islam, synagogue decoration changed in accord with the aesthetic of the new colonial ruler. Religious symbols predominated, as in the eighth-century Jericho synagogue, which is decorated with stylized symbols and geometric patterning but no images of humans or animals. At numerous sites, including especially Na'aran (a village north of Jericho), synagogue mosaics were iconoclastically purged of animal and human images.

The bustling ancient port of Rome, Ostia, and the wealthy city of Sardis in Asia Minor boast notable diaspora synagogues of late antiquity. The Ostia synagogue building, originally constructed toward the end of the first century, was enlarged during the second and third centuries, and further expanded as a synagogue at the beginning of the fourth century. During the fourth century, the southernmost entrance portal on the eastern wall of the synagogue was sealed and replaced with a large freestanding Torah shrine. This Torah shrine relates iconographically to images of shrines in wall paintings and on gold glasses discovered in the Jewish catacombs of Rome, as well as to scenes on oil lamps discovered in Ostia. The Ostia synagogue bore a number of standard Jewish symbols, including an image of the menorah carved prominently on two of its architectural elements (see pages 30–31). Inscriptions from the catacombs suggest that ancient Rome hosted numerous synagogues and that their congregations included women, who served as "mothers of the synagogue" and "priestesses." We know nothing, however, of the actual functions of these women, or whether the titles were honorific.

The Sardis synagogue, among the largest uncovered, with its main hall measuring 177 by 59 feet, could accommodate perhaps a thousand people. During the fourth century, the Jewish community acquired this imposing building located in

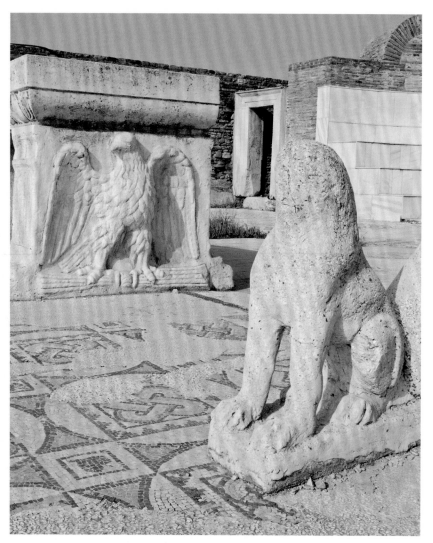

the city's center and remodeled it as a synagogue, installing two Torah shrines on the eastern wall. The name for the shrine was *nomophylakion*, or "place that protects the Torah," according to an inscription. The significance of these aediculae is made clear both by their prominence and by an inscription found nearby that reads, "Find, open, read, observe." A small relief contains both an inscribed menorah and the image of a Torah shrine with its doors open to show scrolls stacked within. In the sanctuary, excavators also discovered a large stone menorah donated by one "Socrates," as well as a plaque showing perhaps the prophet Daniel at prayer in the lion's den. A recently published inscription refers to the Sardis synagogue as the "holy house" of its community.

"New" ancient synagogues emerge almost every year, increasing our knowledge of this institution in its earliest stages as it grew to maturity—from a simple "house of meeting" to a "holy place." Just in recent years, significant discoveries have been made in Israel at Kursi and Huquq and at Saranda in Albania—to name only a few other sites beyond those discussed in this chapter. We can only look forward to what comes next, as scholars discover and interpret the multifaceted history of the synagogue in Roman antiquity.

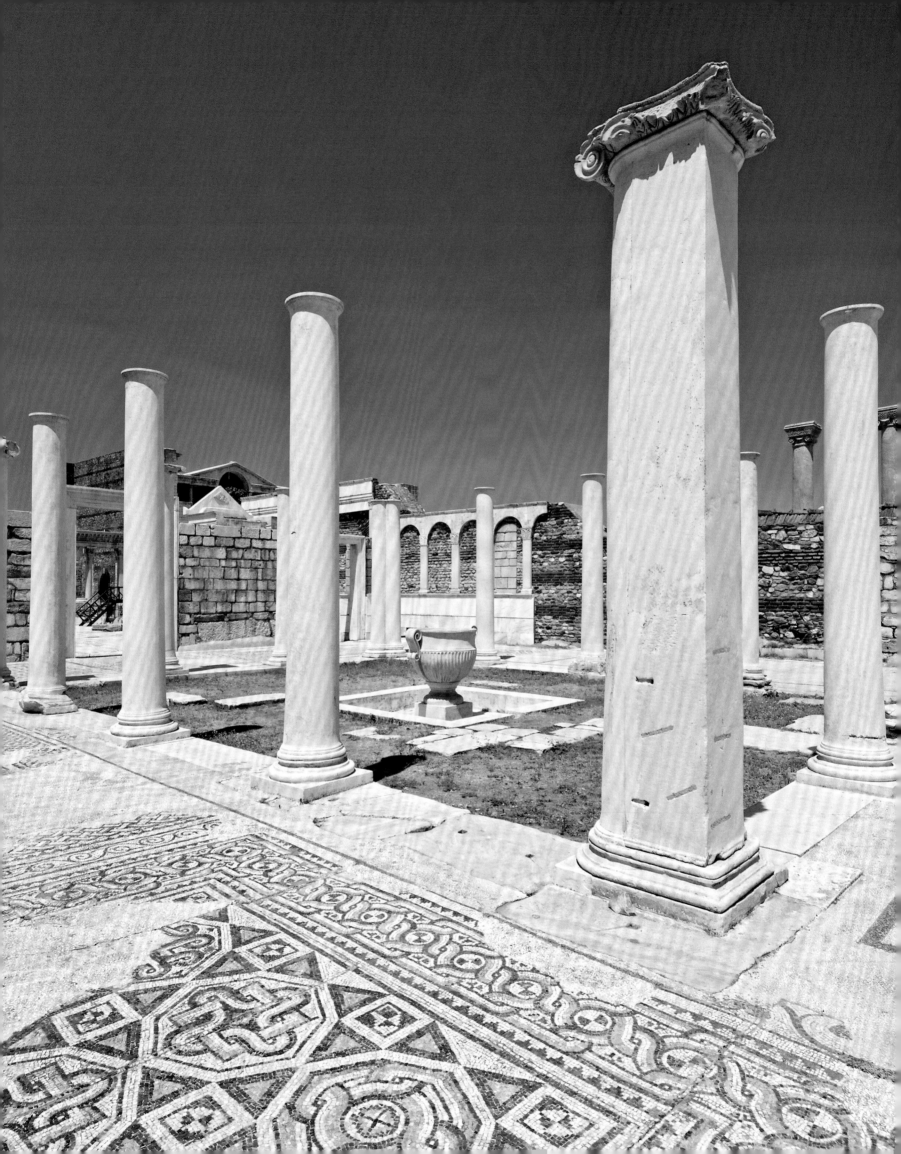

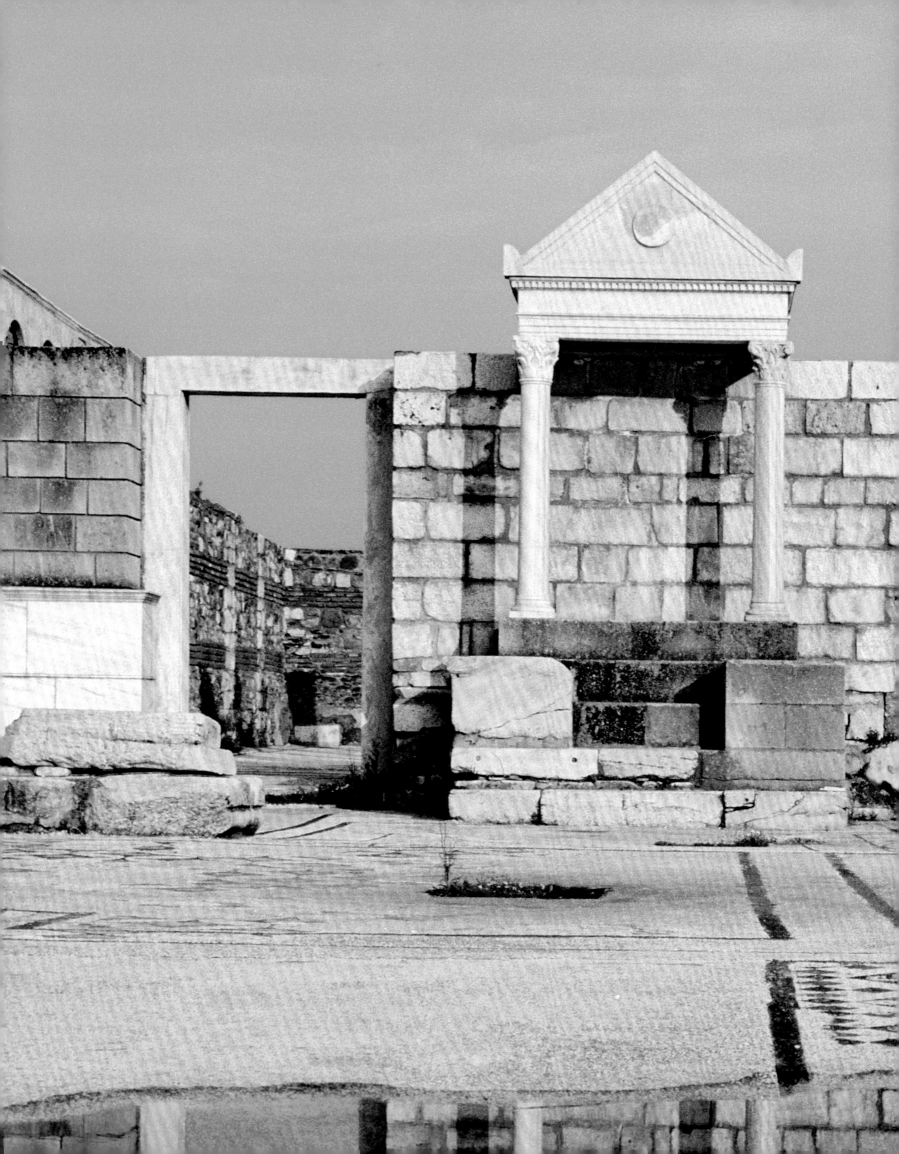

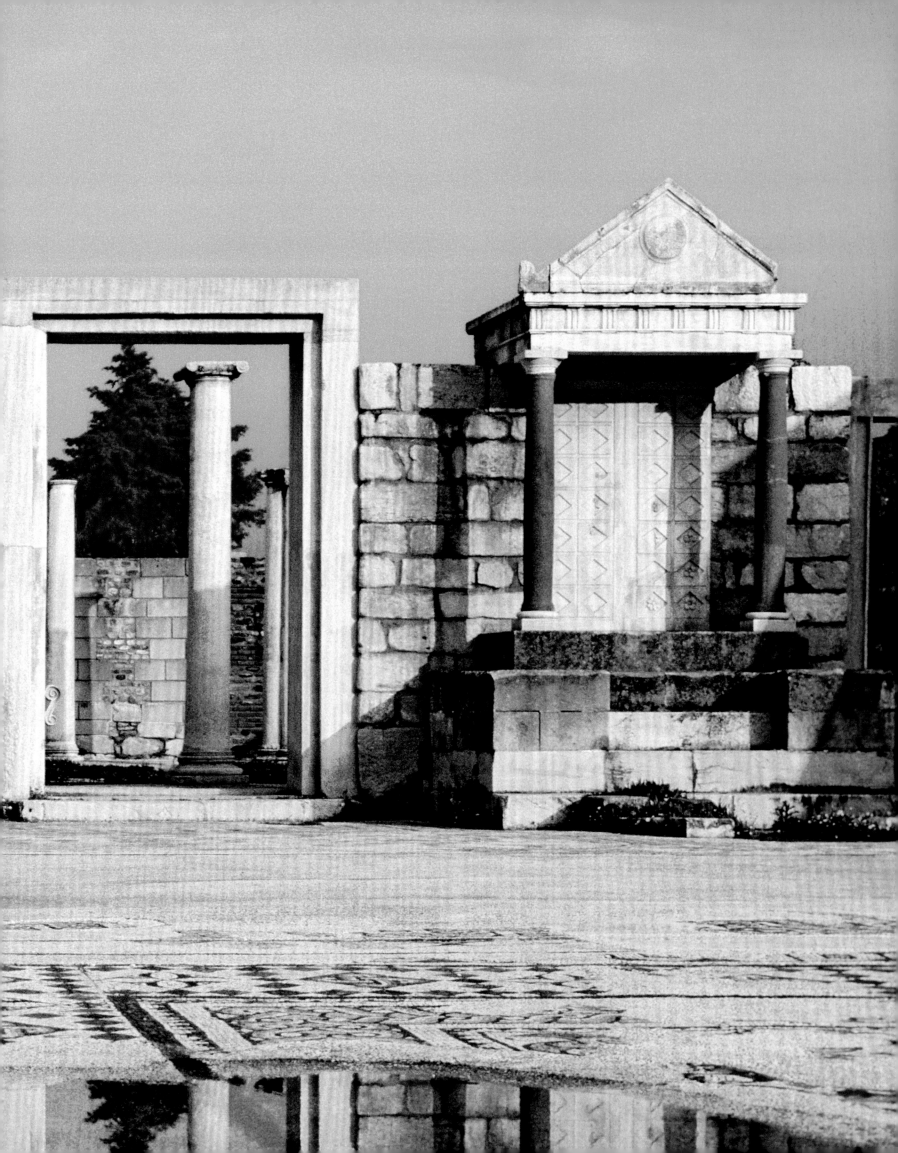

2

2. Synagogues of the Middle East, North Africa, and India

Mohammad Gharipour and Max Fineblum

The earliest Jewish tribes, who inhabited the arid ancient lands of Canaan, Phoenicia, and Palestine, developed the first known form of the Jewish prayer space. Comparable to a tentlike structure, the tabernacle and its identifying features would prove to be a prototype for many synagogues. The tabernacle was a sacred, fenced-off rectangular area that included, at its center, the holy scrolls of the Torah, which were protected by an awning. Furthermore, the holy scriptures could only be accessed by those who had cleansed themselves in the small pool of water within the precincts of the tabernacle.

As mentioned in this book's introduction, a synagogue is not necessarily required for Jewish worship, since communal devotion can be carried out wherever ten Jews assemble. Moreover, the paradigm for worship changed after the destruction of the Temple of Jerusalem (586 BCE) and the later abandonment of ritual sacrifice. All this permitted creativity and freedom in the design of houses of prayer and synagogues. Historical sources indicate that many synagogues may have been used for a variety of communal nonreligious purposes, and so it is not surprising that a number of Jewish communities referred to their synagogues as houses of the people.

Following the destruction of Solomon's Temple, Jews were exiled from the Holy Land, leading to the first of many diasporas, including their flight to neighboring Syria. When the Roman Empire conquered parts of Africa, it allowed Jews to further settle in countries such as Egypt, Tunisia, and the Maghreb. Consequently, the Jewish communities that emerged in the Middle East, Africa, and Asia began to incorporate not just the characteristics of the first synagogues into their houses of worship but also much of the native architecture of the countries where they settled. Here, each of the fine synagogues selected reveals how the complex dialogue with the dominant culture has at times enriched, jeopardized, or transformed their architecture.

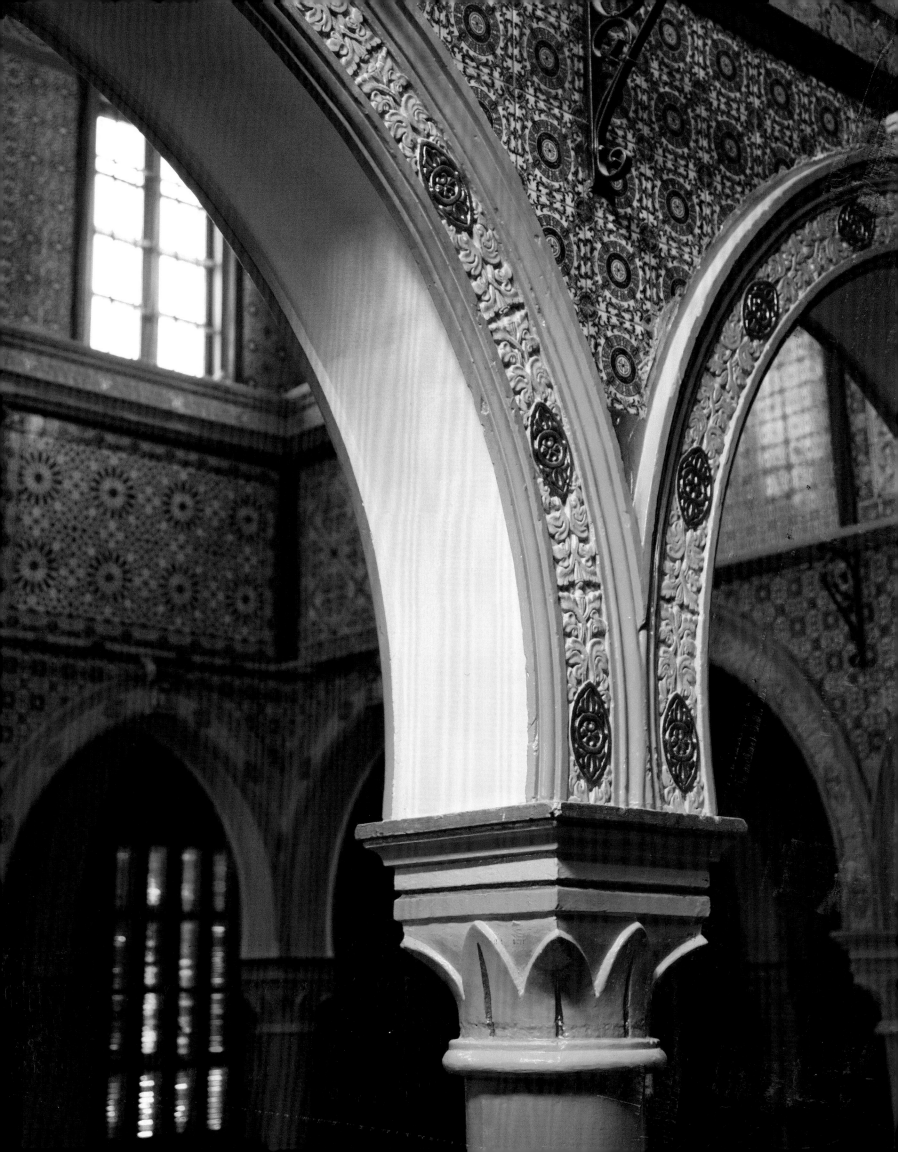

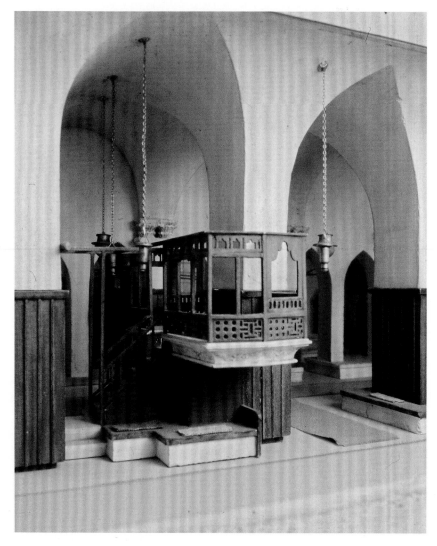

The Central Synagogue of Aleppo, Aleppo, Syria (ninth century, main body sixteenth century)

The Central Synagogue of Aleppo has long served as the primary house of worship for Syria's Jewish community. Located in the country's most heavily populated city, it lies about three hundred miles northwest of Jerusalem. It is traditionally held that the synagogue dates to the fifth century BCE, and was built after the city's conquest by King Solomon. Even if contemporary historians argue that the foundations of the current synagogue date to the ninth century CE, based on an inscription from the year 834, the Central Synagogue of Aleppo can be seen as one of the oldest active synagogues in the Middle East, operating for over a millennium.

The Jews of the region, known as the Mustarabi following the rise of Islam, laid the foundation for the present synagogue, which has since undergone several reconstructions. In the thirteenth century, when the Mongols invaded the territory, the synagogue sheltered Jewish refugees from neighboring regions, and it did so again when the Sephardi Jews left Spain two hundred years later. After the Ottoman conquest of Aleppo, beginning in 1516, the synagogue was converted into a mosque, though only for a limited time as it was described as an active synagogue in the seventeenth century by Pietro della Valle, the famous Italian Jesuit traveler. Jews enjoyed a relatively peaceful life in Aleppo until the mid-nineteenth century, when Syrian Jews faced mounting discrimination from their Muslim neighbors. In 1947, during the formation of the State of Israel, the Central Synagogue of Aleppo was nearly eradicated. However, it has since come under the protection of the Syrian government, and in 1992, underwent a series of renovations.

Designed in the Byzantine style, the Central Synagogue of Aleppo is composed of three main parts: an open courtyard typical of sanctuaries in this warm climate and in keeping with Herod's Temple; a western wing, which served as the main sanctuary for the Mustarabi; and the eastern wing, which accommodated Sephardi Jews in the sixteenth century. This wing, known as the "cave of Elijah," once held the Aleppo Codex, one of the earliest transcriptions of the Torah,

Below: The unpretentious brick exterior of the Yu Aw Synagogue, in Herat, Afghanistan (1393, restored 2007) conceals a handsome, spacious inner sanctuary.

Pages 58–59: Yu Aw's main sanctuary centers on a char-taq four-arch structure with painted floral medallions and hanging lamps reminiscent of Safavid Empire design (1501–1736). The low bimah and mihrab-shaped niches are traditional of the region, as are the rugs, which serve as seating.

applauded for its accuracy by the Jewish scholar Moses Maimonides. This tenth-century codex, long a source of pride for Syrian Jews, mysteriously disappeared during the riots of 1947, only to reappear twelve years later in Israel, where it is now on display at the Shrine of the Book in Jerusalem.

The Aleppo synagogue also houses seven different arks—three along the southern wall facing Jerusalem, three more Torah arks (*heikhals*) on the western wall, and one more in the eastern wing close to the courtyard. The most astonishing aspect of the synagogue, however, is a group of four columns that supports a small cupola in the center of the courtyard, which was eloquently described by Pietro della Valle in 1626. The synagogue incurred serious damage during the Syrian civil war in 2012 and 2017. While currently shuttered, the edifice continues to exude a powerful aura of sanctity, thanks to its rich history.

Yu Aw Synagogue, Herat, Afghanistan (1393)

During several of the diasporas, a number of Jewish merchants and leather artisans migrated from the Near East along the Silk Road, arriving in Afghanistan and settling in the border city of Herat as early as the seventh century CE. The Yu Aw Synagogue reflects the lives of Jews in a non-Jewish world. In Herat, local Islamic law, which has been in place for eight hundred years, prevented the construction of new synagogues without the permission of local leaders. It also restricted the restoration of extant synagogues despite the fact that the Jews of Herat were considered dhimmi—that is, non-Muslims who were granted the right to practice their faith. Above all, the city rulers did not wish synagogues to compete with mosques for dominance of the cityscape, especially in regard to height, location, and ornamentation. Therefore, Herati synagogues tended to blend into the surrounding urban environment. The quality of life for Jewish residents of Herat varied considerably across the centuries. In certain times, Jewish Afghans were forcibly expelled to neighboring countries and, in 1839, the Afghani government sanctioned the looting of Jewish-owned properties. Although discrimination, pogroms, and plundering persisted

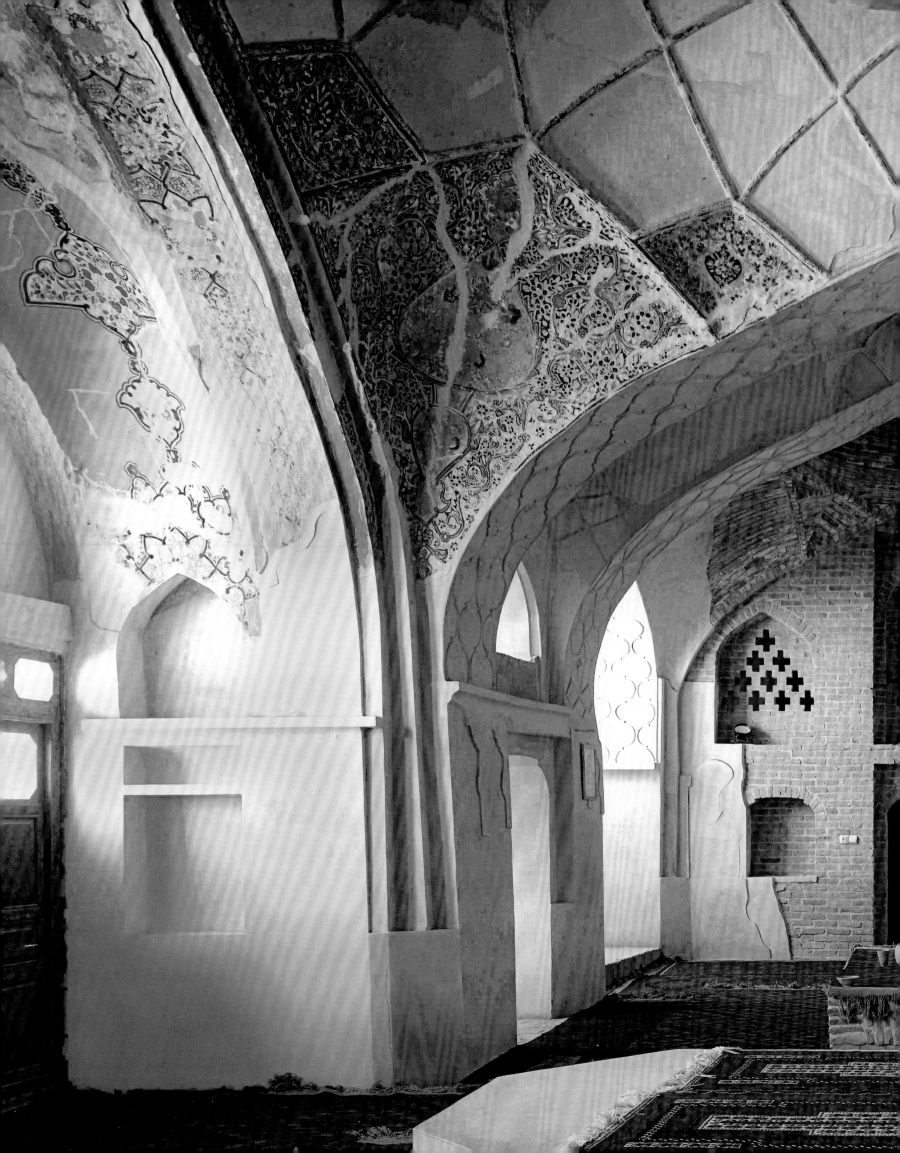

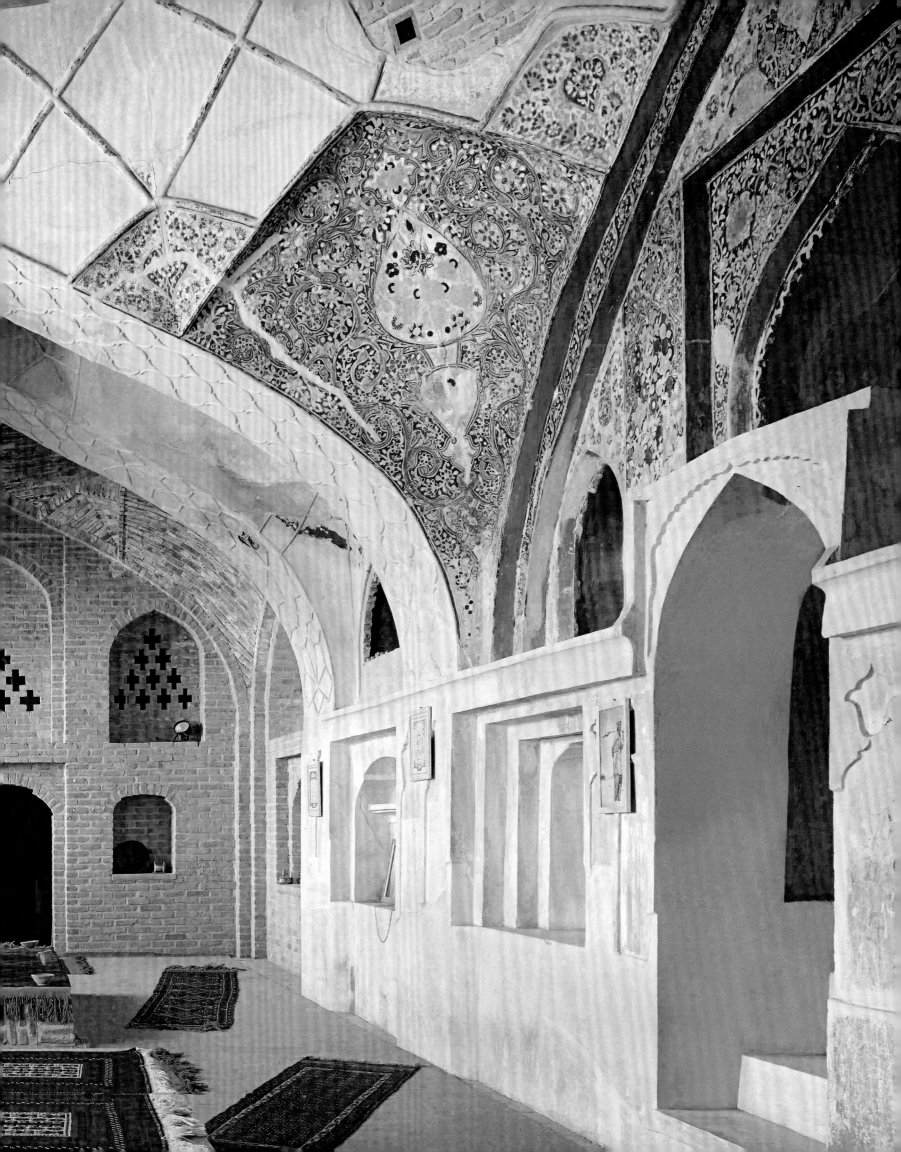

throughout the nineteenth century, Jewish life improved briefly in 1929 with the conferment of equal rights upon Jews in Afghanistan. After 1933, amid increasing anti-Semitism across the world, Herat was one of the few Afghan cities that did not banish Jews.

The Jewish quarter of Herat originally housed four synagogues, including the Yu Aw Synagogue, which is the only one still standing, if only as a dusty remembrance of the Jewish quarter's relative former eminence. Typically, Yu Aw presents a modest facade with few openings onto the street. With little ornamentation on its exterior, most onlookers, past or present, would hardly suspect that a Jewish house of worship lies within. The synagogue's lack of external markings and its thick mud-brick walls (features it shares with neighborhood mosques) help it blend in with the surrounding buildings and local architectural vernacular.

The pressure on the synagogue to conform to the local style manifests itself even in its spatial order. Like mosques in Herat, the main sanctuary consists of a domed prayer hall flanked by aisles with walls and ceilings of brickwork covered in plaster, rich with brilliant patterns and geometric designs, typical of the ruling Timurid dynasty at the time of the synagogue's founding. Furthermore, in line with the local architecture, the synagogue opens onto a courtyard. Even the form of the niches that hold the holy Torah recalls those of Muslim houses of worship, not to mention the richly painted floral patterns inspired by Persian design that adorn the main sanctuary. The key differences are a slightly wider central aisle, inscriptions in Hebrew, and the orientation of the ark with the Torah scrolls, facing toward Jerusalem (as opposed to Mecca).

The pressure to assimilate evaporated when Jews left the city in 1978. Soviet aerial bombing campaigns subsequently destroyed much of Herat's four synagogues. Recently, there have been some attempts to refurbish the Yu Aw Synagogue, such as restoring its brightly decorated paintings and moldings. The synagogue currently serves as an educational center for local children, reflecting the building's adaptability to current circumstances.

Paradesi Synagogue, Kochi, Kerala, South India (founded in 1568, present building ca. eighteenth century)

As in Afghanistan, the Jews who went to South India settled in a region dominated by other faiths, in this case primarily Hinduism and Islam. The Paradesi Synagogue, located in Kochi, Kerala, is the oldest active synagogue in South India. It was built by Sephardi Jews arriving from Spain and Portugal through Turkey as well as from Syria and Persia. They settled there around 1512 in search of a place to peacefully congregate. Similar to their arrival in Afghanistan, they originally met with an accommodating reception, which then varied through the years.

The rajah of Kochin endowed the Jewish community with land to construct its synagogue, which was adjacent to his palace, in order to benefit from their commercial and administrative savvy as well as to offer protection against rival communities. The Kochin Jews, who happened to be quite prosperous, consisted mostly of Sephardim from Spain and Portugal fleeing the Spanish Inquisition and included many merchants. There was also an older community, the Malabari Jews, who had arrived by the twelfth century. Powerful Portuguese rulers seeking to extend their colonial authority in India soon caused trouble for the Jews in Kochi. The Paradesi Synagogue caught on fire in 1662 but was restored a year later when the Dutch settled in the surrounding region of the Malabar Coast.

The synagogue is a rectangular building with a white-walled facade. Originally a complex of four buildings, it includes a main sanctuary linked to a series of rooms by thick limestone walls. It features steep-pitched tile roofs with deep eaves, wooden shuttered windows, and outdoor covered spaces with roofs that extend over a courtyard. Inside, an intricately carved and gilded bimah rises in the center of the main sanctuary, which has a women's gallery running across its rear wall.

The Star of David adorns the iron entrance gates, deliberately announcing the sanctuary's Jewish identity to the city at large. Like many other Jewish houses of worship in Asia, such as the Yu Aw Synagogue, it has an inner courtyard. Unusually, the synagogue features a clock tower, which was gifted by a Jewish

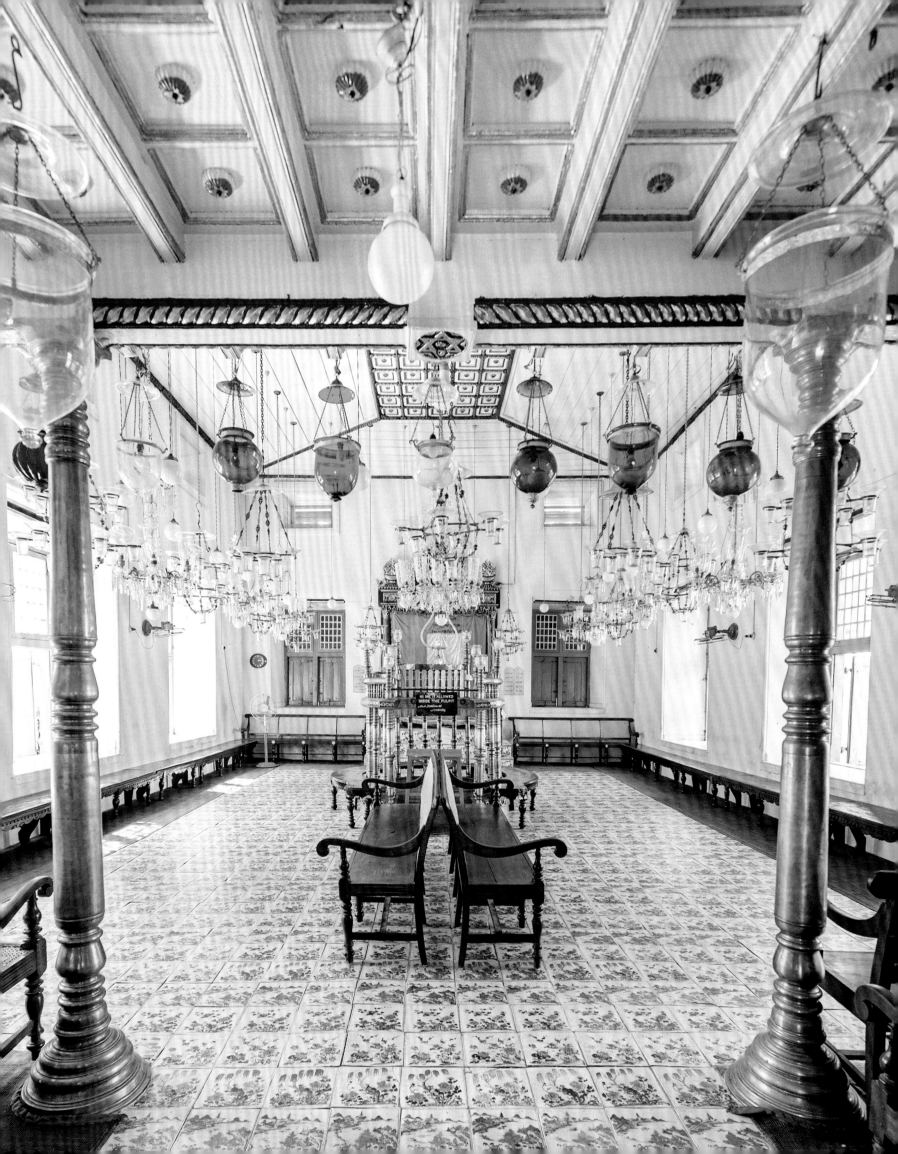

Below: Built in the heart of Fez's Jewish ghetto, known as the Mellah, the Ibn Danan Synagogue originally belonged to a wealthy family. Thanks to the 1996 renovation under the auspices of the World Monuments Fund, the original furniture from this mid-seventeenth-century synagogue is largely intact, including the wrought-iron bimah enclosure, bronze hanging lamps, and wooden benches that are set on green and white zellige marble tiles.

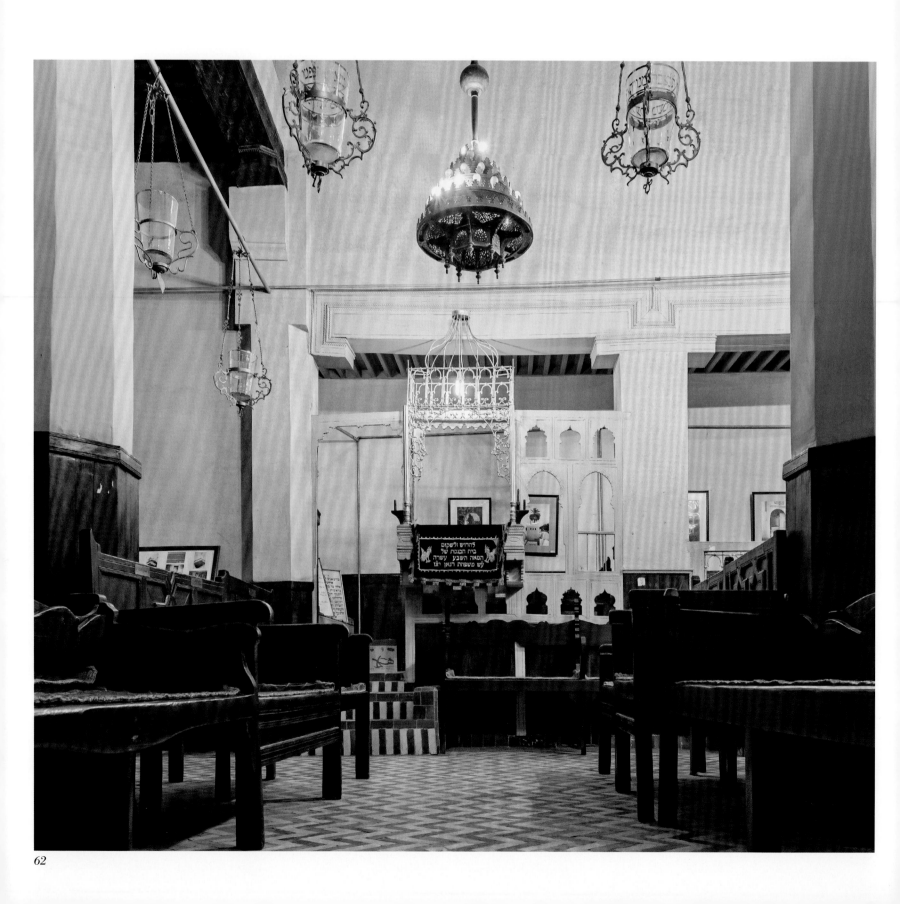

Pages 64–65: Tracing its roots back to the sixth century, the current sanctuary of El Ghriba on the island of Djerba, Tunisia, dates to the nineteenth century. Its polychrome wall tiles, inspired by geometric zellige designs, complement the turquoise painted plasterwork of the double arcade. Blue shutters provide a filtered light that softens the explosion of color and wards off midday heat.

Pages 66–67: The synagogue's stark whitewashed courtyard with Mudéjar arches provides a shady respite for the numerous pilgrims, many of whom come to celebrate the island's famed Lag B'Omer festivals.

merchant named Ezekiel Rahabi in the eighteenth century. Four clocks are mounted on the rectangular tower, each with a different style of numeral on its face (Hebrew, Roman, Indian, and Islamic). The Hebrew numbers face the synagogue, the Roman the rajah's palace, the Indian the harbor, and the Islamic numerals look onto the city.

Inside the main hall, inscribed copper plates from the seventeenth century testify to the rights of the Jewish community and to their independence. Within, the floor is covered with hand-painted blue-and-white porcelain tiles from China. A sea of chandeliers made of Belgian crystal and colored glass lamps illuminates the interior. The Ethiopian emperor Haile Selassie bestowed a fine Oriental rug on the congregation. The synagogue also houses ten paintings illustrating the biblical history of the Jews, including stories such as the Binding of Isaac, as well as two brass columns alluding to Solomon's Temple.

Well maintained over the centuries, with many of its fine embellishments still intact, the Paradesi Synagogue has undergone very few structural changes. Today, it still serves the local Jewish community as the only active synagogue out of the seven that were built in the Jewish quarter over the past 450 years and continues to attract many tourists from around the globe.

The Ibn Danan Synagogue, Fez, Morocco (ca. mid-seventeenth century, restored in 1996)

Built around the same time as the Paradesi Synagogue, thousands of miles to the East, the Ibn Danan Synagogue illustrates the powerful impact of local architecture on Jewish houses of worship in North Africa. Located in the royal city of Fez's Jewish quarter—the Mellah—the Ibn Danan Synagogue was initially owned by a private mercantile family.

The Mellah, a thriving commercial and artisanal quarter, served as a buffer between the Muslim state in Morocco and its enemies, including those in Fes el Bali. Despite their wealth, the Jewish community met with a mixed reception. During the Wattasid dynasty (1472–1554), the rulers expelled the Sephardi Jews, who had fled Spain to escape the Inquisition. In general, the Muslim rulers of Fez imposed harsh restrictions on the Jews, prohibiting synagogues from appearing ornate or visibly identifiable as Jewish houses of worship from the street.

Consequently, the modest exterior of the Ibn Danan Synagogue looks apiece with much of the Mellah, which lacked any eye-catching features—such as the brightly colored roofs of the mosques with their tall minarets. The narrow vestibule leads to a rectangular two-nave sanctuary divided by painted turquoise octagonal piers. The synagogue, like all the structures in its neighborhood, was constructed with size limitations. Much of the interior decoration was probably made by Jews, who were restricted to artisanal work under Muslim supervision. Here, the brightly colored tiles along the internal walls and the glazed green-and-white-herringbone floor would have suggested the fine workmanship of the congregants and the wealth of the synagogue's original owner.

The second floor housed the traditional women's balconies as well as additional spaces for a study hall and living and guest quarters of the synagogue. The main sanctuary features an ornamented ark with its original Torah scrolls made of gazelle skin, as well as wooden benches, oil lamps, and embroidered hangings. Across from the ark, a raised wooden alcove, screened by carved arches, was reserved for distinguished members of the congregation. The structure faces a wooden bimah topped by ornate ironwork. A narrow stairwell leads down to the former mikvah ritual bath.

Although the inside of the synagogue has painfully deteriorated, it retains vestiges of its former elegance. Following an initial restoration in the 1990s, Morocco's Ministry of Culture in conjunction with other public and private entities now maintains the synagogue, thereby helping to preserve the link between the ruling class and the Jewish minority of Fez.

El Ghriba Synagogue, Djerba, Tunisia (founded in the early sixteenth century, major renovation in 1840, restored in 1994)

The El Ghriba Synagogue lies on an island oasis in the Mediterranean Sea, off the coast of Tunisia. Unlike the strict restrictions imposed on synagogues in Fez, its isolation has

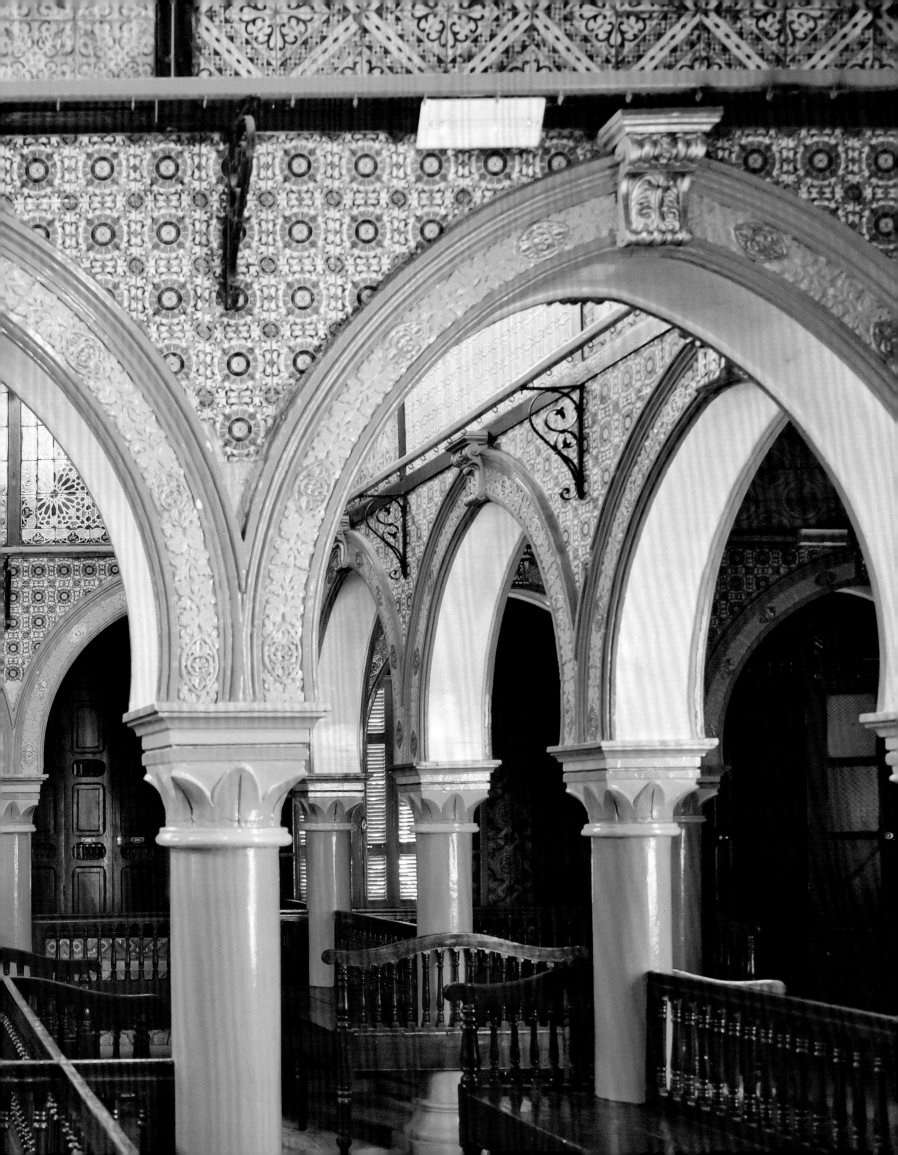

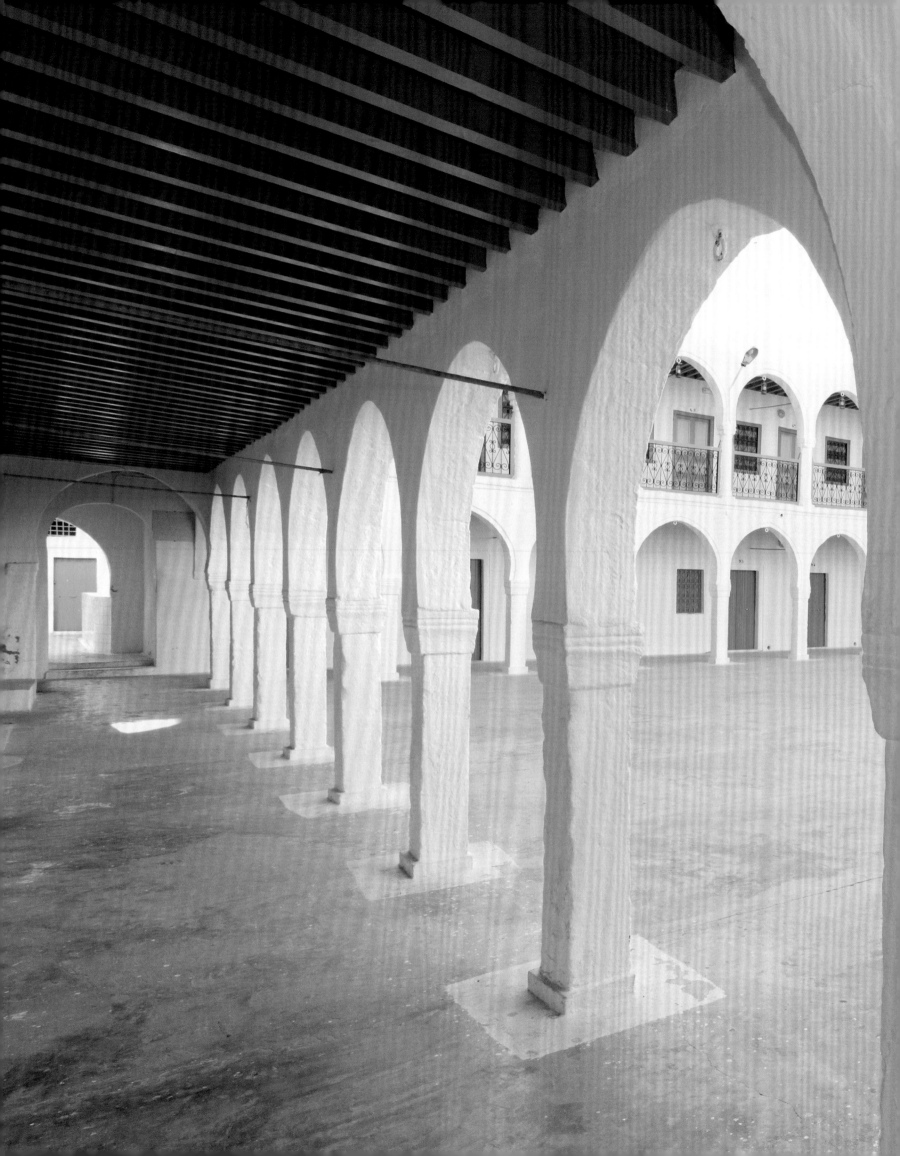

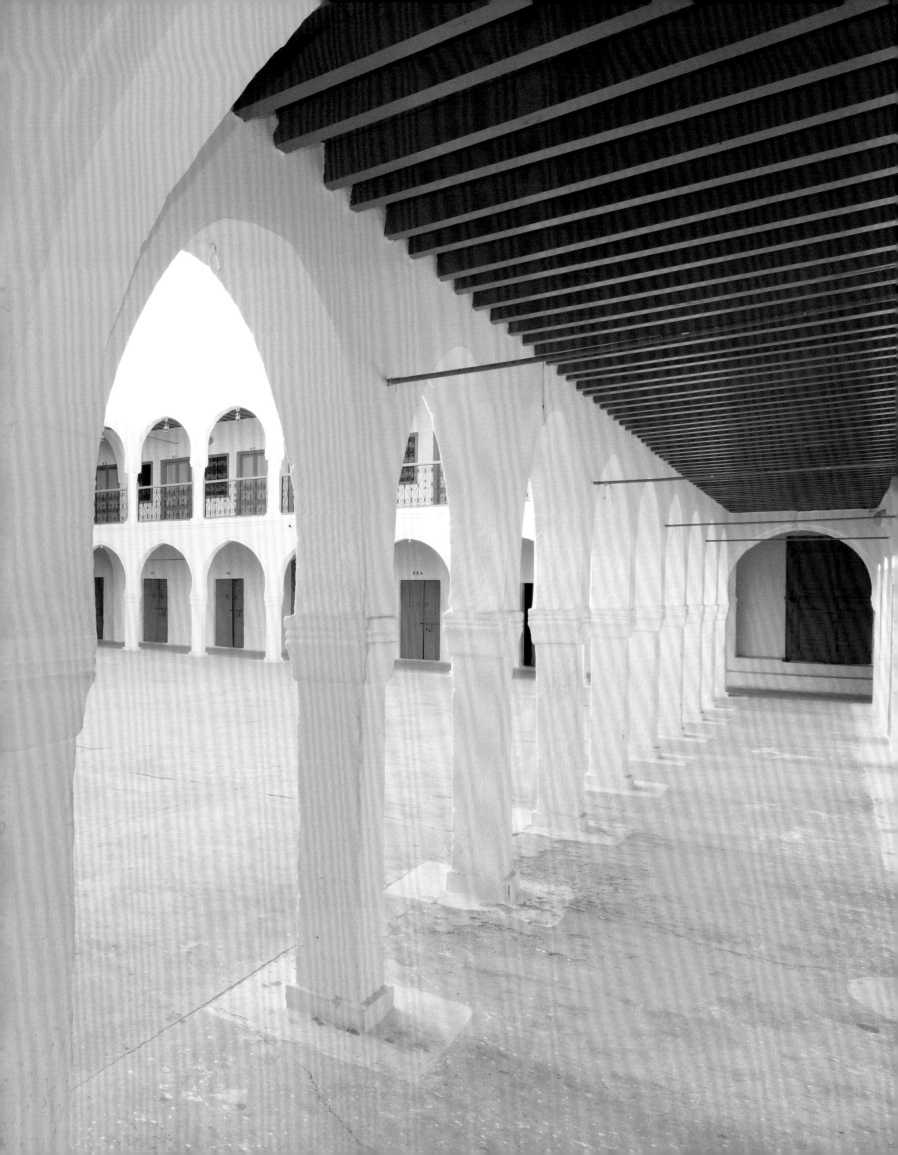

Opposite: At El Ghriba, copper yizkor
memorial lamps with votive inscriptions
along the rim are suspended from
the ceiling in honor of the dead.
Traditionally, mourners light the oil in
the glass vessels while offering prayers
for the deceased. These lamps may
reflect the fine craftsmanship of
the local Jews, known for their metal
joinery and filigree work.

protected it from the traditional prejudices and strict legislation generally imposed on Jews in North Africa. Arriving as early as the seventh century CE, the Jews of Djerba have lived not only with people of other faiths, but also with Jews from different regions of the world. Built in the early sixteenth century, the original El Ghriba Synagogue was destroyed by the Spanish military shortly thereafter, but it was quickly reconstructed in 1647. The seventeenth-century synagogue underwent major renovations in 1840 when the Ottoman Empire lost control of Tunisia.

Nestled in a rural region, the synagogue is accessible only by a footpath from the Jewish village of Hara Sghira. The journey to the complex is considered sacred, similar to pilgrimages by Muslims along lonely pathways to isolated mosques elsewhere on the island. Today, the El Ghriba Synagogue, along with an inn for pilgrims, stands alone amid cacti and olive trees. During the Hebrew month of *Iyar* (which usually falls in the spring between April and June), the yearly festival of Lag B'Omer reflects the Jewish diaspora. The annual pilgrimage presents an opportunity to unify Muslims and Jews as well as members of other faiths. In addition to common traditions, the mosques and synagogues of the island share many architectural features: colonnaded courtyards, sparse exterior ornamentation, and thick whitewashed walls.

Typically, from the street, El Ghriba presents a spare white facade with large windows protected by blue *fer forgé* grilles and a balustrade that belies the brilliantly colorful world within. The richly decorated rectangular interior consists of a main sanctuary flanked by side aisles, which are marked by a row of colonnaded arches. Above the arches, large glazed windows illuminate the space. Set at the western end of hall, the carved wooden bimah is topped by a great brass lantern. The synagogue's principal note is a vibrant azure enhanced by painted stucco and tile work in geometric patterns. Within the ark, handwritten letters on display recall the practice of attaching notes with prayers to the Western Wall in Jerusalem. The ark contains five cabinets, each of which is adorned with a wooden arch on top etched with either a hand for a blessing or a fish (a religious symbol used by Jews and Muslims alike). An inner courtyard surrounded by roofed loggias supported by rows of arches offers additional space for congregants.

In 1994, the government of Tunisia funded a restoration effort to preserve El Ghriba. Despite a horrific terrorist bombing in 2002, the annual pilgrimages to El Ghriba remain a venerated tradition for local visitors as well as those from all over the world.

Nahon Synagogue, Tangier, Morocco (1878)

Similar to El Ghriba in Tunisia, the Nahon Synagogue in Tangier remains an important cultural site and a religious sanctuary. Constructed in the "old" part of the city, which predates the age of industrialization, like its counterpart in Fez, the Ibn Danan Synagogue, the Nahon Synagogue owes its establishment to a single family. Initially funded in 1878 by Moshe Nahon, a member of a wealthy Jewish banking family, it is esteemed as one of the most beautiful synagogues in Morocco. Its Moorish style reflects the pride of the Nahon family in their Andalusian heritage, which they had been forced to relinquish in the fifteenth century.

The Jewish community of Tangier began to grow in the sixteenth century because of the expulsion of Jews from Spain. The next wave of Jewish immigrants followed the British acquisition of Tangier in 1661 but rapidly diminished after the English left in 1684. To help revive the city's economy and attract Jews back to Tangier, the Jewish treasurer to the sultan, Moses Amman of Meknes, made them exempt from taxation. Henceforth, the Jewish population grew and flourished, particularly between the World Wars.

The Nahon Synagogue is situated on the Calle de las Sinagogas, a major artery leading to the pier, along which other houses belonging to Jewish residents had begun to spring up. While splendid within, typical of synagogues throughout Morocco, it is "tucked away behind a nondescript door." Only the grillwork over the entrance, which features the initials of Ma'asat Moshe and the Hebrew year in which the synagogue was constructed, 5638, call attention to the building as a house of worship. The complex includes a main sanctuary accessed through a small courtyard, a women's gallery with a separate entrance, and a modest *beit ha-midrash* (study house).

Below, clockwise from top left: From the Nahon Synagogue, Sefer Torahs cloaked in brocaded mantles; a rimmonim with bells that caps one of the Torah scrolls seen against the Moresque plasterwork of the ark; a purple velvet parochet covering the ark; chased silver menorahs surround the bimah, which is decked with an embroidered velvet cover.

Opposite: The once private Nahon Synagogue, founded in 1878 in Tangier, Morocco, reflects the religious fervor and wealth of its namesake. This splendidly furnished house of worship, with its double-tiered sanctuary, is resplendent with silver hanging lamps, velvet brocade mantles, and marble floors.

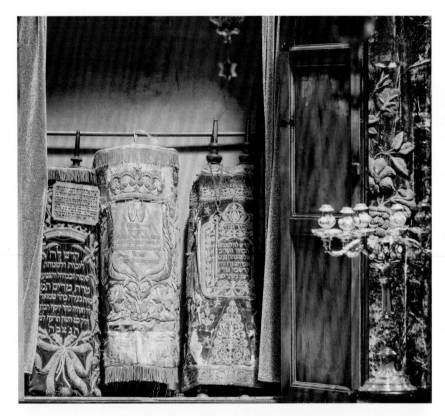

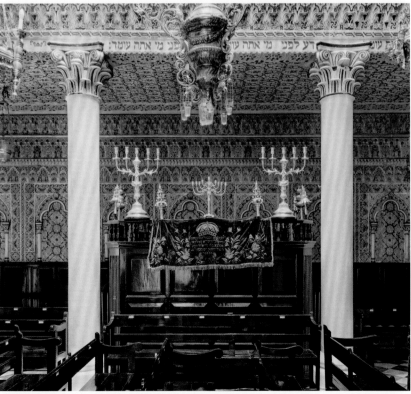

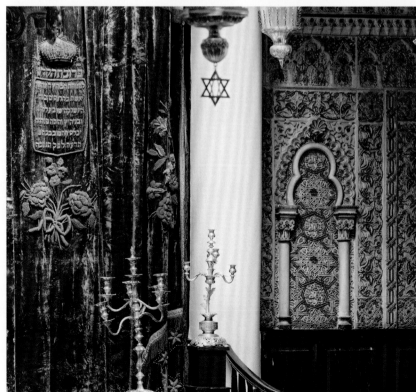

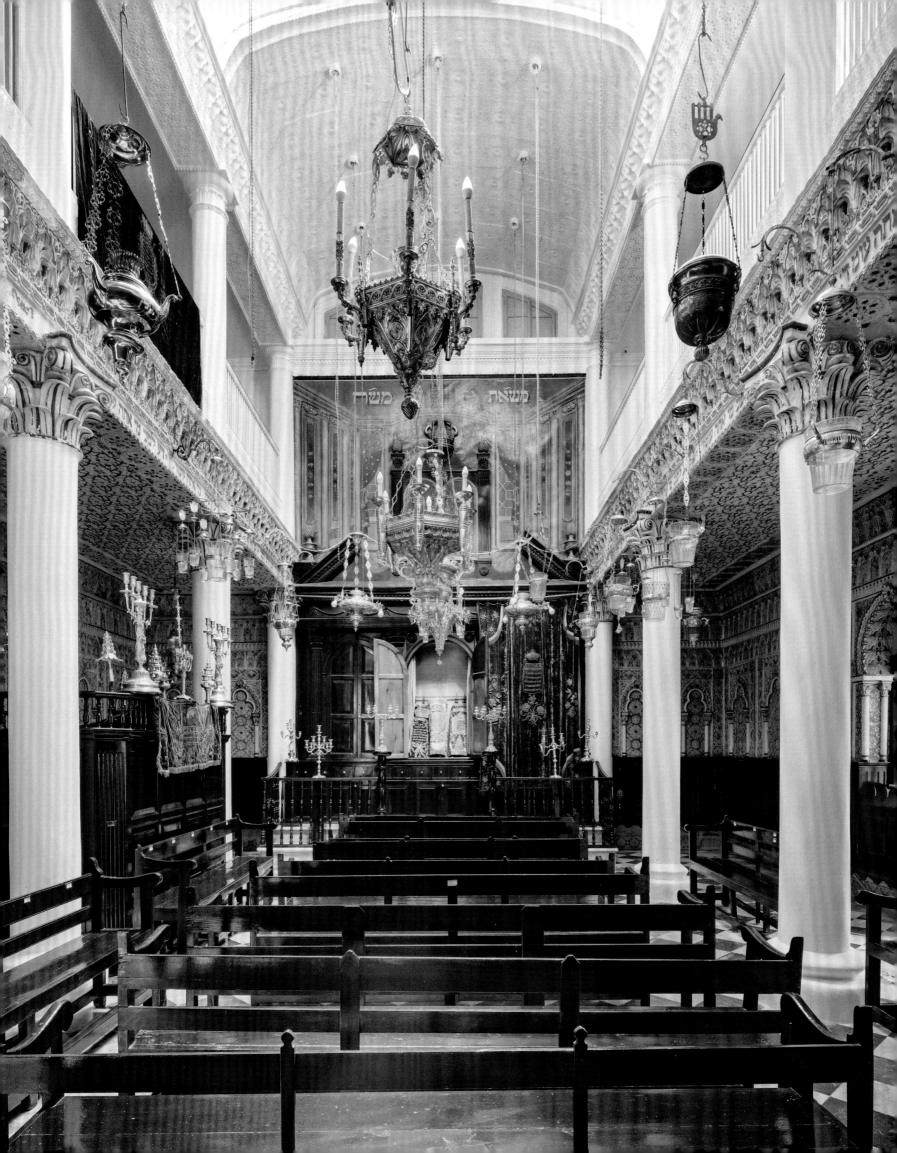

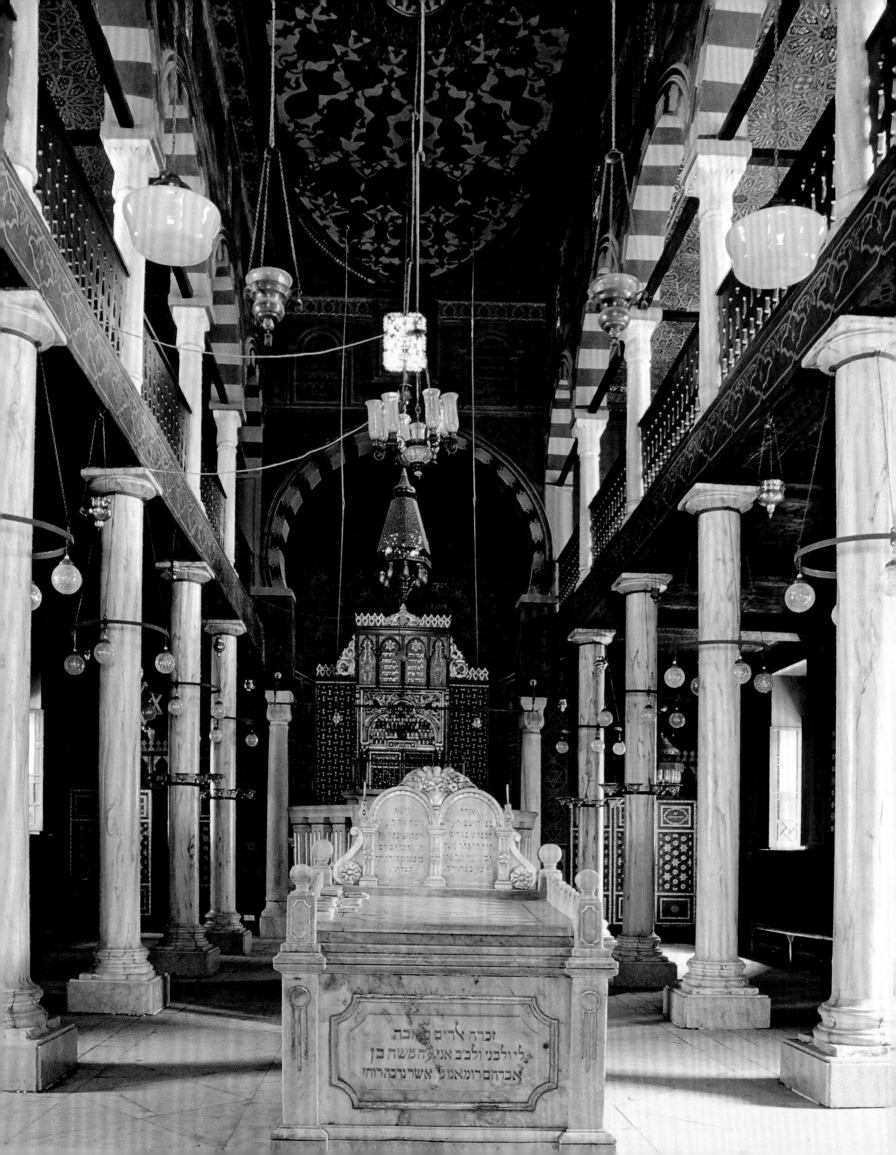

The synagogue integrates Islamic and neoclassical features, reflecting Tangier's rich ethnic amalgamation. Inside, the building's monumental proportions, with grand Corinthian columns, a generous skylight, and the checked black-and-white marble tile floor, suggest its former grandeur. White plaster outlined in ocher adorns the walls throughout, including those of the women's gallery, which is supported by columns with intricate leaf patterns. The eastern wall, which houses the Torah ark, combines Mudéjar elements and Hebrew inscriptions. Other walls feature numerous memorial plaques and epigraphs similar in style to the Arabic inscriptions found in mosques. The removal of the middle aisles in the main prayer hall allowed for additional seating, which increased the synagogue's reputation as the predominant Jewish religious institution in Tangier.

A major restoration campaign, initiated in the 1990s by a Jewish architect, followed the years of neglect that ensued after the exodus of the Jewish community, mostly to Israel. Sadly, as of 2007, the Jews of Tangier number barely one hundred, in dramatic contrast with their former population of 250,000 before the founding the State of Israel. Today, the synagogue serves as a museum of Jewish history, and religious services are no longer held here.

Ben Ezra Synagogue, Cairo, Egypt (founded in 882, reconstruction 1892)

Comparable in its basic rectangular plan to El Ghriba in Tunisia and the Nahon Synagogue in Tangier, the Ben Ezra Synagogue in Cairo is one of the oldest synagogues in continuous use in Africa. Following many previous alterations and restorations, the current iteration was constructed in 1892 in Fatsot (Old Cairo). Yet the original building most likely dated to 882 CE, based on manuscripts found in Ben Ezra's storerooms, predating the country's Islamic age.

In 1012, the Fatimid caliph Al-Hakim Bi-Amr Allah ordered the destruction of Jewish and Christian religious buildings, including the Ben Ezra Synagogue. Rebuilt under the reign of caliph Ali az-Zahir (between 1025 and 1040), the synagogue hosted Jewish pilgrims from across North Africa during the Middle Ages for Passover and Sukkot. In the twelfth century, the famous Jewish polymath Moses Maimonides (who lived for a good part of his life in Cairo) also patronized the synagogue.

Much of what we know about the Ben Ezra Synagogue stems from its reconstruction in 1892. Best described as a basilica-type plan, the building features two floors for prayer, with the ground floor reserved for men and the second floor for women. The fluid mixture of Egyptian, Islamic, and Byzantine architectural styles reflects Cairo's multiculturalism. The main hall is subdivided into three long sections by a double row of marble columns, which are braced by steel bars that support a tall ceiling in an otherwise narrow building. The octagonal marble bimah stands in the center of the main prayer space. Painted geometric and floral designs of Ottoman inspiration adorn the ceiling and walls while the floors are a light gray flecked marble.

The rebuilding of the synagogue in the 1890s yielded the discovery of the *geniza*, a storage area that held a wealth of secular and sacred manuscripts from the Hebrew and Aramaic faiths, mostly dating to the Middle Ages. Ben Ezra Synagogue also harbored other relics that have withstood the building's many transformations, such as a carved wooden Torah ark that dates to the eleventh century. The last major restoration of the Ben Ezra Synagogue occurred in the 1980s. Today, the synagogue is a Historic Cairo UNESCO World Heritage Site.

The Grand Synagogue of Edirne, Turkey (reconstruction 1909, restored in 2013)

Jews have lived in what is now northwestern Turkey since at least the fifth century BCE and were well established there during the Byzantine period. During Roman and Byzantine times, they specialized in the textile, leather, and wine trades. Following the Turkish conquest of Edirne in 1361, waves of Jewish migrants arrived in the city from Hungary in 1376 and from France in 1394. By the eighteenth century, some five thousand Jews lived in various ghettos in Edirne. Rising regional tensions during the Balkan Wars and the eventual fall of the Ottoman Empire had reduced the Jewish population to single digits by the end of the twentieth century.

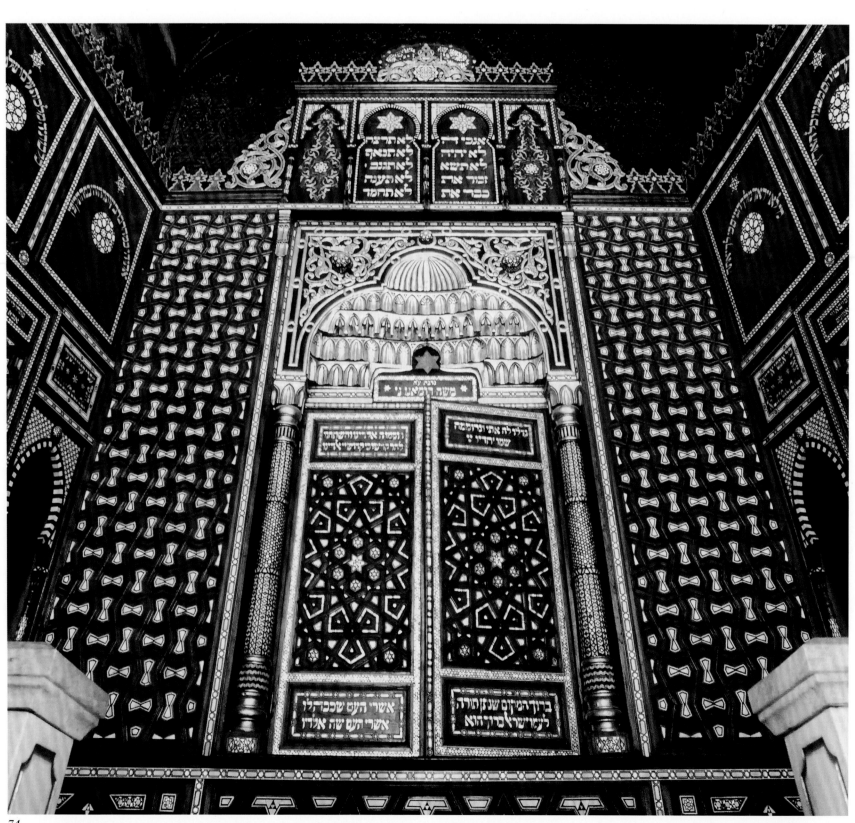

Below: The glorious inlaid-wood-and-ivory Torah ark in the Ben Ezra Synagogue takes its inspiration from Egypt's Mamluk Sultanate (1250–1517), combining geometric and arabesque patterns with Hebrew inscriptions. This nineteenth-century reconstruction possibly incorporates some of the precious wooden intarsia from an older bimah, destroyed in a fifteenth-century fire. It reflects the wealth and standing of Cairo's Jewish community in medieval times.

*Below: Nineteenth-century panels of
precious wood inlaid with Stars of David
surmounted by a row of mihrab-shaped
fretwork flank the synagogue's ark.*

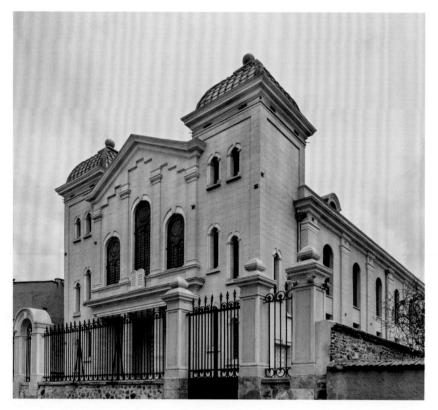

Yet during the late nineteenth century, the Ottoman Empire supported the Jewish community and approved of the rapid rebuilding of the Grand Synagogue of Edirne, which had been destroyed along with thirteen others in the great conflagration of 1905. Designed by the French architect France Depré and completed within three years, the Grand Synagogue of Edirne was constructed in the Moorish Revival style popular throughout Europe. Costing twelve hundred gold coins, it could accommodate 1,200 Jewish congregants. The sanctuary's grand central space along with its twin-domed towers served as a source of inspiration for synagogues as distant as the Kiever Synagogue in Toronto. The sanctuary featured fine Hebrew inscriptions and brilliant mosaic pavements. As the Jewish population dwindled, the synagogue was forced to close in 1983, leading to its neglect and the eventual collapse of its roof. In 2013, the remaining community restored the synagogue at a cost of $2.5 million. Over five years, the roof was rebuilt, the foundations shored up, and the marvelous mosaic floor restored. Upon the completion of its restoration, presiding Rabbi David Azuz remarked that the Great Synagogue of Edirne exemplified how different religious groups can peacefully coexist in the same city. At the time of this writing, the Grand Synagogue of Edirne has not yet reopened but can be viewed from the outside.

Synagogues across the Middle East, Asia, and North Africa did not share many overriding architectural forms since they were heavily influenced by the predominant styles of their surroundings. However, despite their differences, and regardless of their locations, synagogues often display specific features and characteristics. The bimah, for instance, might vary in its placement within the synagogue, but it always exists. Similarly, the ark might take different forms, whether visible or hidden from view, but it is always directed toward Jerusalem. The presence of these elements within the synagogues suffices. The struggle of their ancestors is deeply ingrained in the Jewish faith, and synagogues—no matter where they might be—are a reminder of Jewish perseverance. Jews have been exiled from Jerusalem, or hidden in the Jewish quarter of Fez, yet their traditions have survived and their synagogues continue to be built and restored.

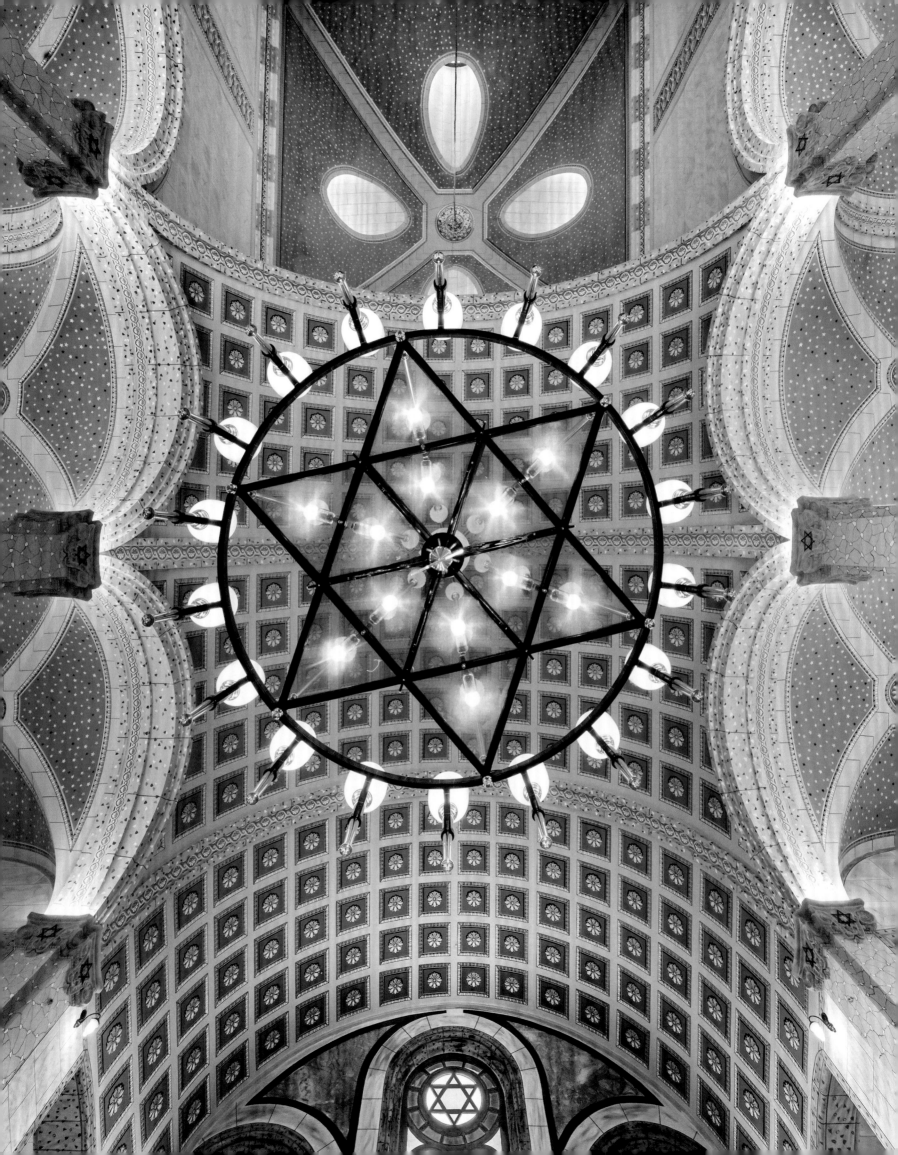

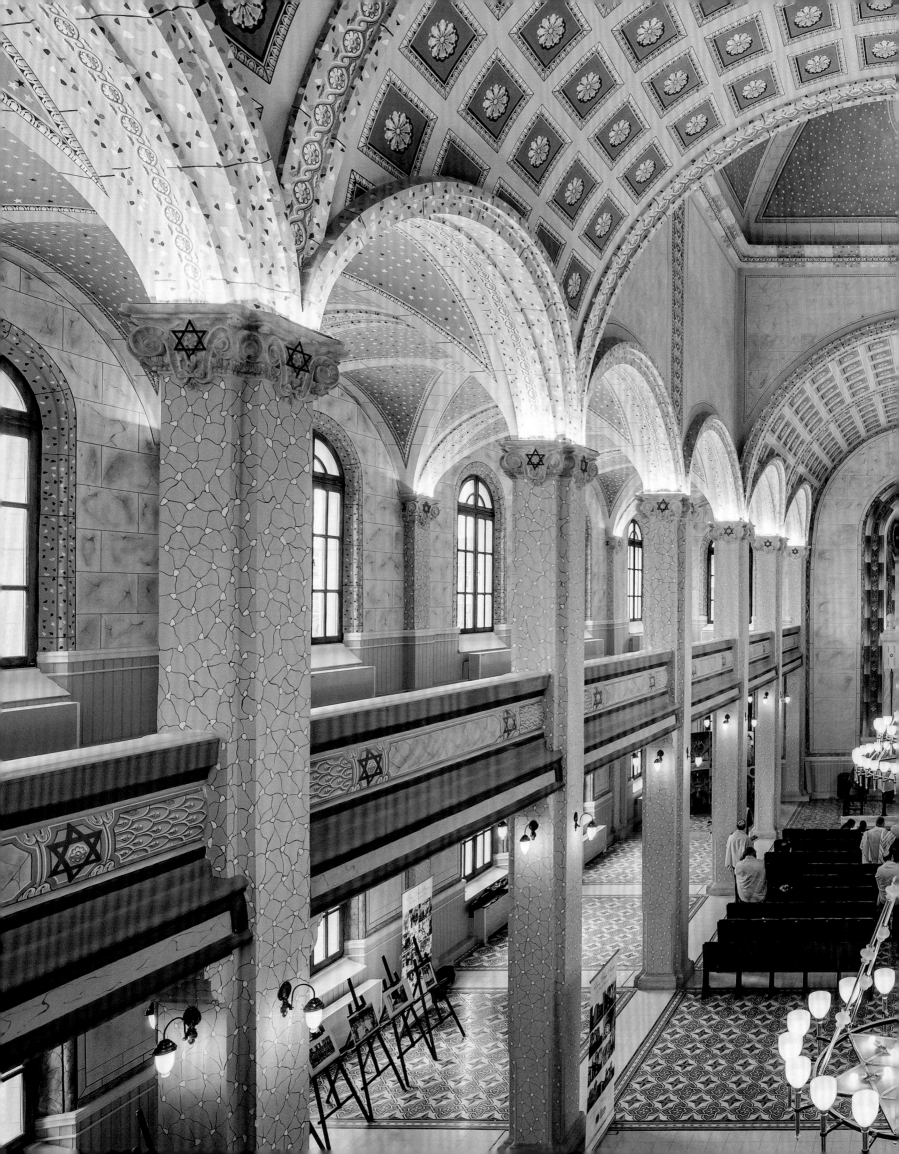

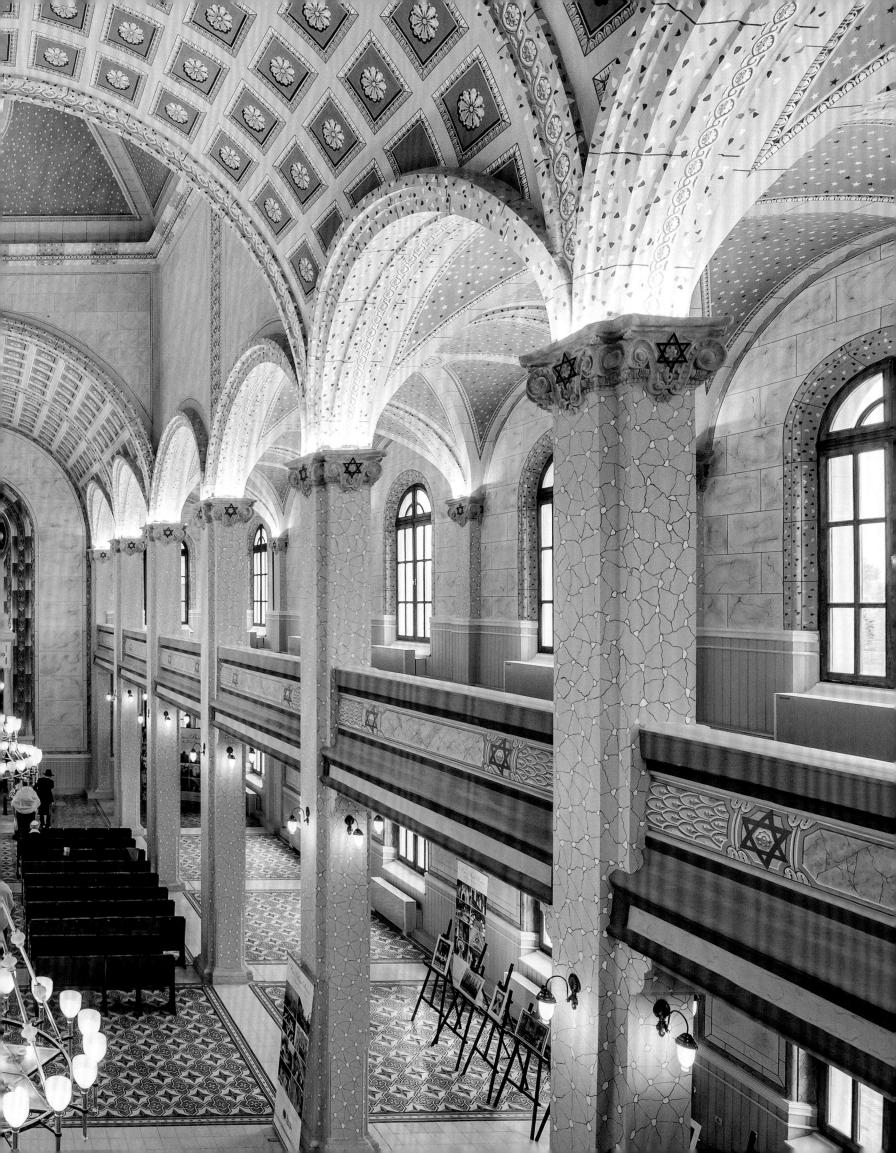

3

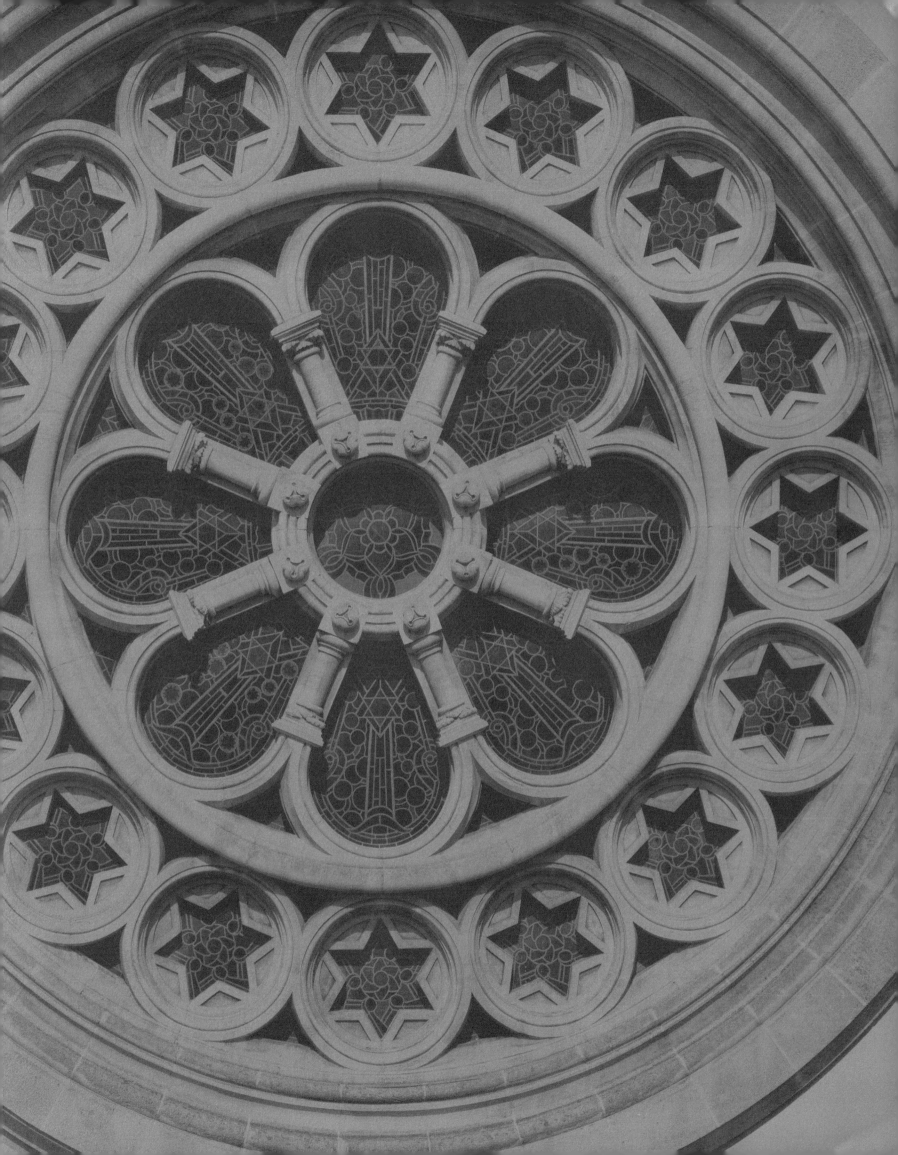

3. Synagogues of Western and Central Europe

Edward van Voolen

From the Middle Ages to the present, Jewish communities throughout Europe have adopted an astonishing variety of architectural styles for their synagogues. A number of striking sanctuaries have either survived the vicissitudes of history—pogroms, expulsions, fires, decay, and destruction— or have been occasionally replaced by larger structures in bold new styles. Along with a wealth of written sources, archaeological evidence, and Jewish illuminated manuscripts, these synagogues testify to active centers of Judaism in many parts of Europe and a lively dialogue between Jews and their surrounding cultures. Today, fewer traces remain of the many smaller Jewish congregations and charitable organizations that held services in rented spaces or in the homes of wealthy Jewish families.

In many European countries Jews were barred from joining craft guilds. That is why non-Jewish architects and artisans were largely responsible for building synagogues, relegating Hebrew inscriptions and occasional Jewish symbols mainly to the interior of the sanctuary. Before the Jewish emancipation during the course of the nineteenth century, most synagogues were designed to be inconspicuous. In many countries, local laws prescribed that they had to be smaller and with lower profiles than churches. For their safety, many communities located their synagogues around internal courtyards, largely invisible from the outside.

Up until the 1800s, Ashkenazi and Sephardi communities enjoyed partial autonomy, with their own jurisdictions based on Jewish legal codes. Medieval Ashkenazi Jews in northern Italy and northern France, the Germanic lands, England, and parts of eastern Europe adhered to their own customs, maintained forms of Hebrew pronunciation, and adopted the use of Yiddish. Sephardi Jews, on the other hand, proudly followed their Iberian heritage. Whether or not they were forced into ghettos, most of these Jews lived in proximity to their institutions, be it their synagogue, school, ritual bath, bakery, slaughterhouse, town hall, hospital, or charitable organizations.

During the Muslim rule of the Iberian Peninsula, Sephardi Jews generally enjoyed better conditions than their Ashkenazi contemporaries in Christian Europe. When Christians conquered Spain and Portugal in 1492 and 1497, respectively, they expelled the Jews from the peninsula and harshly persecuted them, destroying their synagogues or converting them into churches. Even in the subsequent diaspora—ranging as far as Amsterdam, Hamburg, London, the Ottoman Empire, and northern Africa—Jews continued to proudly cling to their Iberian roots.

In Sephardi synagogues, the bimah is usually located at the rear (western side of the building), opposite the Torah ark that is always positioned in the direction of Jerusalem; seating is along the walls, and congregants face one another. In Ashkenazi synagogues, the bimah is situated in the center, with seats surrounding it on three sides. In the large nineteenth- and twentieth-century Reform synagogues, the bimah and the rabbi's pulpit are often placed in front of the Torah ark, with the officiants typically facing the congregation.

As a result of the emancipation movement in the nineteenth century, Jewish communities adopted a more visible public profile. They particularly looked to early examples of Moorish architecture, such as the two medieval synagogues in Toledo as well as the great Moorish palaces of Alcázar in Seville, and the Alhambra in Granada. All of these buildings of the Iberian Peninsula dated from the time when Spanish Jews, Christians, and Muslims lived together in relative peace. Inspired by the "Sephardi myth" of the *Convivencia* that arose in the 1800s, Jews regarded this neo-Moorish style as a symbol of integration and equality.

Only in the nineteenth century did European synagogues commonly incorporate into their exterior architecture Jewish texts and symbols, such as the Tablets of the Law, the seven-branched candelabrum of the Temple, or the six-pointed star (also known as the Shield of David). Until fairly recently, women played a marginal role in the synagogue, praying in an adjacent room or in a separate section at the back, or on a second-floor balcony. Today, women in most currents of Judaism actively participate in Jewish congregational life and, in some cases, serve as rabbis, cantors, and communal leaders.

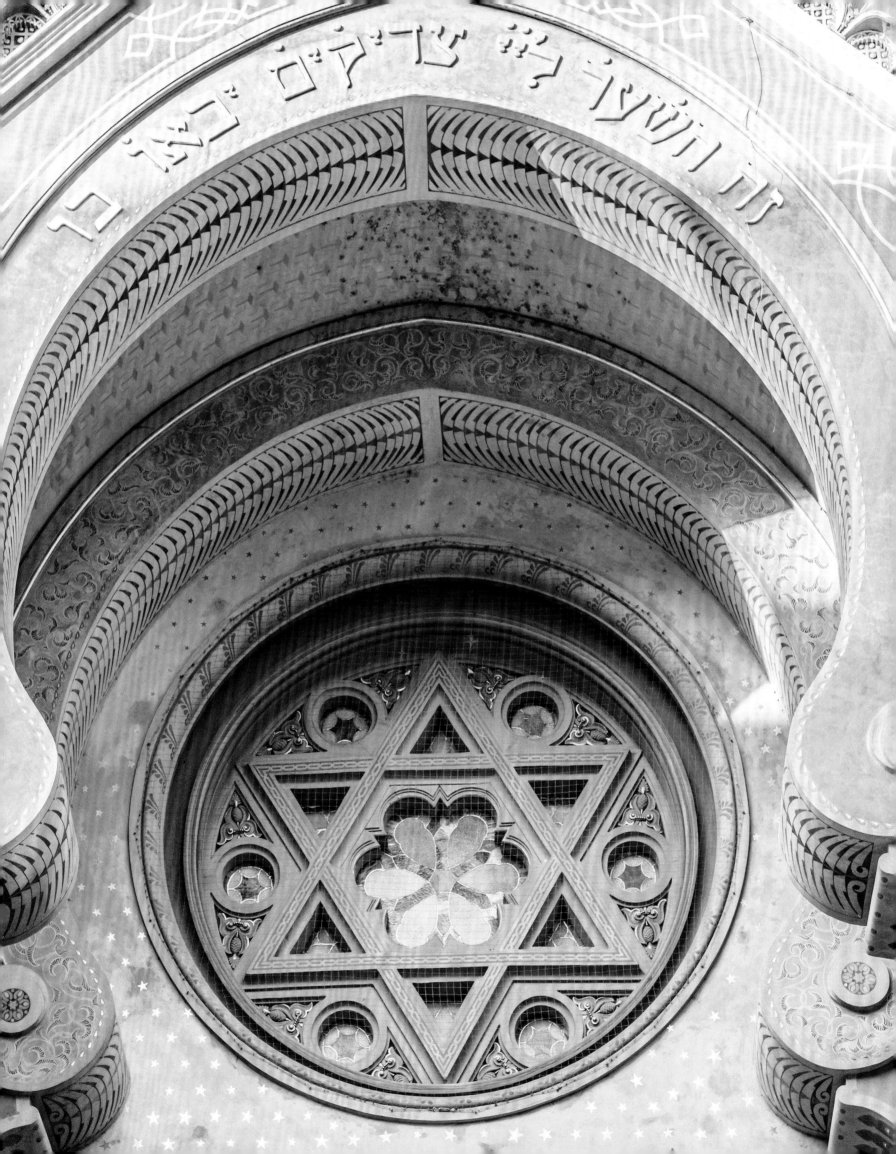

Page 83: The Jubilee Synagogue on Jerusalémská Street in Prague exhibits the signature exuberant style of the Jewish Viennese architects Wilhelm Stiassny and Alois Richter, who were inspired by Moorish and art nouveau sources. Inaugurated in 1906 in honor of Franz Joseph I, the synagogue testifies to the Austrian emperor's unusual goodwill toward the Jewish community at that time. The Hebrew text on the horseshoe arch is a quote from Psalm 118:20: "This is the Gate to the Lord, through which the righteous may enter."

Opposite: Marking the apogee of Judaic culture in medieval Spain, the Joseph ibn Shoshan Synagogue, in Toledo (ca. 1180) was subsequently converted into the Church of Santa María la Blanca in 1411. Its extraordinary capitals with carved pinecones and its cusped windows are the hallmarks of the finest Moorish architecture.

Pages 86–87: Rows of horseshoe arches line the light-filled sanctuary of the Joseph ibn Shoshan Synagogue. The unusual five-aisled plan may have been executed by Moorish craftsmen at the behest of Joseph ibn Shoshan, the prosperous son of a minister of finance to Alfonso VIII of Castile.

The Synagogues of Spain: Joseph ibn Shoshan Synagogue, Toledo, Spain (ca. 1180, converted into the Church of Santa María la Blanca in 1411) and Synagogue Don Samuel Halevi Abulafia, Toledo, Spain (1357, converted into the Church of Nuestra Señora del Tránsito after 1492)

Jews first arrived in Spain during the Roman Empire and maintained an active presence prior to the invasion of the Muslim Umayyads in the eighth century. However, it was under Islam that Jewish life began to flourish in the prosperous cities that had developed dynamic centers of learning, such as Córdoba, Granada, and Toledo. This last city, located in the center of Spain, was twice heralded as the "New Jerusalem," first, when it was conquered by the Muslim General Musa bin Nusayr in 712, and then, after 1085, under Christian Castilian sovereignty. In 1492, the Jews were expulsed from Spain. Today, only two of the more than ten synagogues and five houses of study that had prospered in fourteenth-century Toledo survive—and only thanks to their conversion into churches in the fifteenth century.

Joseph ibn Shoshan Synagogue is a rare and extraordinary example of a five-aisled synagogue. It features octagonal pillars and delicately ornamented capitals that support twenty-eight Islamic horseshoe arches. Built in the late twelfth century on the outskirts of Toledo in brick with courses of stone and plaster, the synagogue was restored prior to 1205 by Joseph ibn Shoshan, a community leader and member of a prominent Jewish family who was close to the Spanish court. The geometric plastered wall ornamentation (which includes scroll, shell, and floral motifs along the three interior aisles) now contrasts with the blank bands that probably once contained Hebrew inscriptions. The Torah niche and the balcony for women to attend services no longer exist. Converted into the Church of Santa María la Blanca in 1411, the building is now a museum.

In 1357, Don Samuel Halevi Abulafia, adviser to King Peter of Castile, built a second house of worship, the Synagogue Don Samuel Halevi Abulafia Synagogue, within walking distance of the Joseph ibn Shoshan Synagogue. Renamed Nuestra Señora del Tránsito after the Jewish expulsion in 1492, this exquisite former sanctuary

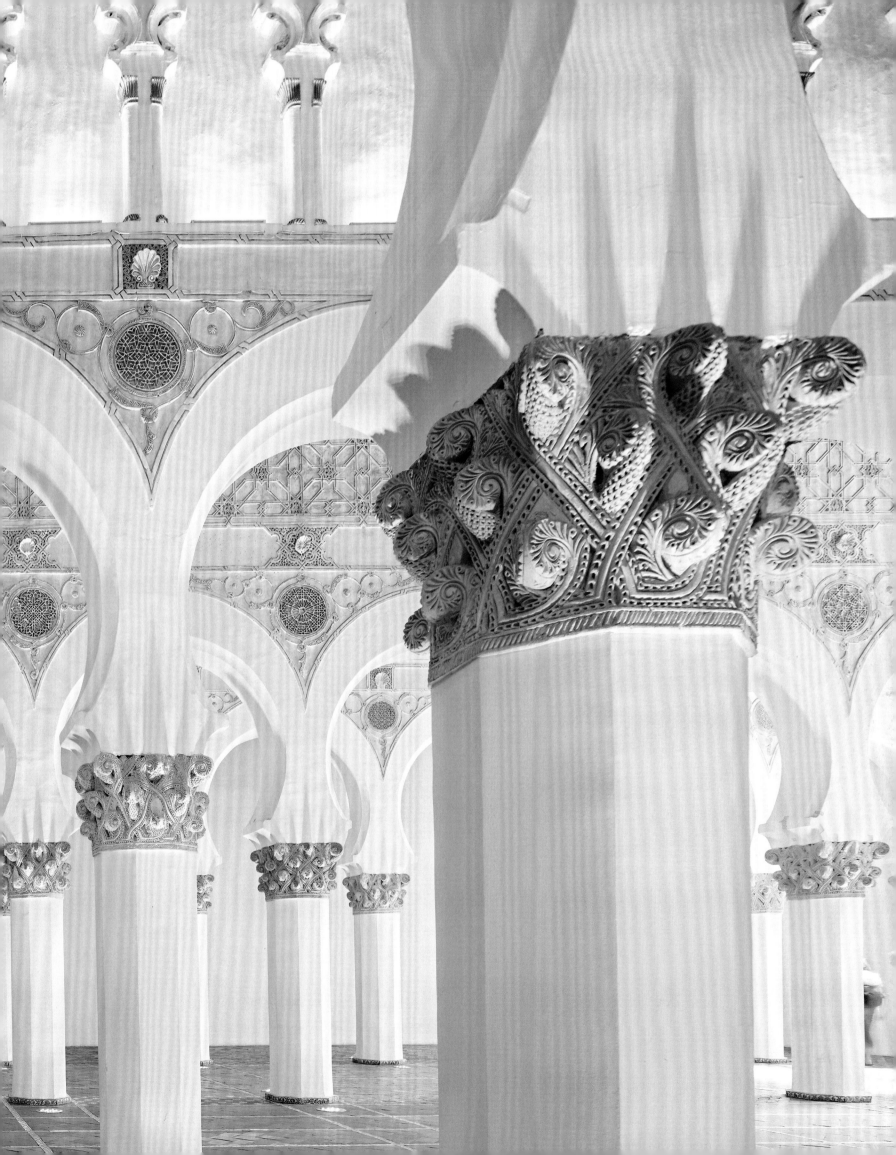

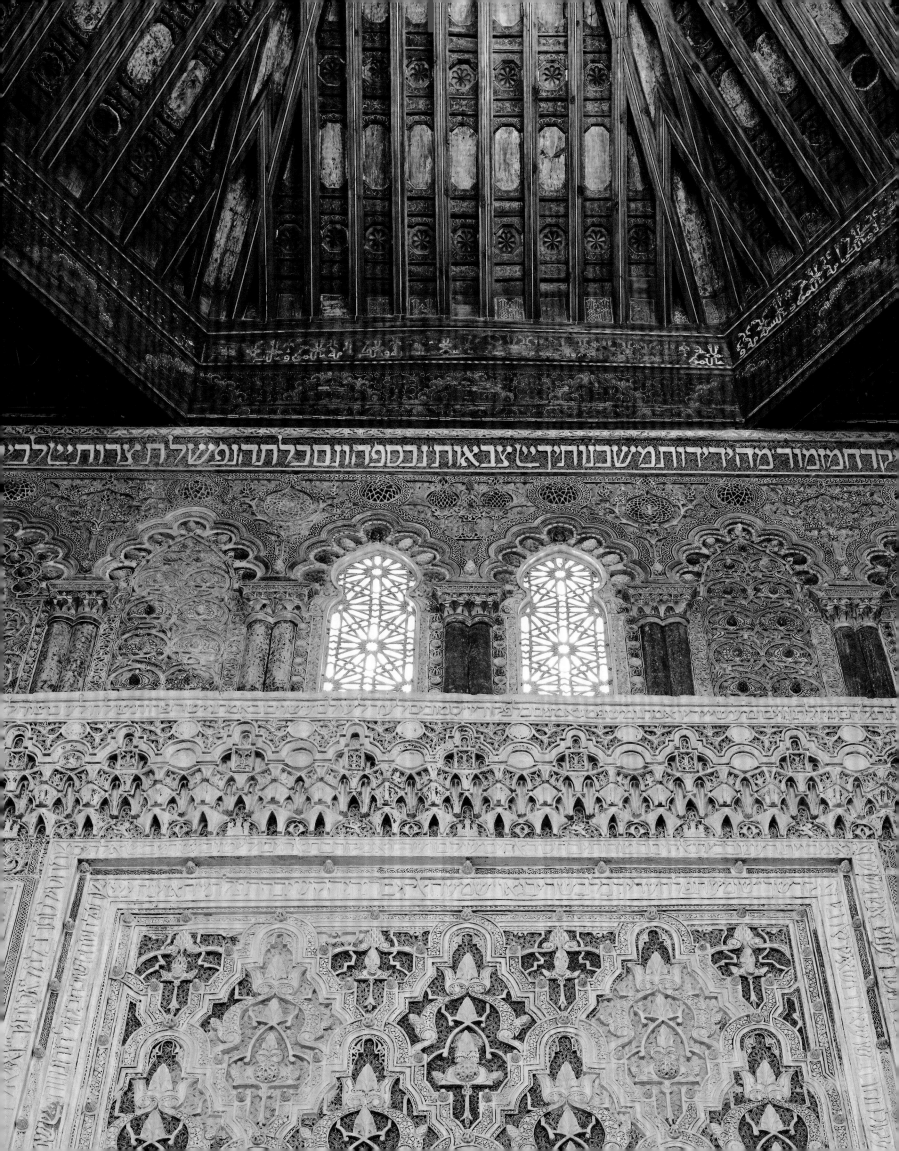

now serves as a Jewish museum. The brick and stone structure follows a simpler rectangular plan than its neighbor, with chambers along its northern and southern sides that include a women's gallery. An intricately carved wooden ceiling in the Moorish style known as *artesonado*, with supplementary interlaced laths, spans the large hall. The synagogue's magnificent horseshoe-shaped windows are adorned with rich Mudéjar stucco decoration in the fine floral and abstract patterns typical of the Nasrid dynasty style in Muslim Granada in southern Spain between 1230 and 1492.

Altneu Shul (Old-New Synagogue), Prague, Czech Republic (late thirteenth century)

Around the same time that Jews developed dynamic communities in Spain, they also flourished in central Europe. To this day, Prague boasts Europe's only functioning medieval Ashkenazi synagogue, a historical cemetery, the footprints of Franz Kafka, an astounding collection of Judaica, and five major synagogues in a variety of styles, which are now museums or houses of worship mostly open for special functions.

The Altneu Shul (Old-New Synagogue), a freestanding building supported by heavy buttresses with a large saddle roof and late Gothic gables, owes its name to a legend. Accordingly, its foundation stones were brought by angels from the destroyed Temple of Jerusalem on the condition (Hebrew: *al-tenai*) that they would be returned when the Temple was rebuilt in messianic times. Crowned by a beautiful tympanum with vine leaves and grapes, a small portal opens onto the impressive interior where the floor was lowered to increase the sanctuary's sense of height. Twelve Gothic windows illuminate the hall, which is separated into two naves by two octagonal pillars. At the center, the bimah is enclosed by a late-Gothic grille surmounted by a banner with the Star of David dating from 1716. The surrounding lower structures were added later for use as a vestibule and a prayer room for women, who could listen through openings in the thick walls. The building is said to be protected by the legendary golem, a magical creature thought to live in the attic.

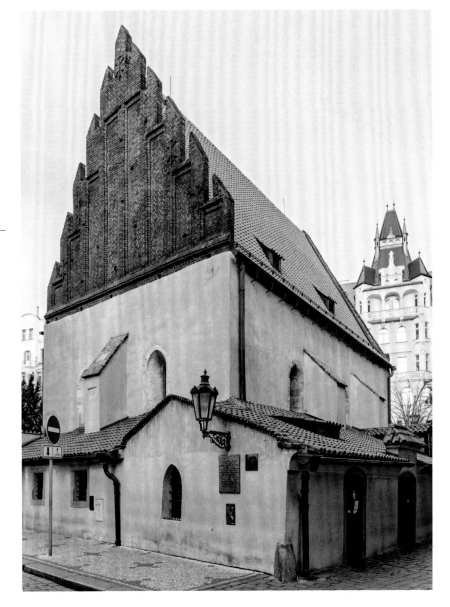

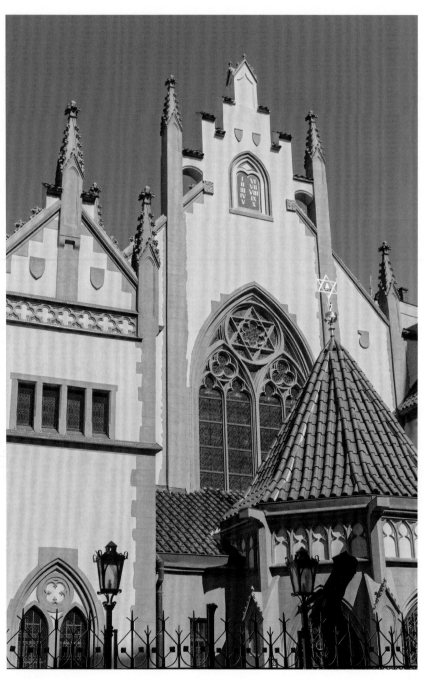

Together with the sixteenth-century Jewish town hall, which is adorned with a clock with Hebrew lettering, the Altneu Shul once dominated the surrounding buildings of the Jewish ghetto. In the late nineteenth century, the city initiated an urban renewal project that transformed the ghetto into a district of elegant middle-class houses. Like the Kazimierz quarter of Kraków in Poland, Prague's former ghetto now attracts numerous visitors in search of a vanished world. It includes a number of other historical sanctuaries, such as the Maisel Synagogue, originally built in 1592 by financier and philanthropist Mordecai Maisel (1528–1601), and the Baroque Klausen Synagogue, dating from the seventeenth century.

Maisel Synagogue, Prague, Czech Republic (1905)

Around 1590, the Habsburg emperor Rudolf II gave Mordecai Maisel, a highly successful financier and philanthropist, permission to build his own private synagogue in the ghetto. Largely responsible for the growth and embellishment of the Jewish quarter during Prague's Golden Age in the sixteenth century, Maisel later bequeathed his synagogue to the Prague community. Between 1893 and 1905, the Prague-born Jewish architect Alfred Grotte (1872–1943) converted the synagogue into its current neo-Gothic style building, including the cream-colored stone facade edged with brownstone and surmounted by a red-tile roof. Its spacious and largely original interior is surmounted by a ribbed vault and flanked by side alcoves that support the women's galleries on the floor above. As was the case with all Prague synagogues, Nazis used this building to store stolen Jewish property.

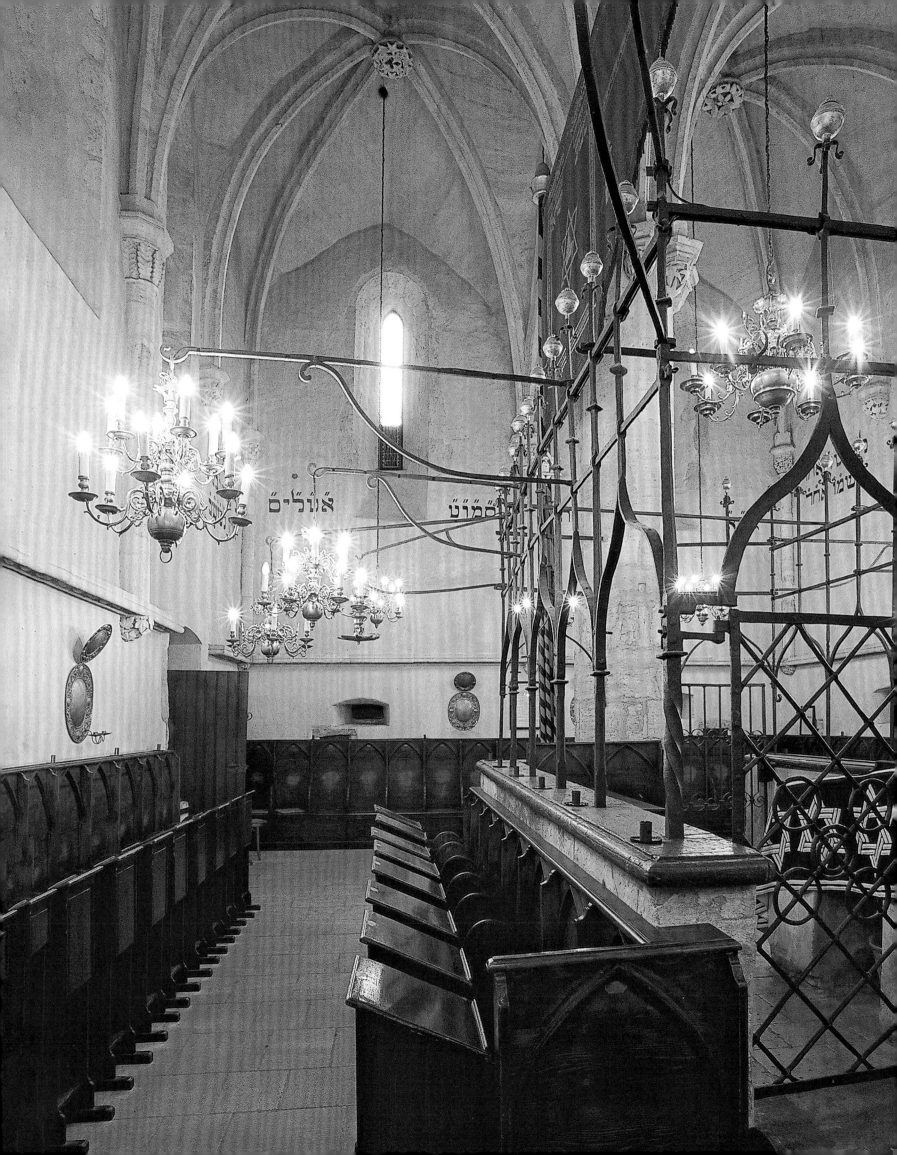

Below: The Klausen Synagogue in Prague is a rare example of the late seventeenth-century Bohemian Baroque-style synagogue, with its cream-colored walls, delicate floral ornamentation, and wide double-storied windows. The elaborate gilded and faux marble Torah ark suggests the wealth and prestige of the Jewish community under the Habsburgs.

Klausen Synagogue, Prague, Czech Republic (late seventeenth century)

Nearby, the light-filled Klausen Synagogue replaced an earlier building destroyed by fire and is the only preserved Baroque synagogue in the heart of the former ghetto. The grand three-tiered Torah ark in the large sanctuary was donated by Samuel Oppenheimer (1630–1703), the affluent banker and influential diplomat of the Habsburg emperors who ruled large parts of Europe at that time. Although restored on several occasions over the course of time, the building preserves its original character. It is now part of the Jewish Museum in Prague, along with all of the synagogues in the historic district.

Jubilee Synagogue (Jerusalem Synagogue), Prague, Czech Republic (1906)

A near contemporary of the neo-Gothic Maisel Synagogue, the Jubilee Synagogue in the Moorish style presents an entirely different aesthetic. Just a stone's throw from the Central Railway Station in Prague, this glorious synagogue was named for the 1898 Silver Jubilee of the Austro-Hungarian emperor Franz Joseph I—the same year that its building was officially sanctioned. Its red-and-yellow-stone facade stands out boldly on the narrow Jerusalem Street, with its large horseshoe arch framing a rose window emblazoned with the Star of David. Inaugurated in 1906, the synagogue is a splendid combination of Moorish architecture and art nouveau elements. Its fine restoration over recent years has successfully brought to life the triple-aisle nave plan with its women's gallery, the original liturgical furniture, and the meticulously decorated walls and ceilings—all bathed in the light of fanciful stained-glass windows. Today, the Jubilee Synagogue is one of the few well-preserved works of the celebrated Viennese Jewish architect Wilhelm Stiassny (1842–1910) and is once again open for religious services and cultural activities.

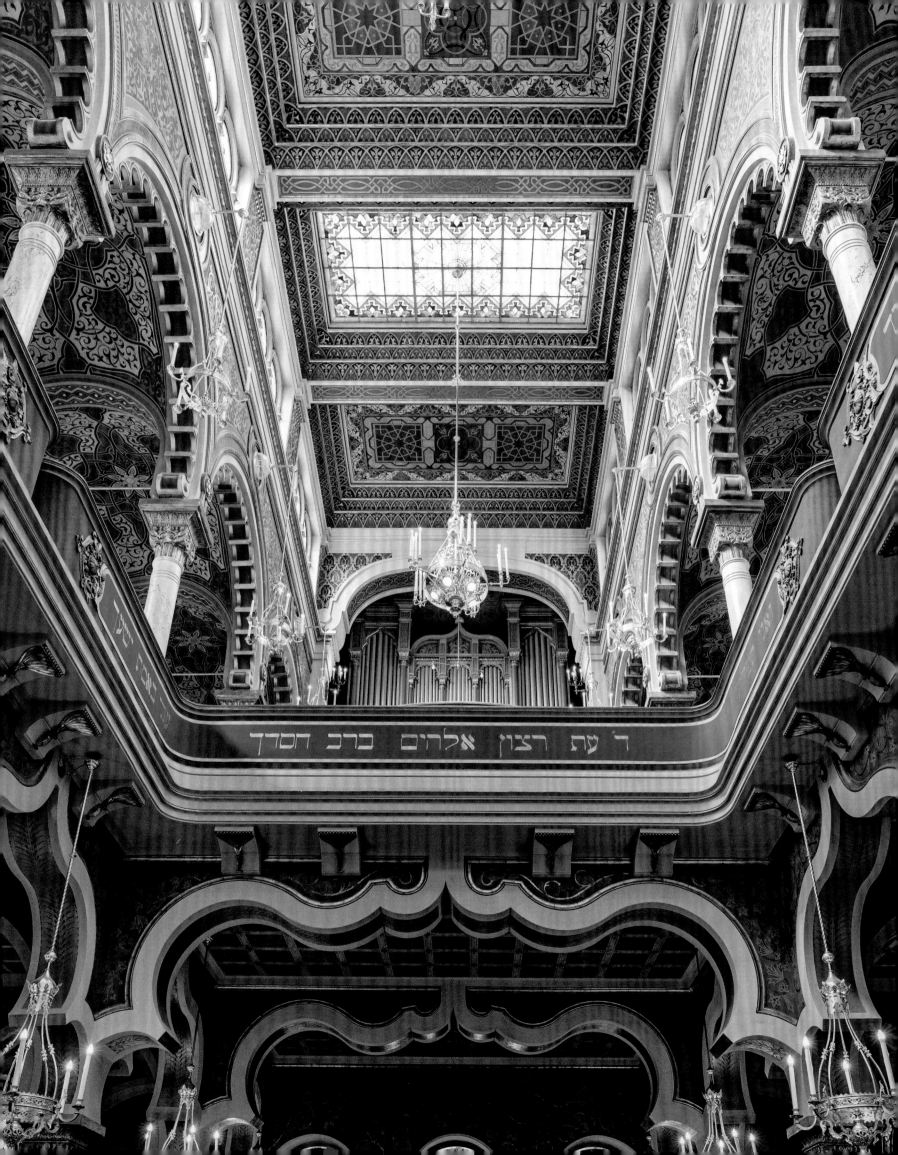

Opposite: The Jewish Viennese architect Wilhelm Stiassny, who renovated the Stadttempel (see page 102), was responsible for designing its stylistic opposite, the Jubilee Synagogue of 1906 Prague. Prominent Moorish arches, gilded Hebrew calligraphy, and stenciled designs in flamboyant color enliven its unique interior. Note the fine organ across the hall from the ark.

Below: Detail of the Jubilee Synagogue. The stained-glass oculus fuses high Gothic tracery with Jewish symbolism while flooding the ark with light.

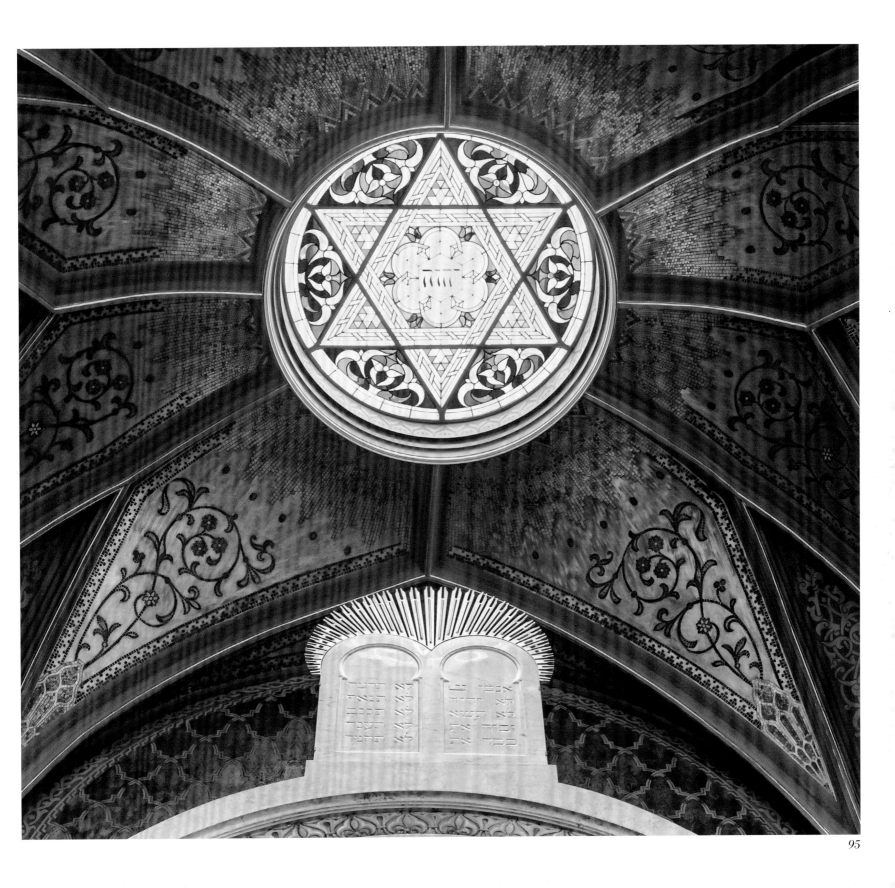

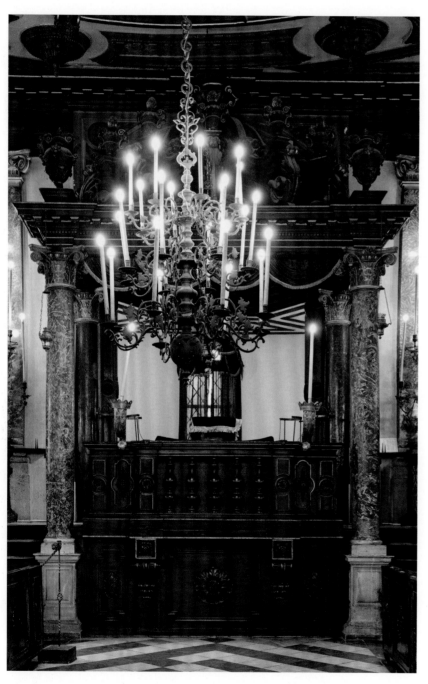

Scuola Grande Spagnola (The Great Spanish Synagogue), Venice, Italy (post-1589, major renovations ca. 1655, 1830, and 1838)

While Jews settled in Prague in the tenth century, they had already been established in Italy since Roman times. As in Prague, they also began to flourish as moneylenders and merchants in the Veneto region, living mostly in the Giudecca quarter of Venice. Following the Jewish expulsion from Spain in 1492 (and the consequent diaspora), the Venetian authorities began to restrict both these new arrivals and longtime Jewish residents to the ghetto.

Built for the Spanish refugees, the Scuola Grande Spagnola (The Great Spanish Synagogue) is the most impressive of the five remaining synagogues in the crowded Venetian ghetto. Unpretentious from the exterior, the actual sanctuary occupies the second floor of an apartment complex. It is accessed by a double stairwell that culminates surprisingly on either side of the bimah. The stairwell opens onto an ornate rectangular prayer hall with large light-filled windows capped by an oval clerestory gallery. The interior is attributed to the followers of renowned Venetian architect Baldassare Longhena–and dates to ca. 1655. An elaborate scrolled canopy inspired by Gian Lorenzo Bernini's famous Roman baldachin in St. Peter's Basilica overhangs the bimah, although it is now largely barred from view by an organ donated in the 1820s. Consequently, the reading desk was moved in front of the Baroque polychrome marble Torah ark. Today only a tiny population of Jews still inhabit the Venetian ghetto, which was once home to a community of five thousand.

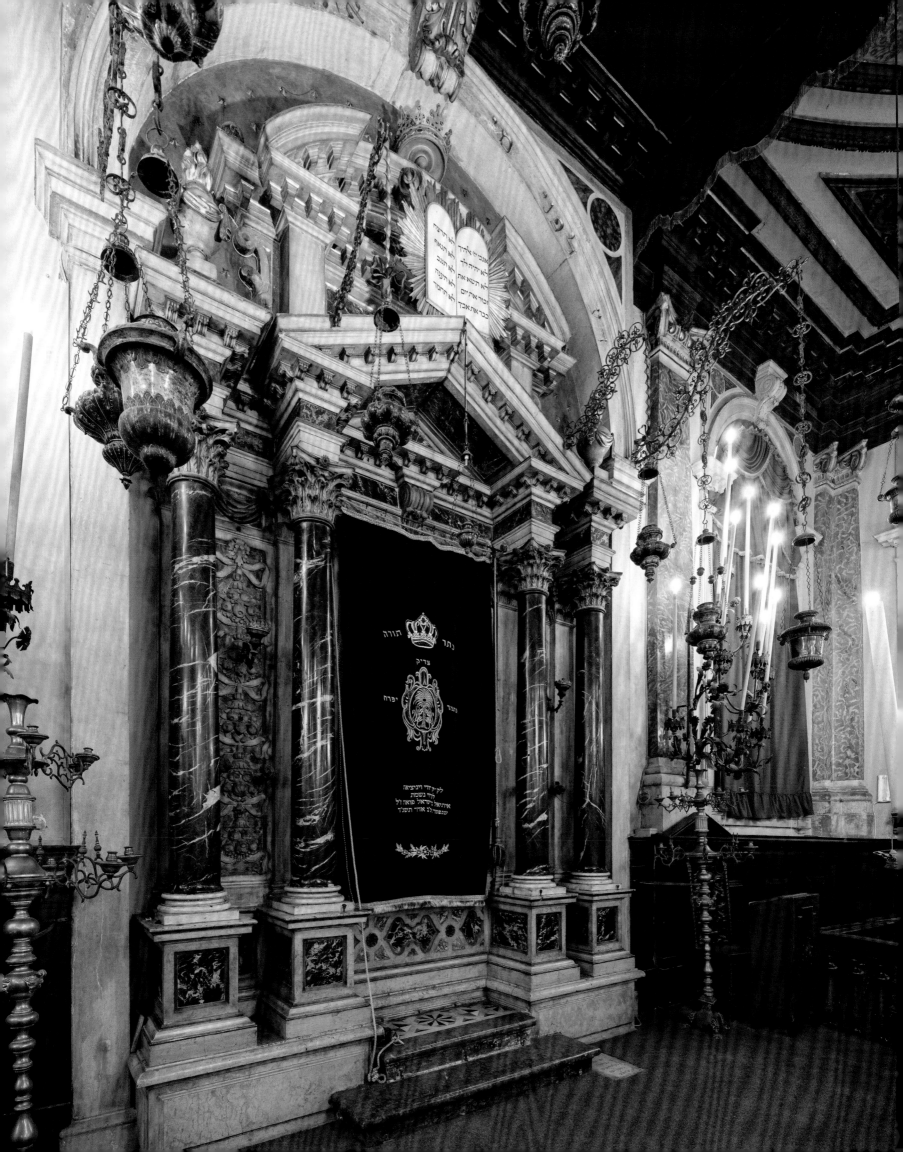

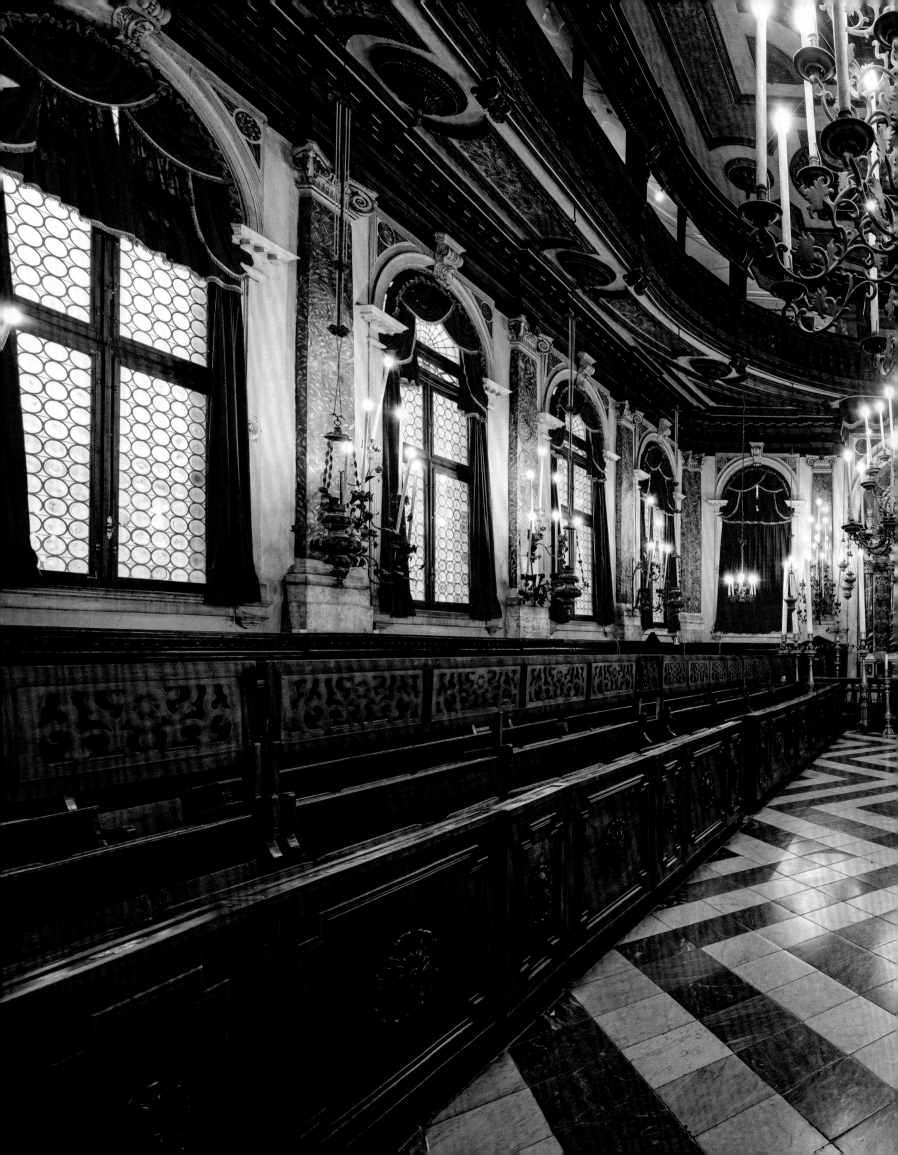

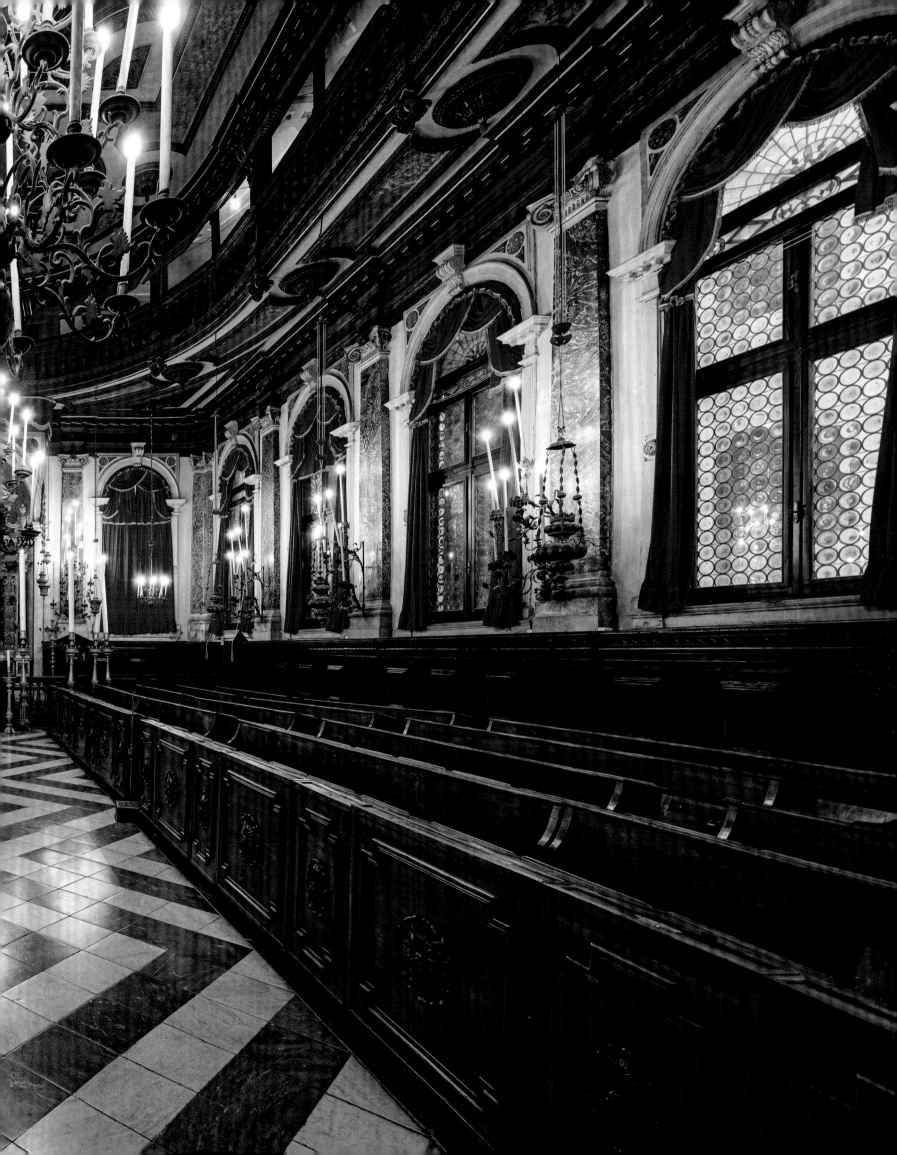

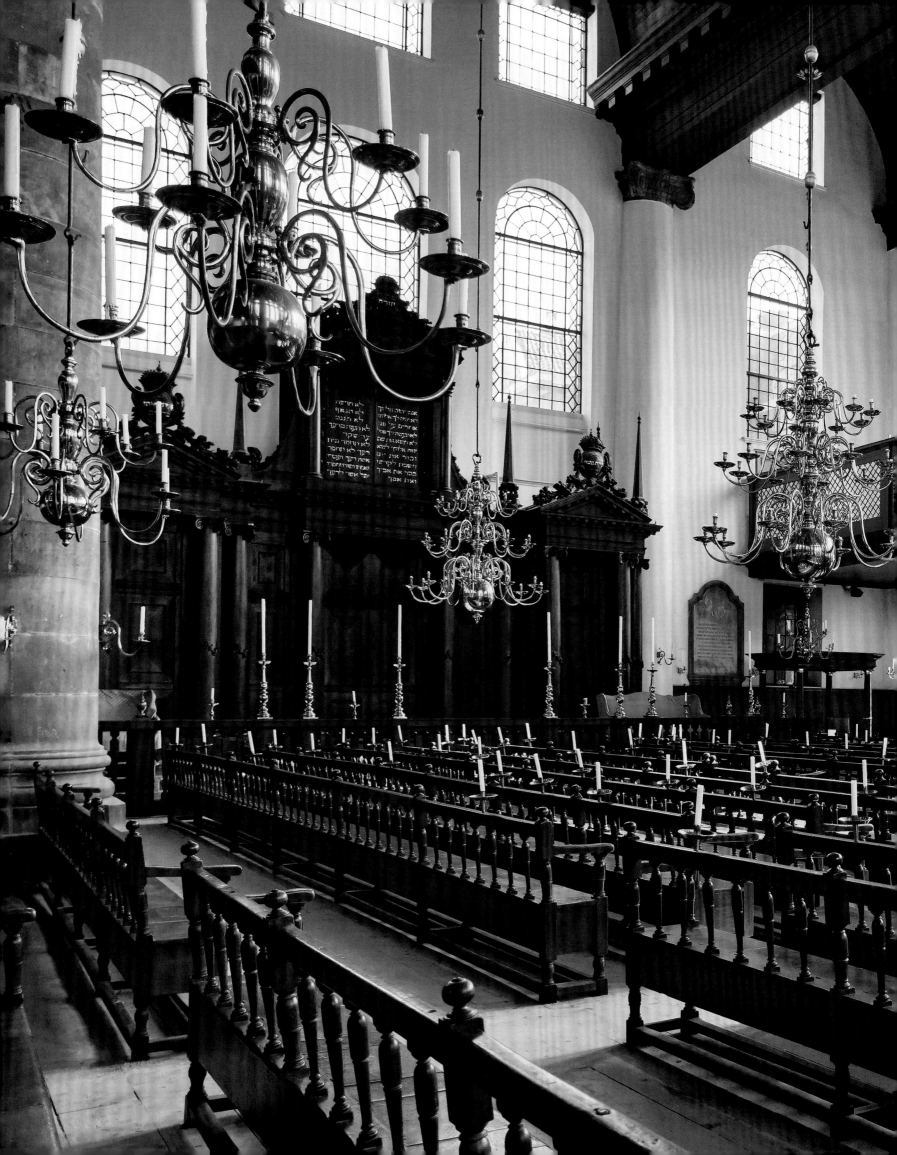

Esnoga (Portuguese Synagogue), Amsterdam, The Netherlands (1675)

Following their expulsion from Spain, many Jews fled to Amsterdam, as well as to Italy, eastern Europe, and the Ottoman Empire. During the Dutch Golden Age in the seventeenth century, though barred professionally from the guilds, the Jews of Amsterdam were not constrained to living in a ghetto or wearing distinctive clothing. Thanks to their international connections and knowledge of diverse languages, Sephardi Jews helped boost the city's economic growth. These Jews of Spanish and Portuguese origin, as well as Ashkenazi Jews fleeing persecution elsewhere in central Europe, all benefited from the climate of tolerance fostered by Protestantism and the Dutch rejection of Catholic Spain. In 1675, the affluent Sephardi community was able to replace an earlier, smaller synagogue with the new Esnoga ("synagogue" in Portuguese) building. This imposing urban landmark, designed by the non-Jewish architect Elias Bouman (1636–1686), occupies almost an entire city block and accommodates seventeen hundred people. The largest and most admired synagogue of its day, the Esnoga completely overshadows the neighboring Ashkenazi Great Synagogue built in 1671 by the same architect. Both synagogues resemble other contemporary, equally austere white-walled Protestant basilica-style churches in Amsterdam— these were the first monumental synagogues in Europe that were highly visible from the outside and still form a distinctive part of Amsterdam's skyline.

Starting on Friday, August 2, 1675, the Esnoga's inaugural festivities lasted eight days, echoing the duration of investiture of the Temple of Jerusalem. Like the biblical accounts of the Temple, this truly majestic synagogue stands in a courtyard, surrounded by lower buildings that serve various communal purposes. Supported by four huge Ionic sandstone columns, the wooden barrel vault covers a light-bathed three-aisled sanctuary. Following the Sephardi tradition, rows of benches along the walls face each other, while the large monumental wooden shrine for the Torah scrolls stands against the eastern wall with the bimah near the entrance on the opposite side. Two parallel women's galleries, supported by twelve elegant Ionic columns and accessed via staircases at the rear, were added between 1773 and

Below: In the early 1900s, the famous Viennese Jewish architect Wilhelm Stiassny renovated the Stadttempel, opening up the space and unifying the design into a single oval form with spare ornamentation. The elegant lines defining the tablets of the Ten Commandments above the ark as well as those of the staircase leading to the women's balcony reflect the Viennese architect Josef Kornhäusel's admiration for the German Biedermeier style.

Opposite: A sky blue oval dome painted with gold stars surmounts the main sanctuary of the Stadttempel on Seitenstettengasse, in Vienna (1826). Its architect, Josef Kornhäusel, known for his theater design with fine acoustics, adopted a hybrid of neoclassical and Empire Biedermeier styles, focusing on clarity, minimal ornamentation, and fine craftsmanship.

1774. Originally, fine white sand covered the floor in the Dutch tradition to absorb rain, mud, and noise. The Esnoga set the standard for synagogues in cities all over the Sephardi diaspora, such as London; Newport, Rhode Island; and New York.

While 80 percent of Dutch Jews were murdered by the Nazis and their synagogues plundered, miraculously the Esnoga, along with its famous Ets Haim/Livraria Montezinos Library, survived and remains in use to this day. The synagogue forms the core of the Jewish cultural quarter, which includes four Ashkenazi synagogues (now the Jewish Historical Museum) and the National Holocaust Museum.

Stadttempel (Seitenstettengasse Temple), Vienna, Austria (1826)

In contrast with the sobriety of the Esnoga, the interior of the Stadttempel in Vienna presents an opulent theatrical design in keeping with the tastes of such prominent Jewish families as the Arnsteins and the Rothschilds. Designed by the fashionable Viennese architect Josef Kornhäusel (1782–1860), the synagogue lies hidden behind a five-story building, in compliance with the restrictive regulations for non-Catholic houses of worship. (Jews eventually received equal rights in 1867.) Distinctively different from Viennese church architecture, the prayer hall occupies an elegant oval space surmounted by an elliptical dome. Reflecting an eclectic style, the interior combines neoclassical and Biedermeier elements. Twelve Ionic columns support the surrounding women's galleries, which are partially screened by fine latticework. In the 1900s, noted Jewish architect Wilhelm Stiassny, who went on to build the Moorish Jubilee Synagogue in Prague, renovated the galleries, adding two bays directly to the left and right of the Torah ark.

From its inception, the Stadttempel benefited from the leadership of Rabbi Isaac Noah Mannheimer (1793–1865), a passionate preacher and staunch supporter of social causes. The extraordinary music of cantor and composer Salomon Sulzer (1804–1890) enriched the services and reflected the intense cultural life of Viennese Jewish society.

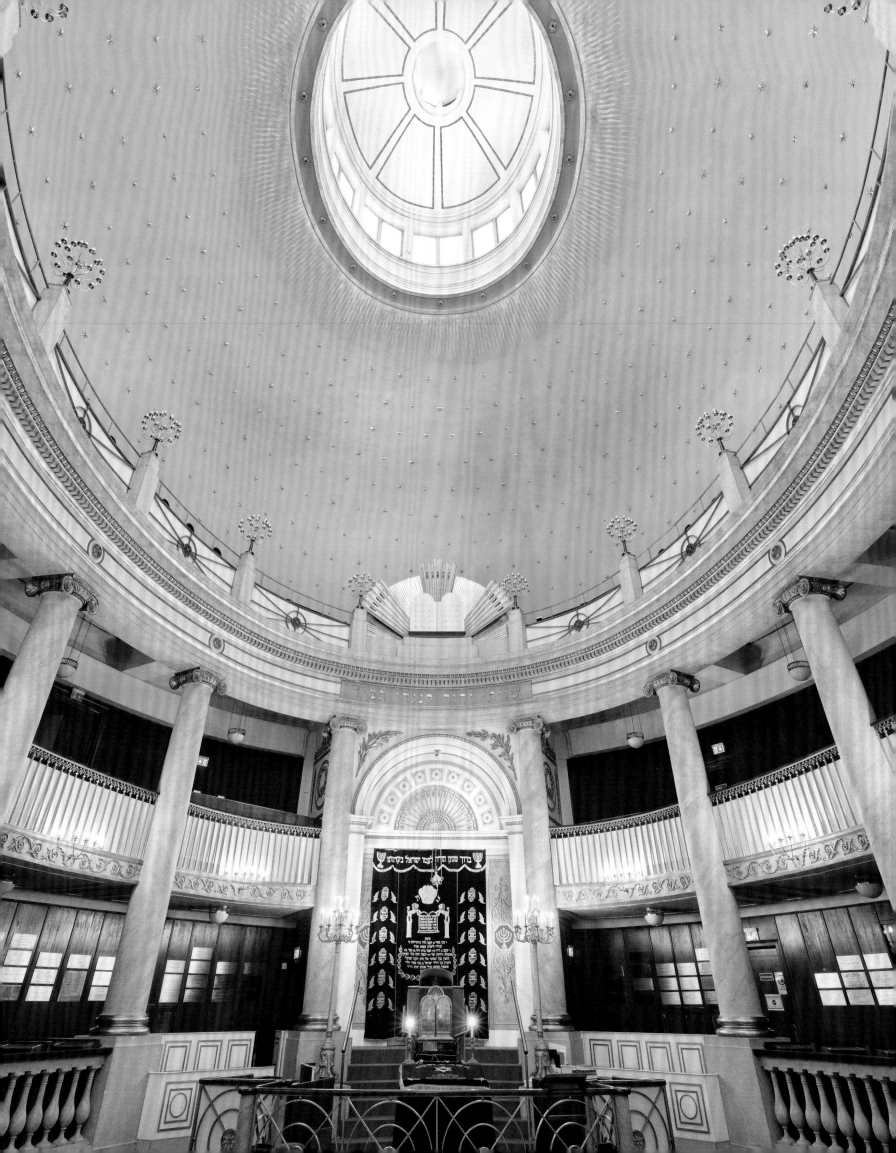

Before 1938, Vienna counted more than a hundred synagogues and houses of prayer, all of which were destroyed, except for the Stadttempel (although it was damaged during Kristallnacht). Beautifully restored in 1963, the synagogue is still in use and serves as a beacon of Jewish faith and culture. It is located near the Jewish Museum and the Judenplatz Holocaust Memorial, designed by British artist Rachel Whiteread and unveiled in 2000 as a tribute to the two hundred thousand Jews of pre–World War II Vienna.

Great Synagogue on Dohány Street, Budapest, Hungary (1859)

Though many Jews remained poor, in capitals such as Vienna, Berlin, and Budapest, a number became wealthy and more sophisticated as their population grew. This elite group sought to hire the finest architects for important commissions. In Budapest, the Great Synagogue on Dohány Street (Tabakgasse), built between 1854 and 1859, with seating for about three thousand, embodies this trend. It ranks as Europe's largest synagogue and is still in use by Neolog Jews (a Conservative movement that originated in Hungary). The prominent Christian Viennese architect Ludwig Förster (1797–1863) designed the building. Known for his work on the Ringstrasse and the Reform Tempelgasse Synagogue in Vienna, Förster was inspired by both the Islamic architecture in Spain (the Alhambra and the Alcázar) and the excavations of Nineveh and Babylon in the 1840s. The Moorish facade, made with the special burned-brick technique, is flanked by two slim octagonal towers with onion-shaped cupolas. The building combines elements associated with the Temple of Jerusalem, such as the columns of Yachin and Boaz, and church architecture. Förster's associates, Ignaz Wechselmann (1828–1903) and Frigyes Feszl (1821–1884), were responsible for the interior of the synagogue's double-galleried rectangular basilica. They placed the bimah directly in front of the domed Torah shrine in the apse—an innovation that conforms to both the Reform and Conservative need for greater decorum. The synagogue's organ was played by such luminaries as Franz Liszt and Camille Saint-Saëns. The building inspired the Central Synagogue in New York City (1870–1872) (see Chapter Six, page 198), among many others. Damaged

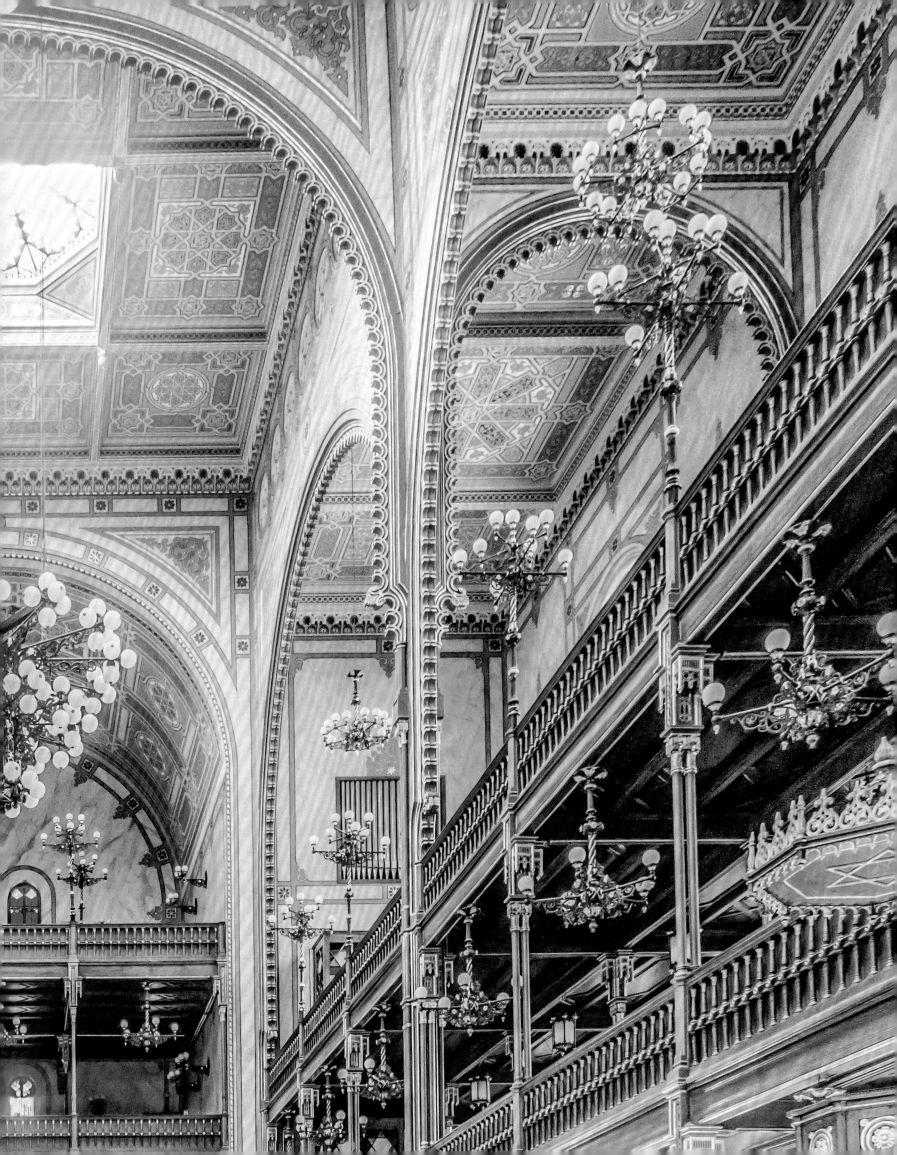

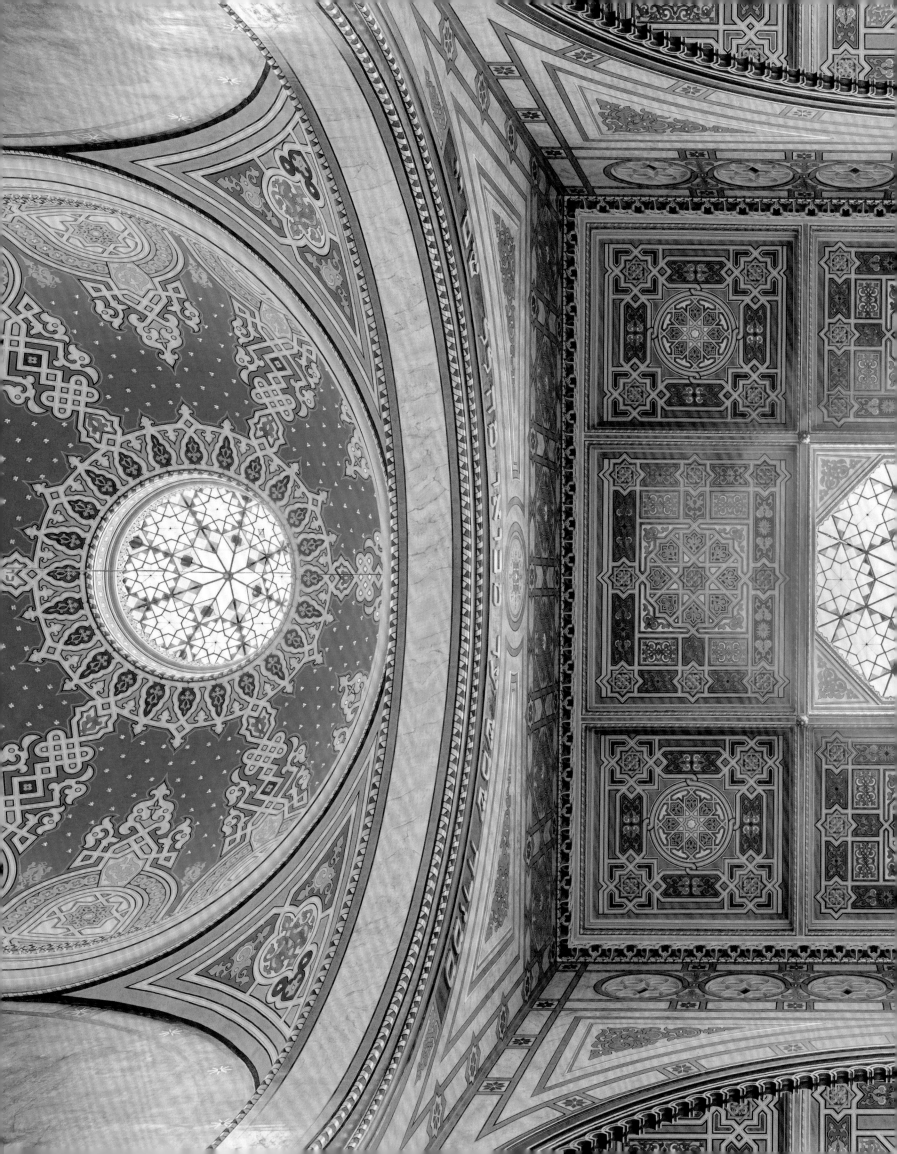

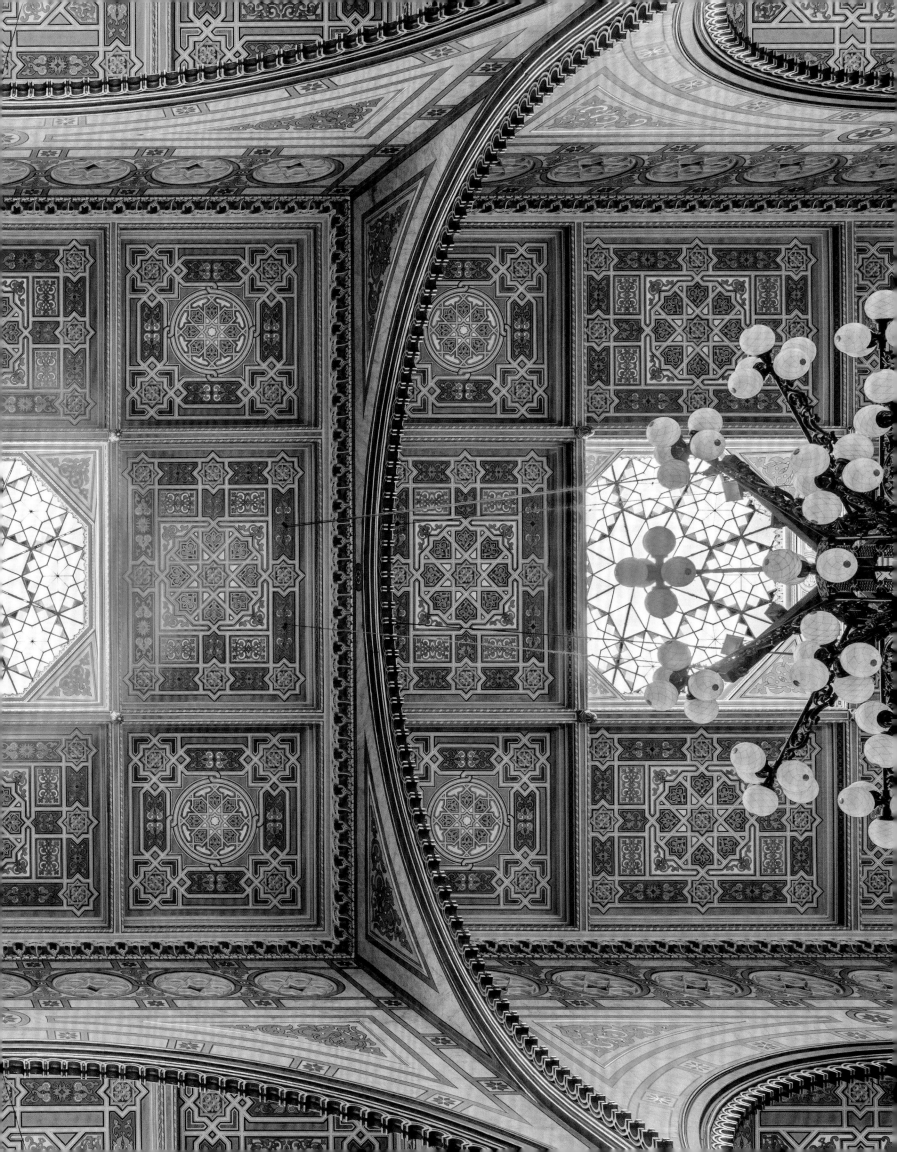

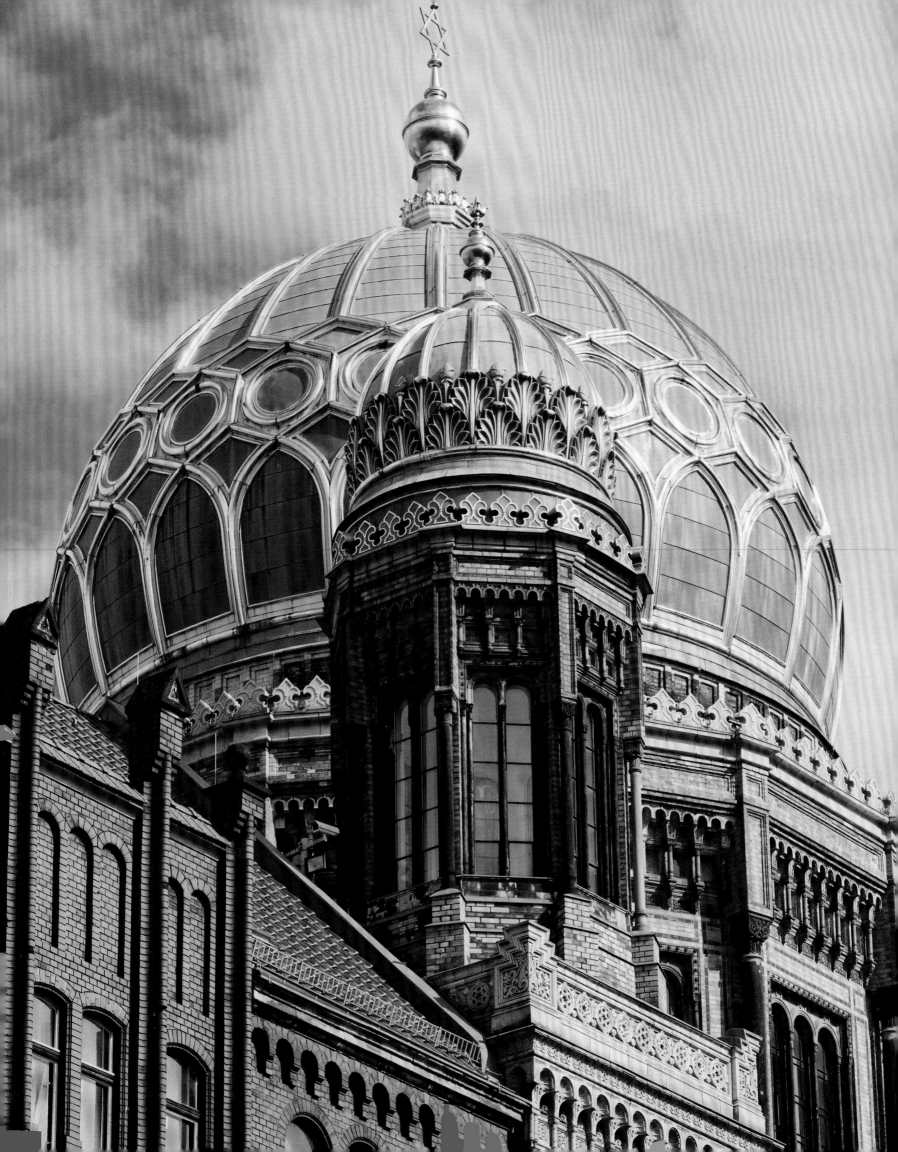

by both Hungarian Nazis and the Allied air raids during the World War II and further neglected under Communism, the synagogue was restored to its former glory during the decade after Hungary's independence in 1989. Today, its main function is as a museum. On the third floor, a small sanctuary serves as a prayer room run by a Masorti (Conservative) rabbi. An arcade now connects the Dohány Street Synagogue to the Heroes' Temple, a memorial to Hungarian Jews killed in World War I.

Neue Synagoge on Oranienburger Strasse (The New Synagogue), Berlin, Germany (1866)

Built in the following decade, the Neue Synagoge (The New Synagogue) of Berlin did not survive intact like the Great Synagogue on Dohány Street in Budapest. Yet to this day, the monumental dome with its gilded ribbing, which stood over the original entrance, still dominates the Berlin skyline. Designed as a Reform synagogue by Friedrich August Stüler (1800–1865) and Eduard Knoblauch (1801–1865), both Protestants, it showcased the work of Berlin's leading architects. The Neue Synagoge replaced the modest eighteenth-century synagogue in Heidereutergasse (1712–14), which had been designed for six hundred worshippers. The new building, with thirty-two hundred seats, was the largest and most beautiful synagogue ever built in Germany and reflects the short period in which Jews enjoyed increasing social acceptance as entrepreneurs, merchants, and bankers. The synagogue was dedicated with full pomp and circumstance in 1866, just five years before equal rights were granted to German Jews.

As in Budapest, both the interior and exterior designs display the taste for the neo-Moorish style, which was considered particularly suitable for Jewish buildings (as the Romanesque and Gothic designs were viewed as typically Christian). Marble, mosaics, colored tiles, and stained-glass windows adorned the interior. The gas lighting, then a novelty, imparted a fairy-tale quality, as visitors of the time observed. Despite the traditional separation between men in the main sanctuary and women in the upstairs galleries, the Neue Synagoge adopted many of the new reforms. For instance, the bimah stood near the ark—not in the middle of the prayer hall. Characteristically, the synagogue featured a gigantic organ upon which many luminaries performed. Louis Lewandowski (1821–1894) led the choir and composed liturgical music that is still enjoyed today, and Albert Einstein played his violin there in 1931.

Before the Nazi era, the Neue Synagoge dominated Jewish Berlin, and it was surrounded by synagogues of different denominations, schools and academies, charitable organizations, kosher stores and restaurants, and a Jewish museum. Untouched during Kristallnacht, the synagogue was severely damaged during the Allied bombardments and partially torn down after the war. Today, the interior is marked by an empty space visible from the upstairs rooms, where synagogue services are once again being held. The still-standing front section, which originally consisted of a large entrance area and vestibule, now houses a Jewish museum. Berlin continues to attract Jews from Russia, Israel, and elsewhere, contributing to the revival of Jewish life in all its variety.

West London Synagogue, London (1870)

Following the lead of Berlin's highly visible Reform Neue Synagoge on Oranienburger Strasse, the West London Synagogue was constructed in Central London, near Marble Arch and Hyde Park. It houses the oldest, largest, and most vibrant Reform congregation in Great Britain. Calling for a German–inspired Reform Judaism with more decorum and organ music, its initiators belonged to a group of prominent "dissenters" including the Goldsmid family, the Montefiores, and the Mocattas. The Jewish architects Henry David Davis (1839–1915) and Barrow Emanuel (1842–1904) adopted a neo-Byzantine style for both the interior and the exterior, along with ornamentation inspired by the Italian Romanesque. The square sanctuary seats a thousand worshippers. Surrounded on three sides by galleries originally designated for women, the prayer hall is dominated by a large marble Torah ark enshrined in a semicircular apse. Behind the ark, a marble screen partially conceals a huge organ with space for the choir on either side of the bimah. Originally, the bimah had been located beneath the large central dome (damaged during World War II), but it is now united with the ark and pulpit at the eastern end of the hall.

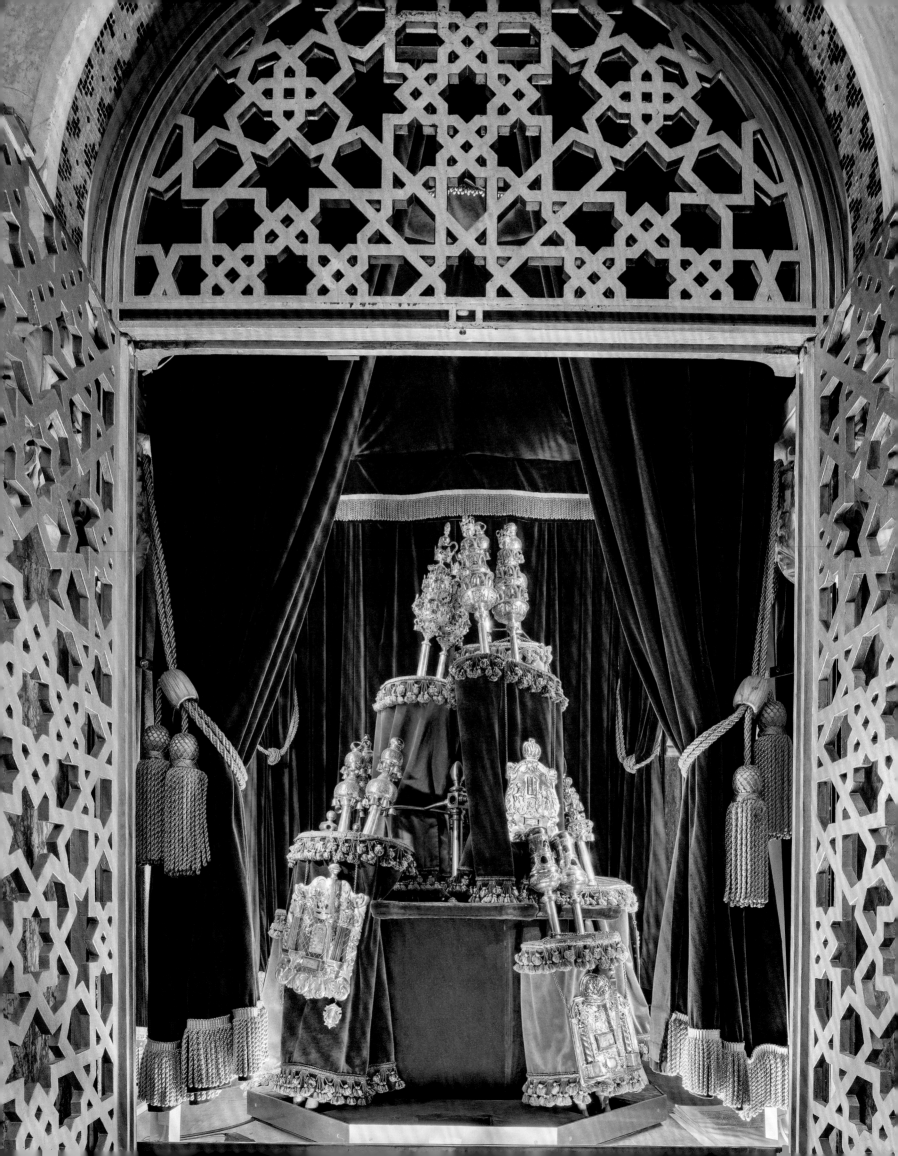

Opposite: Built by London's wealthy and influential Jewish Reform community, the ark of the West London Synagogue's main sanctuary contains precious Sefer Torah scrolls with rare silver rimmonim finials.

Below: The West London Synagogue (1870) was designed by Jewish architects Henry David Davis and Barrow Emanuel, in a neo-Byzantine and neo-Romanesque style. The wooden balconies, originally reserved for women, now accommodate all worshippers.

Pages 114–15: The synagogue's world-famous organ, designed by Harrison & Harrison in 1908 (restored in 2007), demonstrates the importance of choral music to London's Reform community. Such noted organists as Christopher Bowers-Broadbent perform there along with an outstanding choir.

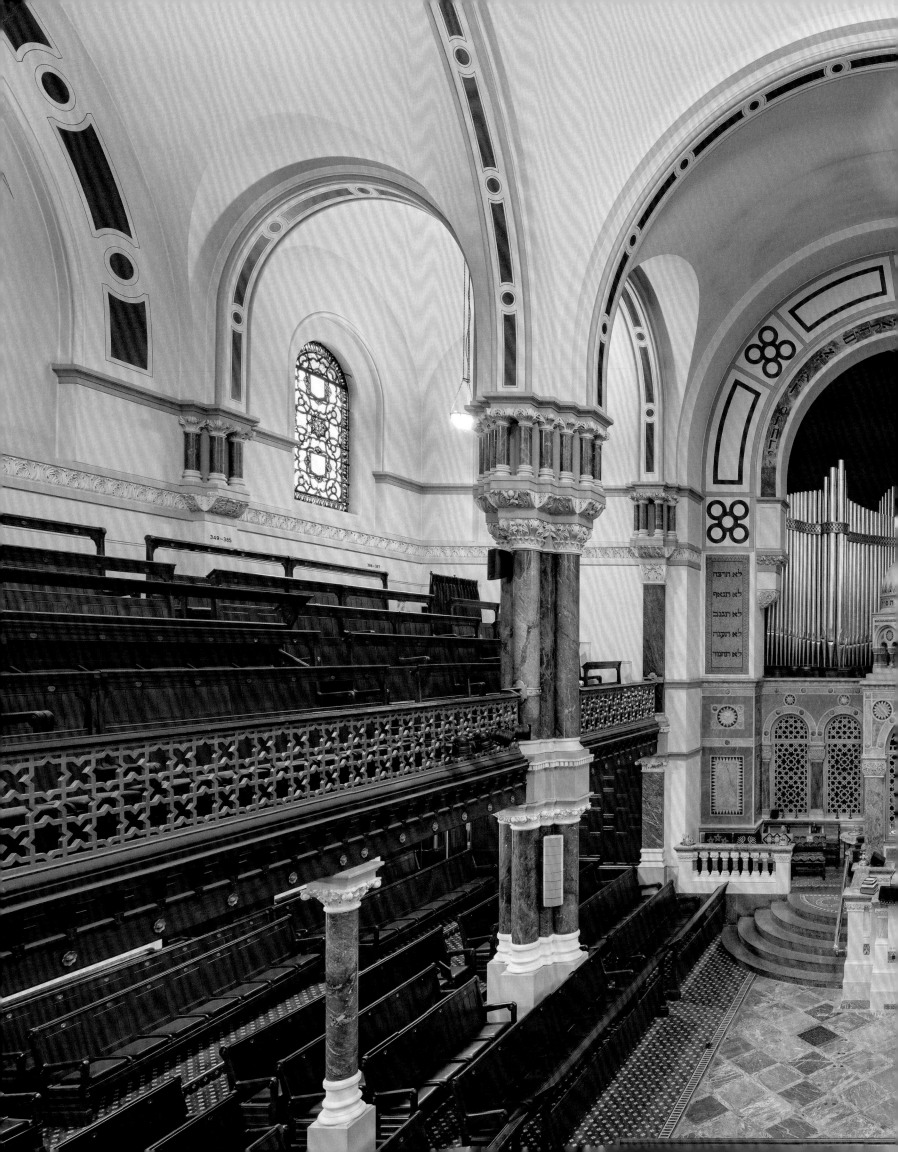

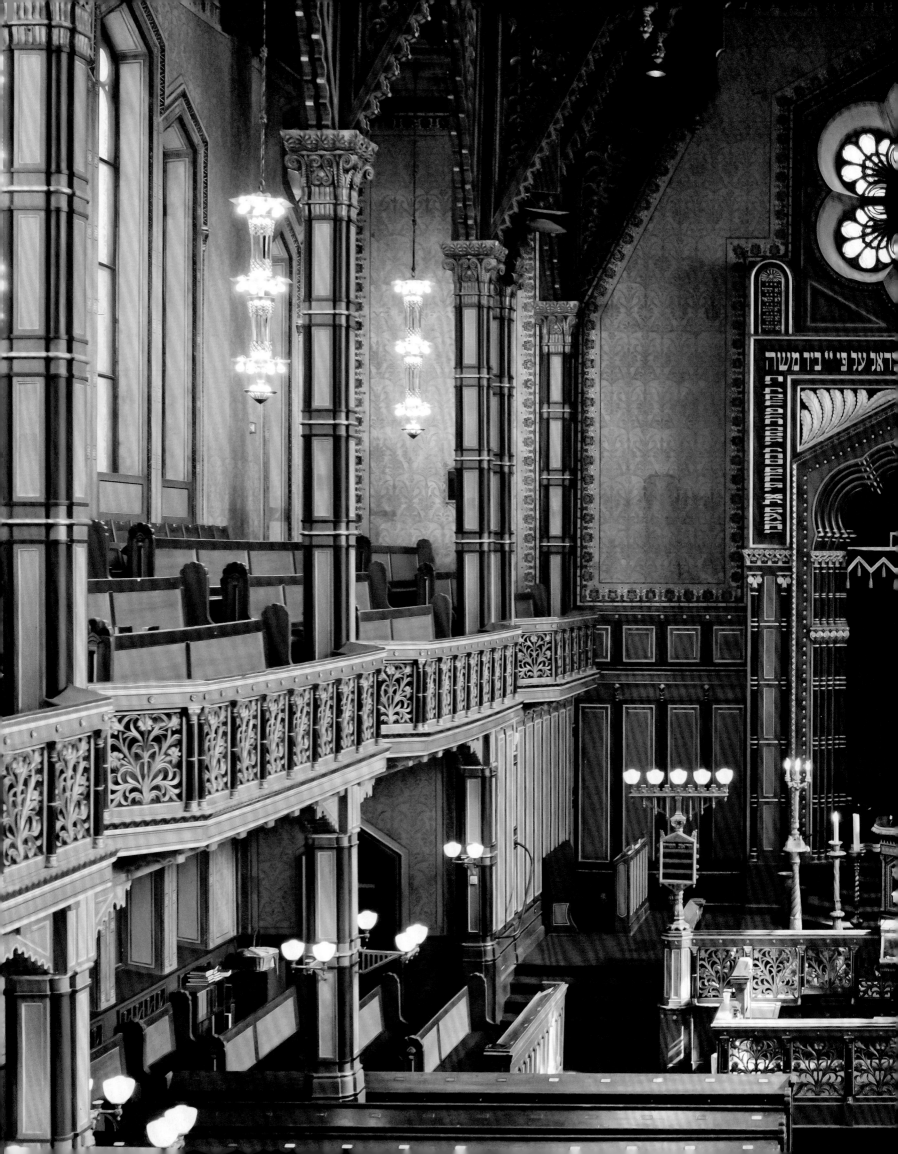

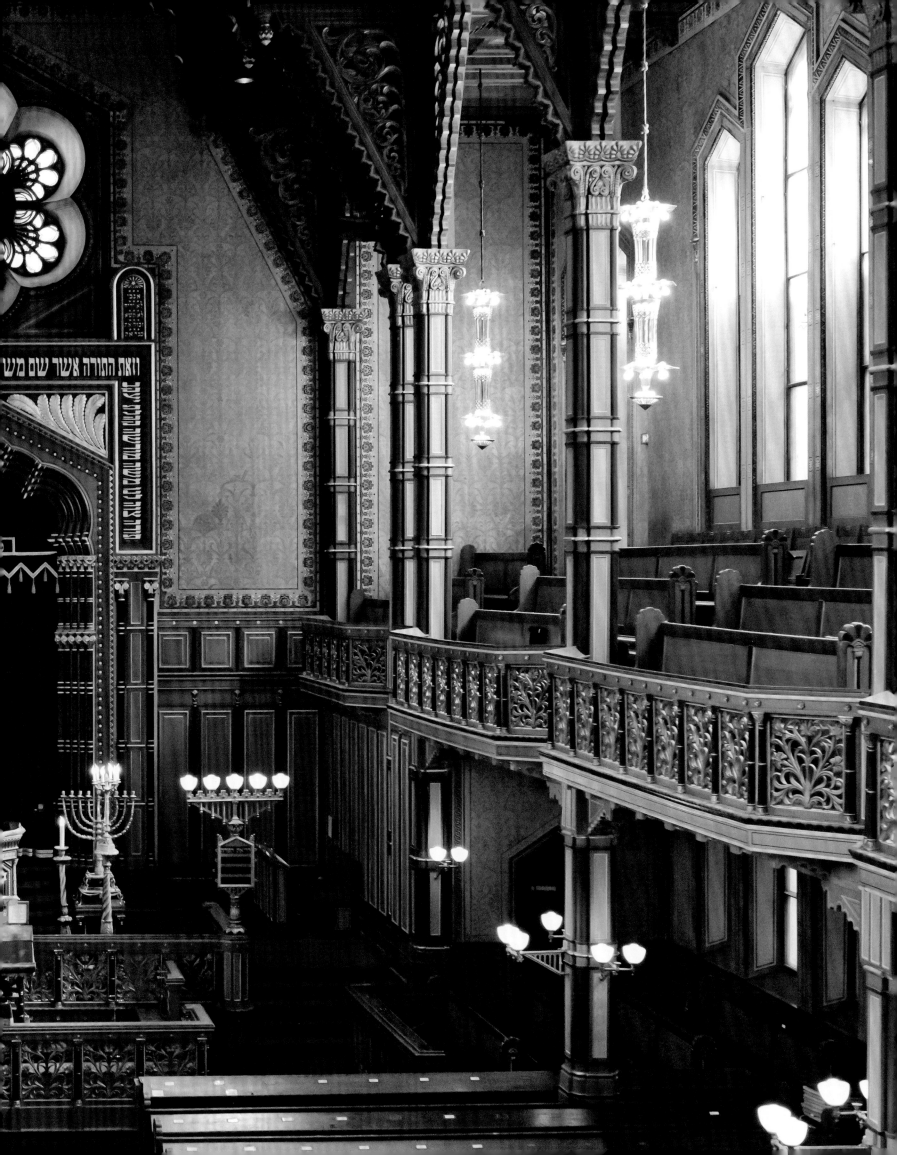

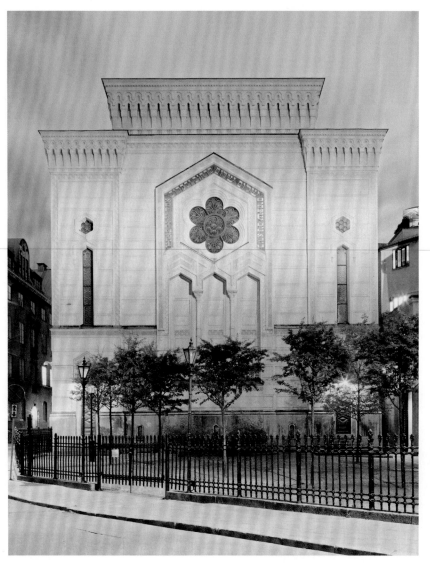

Great Synagogue of Stockholm, Stockholm, Sweden (1870)

The same fervor for embracing the new ideas of emancipation and nationhood that characterized most European Jewish communities prevailed in Sweden. The exterior of the Stockholm Synagogue, inaugurated in the year Swedish Jews received equal rights, is reminiscent of "the Oriental lands" as its architect Fredrik Wilhelm Scholander (1816–1881) stated. The massive rectangular brick building maintains the aura of ancient Near Eastern palaces and temples familiar from archaeological publications and reconstructions of the times. Its monumental entrance facade is composed of a tall central bay with five lancet windows flanked by two recessed bays with single windows, set off by a heavy carved cornice. Narrow peaked windows crowned by diamond-shaped porthole fenestration cleverly suggest a reworking of the Gothic style. The vast, virtually uninterrupted interior space with seating for nine hundred worshippers has the appearance of an austere classical basilica with piers that support the lateral galleries and the skylighted ceiling. The decoration freely incorporates Assyrian, Gothic, and Moorish elements into a truly original whole. Like so many Reform synagogues, services can be accompanied by a large organ, and the bimah is typically located near the Torah ark at the eastern wall. Currently, the community defines itself as Conservative.

Below: Built on a narrow street by French architect Alfred-Philibert Aldrophe, the facade of the Grande Synagogue of Paris was inspired by Venetian Renaissance architecture. Originally planned for the more prominent rue St. Georges, the less prestigious location was outweighed by its ties to Napoleon III's family and the synagogue's opulent neo-Romanesque interior.

The Grande Synagogue of Paris (Synagogue de la Victoire), Paris, France (1874)

Jews formed a vibrant community in Paris during the Middle Ages prior to their expulsion in 1392. After their suppression for virtually four hundred years, they gradually returned to Paris around the time of the French Revolution. Paris's main synagogue on rue de la Victoire exemplifies the modernist ideas of the *Consistoire Israélite*, the umbrella organization of Orthodox Jews in France initiated by Napoleon I.

As part of the great urban renewal plan of Georges-Eugène Haussmann, the Grande Synagogue was designed by Alfred-Philibert Aldrophe (1834–1895), a Jewish architect who worked for the Rothschilds. Like many Parisian churches of this period, the synagogue was built in the neo-Romanesque style with French rose windows, which were adorned with the Star of David rather than with the usual Christian scenes. Thanks to its grand facade, slightly set back in the relatively narrow street, the building presents a commanding seat for the city's chief rabbi. On either side of the large vestibule, twin staircases access the women's galleries and social rooms. A large barrel vault spans the ample main prayer hall, where all the benches face the raised apse housing the bimah, the Torah shrine, and the choir. The twelve windows in the apse bear the names of the Twelve Tribes of Israel, while five roundels contain the names of the Five Books of Moses as well as stars of David. The central apse with its elaborately decorated ark is illuminated by stained-glass windows gifted by Baron Gustave de Rothschild. The large ark that frames the Torah shrine is inscribed in French with a citation from the Bible reminding visitors and the congregation to love God with all their heart (Deuteronomy 6:5). It was here that Alfred Dreyfus was married in 1890.

Following its vandalization by French Nazi sympathizers in 1941, the Grande Synagogue was repaired, and it remains active and vital to this day.

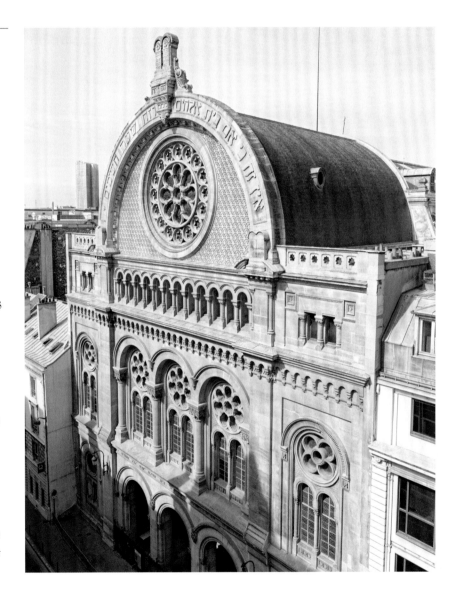

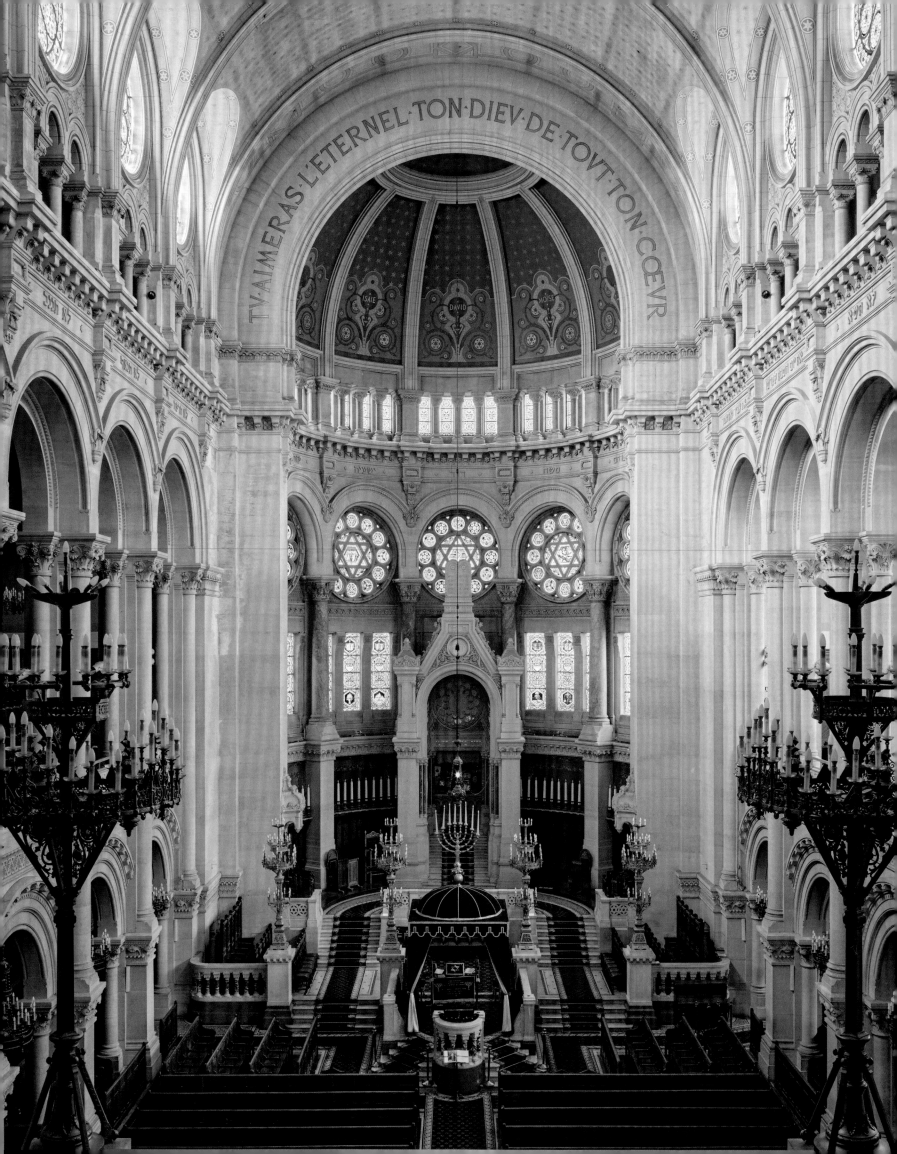

Opposite: The Grande Synagogue's stately barrel vault culminating in the ark with an organ as well as seats for a choir could be viewed by more than five thousand congregants, roughly one-third of the Parisian Jewish community at the time of the building's inauguration in 1874. In keeping with the lavish style of the Paris Opera House, the dominance of red and gold suggests the synagogue's allegiance to the Second Empire, notably the opulent crimson velvet canopy over the bimah, and the upholstered red seating in the balcony.

Below: The elaborate stained-glass rose windows with the Star of David, gifted by Baron Gustave de Rothschild, suggest the community's desire to integrate a Jewish symbol into an art form closely identified with France's heritage.

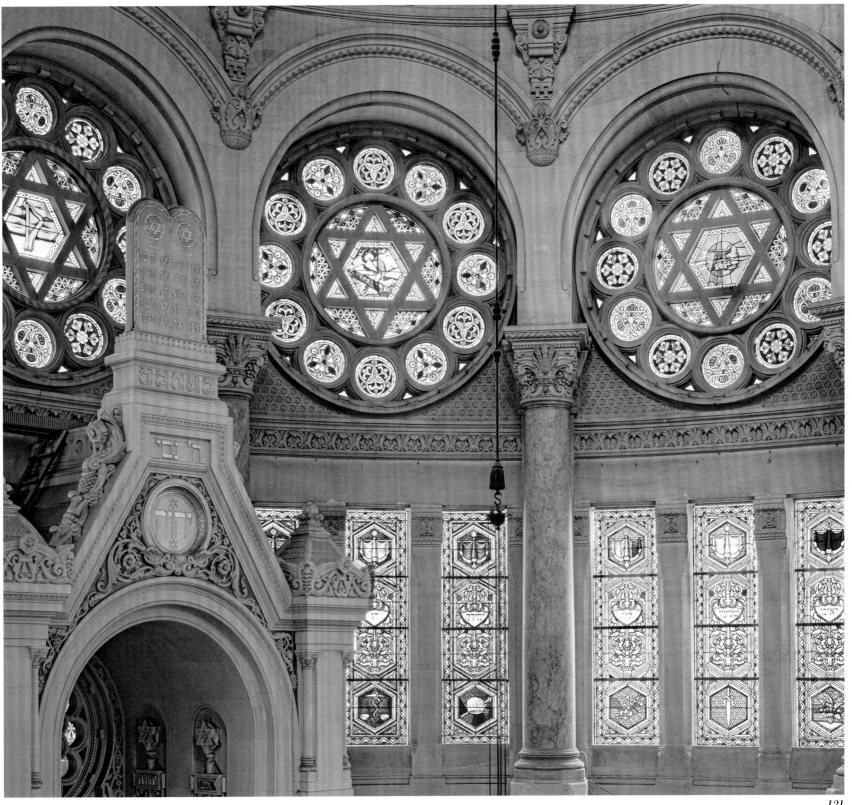

Below: The Tempio Maggiore Israelitico in Florence (1882), initiated when the city became the new capital of Italy (1865–71), benefited from the wealth and cultural status of the city. Built by Mariano Falcini, Vincente Micheli, and Marco Treves between 1874 and 1882, the synagogue features a tall dome that pays homage to Brunelleschi's Duomo on the Florentine skyline.

Opposite: The synagogue's wide side-aisle gallery, with its intarsia marble floor and richly patterned walls, reflects the taste for Moorish ornamentation, a style associated with the Jewish emancipation.

Pages 124–25: Built in the form of a Greek cross, the main sanctuary features a central bimah, a Moresque-style pavilion over the ark, and a pulpit in the form of a minbar, all inspired, according to its planners, "by Spanish and Egyptian" models.

Pages 126–27: The glorious dome, illuminated by a ring of cylindrical windows, emphasizes the rich geometry and arabesque designs, which are interwoven with Jewish symbols and inscriptions.

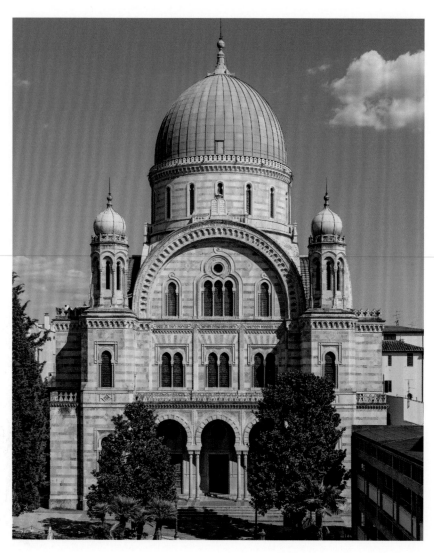

Tempio Maggiore Israelitico (Great Synagogue of Florence), Florence, Italy (1882)

The freestanding Tempio Maggiore Israelitico, built shortly after the Grand Synagogue of Paris, takes its chief inspiration from Byzantine and Ottoman architecture. The synagogue dominates a fashionable area just outside the old city center. Three Florentine architects—Mariano Falcini (1804–1885), Vincente Micheli (1830–1893), and the Jewish Marco Treves (1814–1898)—collaborated on its highly eclectic design. Thus, the splendid green copper dome that rises over the Florentine skyline recalls not only Hagia Sophia, but also the domes of synagogues in London and Cologne, and its horseshoe arches evoke the Neue Synagoge of Berlin. While in Paris, Marco Treves must have been inspired by the huge barrel vault of the Grande Synagogue on rue de la Victoire. The small minaret-like towers echo those of the Rumbach Street Synagogue in Budapest.

The interior follows a Greek-cross plan, with four equal arms and an elevated dome over the central crossing. Three women's galleries run along the north, south, and western sides, with the Torah shrine embedded in the eastern apse. The brilliantly colored interior looks Moorish, with the lectern resembling a minbar (pulpit) in a mosque; however, the floor tiles feature six-pointed Jewish stars instead of the Islamic octagonal pattern. The principal Florentine synagogue was not alone in flaunting its uniquely Jewish identity. Others, such as the Tempio Maggiore in Rome (1904), also stressed their individuality. The Italian unification between 1859 and 1866 brought about the complete emancipation of Italian Jews. By that time, Jews proudly professed their unique heritage while simultaneously proclaiming their patriotic allegiance to Italy.

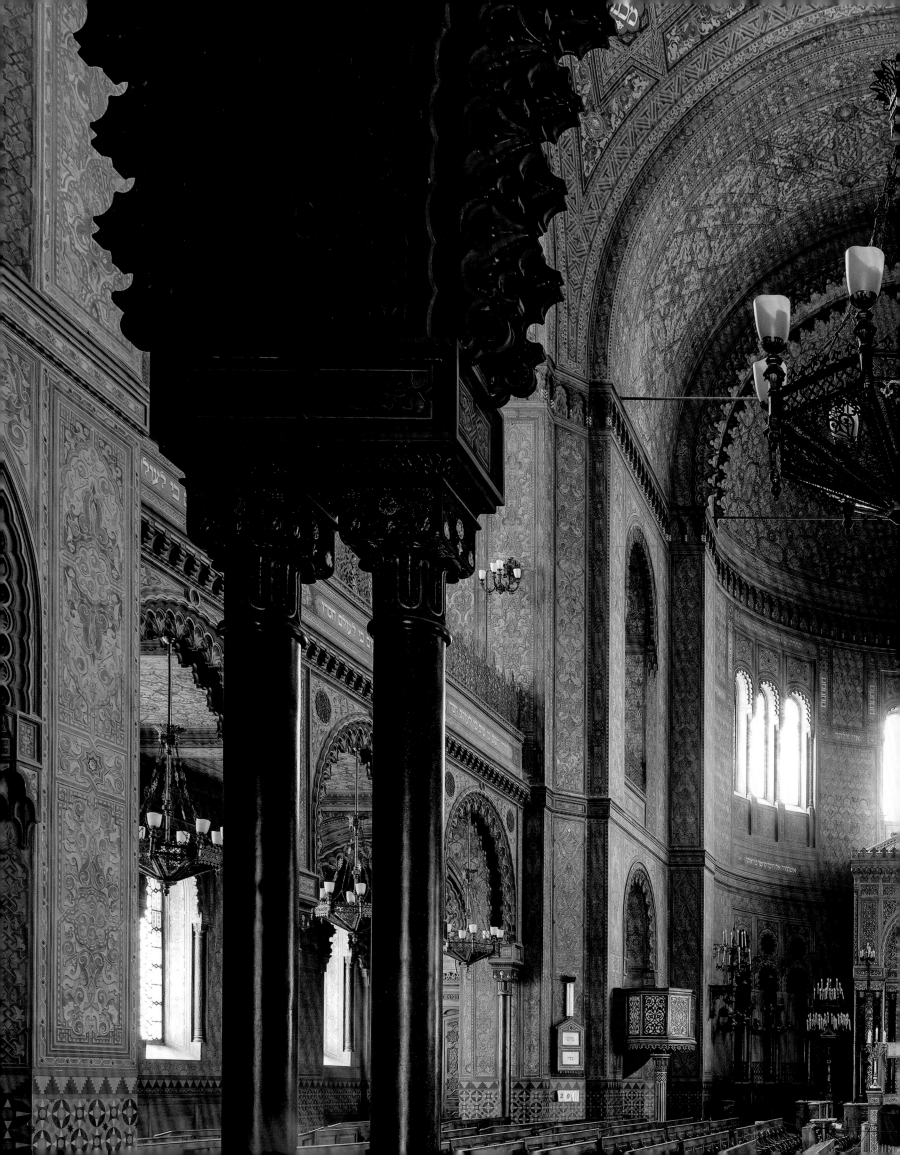

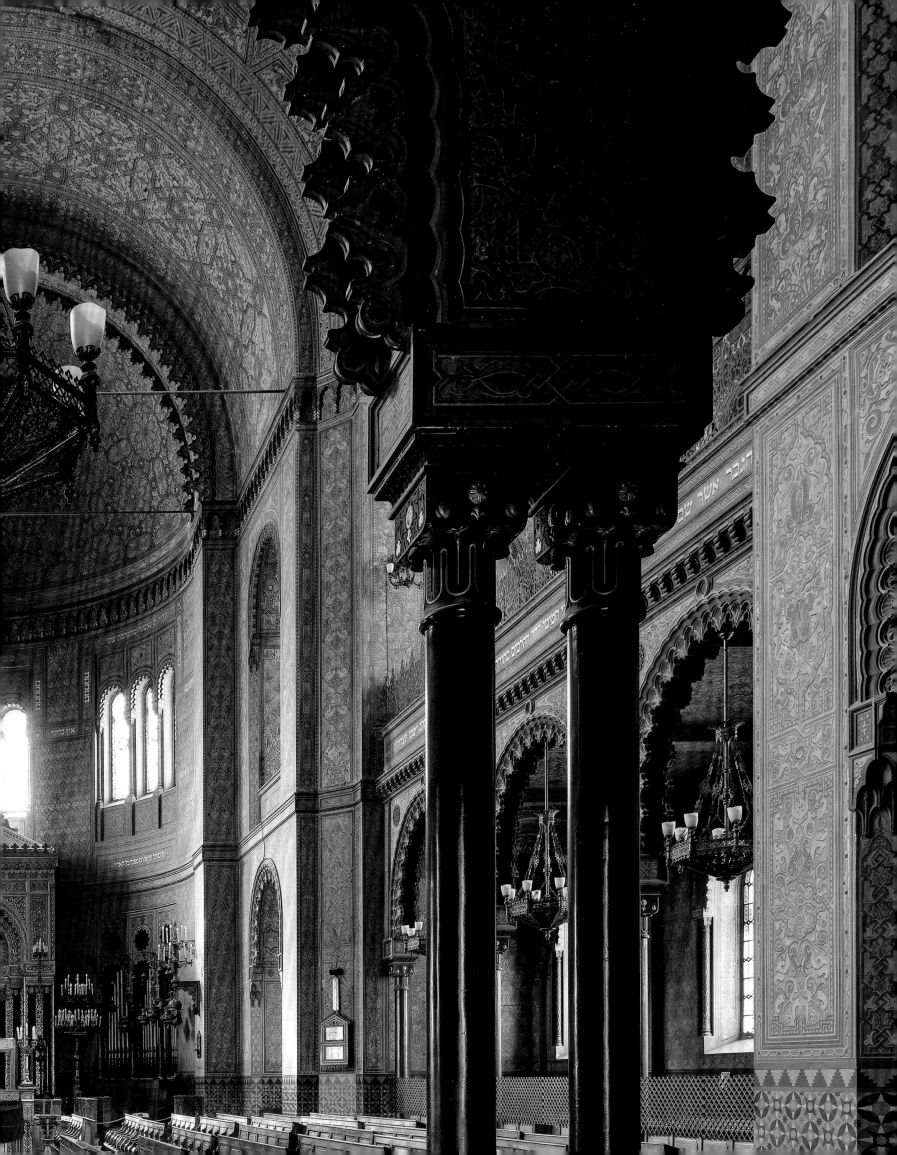

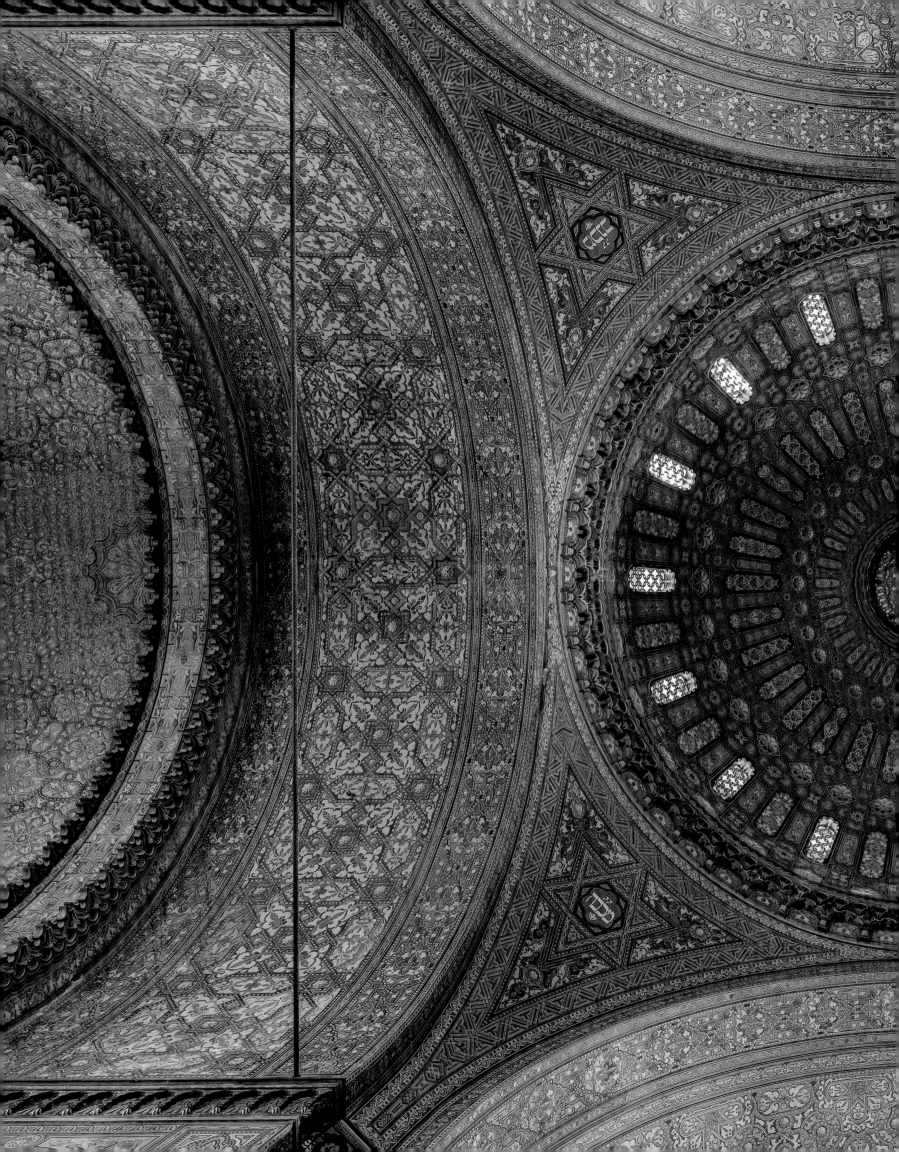

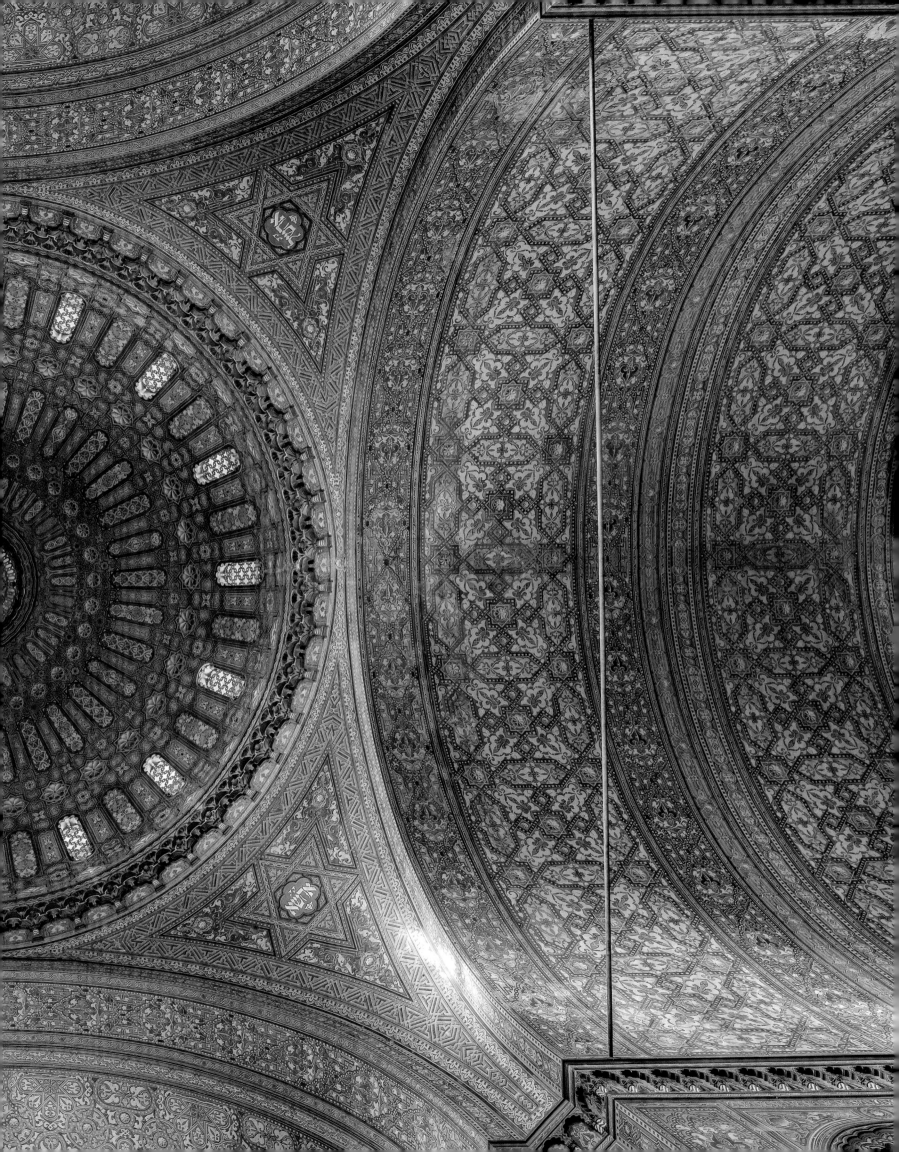

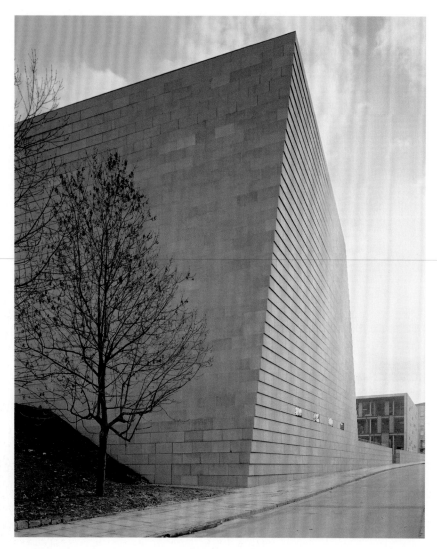

Neue Synagoge (New Synagogue), Dresden, Germany (2001)

While Florence largely survived World War II intact, Dresden suffered almost complete destruction in 1945. When the Jewish community decided in 1997 to build a new synagogue in the heart of the city, they chose not to resurrect the former synagogue. Instead they set their sights on an entirely new minimalist building that purposefully contrasts with the reconstructed Baroque style of Dresden's city center.

The Neue Synagoge stands alone on an elevated platform, with the synagogue on the left and a community center on the right. Between them, a white-pebbled plaza marks the outlines of the torched former synagogue. The new building occupies the site of its famous neo-Romanesque predecessor (1840), the only religious building designed by Gottfried Semper (1803–1879), one of Germany's most prominent architects.

The most striking feature of this eight-story-high monolithic structure is the gradual horizontal rotation of the separate stone courses of the exterior walls. Both material and color recall the Elbe sandstone of the former synagogue, the dominant shade of much of old Dresden, as well as the Western Wall of the Second Temple of Jerusalem. The interior space is designed as a cube within a cube, curtained off by a large golden-mesh drape. It evokes the Tabernacle, the traveling sanctuary of the biblical Jews from the time of their journey through the desert. Dedicated on November 9, 2001, this complex marks a new, self-confident start for Jewish life.

More than any other German firm, the synagogue's architects, Wandel Hoefer Lorch + Hirsch, have focused on synagogues and Holocaust memorials, commenting, "The Neue Synagoge represents an attempt to investigate the conflict between stability and fragility, between the permanent and the temporary, the temple and the tabernacle." Their work has received numerous prizes and international acclaim.

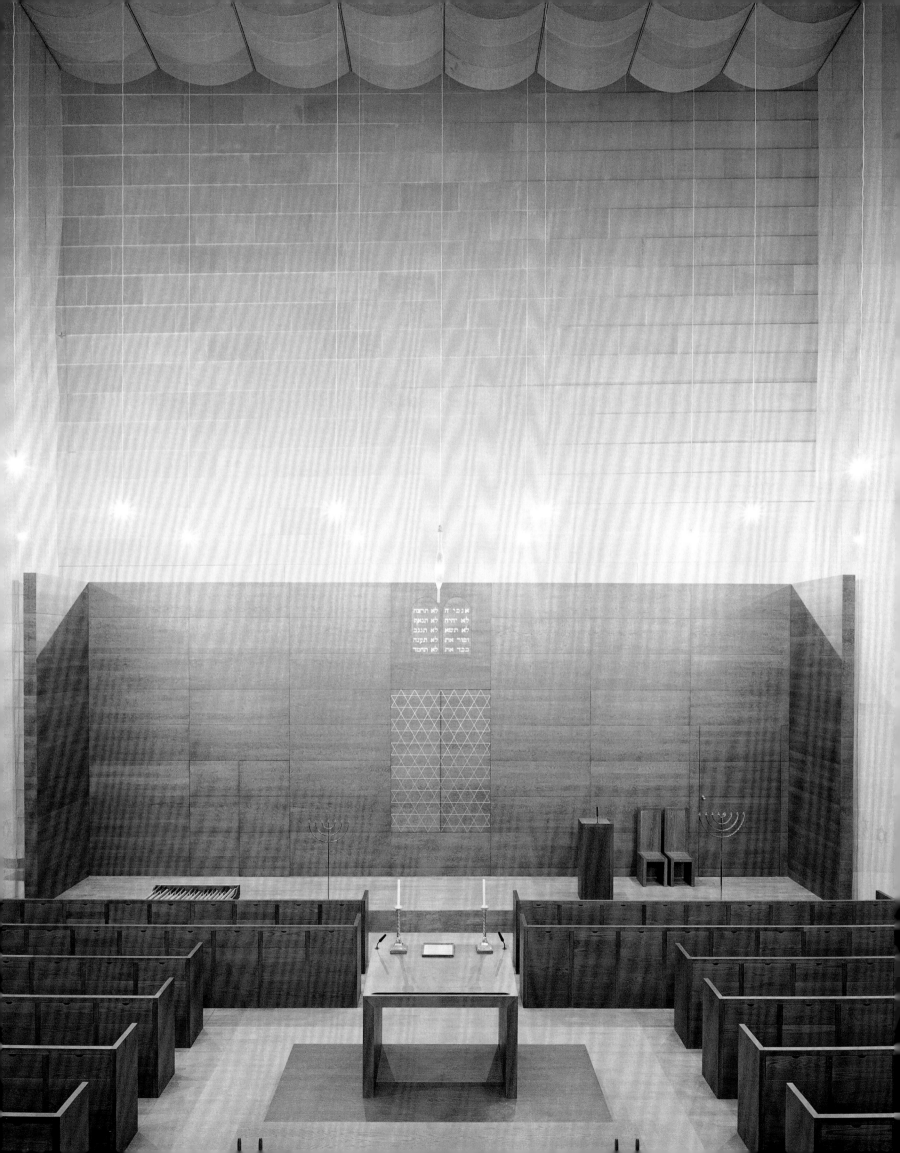

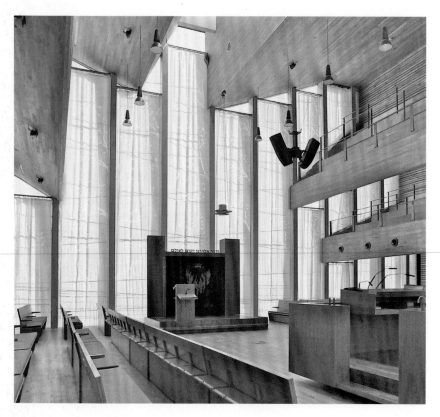

Liberal Synagogue Beth Israel (Liberal Jewish Congregation of Amsterdam), Amsterdam, The Netherlands (2010)

Since the nineteenth century and increasingly in the new millennium, Jewish communities in Europe have invited innovative architects to design synagogues in prominent city locations. The Liberal Synagogue Beth Israel of Amsterdam, inaugurated by the crown prince (as of 2013 King Willem-Alexander), is a positive symbol of the revival of Jewish life after the Shoah. Replacing an earlier synagogue, architects Bjarne Mastenbroek and Uda Visser of SeARCH designed a new, four-story rectangular community center, sheathed in tiles featuring the Star of David and surrounded by water. The large windows of the sanctuary, disposed on the exterior to resemble the seven-branched Temple menorah and the Tree of Life, echo the profile of two stepped balconies inside. The main entrance of the synagogue is marked by bricks from its predecessor. Specially designed curtains temper the sea of light from the large windows in this truly impressive sanctuary that accommodates well over eight hundred worshippers. Thanks to its large halls for social functions, offices, nine classrooms, and a ritual bath, the building does justice to the definition of a synagogue as a meeting house in ancient Greek: It is not only a house of prayer but also a gathering place and a house of study for a Reform community with more than twenty-two hundred members.

Synagogues reflect the diversity of their various communities—whether rational or mystic, scholarly or commercial, traditional or liberal—as well as the current architectural vocabulary of the age, be it Moorish, Gothic, Renaissance, Baroque, neoclassical, neo-Romanesque, neo-Gothic, Byzantine or Near Eastern, or modernist. All of these buildings proudly express Jewish presence and identity within European civilization.

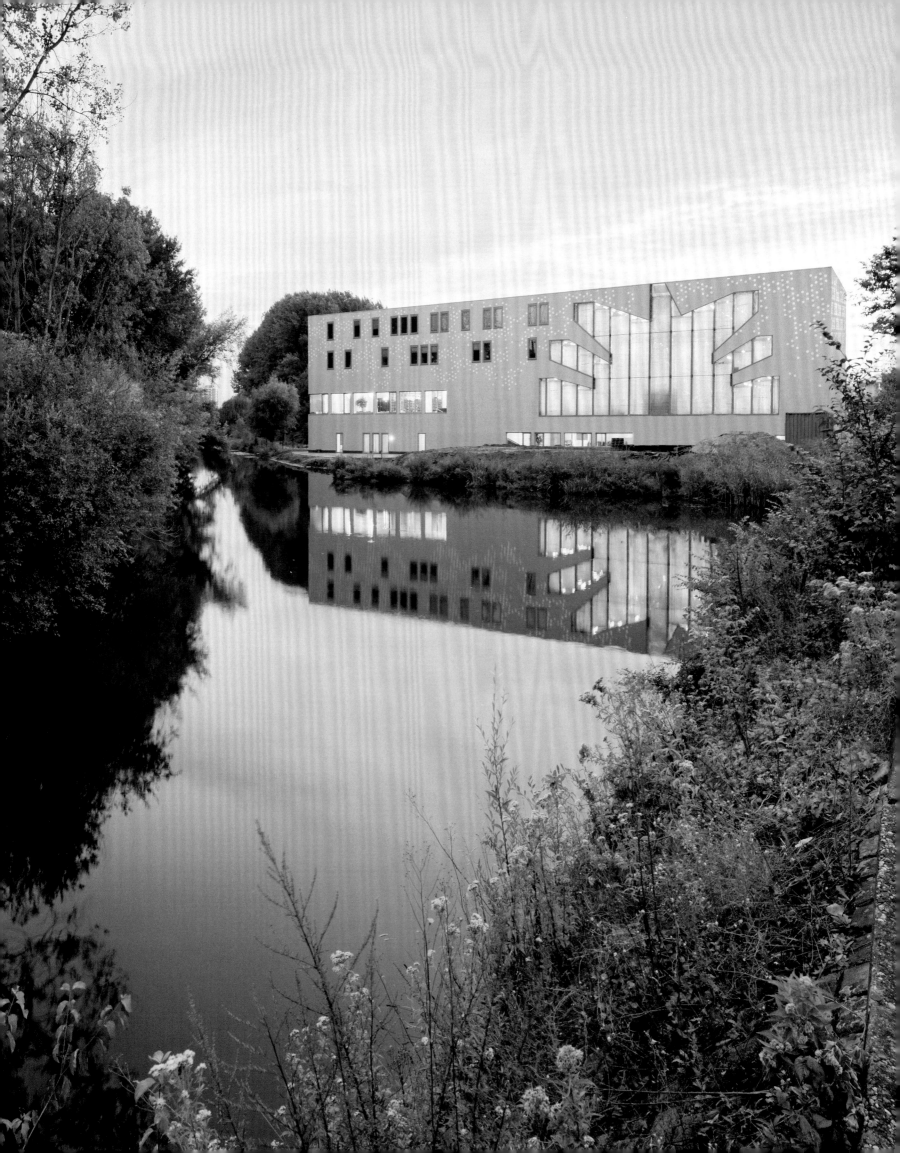

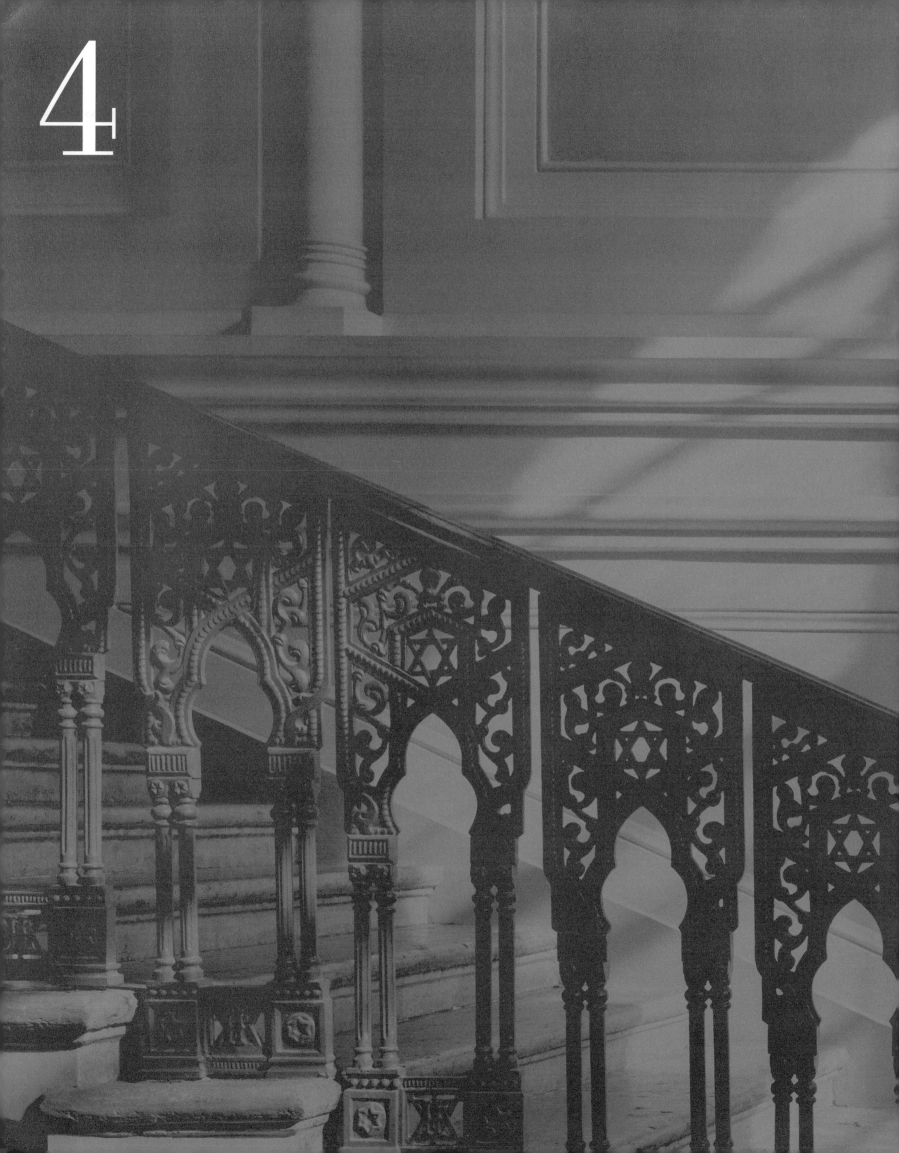

4

4. The Synagogues of Poland, Ukraine, Belarus, and Russia

Sergey R. Kravtsov

By the middle of the sixteenth century, Poland was home to two-thirds of the world's Jewish population, leading to the extraordinary concentration of synagogues in this country. Most Jews arrived in medieval Poland from neighboring German lands and from Bohemia, where they had been subjects of the Holy Roman Empire. In the Middle Ages, Jews were often accused of poisoning the wells, which was associated with causing the Black Death of 1348–1351; and thus, they were expelled eastward. They eventually found a more tolerant reception from the Polish dukes and kings. On the one hand, the Polish aristocracy protected the Jews for their merchantile skills while still taxing them heavily. On the other, the burghers and the dominant Catholic Church sought to reduce their influence as financiers and leaseholders. They worked to bar Jewish artisans from joining trade guilds and in general to minimize their presence in the public arena. Borrowing laws from the Holy Roman Empire, they imposed restrictions on the height and external decoration of synagogues in Poland. Jewish communities remained confined to their quarters on the margins of medieval cities. Yet, there, despite the threat of riots and pogroms, Jews managed to uphold their way of life, and especially their practices of prayer and learning.

Poland's eastward expansion and that of neighboring Lithuania led to the formation of the mighty Polish-Lithuanian Commonwealth, which favored fiefdoms and "private cities." There, Jews acted not only as estate managers and moneylenders but also, more typically, as petty traders, craftsmen, and innkeepers. Prosperous Jews built fine wooden or masonry synagogues under the patronage of their noble landlords. In the old "royal" cities, unlike in the new "private" ones, the clergy and burghers often drove the Jews outside the city walls to the suburbs, where they sought the protection of the royal castellans. The Catholic Synod of 1542 prohibited the building of new masonry synagogues in the "royal" cities, permitting only the reconstruction of existing ones. However, as wooden synagogues often burned down, the Jews replaced them with masonry buildings, which were officially designated as part of the ramparts.

Hebrew remained the language of prayer, but Yiddish was the spoken language of Polish and Lithuanian Jews. The Ashkenazi (Jewish-German) heritage also continued the distinct *nusa* (rite) and *minhagim* (customs) that dictated the liturgical arrangement of the synagogue space. As these communities expanded and grew wealthy, they hired skilled architects, who created grand new synagogues in the Renaissance and Baroque styles. At the same time, Jewish Lurianic manuscripts and prayer books from the Ottoman Empire introduced the Lurianic Kabbalah and its concept of cosmic repair (*tikun olam*). This influenced Ashkenazi liturgy, prayer texts painted on the walls, and spatial arrangements of the synagogue. All of these changes led to the so-called Great communal synagogues that continued into the nineteenth century. Some "Polish" synagogue designs were exported to Moravia, Hungary, and Germany. During the High Holidays, hundreds of Jews attended the Great synagogues, despite the spread of Hasidism. Initially, Hasidim favored independent gatherings in humble synagogues or in study houses. As of the sixteenth century, skilled Jewish carpenters specialized in the elaborate wooden synagogues that became a feature of this densely forested area.

Between 1772 and 1795, the Commonwealth succumbed to its powerful neighbors and was divided up between Austria, Russia, and Prussia. Thus, the former Jews of Poland and Lithuania, who had remained in their hometowns, found themselves under a more restrictive foreign rule. Concurrently, the French Revolution ushered in the age of Jewish emancipation across Europe, spreading the *Haskalah* (the Jewish Enlightenment) and religious reform. The emergence of Jews from the ghettos and shtetls (little towns) of eastern Europe resulted in the disintegration of the collective Jewish identity and its fragmentation along religious, economic, social, and political lines.

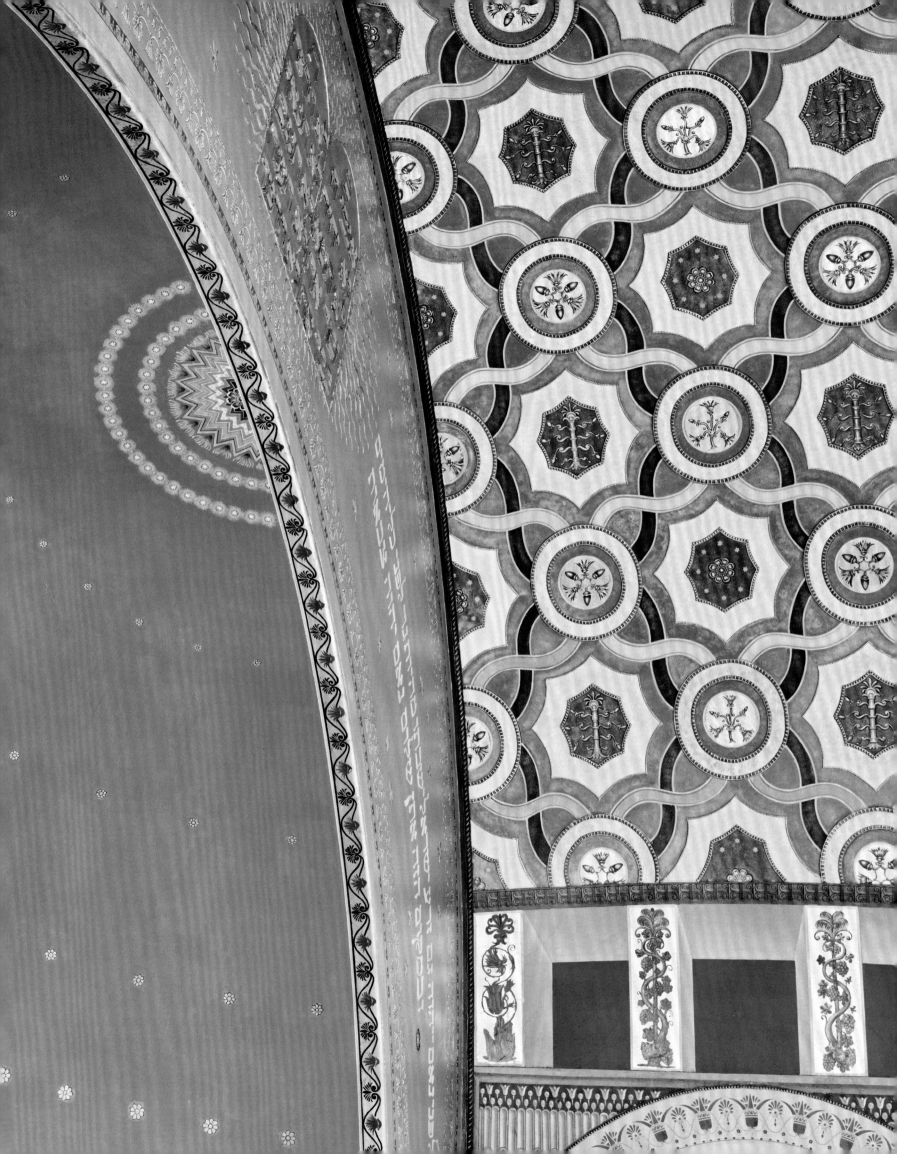

In the course of the nineteenth century, the process of emancipation was uneven. Austria-Hungary granted equal civil rights to all of its citizens under the constitution of 1867 as did Germany following its unification in 1870. However, in Russia, Jewish emancipation was not achieved until the February Revolution of 1917. These changes affected the synagogue, in terms of its architectural style and gave it greater visibility within the urban space. As architecture emerged as a modern profession, Jews began to access this pool of talent, especially in central and eastern Europe, creating sophisticated and costly buildings in a wide variety of styles.

Old Synagogue of Kazimierz, Kraków, Poland (end of the fifteenth century, rebuilt in the mid-sixteenth century)

The oldest extant synagogue in all Poland is the Old Synagogue of Kazimierz, near Kraków. It occupies a position next to the city walls. Built at the end of the fifteenth century, when the community began to absorb the expelled Jews of Kraków, the Kazimierz synagogue was shared by Polish and Bohemian Jews. In selecting the design for their new synagogue, the community drew inspiration from the floor plan of the famous Altneu Shul of Prague (see Chapter Three, pages 89–91), the oldest extant synagogue in Europe. Like the Altneu Shul, the Old Synagogue of Kazimierz features a double-nave men's prayer hall, with Gothic vaults supported by two massive pillars, evoking the Temple of Jerusalem. The central bimah lies between them, with the Torah ark built into the eastern wall. In all of these medieval synagogues, the cramped interior, devoid of elaborate decoration, reflects the intense devotion promoted by the Ashkenazi Hasidim (Jewish-German pietists). Its exterior was capped with a steep roof and reinforced with buttresses.

By the mid-sixteenth century, the southern women's section and western council house were added to the synagogue. The edifice burned down and was rebuilt in stone, preserving the old foundations and floor plan of the prayer hall. The Jewish community hired the architect Matteo Gucci for its restoration. He reconstructed the two pillars along the central axis in the form of slender columns with Tuscan capitals, matching the new Renaissance wall brackets. The prayer hall was re-spanned with ribbed groin vaults, a tribute to the original Gothic style. An Italianate parapet (to deter fires) adorned with a blind arcade and large corner finials hid the roof. The reconstruction also embraced the southern women's section and western council house. Around the same time, the community added a single-story women's section, spanned by a barrel vault and accessible only from the outside on the north side of the prayer hall. Low latticed openings in the adjoining wall allowed women to see and hear the service. The new ark was shaped in the Renaissance style. It served as an allusion to the Temple of Jerusalem and marked the direction of prayer. The reconstructed interior, though echoing the medieval Ashkenazim synagogues, now glowed with light and met the new standards of fashionable decoration.

Continuously renovated over the centuries, the Kazimierz synagogue underwent additional restorations from the 1880s to 1925, becoming ever more neo-Renaissance in keeping with prevalent fashion. During the World War II, the Nazis razed the synagogue's roof, demolished the vaults, and destroyed the stone and metalwork interior ornamentation. Between 1955 and 1961, the Polish government undertook a meticulous reconstruction of the Old Synagogue, which, with the agreement of the remnants of the Jewish community, was converted into a Jewish museum. Today, it occupies an important place in Jewish heritage tours of Kazimierz.

Great Synagogue of Łańcut, Łańcut, Poland (1761)

Roughly one hundred miles from Kazimierz, Prince Stanisław Lubomirski sponsored the Great Synagogue in his "private" city of Łańcut in 1761. The new stone synagogue replaced the wooden one to accommodate the 820 members of the bustling Jewish community. Its prayer hall is based on the square plan with a central bimah surrounded by four powerful columns at each corner. Over the bimah, a massive stone canopy, known as a bimah-tower, carries the series of ceiling vaults: barrel vaults on each of the four sides of the hall, groin vaults in the corner bays, and a small dome capping the bimah. Such bimah-

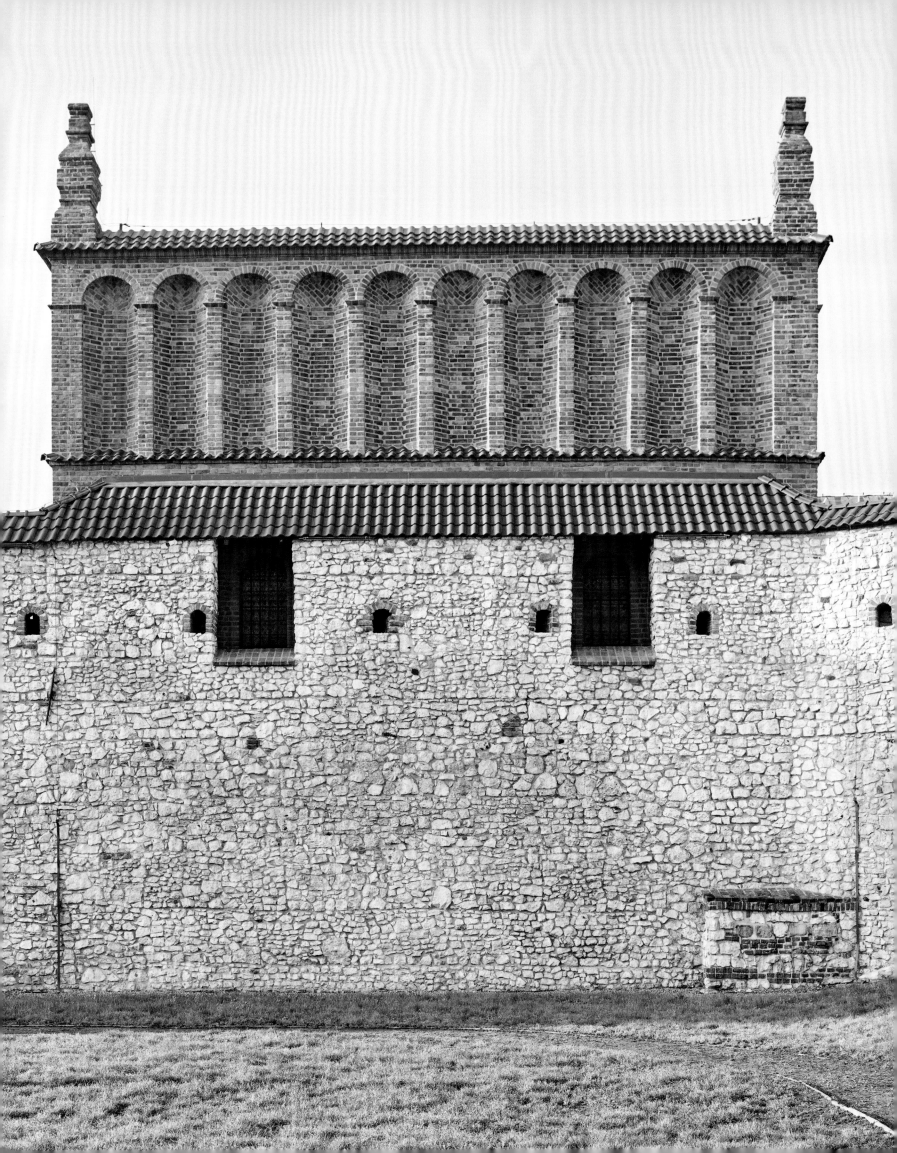

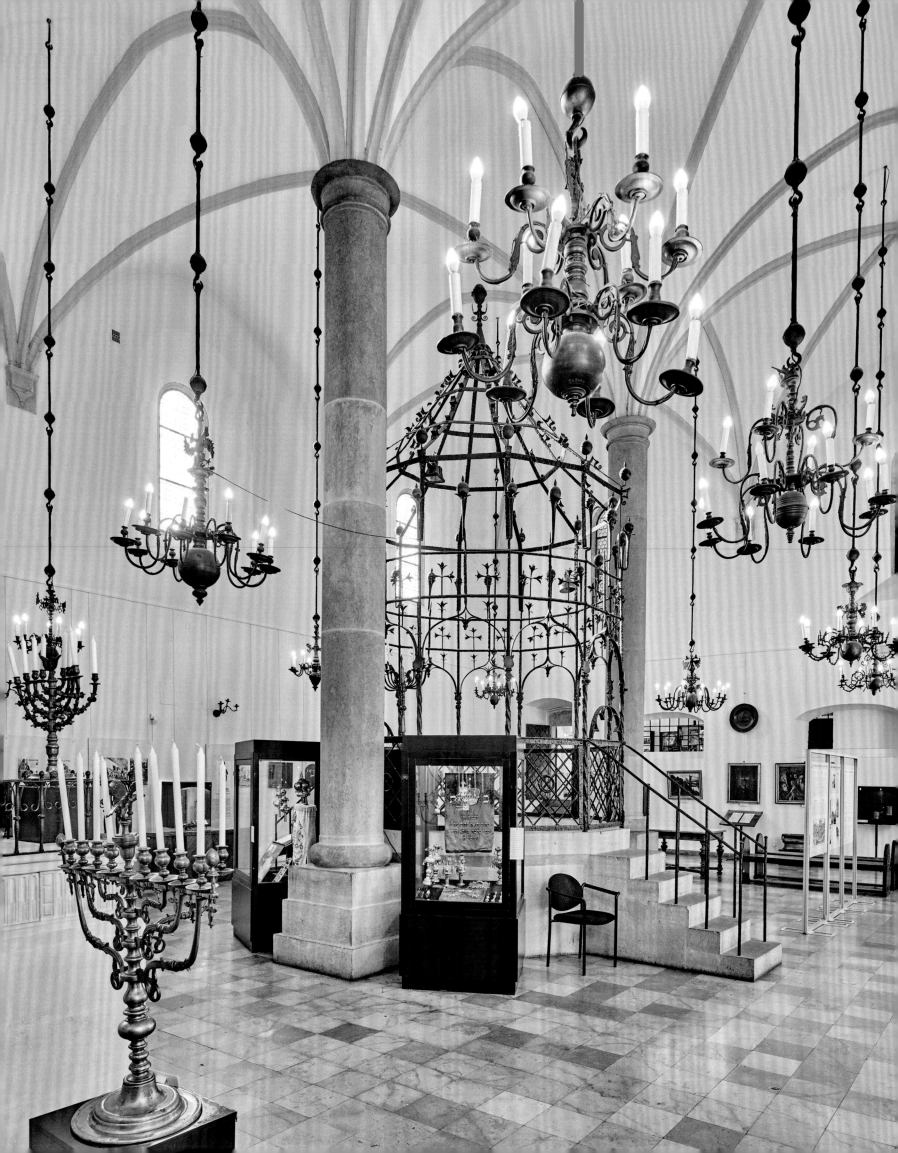

Opposite: In the Old Synagogue of Kazimierz, twin columns support the elegant Gothic-style ribbed vaulting (ca. 1550). A wrought-iron canopy draws attention to the bimah at the center of the hall, which is illuminated by round-arched windows and an abundance of bronze chandeliers.

Below: A stone podium in the Old Synagogue leads to the Renaissance-style Torah ark, which was most likely designed by the Italian architect Matteo Gucci in the mid-sixteenth century. Above the ark, an inscription in the entablature reads, "By me, Kings reign" (Proverbs 8:15). It is surmounted by the Crown of the Torah and scrolls referencing the Tree of Life.

Pages 140–41: The massive bimah tower in the Great Synagogue of Łańcut, Poland, built in 1761, dominates the sanctuary. Its colored plasterwork showcases the Mishnaic Four Crowns. Here, two lions support a cartouche capped with the Crown of Kingship and inscribed with its name. In the distance, a series of painted arches frame Hebrew prayers. (The murals and prayer texts were heavily restored in the twentieth century, while the scenes in the spandrels are innovations.)

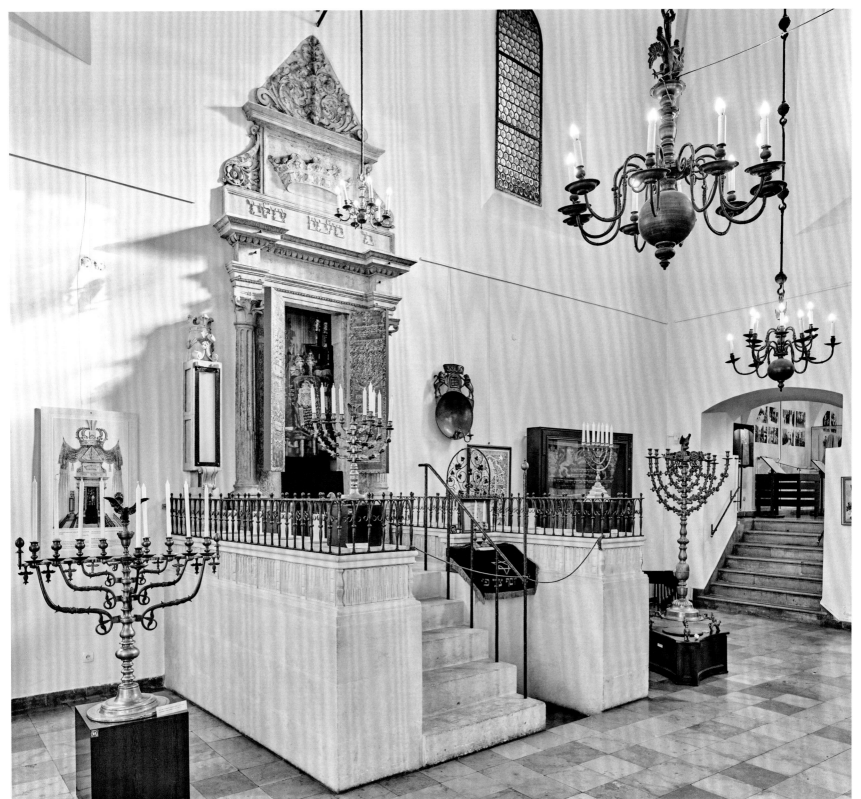

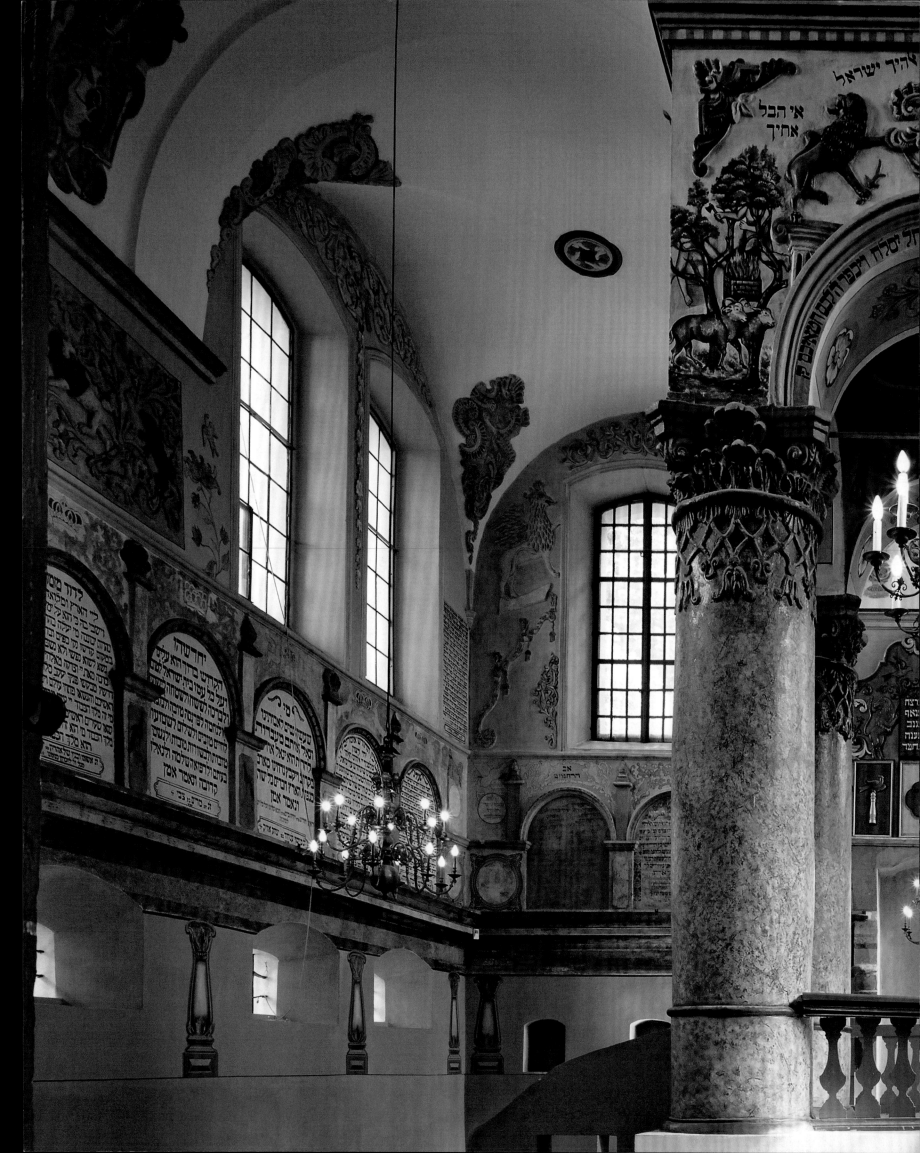

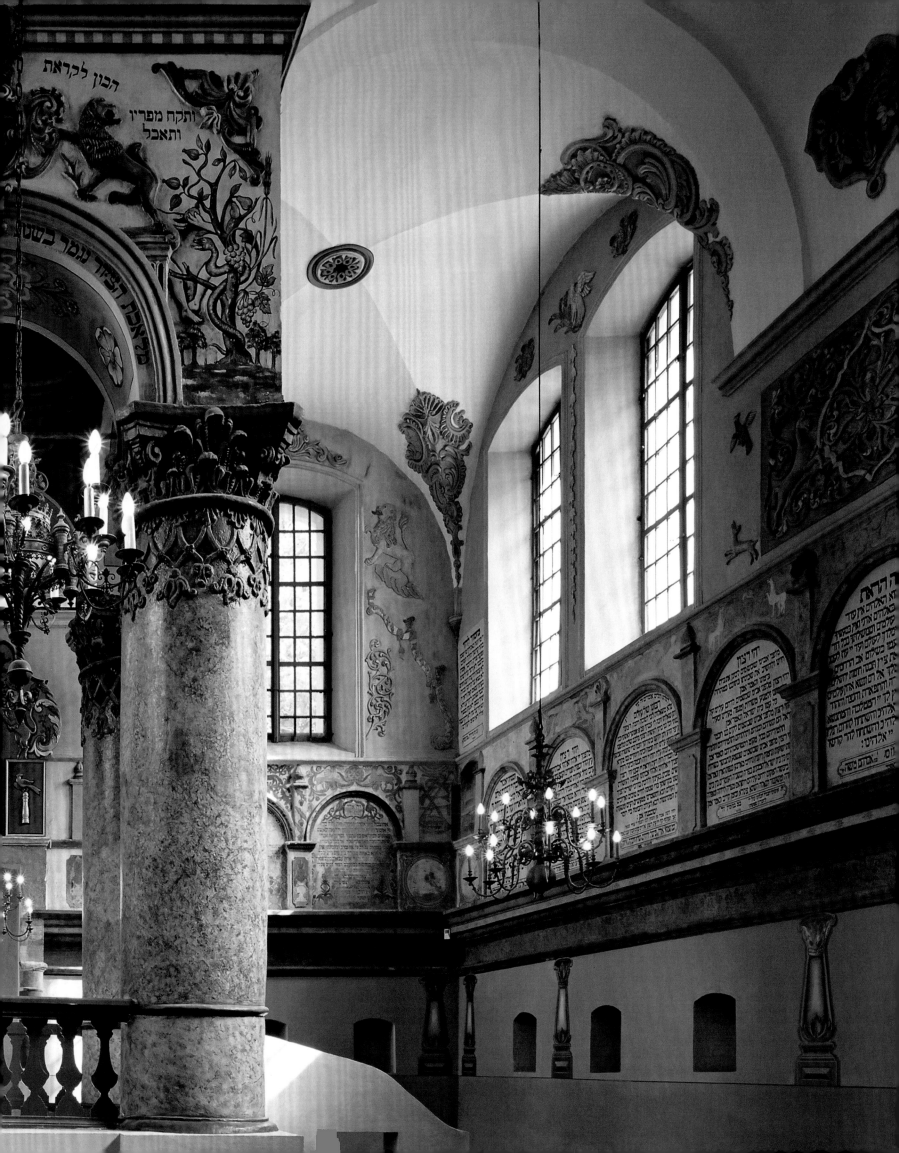

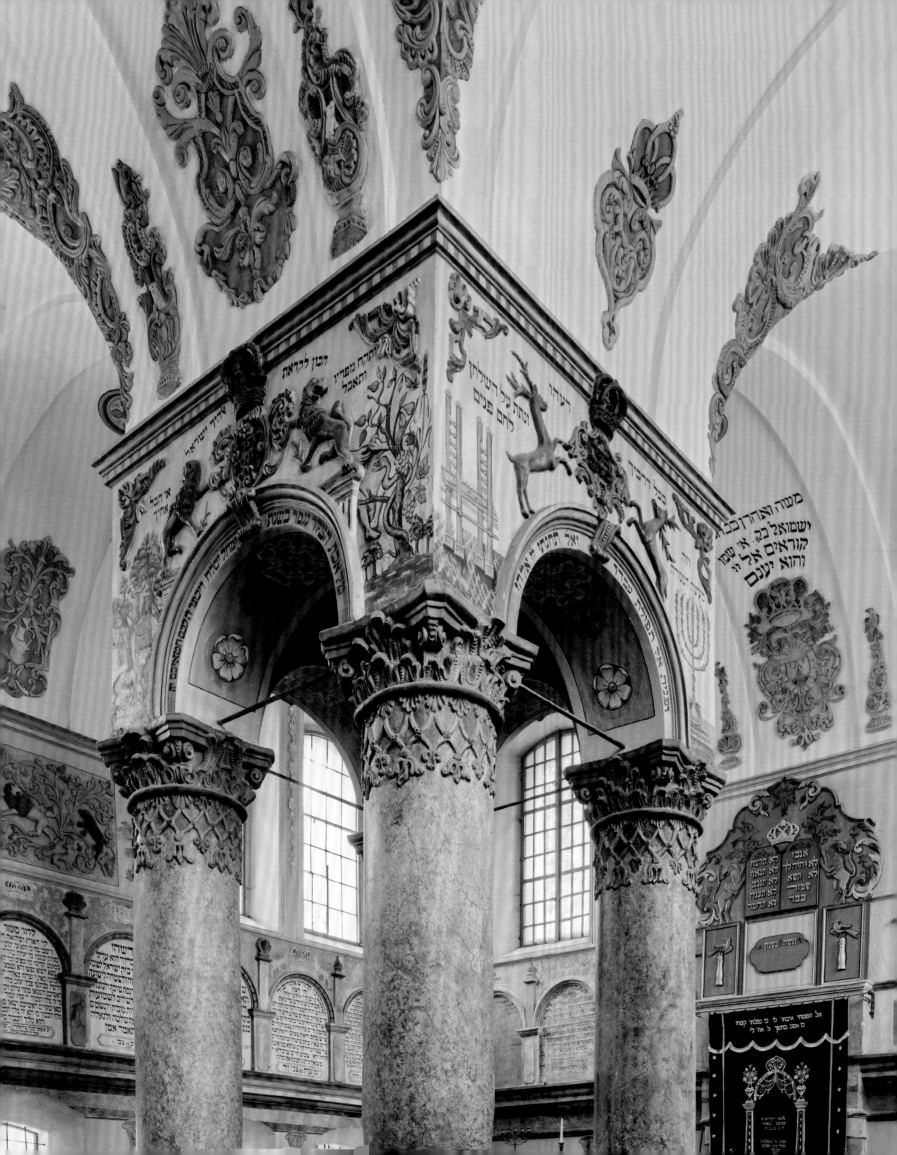

towers are found in sixteenth-century Polish synagogues, but do not occur in local churches. The tower may allude to the inspirational biblical tower (Proverbs 18:10) or to the hollow pillar for spirits and prayers to reach God (Zohar I:42a).

Fine plasterwork and paintings decorate the canopied bimah bearing designs of crowns, each labeled according to the Mishnah: "There are three crowns: The Crown of the Torah, The Crown of Priesthood, and The Crown of Kingship; but The Crown of a Good Name exceeds them all" (Pirkei Avot 4:13). Other iconographical subjects that appear on the canopy include the Fall of Man, Noah's Ark, the Binding of Isaac, and the Temple of Jerusalem. Lively framed prayer texts, stucco decorations, and narrative paintings animate the hall walls, reaching right up to the vaults. Twelve windows illuminate the Łańcut synagogue's prayer hall and might refer to the number of windows in "the celestial synagogue," according to the Zohar (II:251a).

After much deterioration following the World War II, the Łańcut synagogue was preserved through the heroic efforts of Dr. Stanisław Balicki to commemorate the loss of virtually all the city's Jews, previously representing 45 percent of the population. The synagogue houses a Judaica museum.

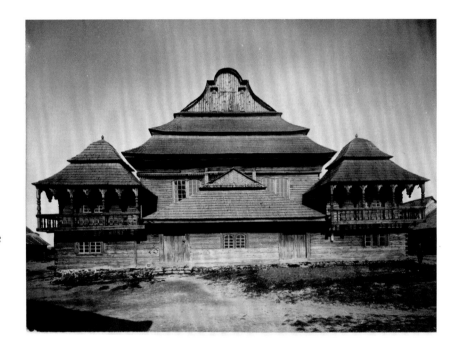

Volpa Synagogue, Volpa, Belarus (ca. 1750, no longer extant)

Many members of the Jewish community preferred to construct their "Great" synagogues of wood, which was considered a worthy material alongside of stone. Believing that such wooden synagogues were divinely protected and thus inflammable, they would even bring their belongings to them during fires. Therefore, they commissioned many extraordinary, complex wooden structures that took advantage of both the rich supply of timber and the availability of skilled Jewish architects and craftsmen.

Built of larch wood in the first half of the eighteenth century, the now-destroyed synagogue in Volpa still serves as a magnificent example of Jewish architecture and workmanship. Jewish tradition holds that it was sponsored by the city's overlord, Prince Sapieha. The Volpa synagogue represented

an amalgam of the typically eastern European log house combined with a truss construction borrowed from the western European Gothic style. The interior was informed by the contemporary masonry four-pillar synagogues, however, the use of timber allowed for greater experimentation and flexibility. The architects (unknown) designed a series of ascending coved domes, tied to the roof rafters, pierced with octagonal openings that diminished in size. This intricate roof construction gave the impression of a celestial ceiling floating above the congregation. Outwardly, the interior domes formed an elaborate multi-tiered roof fronted by a decorative gable.

The two posts in the gable symbolized the pillars of Jachin and Boaz in Solomon's Temple. Volpa's corner pavilions flanking the synagogue's main facade were inspired by the reconstruction of the Second (Herodian) Temple, as described in the Mishnah's tractate Middot 4:7: "The Sanctuary was narrow behind and wide in front, and it was like to a lion . . . *Ho, Ariel, Ariel* [literally: the Lion of God] . . ." (Isaiah 29:1).

Today, none of the twenty related wooden synagogues from the early eighteenth century, of which Volpa was the crowning jewel, still exist. In commemoration of the vanished culture, a full-scale replica of the Volpa Synagogue was built in Biłgoraj, Poland, in 2015 by entrepreneur Tadeusz Kuźmiński, as part of his project "City on the Trail of Borderland Cultures."

The Great Synagogue of Włodawa, Włodawa, Poland (1771)

Like the wooden synagogue in Volpa, the Great Synagogue of Włodawa in Poland features an impressive facade flanked by pavilions. Built between 1764 and 1771, it was probably designed by Paolo Antonio Fontana, a noted Italian architect who favored a grandiose Baroque style. By the mid-eighteenth century, the prosperous Jewish community, which numbered about two thousand, could afford such a monumental building. They also relied on contributions from the city overlords, the Princes Czartoryski. The women's sections of the synagogue were attached to the north and south sides of the prayer hall. According to the community record book (*pinkas*), in 1774, the

northern pavilion served as a small synagogue for the Tailors' Guild and the southern one for the Shoemakers'. Given that the Volpa Synagogue and other wooden ones of its type predated the masonry synagogue in Włodawa, they probably served as prototypes for this building.

As a sophisticated architect, Fontana would also have been aware of the wide frontage of the Herodian Temple in reconstructions by Christian Hebraists and architectural theorists in circulation since 1630. The prayer hall of the synagogue in Włodawa follows the nine-bay vaulted plan with four evenly distributed columns. The bimah in the middle, surrounded by a masonry balustrade, stands independently of the columns. A brilliantly painted and gilded Torah ark made of plasterwork was installed after the fire of 1936 that had incinerated its wooden predecessor. The current ark is multi-tiered, as typically found in the Polish-Lithuanian Commonwealth from the eighteenth century onward. A sculpted Crown of the Torah surmounts the ark, in accordance with the familiar saying of the Mishnah cited earlier. The ark also features a gilded menorah—accompanied by the verse: "I will bow down toward Thy holy Temple in the fear of Thee" (Psalms 5:8). Cartouches on either side of the menorah depict baskets of fruit and hands joined in the Priestly Blessing. The ark is flanked by twisted, or so-called Solomonic columns similar to those in St. Peter's Basilica in the Vatican. Painted reliefs of musical instruments on either side of the ark illustrate Psalm 150. Restored in the 1970s and 1980s, the Great Synagogue of Włodawa, together with the neighboring *beit ha-midrash* (study house), is one of the best preserved large synagogues of Poland and serves as a regional museum.

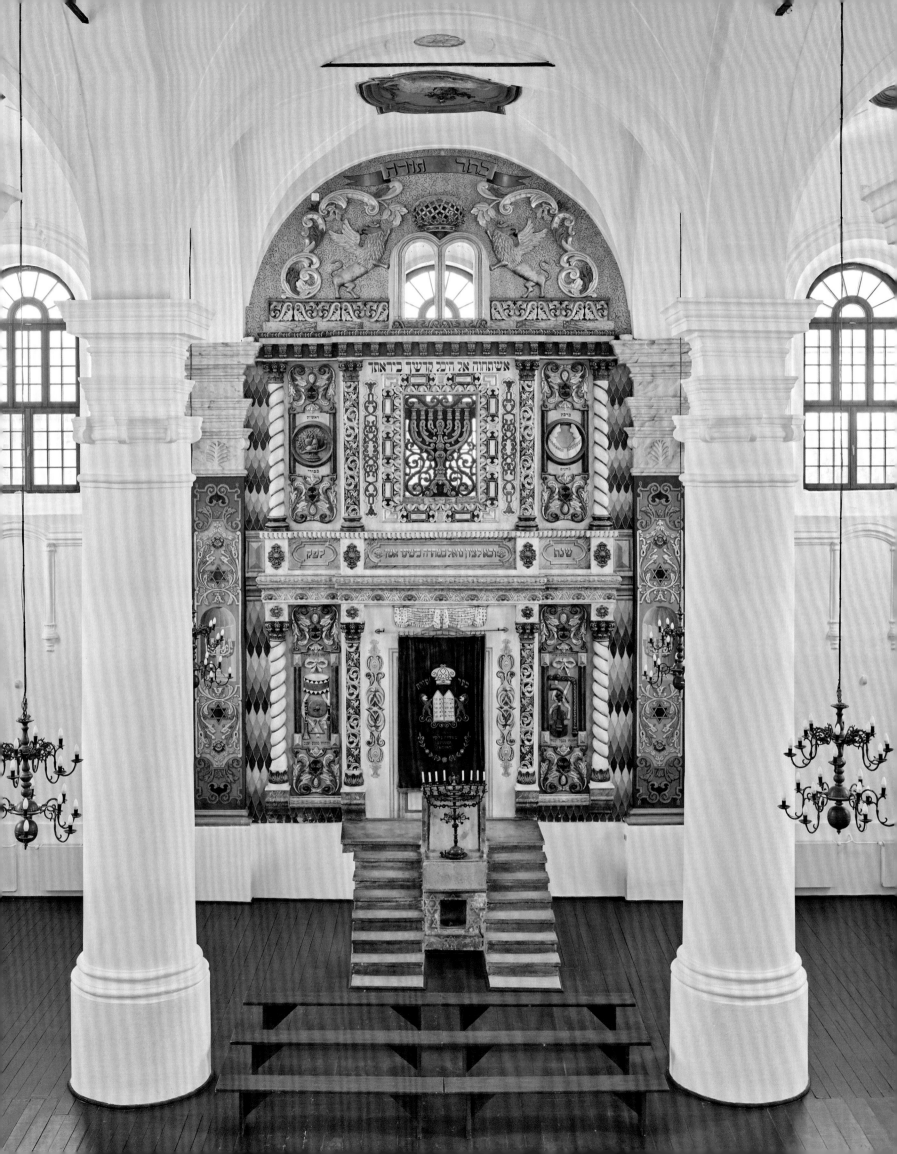

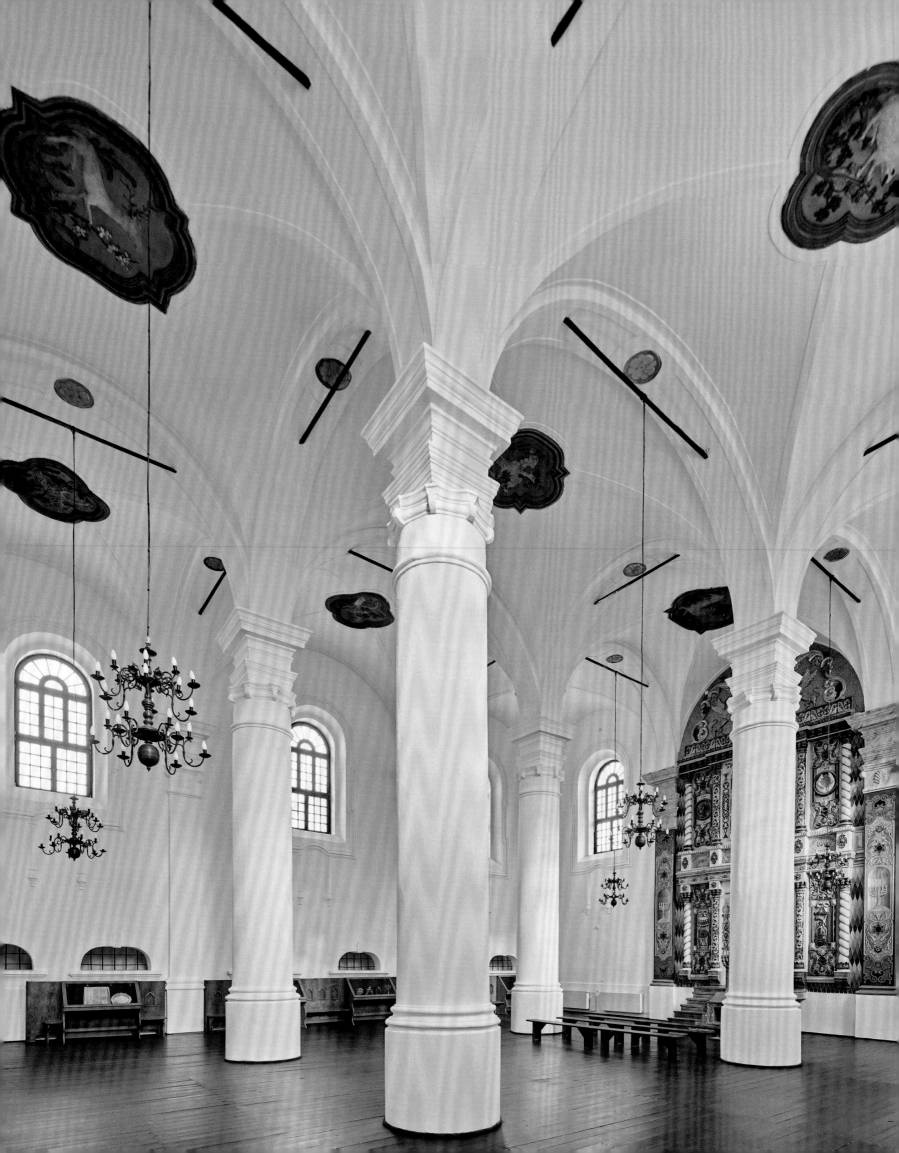

Opposite: The airy nine-bay vaulted prayer hall of the Włodawa synagogue features a ceiling decorated with polychrome medallions depicting animal and vegetal motifs elucidating religious and ethical precepts.

Below: Details of four medallions from the synagogue's ceiling. These medallions were inspired by the opening words of the Mishna by Rabbi Judah ben Tema, "Be strong as a leopard, swift as an eagle, fleet as a gazelle, and brave as a lion according to the will of Your Father who is in heaven."

Below: The Tempel Synagogue of Kraków's adoption of the round-arch style testifies to this Polish congregation's strong identification with the German Jewish Reform movement. The synagogue was designed by Ignacy Hercok in 1862 and remodeled by Beniamin Torbe in 1893–94. Its elegant, evenly plastered exterior with Romanesque arches, which frame the three entry portals, the windows, and the Tablets of the Law, sets it apart from earlier synagogue and church designs in the city.

Opposite and pages 150–51: This prominent Polish Progressive (Reform) community espoused the elongated prayer hall, which culminates in the bimah before the ark on the eastern wall. The congregation favored a splendid interior with Moorish-inspired elements, painted plasterwork, and abundant gilding.

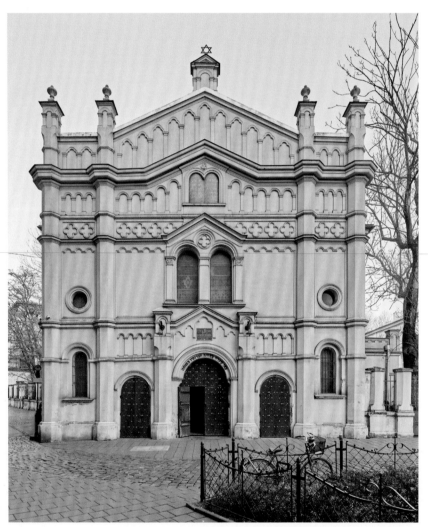

Tempel Synagogue, Kraków, Poland (1862, remodeled 1894)

Built a century after the synagogue in Włodawa, the Tempel Synagogue reflects the spreading of Reform Judaism, and the greater wealth of its commissioners. The dynamic German Reform congregation of Kraków built the Tempel Synagogue between 1860 and 1862, when the city belonged to the Habsburg Empire. Situated not far from the Old Synagogue and the later historic synagogues clustered in the Kazimierz district, it differs from them radically in architectural style and liturgical arrangement. Its architect Ignacy Hercok was a government official who initially specialized in public buildings in the neoclassical style. However, while he maintained the traditional square ground plan with four main columns for the prayer hall along with the women's gallery at the rear (later modified), he adopted the new, highly fashionable *Rundbogenstil* (round-arch style) for the exterior. Hercok modeled his facade on that of the German city of Kassel's traditionalist synagogue.

Following various additions between 1893 and 1894, the Jewish architect Benjamin Torbe working in the more elaborate neo-Moorish style, introduced an organ and choir gallery over the marble Torah ark. A mixed choir was permitted in the synagogue—contrary to Orthodox practice. However, women were still confined to the upstairs galleries that ran around three sides of the hall. Between 1894 and 1909 and with further installations in 1925, the synagogue acquired forty-three radiantly colored stained-glass windows, one of them copying an eighteenth-century depiction of the Jerusalem Temple in the shape of the Dome of the Rock. During World War II, the Nazis greatly damaged the synagogue by using it for storage and as stables. Fortunately, between 1994 and 2000, the World Monuments Fund initiated a restoration program. Now the Tempel Synagogue hosts occasional services, community events, and concerts.

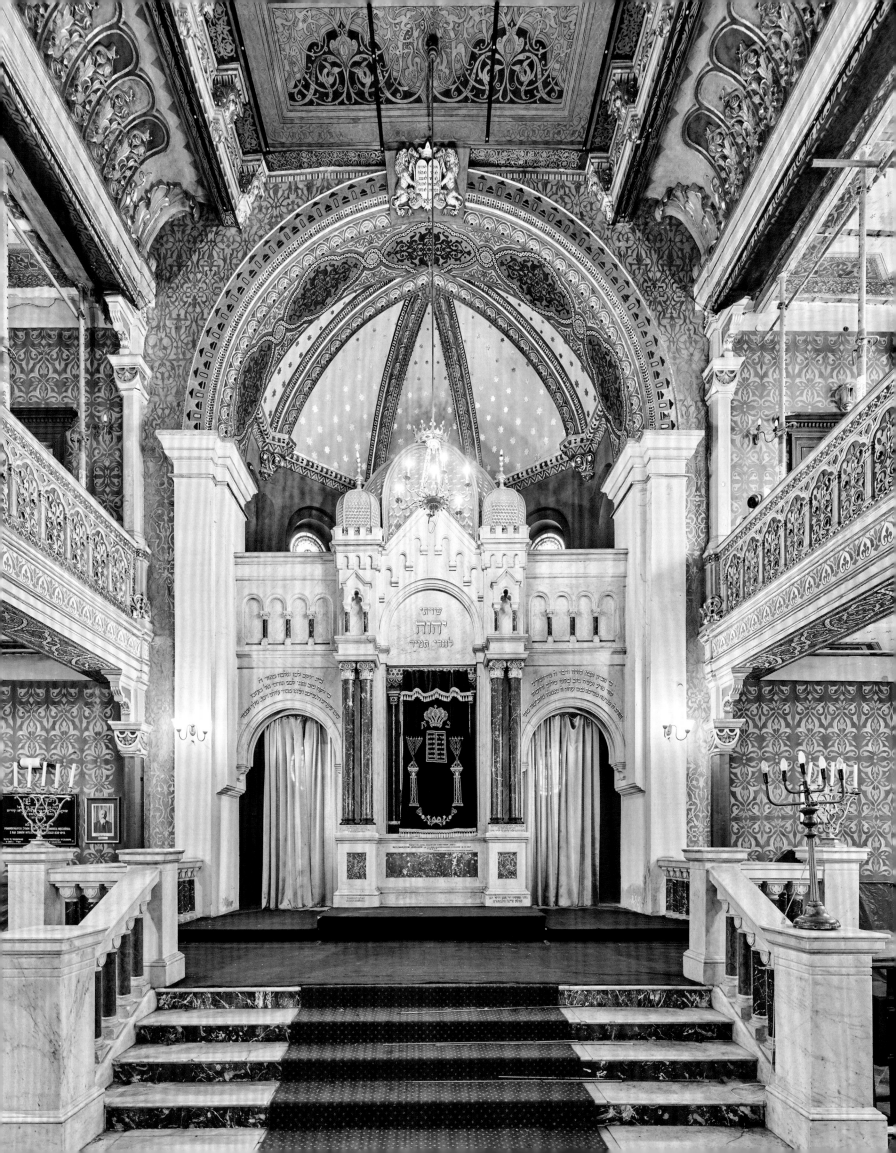

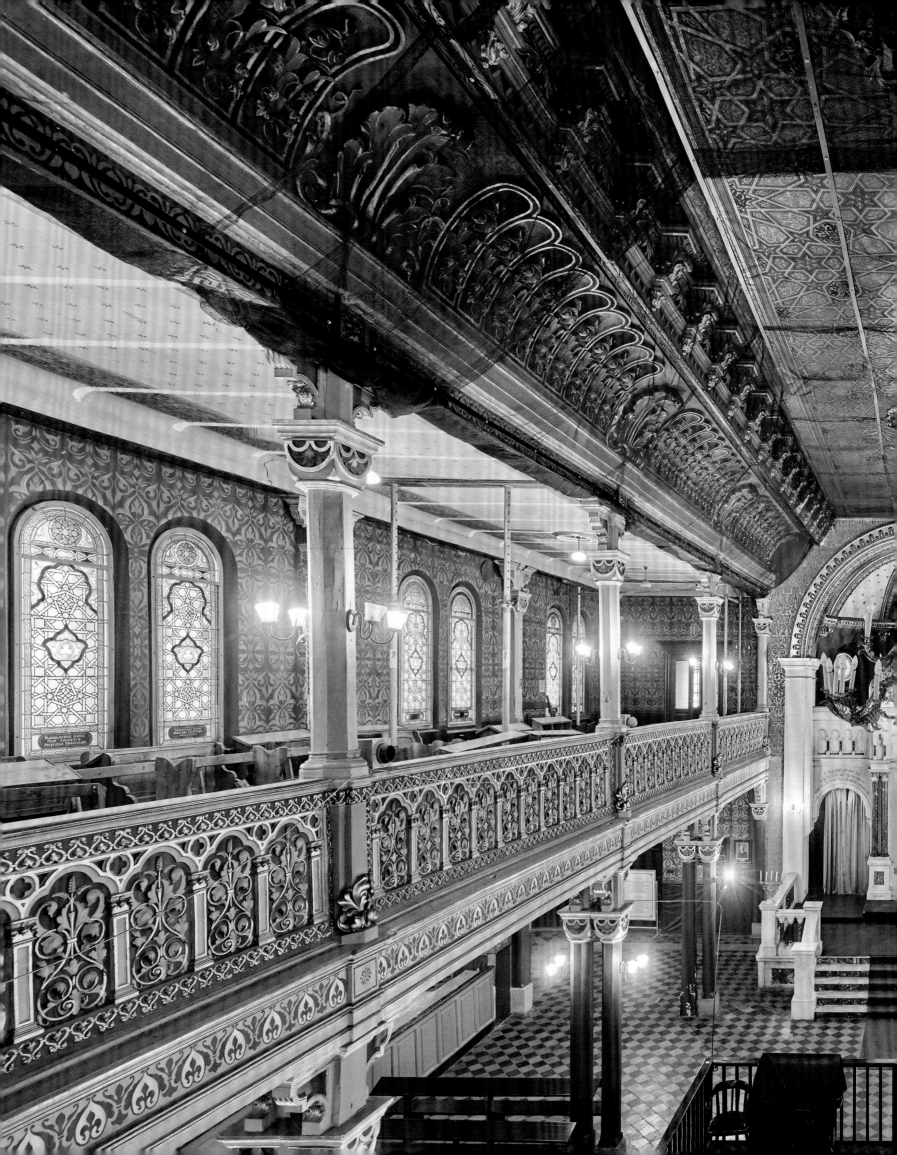

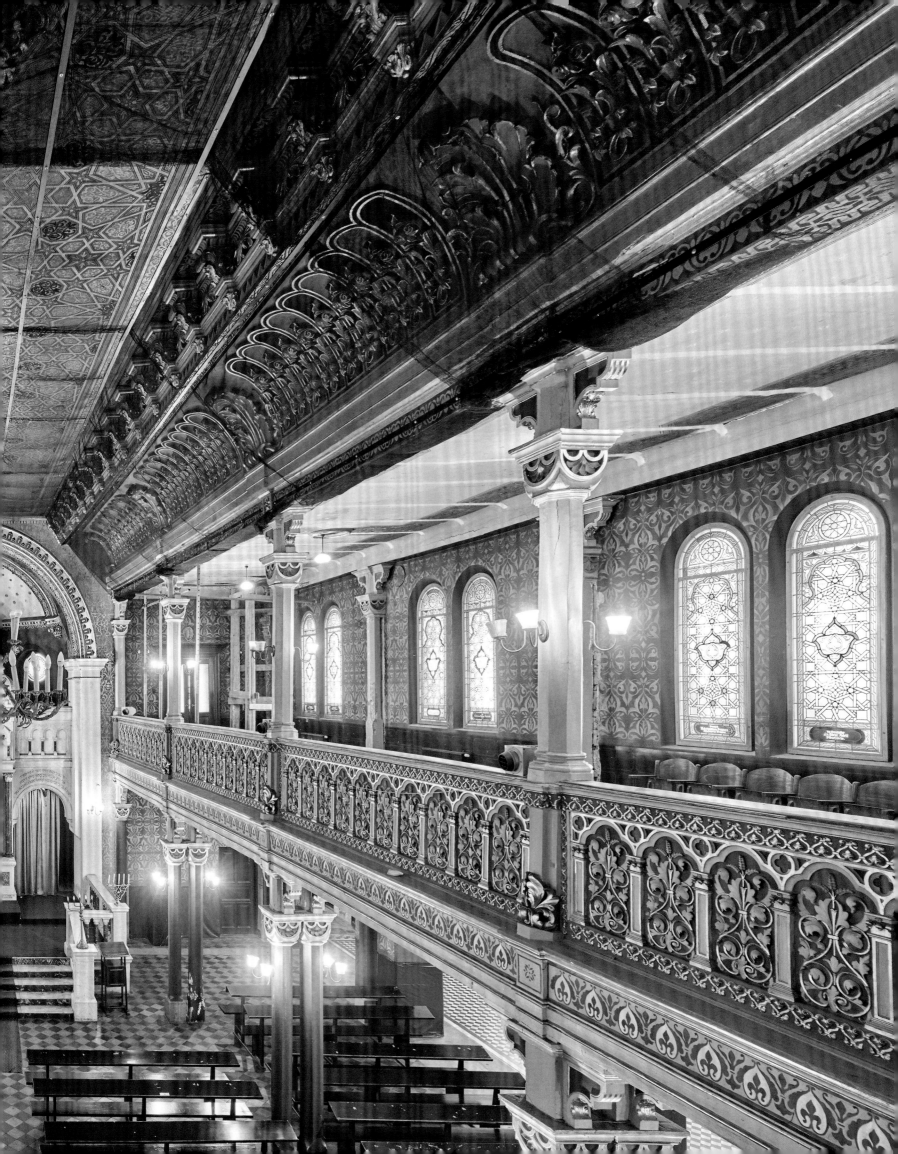

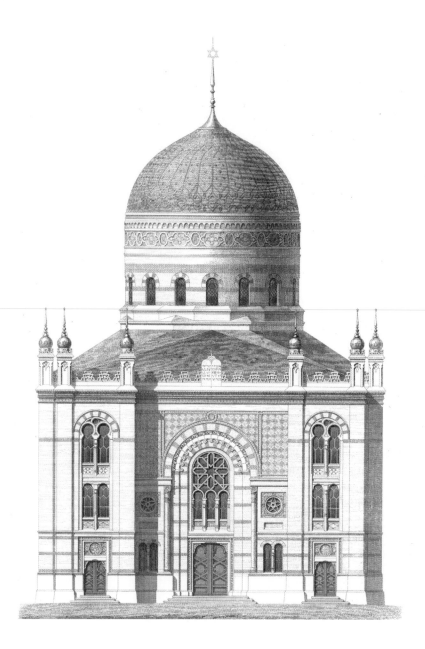

Temple Synagogue of Chernivtsi, Chernivtsi, Ukraine (1878, line drawing)

In the most easterly end of the Habsburg Empire—now part of Ukraine—a fundamentally different form of synagogue architecture took flight. In the provincial capital of Chernivtsi (known as Czernowitz in German), a significant faction of the Jewish community adhered to a conservative type of Reform Judaism that followed the Viennese rite. These reformists managed to secure a centrally located plot and a considerable budget for the construction of a monumental temple built between 1873 and 1878. They hired a cosmopolitan architect Julian Zachariewicz, who was born in Lviv and trained in Vienna. An ambitious designer, Zachariewicz modeled his immense centrally planned and domed synagogue on the famous Neue Synagogue in Dresden. However, unlike its German counterpart, which was neo-Romanesque outside and Moresque within, the Temple Synagogue of Chernivtsi adopted aspects of the patriotic "Viennese Renaissance" following 1848. This new imperial style drew on multiple sources from across the Habsburg Empire's historical domains, including Moorish and Venetian architecture. It also combined Romanesque aspects from the Germanic areas and Byzantine aspects from the Balkans. Zachariewicz opted for a popular "Jewish" variant of this style, emphasizing the Moresque elements and the Middle Eastern identity of the congregation. Today, little remains of the Temple Synagogue of Chernivtsi following its desecration during the World War II and its subsequent conversion into a cinema.

Grand Choral Synagogue of St. Petersburg, St. Petersburg, Russia (1893)

Despite cultural exchanges between the Russian and Habsburg Empires, German influence prevailed in a distinctive Russian variant of the Reform Judaism and new synagogue style, which was pioneered in St. Petersburg. The Grand Choral Synagogue of St. Petersburg arguably represents its finest expression. Choral, similar to the Yiddish *khorshul*, refers to synagogues from eastern Europe and Russia, whose congregations follow a certain type of reform expressed in the orderliness and decorum of the liturgy, and where the boy's choir accompanied the Sabbath prayers. Choral synagogues favor the grouping of the bimah, the ark along with the cantor's pulpit against the eastern wall with pews facing them, as well as a gallery for a large male chorus.

The construction of the Grand Choral Synagogue of St. Petersburg involved a complicated and protracted process. The relatively progressive Tsar Alexander II allowed affluent Jews to take up residence in the city only as of 1859 and granted them a special permit for the building of a synagogue ten years later. In 1879, he finally consented to the purchase of the site, which was well away from the city center. Another two years passed before his successor, Alexander III, approved the design in 1881, but on a greatly reduced scale, that featured a single dome, rather than the four cupolas originally requested by the Jewish community.

After considerable debate, the community selected a Moorish style in keeping with the flamboyant Neue Synagoge on Orienburger Strasse in Berlin. The design was prepared by Lev Bakhman, the first Jew to graduate from the St. Petersburg Academy of Arts, together with Russian architect Ivan Shaposhnikov. Alexei Malov completed the project between 1883 and 1893 with numerous alterations. Only the main facade originally approved by the tsar remained unchanged.

The style and decoration quote extensively from a variety of Islamic architectural sources, such as the Alhambra in Granada, while the cupola was modeled on the Mausoleum of Mamluk Amir Tarabay al-Sharifi in Cairo. Hebrew illuminated manuscripts

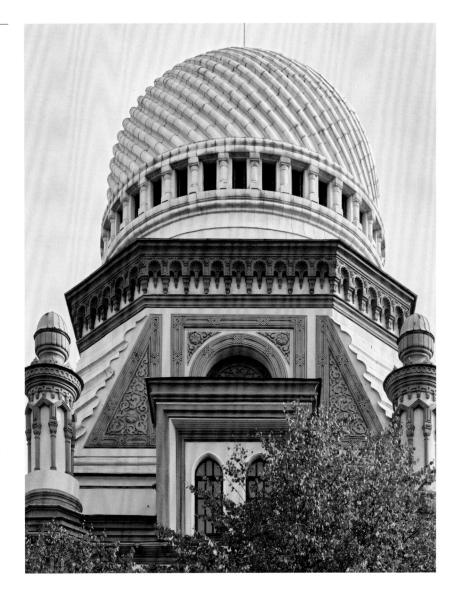

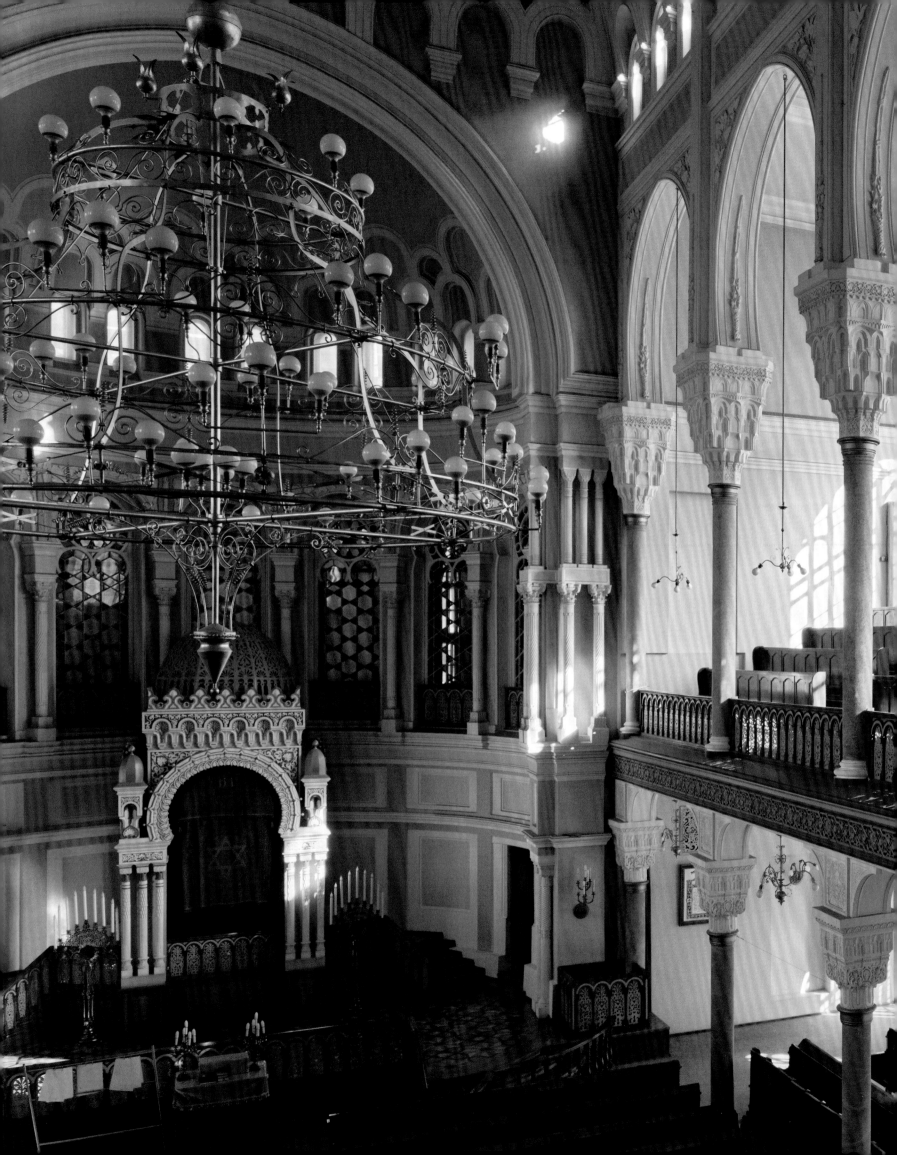

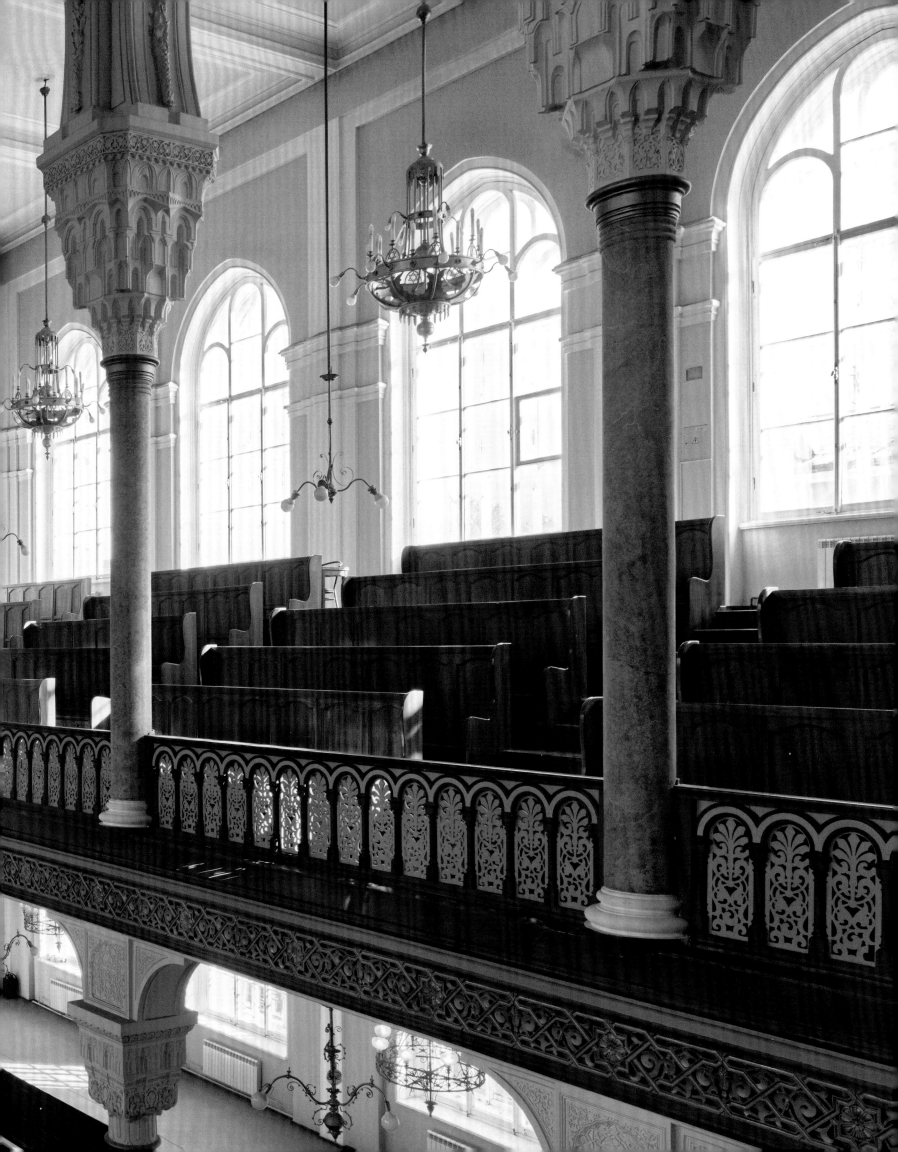

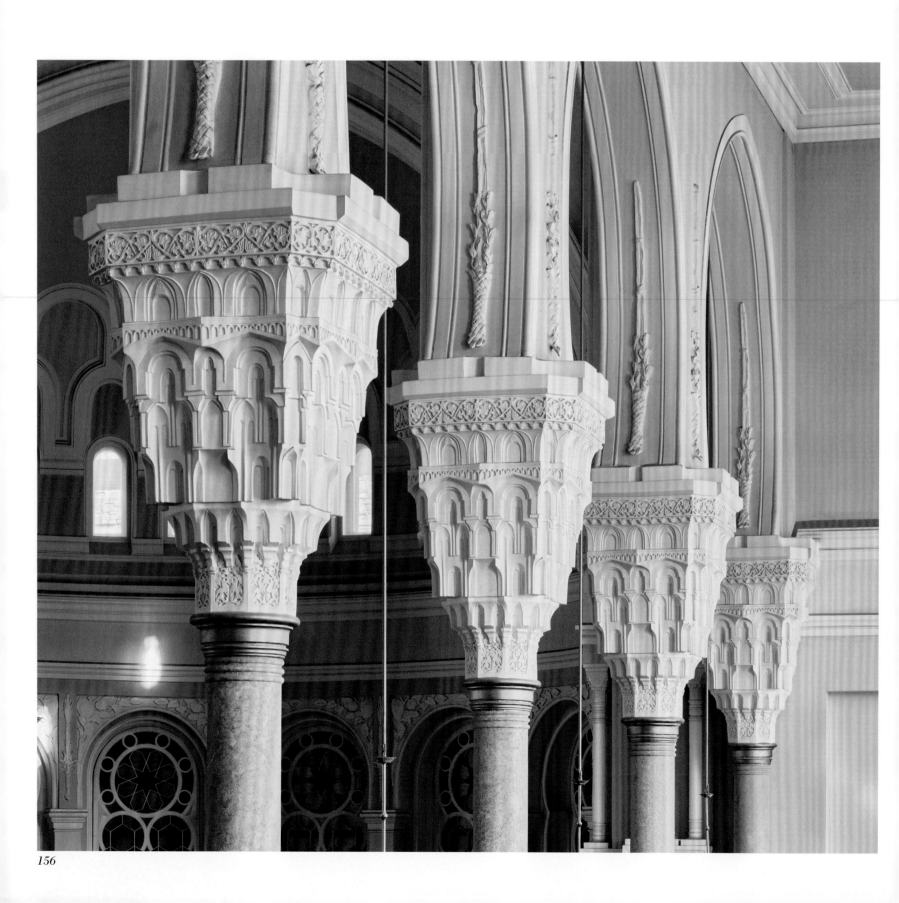

Below: Muqarnas-*shaped capitals adorn slender columns in the Grand Choral Synagogue women's gallery. The glorious details showcase the fine restoration in 2001, thanks to donor Edmond Safra.*

Below, left: In the apse surrounding the ark, a series of Moorish horseshoe arches such as this one, frame stained-glass windows with the Star of David.

Below, right: Detail of column capitals with muqarnas—a honeycomb-style architectural feature associated with the Middle East—that signal the congregation's ties to the Holy Land.

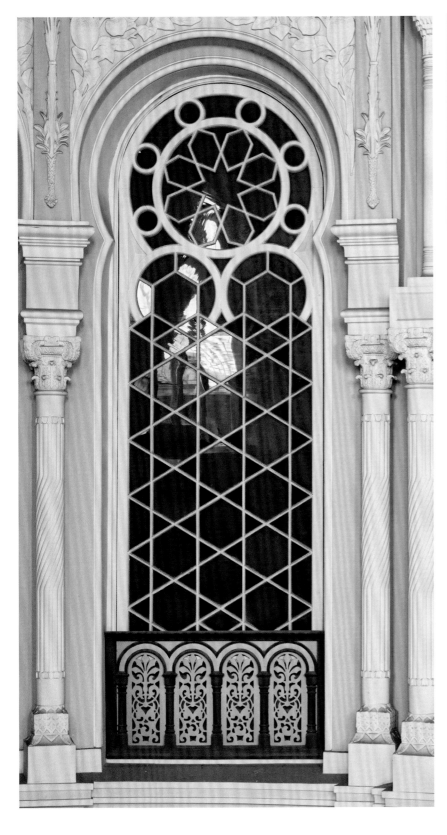

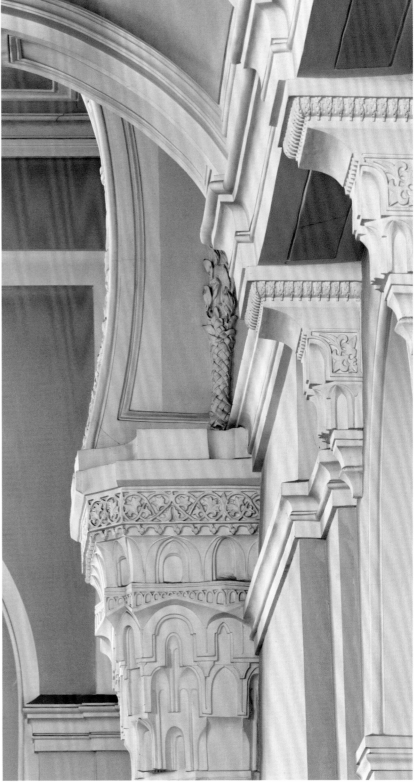

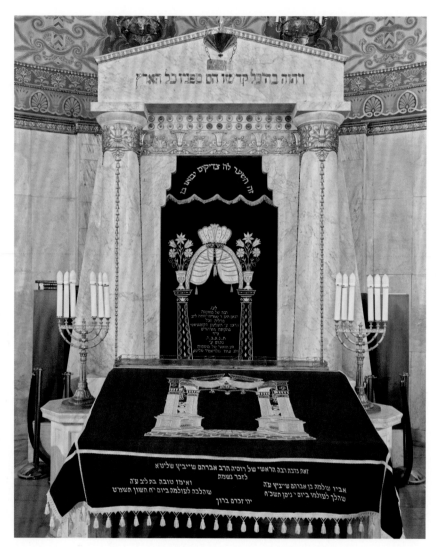

in the locally held Firkovich Collection inspired the ornamental
grillwork of the railings and front gates. These last were designed
by architect Ivan Ropet in 1907 and completed by Alexander
(Isaac) Shvartsman. Inside, the canopied Torah ark loosely follows
that of Berlin's Neue Synagoge on Oranienburger Strasse.

Soviet authorities closed the synagogue in February 1930,
but due to Stalin's changing policies, it reopened in June
of that year. Religious services continued to be held at the
sanctuary even during the Siege of Leningrad between 1941
and 1944. Now, following a restoration in 1999 on behalf of
to the Safra family, the Grand Choral Synagogue presents a
luminous yellow-and-white interior with graceful balconies
embellished by elegant woodwork and a sky blue dome. It can
accommodate twelve hundred worshippers and is the largest
synagogue in Russia.

Moscow Choral Synagogue, Moscow, Russia
(ca. 1893, dedicated in 1906, restored beginning 2001)

In a parallel development farther south, the Moscow Choral
Synagogue was built close to the quarters of the Jewish army
veterans who had been permitted to settle in the city from the
1830s on. The Jewish community, then headed by entrepreneur
Lazar Polyakov, purchased a plot in the former potters' district.
After much controversy, the community eventually approved a
design in 1886 by Simon Eibuschitz, an Austrian-born Jewish
architect who had converted to the Lutheran Church and
studied in Moscow. He based his design largely on the Great
Synagogue in Warsaw, which featured a domed neoclassical
basilica with a Corinthian portico. However, the Holy Synod
halted construction—on the grounds that it caused offense
to Orthodox Christians—rescinding their ban only after the
synagogue's cupola was dismantled and the Tablets of the Law
removed from the facade. Although the work was completed by
1891, it coincided with a mass expulsion of Jews from Moscow.
The authorities then closed the synagogue and demanded that
it be sold or converted into a charitable institution. Originally
transformed into a vocational school, it later served as a
Talmud Torah (religious elementary school).

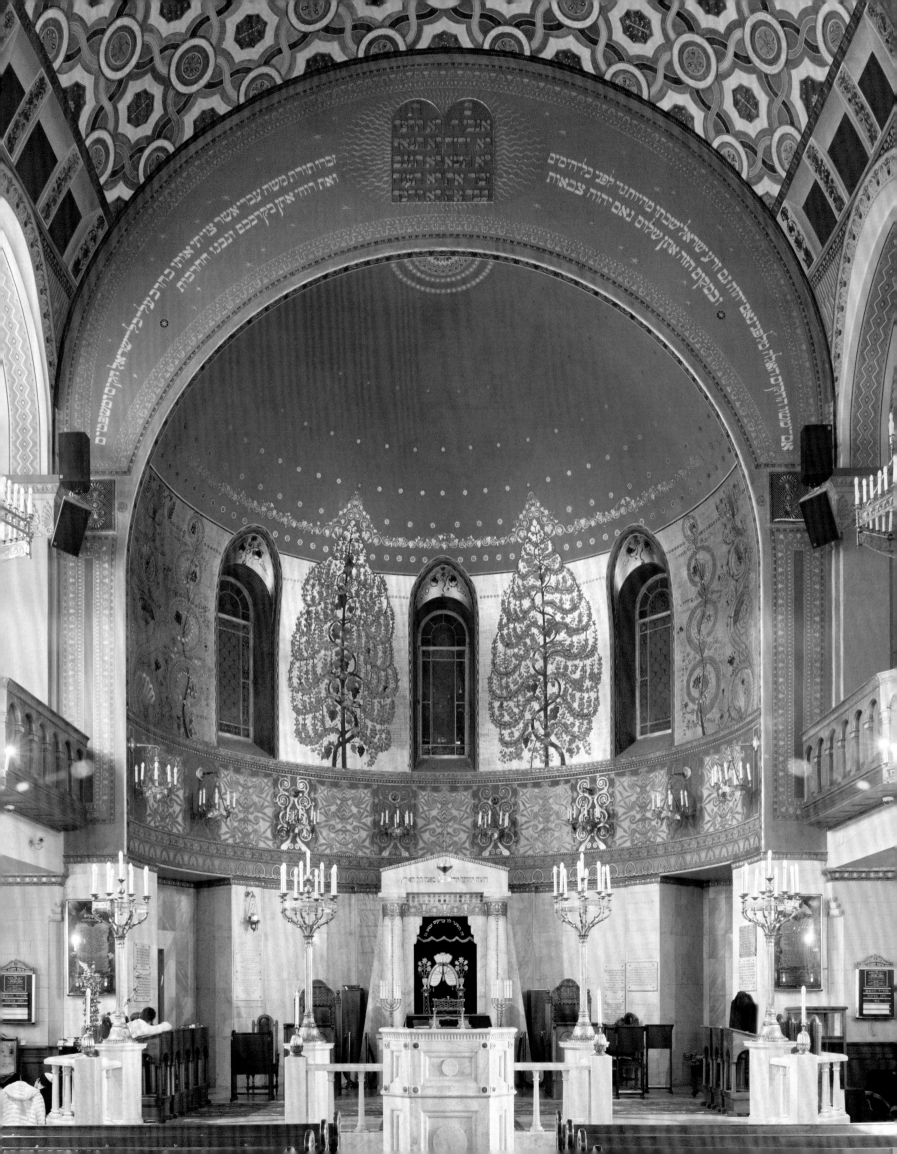

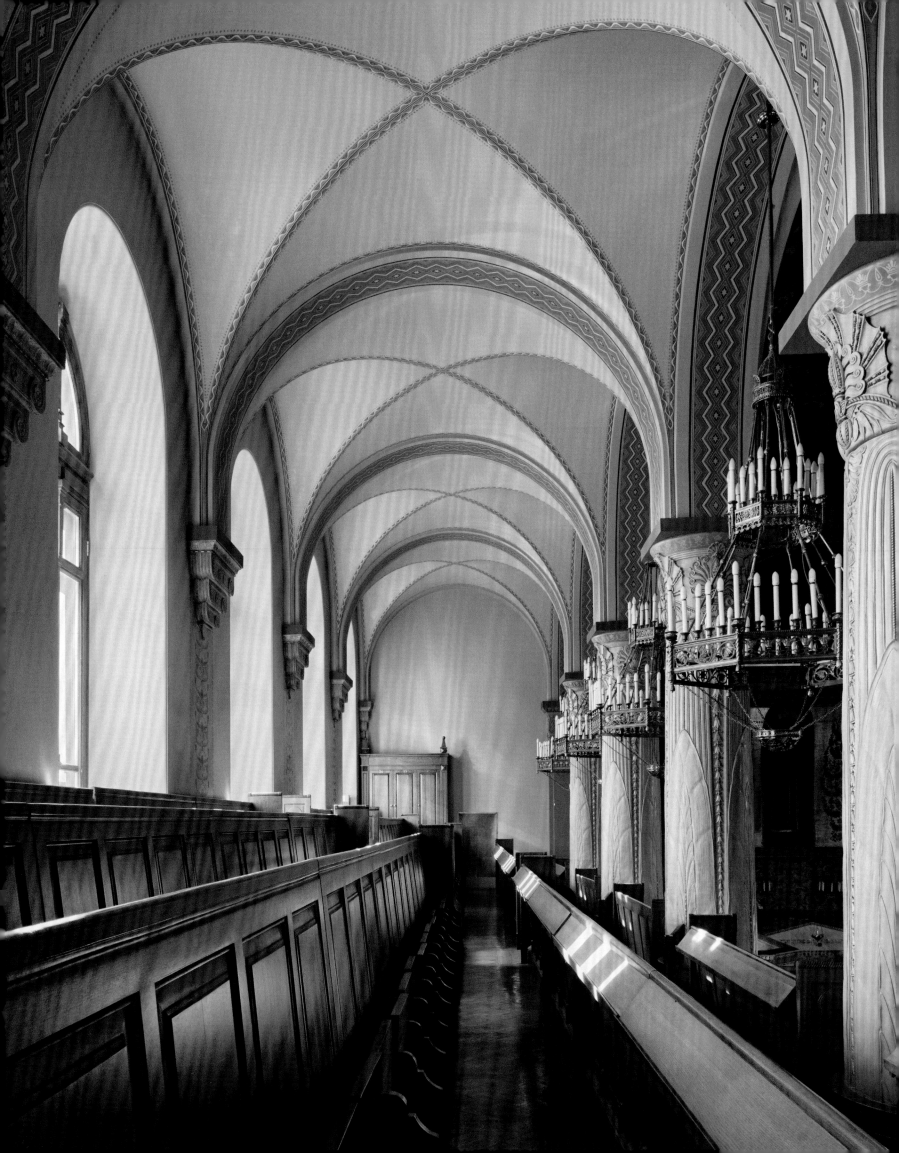

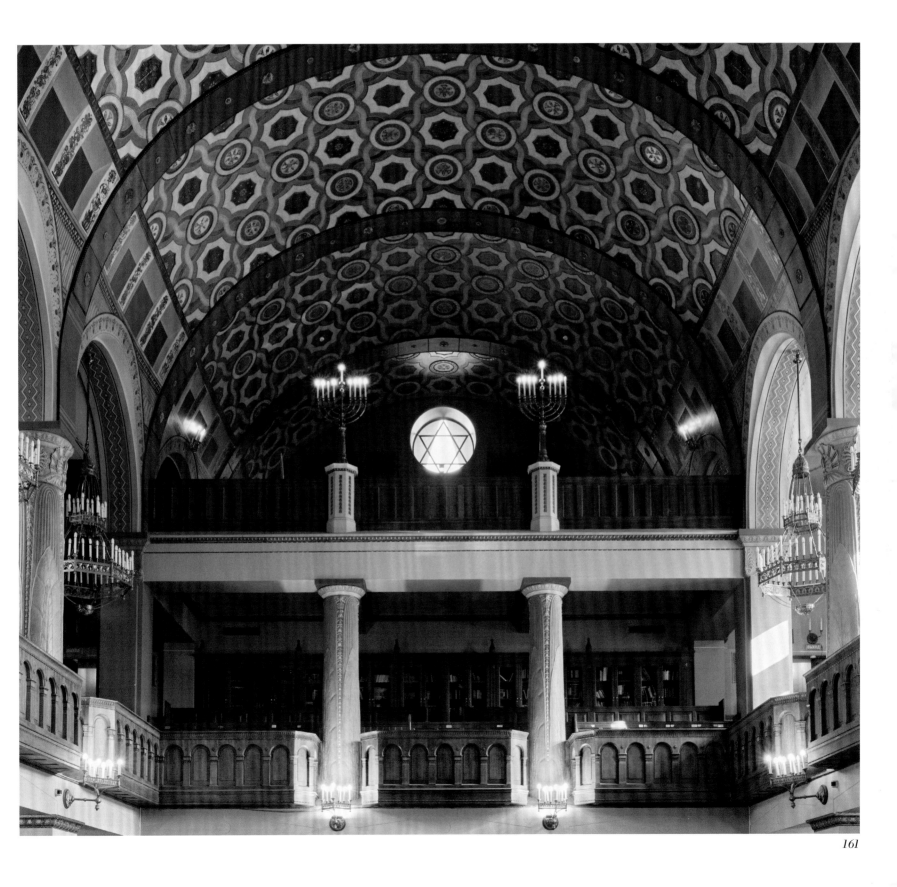

Opposite: A row of heavy bronze chandeliers illuminate the women's balcony of the Moscow Choral Synagogue. The colonnade features Egyptianizing lotus designs, which allude to the role of ancient Egypt in Judaism.

Below: In the main sanctuary, massive columns support an enormous barrel vault over the central nave illuminated on the western end by an oculus with the Star of David.

Following the April decree issued during the 1905 Revolution, the synagogue opened at last, and its interior was restored by the renowned Russian-German architect Roman (Robert Julius) Klein. During the years of Communist rule, despite attempts to close it in 1923 and 1930, the Choral Synagogue was tolerated as an official house of worship. In 2001, the Russian Jewish Congress, the Jewish Community of Moscow, and the American Jewish Joint Distribution Committee launched an ambitious reconstruction plan. They arranged for the Palladian exterior to be painted in a welcoming light yellow with white trim, and for the restoration of the cupola to its former glory, complete with the Crown of the Torah, all in accordance with its original design. Today, thanks to its superior acoustics, the synagogue hosts numerous concerts.

Synagogues of eastern Europe reflect the vibrant religious life of a large and dynamic community. The locally developed "Great" synagogue types speedily replaced the double-nave plan and Gothic style. Drawing inspiration from Renaissance and Baroque architecture, new design concepts enabled unprecedented spacious prayer halls based on a square plan centered on the bimah. The painted and relief decoration of these magnificent spaces was imbued with Jewish symbolism. As of the sixteenth century, the presence of women in the synagogue became habitual, although they were often confined to secluded annexes. With the proliferation of the Reform Judaism, novel types of synagogues became popular across eastern Europe. New styles, including the *Rundbogenstil* and neo-Moorish, alluded to the eastern origins of the Jewish people and reflected their loyalty to their host societies. The rise of these synagogues lasted until the first half of the twentieth century. However, beginning with World War I, increasing secularization, the Great Depression, growing anti-Semitism, and Soviet antireligious campaigns harshly confined Jewish religious life. After the Holocaust erased entire Jewish communities, postwar Communist authorities often deliberately defiled, damaged, and razed synagogues. Only with the end of the Cold War and the revival of Jewish communities in eastern Europe and around the world did the remaining synagogues begin to be restored and revitalized.

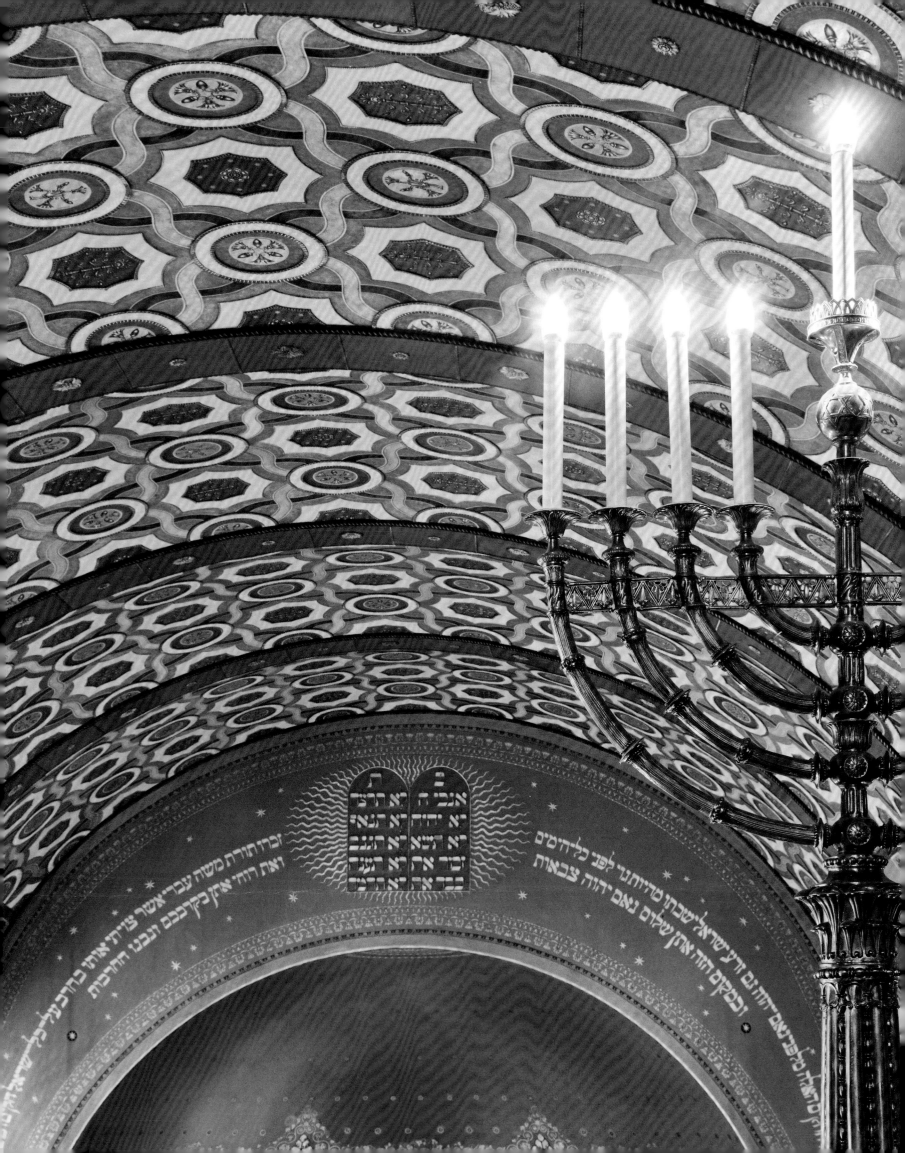

5

5. Synagogues of Iran, the Caucasus, and Central Asia

Lidia Chakovskaya

*Just as our ancestors, after leaving Egypt, wandered
about the wilderness for forty years, crossed the Red Sea,
crossed the Jordan, came to Canaan,
erected the Holy Temple and happily lived
in a country flowing with milk and honey—
we wandered for a long time, crossed the sea,
rivers and found peace in the country of
mountains rising to the skies . . .
and they built the House of God here.*

—Pinhas ben Nason (after 1646),
cited in *On the Origins of the Kuba Jewish
Community* by Ilya Sharbatovich (1898)

When the nineteenth-century ethnographer Ilya Anisimov, the son of a rabbi, attempted to describe the everyday life of the Mountain Jews—the Jews inhabiting the mountainous region of Caucasus—he was amazed that they viewed themselves as the descendants of one of the most ancient Jewish communities. He recorded that their lives were fully dependent on the policies of their region and that they had been forced to flee for their survival into the mountains. Nevertheless, some of these isolated communities flourished, building synagogues that are now silent testimonies to their dignity and aspirations.

According to oral tradition, the Jews of the Caucasus and Central Asia are descendants of the lost tribes of Israel, those who never returned to the Holy Land after the Assyrian Empire had conquered the Kingdom of Israel in 722 BCE, but historians hold that they trace their lineage to the Jews of Babylon. The Mountain Jews, along with Jews of Georgia, Bukhara, and Uzbekistan, originate from Persia, which had long influenced and at times dominated the Caucasus region.

Persian Jewish traditions strongly inspired the Jews of the Caucasus region, who eventually formed several distinct communities: Mountain Jews, who were scattered to the east and north Caucasus in areas that had been and are still predominantly Muslim; the Jews of Georgia; who were primarily surrounded by Christians; and the Jews of Central Asia. In each region, Jewish communities preserved their own distinctive customs and synagogue architecture while incorporating local building practices and styles.

*Page 167: Detail of the ark in the modest
exterior of the Pol-e-Choobi Synagogue
in Tehran masks a sumptuous interior
covered in turquoise tiles in the Persian
tradition—along with an embroidered
parochet (curtain), which covers the ark.*

*Below: A discreet blue door inset
with colored glass stars leads to the
Pol-e-Choobi Synagogue, one of the
few active Jewish houses of worship in
Tehran. Established in the eighteenth
century, or possibly earlier, it was
handsomely restored in 1968.*

The Synagogues of Iran

The Persian Jews trace their history to the Babylonian Exile
(586 BCE). When the Persian king Cyrus II allowed them to
return to the Land of Israel in ca. 537 BCE and aided in the
rebuilding of the Second Temple, a considerable number of
Jewish communities remained in the Persian region for years
thereafter and Jewish culture flourished. By the seventeenth
century, disputes over the domination of the Caucasus and
severe persecutions led some Jews to emigrate from Persia.
While the remaining Jewish community had periods of
intermittent prosperity and acceptance, the calamities of the
twentieth century left only twenty-five active synagogues in
this region. Although Jews had gathered in synagogues since
antiquity, the buildings were continuously rebuilt, so the oldest
extant synagogues in Iran date from the eighteenth century
through the twentieth.

The Pol-e-Choobi Synagogue (The Pol-e-Chuba Synagogue), Tehran, Iran (eighteenth century, or possibly earlier, restored in 1968)

Located near Sepah Square in the heart of Tehran, the Pol-e-Choobi
Synagogue owes its present form to its 1968 restoration,
commemorated by an inscription to the right of the Torah ark.
One enters the rectangular synagogue through a cobalt blue door
that opens onto a spacious courtyard cooled by trees and removed
from the noisy street. Inside the courtyard, three beautiful blue
arched portals lead to the synagogue's two sanctuaries.

Access to the lesser sanctuary is achieved through the first
arched door, articulated with blue and white stripes. The
portal is adorned with colored glass cut into diamond patterns.
The second door leads to a vestibule that forms the entrance
to the main sanctuary as well as housing the staircase to the
women's gallery. It is embellished with a blue lattice design and
emblazoned with a gold Star of David (although, here, the Star
resembles the traditional Persian six-pointed star).

Within, a spacious wooden bimah rises in front of the ark (*aron
ha-kodesh*). Nine tall windows provide plenty of light. The

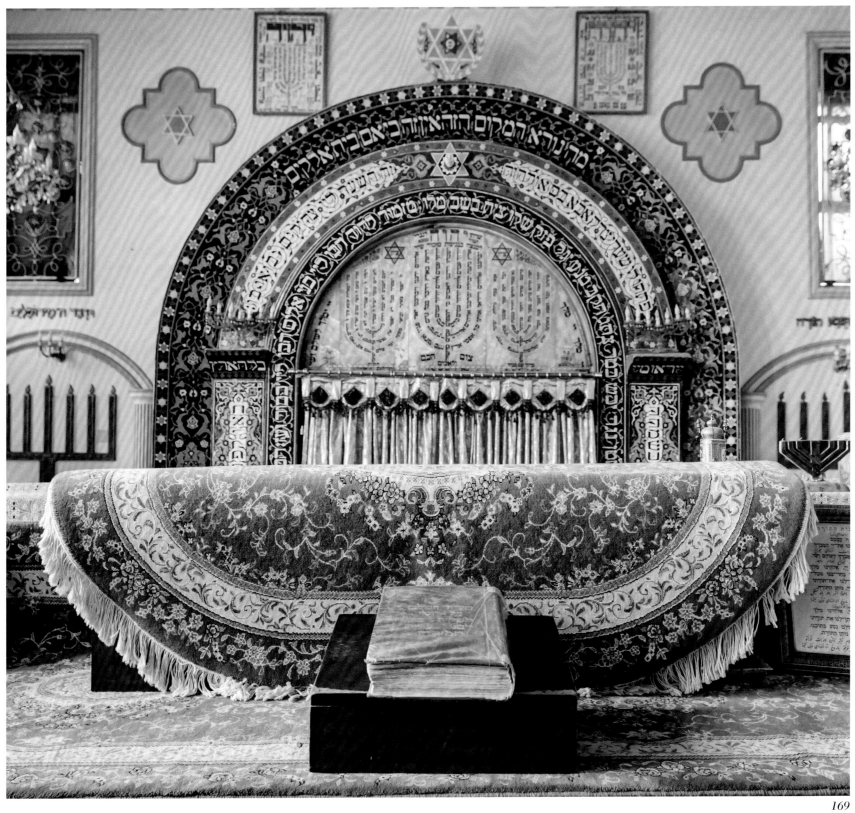

Below: In accordance with Iranian custom, a fine Persian rug adorns the bimah, which is set before the ark. Above the ark, images of shiviti menorahs composed of Hebrew letters announce God's presence to the congregation.

diamond design of blue stripes makes the flat ceiling appear higher and echoes the blue architectural details of the interior. The ark serves as the focal point of the hall. Surrounded by tiles decorated in typical Persian floral designs of blue and green, it is bracketed by columns that reference the twin pillars, Jachin and Boaz, from the Temple of Jerusalem. The top of the ark displays an image of three menorahs, each with arms composed of Hebrew letters (known as *shiviti*), while below, an embroidered curtain (*parochet*) covers the Torah scrolls. The tiles that run along the base of the ark follow a medieval Persian *girih* design of repeated polygons (similar to Penrose tiling). The Jewish and Iranian Muslim traditions share a common preference for calligraphic, geometric, and floral patterns as seen here in the inscriptions referencing Jehovah and various psalms. The Pol-e-Choobi Synagogue is a living testimony to the survival of the Jewish faith in Iran despite the dwindling population of Jews, which numbered as few as eighty-five hundred as of 2018.

The Synagogues of the Caucasus

The mountainous Derbent region in the Eastern Caucasus on the Caspian Sea served as a refuge for Jews and Christians alike through the late Middle Ages. In the sixteenth century, when the Caucasus area was disputed between the Persian and Ottoman Empires, Jews were forced to leave the cities and settle in the mountains. A century later, refugees from Persia continued to strengthen these Jewish communities, settling in major cities such as Derbent (now in the Russian Republic of Dagestan) and Kuba (which is now officially spelled Quba), where they established flourishing Jewish quarters.

In the early eighteenth century, when the Russians withdrew their troops from the Eastern Caucasus, the Persians started a long period of Jewish persecution, which ended only when the Russian Empire took back the entire region a century later. During this time, many Jews left Derbent to live once again in remote mountain villages, leading to the deterioration of Jewish life. However, some Mountain Jews returned to Quba to seek the protection of its ruler, Fatali Khan, who reigned from

1758 until 1789, in exchange for their trading skills. There, they founded their own quarter, known as "the Jewish Village" (later renamed Krasnaya Sloboda), where for the most part, they prospered, eventually gaining their civil rights in 1888 after the Caucasus joined the Russian Empire. Some Jews in this region worked as traders or artisans in leather and carpet production, but most were farmers, growing high-quality tobacco and *morena brasilin*, widely used in weaving.

When the Persian Jews migrated over time to the Caucasus, they gradually began to adopt the customs of this mountainous region, with small settlements featuring sunbaked brick houses or towers of brick, mortar, and stone, used as defensive dwellings for families and livestock. The oldest Jewish community in the Caucasus was situated in Derbent, which by 1905 was wealthy enough to build seven synagogues.

Kele-Numaz Synagogue (Great Synagogue), Derbent, Russian Republic of Dagestan (1914, reconstruction 2010)

Today, the only active synagogue in Derbent is the Kele-Numaz, or "big synagogue," first built in the 1900s and rebuilt shortly thereafter by the Hanukayev mercantile family. In 2009 the Jewish community voted to reconstruct the synagogue, which had fallen into disrepair. The new synagogue, designed by Sergei Yagudaev (b. 1952), preserves some of the older local yellow stonework but follows a totally new design. Kele-Numaz comprises a rectangular sanctuary with an austere exterior featuring tall arched windows adjacent to a three-story community center. A large staircase with a wrought-iron portal adorned with a pair of bronze menorahs serves as the main entrance. Within the principal sanctuary, exquisite inlaid wooden panels cover every surface. The massive aron ha-kodesh in the form of a projecting wooden portal dominates the long wall. Above the ark's velvet blue-and-gold curtain (parochet) a finely carved wood panel bears the Ten Commandments and a verse from Psalms. To the left, a cabinet contains the ritual silver of the Mountain Jews. Wooden benches surround the bimah, which is situated before the ark. A square skylight provides additional light. Here, the contemporary adaption of nineteenth-century design signals

Below: Commissioned by the Hanukayev brothers, the Kele-Numaz Synagogue in Derbent, Russian Republic of Dagestan, was built in 1914. Originally decorated with vivid murals, it was reconstructed by Sergei Yagudaev in 2010 using bricks from the former sanctuary. Today, fine wood paneling adorns the main hall.

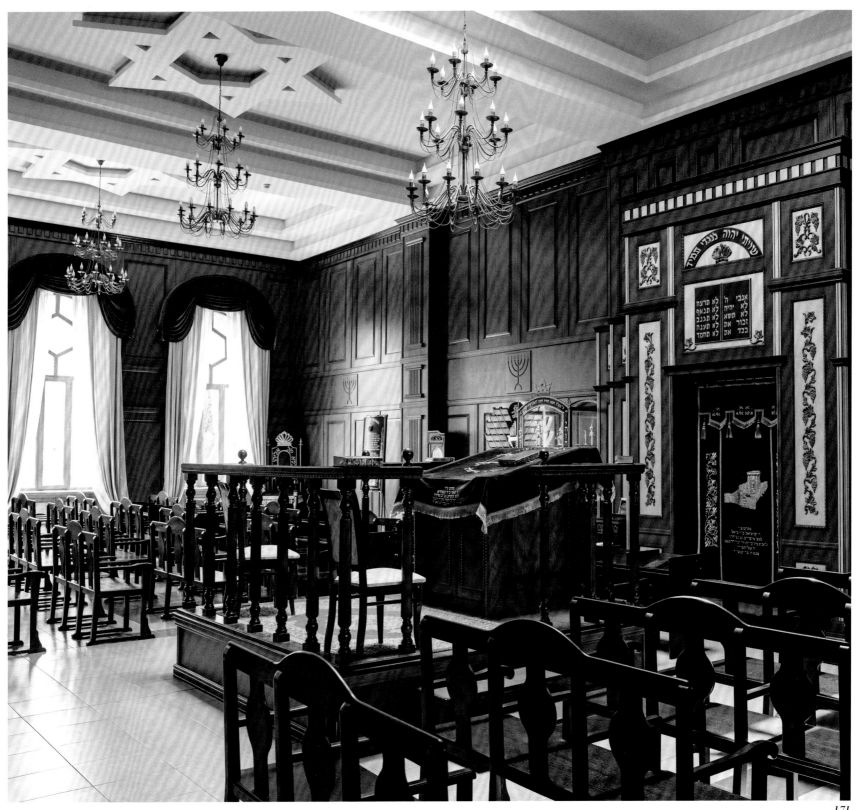

the present-day Jewish community's desire to simultaneously reference its roots and express its new vitality.

Jerusalem in the Caucasus: Krasnaya Sloboda ("Jewish Village"), Quba (formerly Kuba), Azerbaijan

In addition to Derbent, during the eighteenth-century, Jewish Azerbaijani also settled in the Kuba Khanate, where Fatali Khan had allocated land for Jewish settlements on the other side of the Kudial-Chai River. Here, each community had one or more synagogues with their own form of services, although all followed the Sephardi tradition. The Quba "Jewish Village" counted thirteen synagogues, mainly built out of stone and one made of pisé (or rammed earth), and almost all of them are the result of an ambitious nineteenth-century renovation project that took place when the community flourished. The synagogues shared certain characteristics: for one, there were no women's galleries, as women did not attend services except when they gathered in the courtyard for the holidays, and furthermore, no benches were provided for the congregants. Instead, the congregation sat on cushions placed over beautiful local flatweave carpets. This has changed now—all of the synagogues have benches and women can attend services. The ark in the synagogues of the Mountain Jews has always been on the western wall, facing Jerusalem.

These synagogues were built by adept Jewish craftsman and architects, notably Hillel ben Haim, who practiced architecture during the end of the nineteenth century through the early twentieth century and was deeply inspired by Quba's Djuma Mosque (1792–1802) with its extraordinary fifty-foot dome resting on an octagonal drum. Today, Jews continue to live in Krasnaya Sloboda, forming a unique all-Jewish town, a phenomenon that is relatively rare outside of Israel and the United States.

Gilaki Synagogue, Quba, Azerbaijan (1896, restored in 2000)

In 1896, Hillel ben Haim built the Gilaki Synagogue in Quba's Gilani neighborhood. Until recently, this was the only synagogue in Quba that had not been closed during the Soviet period—and it remains active today. Built on top of a rise along the road,

it appears to be a handsome one-story building with six large windows. The hipped roof, visible mostly from the rear of the synagogue, bears an octagonal dome raised on a drum and pierced by a clerestory. From the street, a wide set of stairs leads to the main entry surmounted by the foundation stone, which bears the date 1896 and is protected by a glass canopy. Inside the vestibule, another stone with the *shiviti* menorah marks the founding of the synagogue as 1857, alluding to the original synagogue. From the entry, two doors lead into an impressive square hall that was refurbished in 2000 with fine wooden benches and wool carpets. The renovation uncovered a cache of fifty silver Torah cases, which had been hidden to avoid confiscation by the Soviet authorities. All the sanctuary windows feature transoms adorned with carved wooden screens. The ark is set in an apse with an intricately carved wooden entablature supported by four columns and decked with a velvet parochet. The elevated bimah in the center of the room is accessed by a double staircase.

Six-Dome Synagogue of Krasnaya Sloboda (Great Synagogue), Quba, Azerbaijan (ca. 1907, or possibly 1888, reconstruction 1997)

In about 1907 (some sources say 1888), the Jewish community erected the imposing Six-Dome Synagogue of Krasnaya Sloboda, also called the Great Synagogue, between Quba's Kusari and Gilani neighborhoods along the riverbank in a beautiful and highly visible location. The elaborately ornate brick facade with its four octagonal roof towers is topped by metal onion-shaped domes at each corner and two smaller ones over the center of the main sanctuary. According to local legend, the six domes represent the number of days it took the Mountain Jews of Gyaladuz to relocate to Quba.

The synagogue's twelve tall windows (for the Twelve Tribes of Israel) are topped by a row of keel-arched transom windows that provide a virtual wall of light. The white Star of David at the center of the building's facade clearly identifies the building as a synagogue; however, the Jewish community's desire to fit in with the dominant community can be seen in their adoption of the typically Russian onion domes and keeled arches.

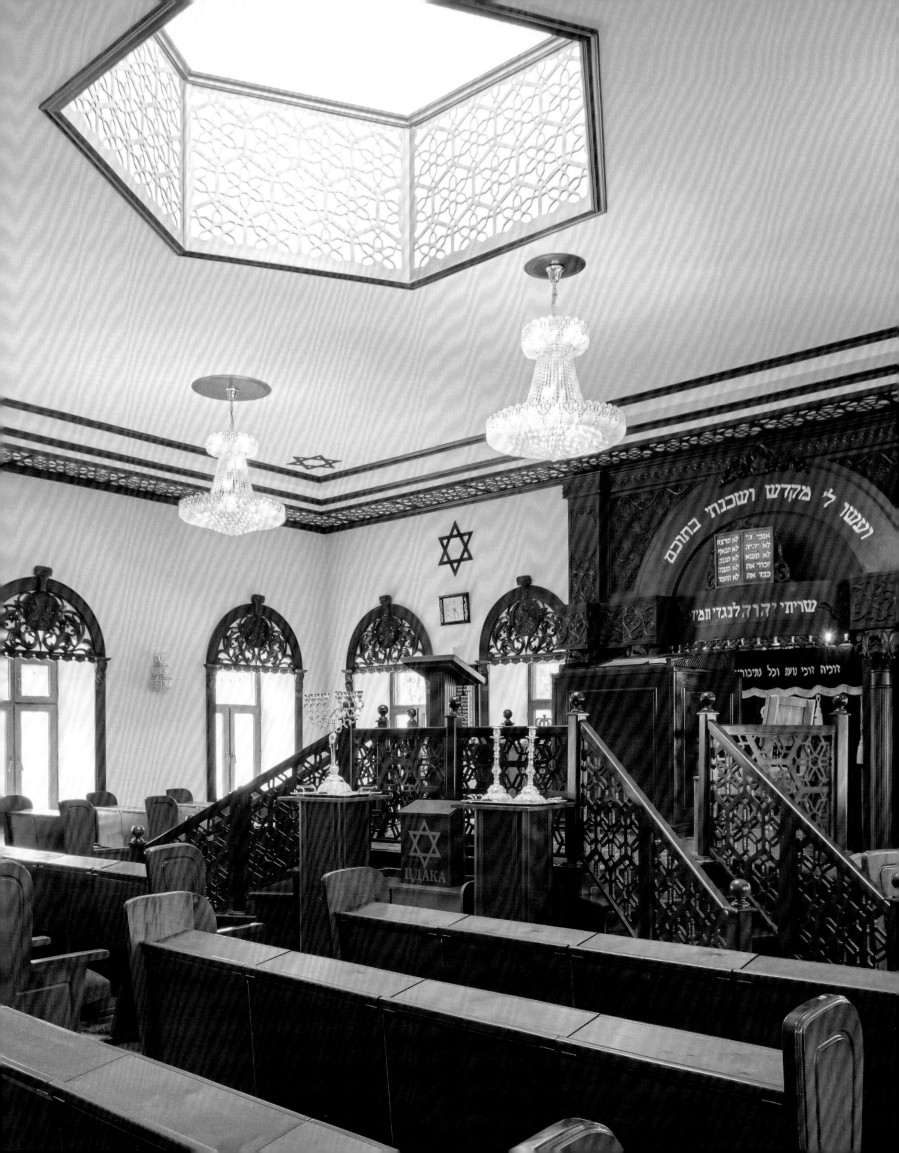

Below: The Six-Dome Synagogue of Krasnaya Sloboda in Quba is one of Hillel ben Haim's masterpieces. Built ca. 1907 and reconstructed in 1997, this sanctuary, raised above ground level, is filled with light from numerous windows.

Opposite: The recently refurbished interior features a carved wooden aron ha-kodesh (ark) with a gorgeous crimson parochet embroidered with gold thread.

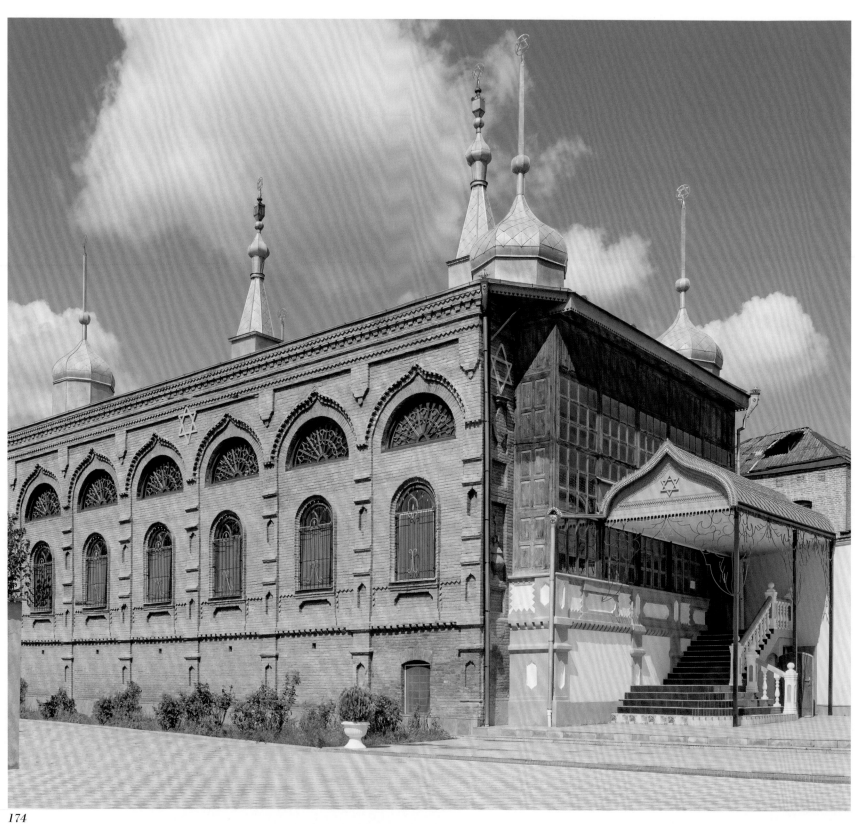

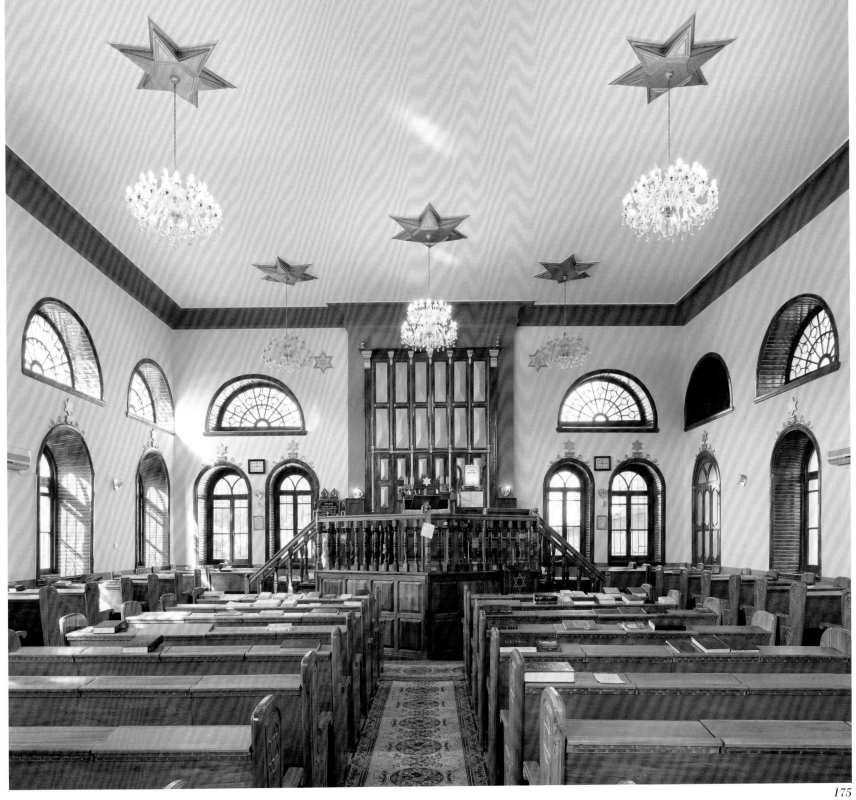

The interior of the synagogue was refurbished in 2011 in a style resembling that of the Gilaki Synagogue. The entrance has been modernized with a large staircase protected by a canopy. Here, everything in the main sanctuary is also made of gleaming carved wood. The congregation is centered on the bimah, which stands before the massive floor-to-ceiling Torah ark, bracketed by lancet windows on the far wall. The synagogue runs an active religious and cultural center that underscores the restoration of the Jewish community in Quba.

Hillel ben Haim continued to build new synagogues up to the eve of the Russian Revolution, experimenting with the domed interior space in particular with the Kruei Synagogue, Quba, of 1906–16, which epitomizes his use of dome forms and lighting. Sadly fallen into disrepair, this synagogue achieved such startling architectural results, which still await their restoration.

The Choral Synagogue of the Ashkenazi Jews (now Rashid Behbudov State Song Theatre), Baku, Azerbaijan (1910)

Around a hundred miles south of Quba, Baku, the capital of Azerbaijan, began to flourish as a major center for oil production during the nineteenth century. As the largest city of the Southern Caucasus, it attracted Jews from the nearby mountains, as well as eastern Europe (known as the Ashkenazim) and Georgia. In the 1920s, the Jews of Baku were represented in parliament and formed an important part of the Zionist movement. The Jewish community rose to such prominence that when the Ashkenazi Jews requested to build a new synagogue, the mayor provided land in the center of the city free of charge. In 1910, the Ashkenazi community commissioned an impressive neoclassical synagogue with a four-columned portico facing the main square. The synagogue also housed a Jewish charitable society, which sponsored separate schools for boys and girls, as well as a library. After most synagogues were closed between 1926 and 1932, the Choral Synagogue was transformed into the Azeri State Jewish Theatre (presently the Rashid Behbudov State Song Theatre) and was never returned to the religious community, although its interior has remained largely unchanged.

Below, top: The New Synagogue of European Jews in Baku presents a spacious main sanctuary with an inlaid wooden aron ha-kodesh. The synagogue, designed by noted local architect Alexander Garber in 2003, features seven white pilasters along the eastern wall that symbolize the Temple of Jerusalem and the menorah.

Below, bottom: The New Synagogue of the Mountain Jews in Baku (2011), also by Alexander Garber, follows an open design similar to his earlier New Synagogue of European Jews but in a warmer palette. It is distinguished by an immense crown-shaped Torah ark with elaborate woodwork and a raised bimah accessed by traditional double wooden staircases in the same style.

Opposite: An exquisite antique embroidered textile plaque inscribed with the Hebrew word mizrach (east) and depicting the Tablets of the Law, the ark, and menorahs, all surrounded by biblical scenes and Jewish symbols, from the New Synagogue of the Mountain Jews in Baku.

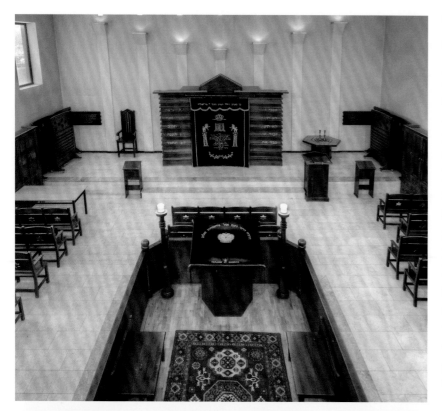

The New Synagogue of European Jews, Baku, Azerbaijan (2003)

In the post-Soviet era, the European Jewish community required a new synagogue. In 2002, Jewish visionary architect from Azerbaijan, Alexander Garber (b. 1955), designed a completely new synagogue building. He adopted the 1920s Tel Aviv Constructionist style using minimalist vertical lines, plain golden limestone blocks, and stark modern fenestration. The massive rectangular building presents three distinctive facades with severe rows of varied windows that correspond to the different functions of the rooms within. The monumental entrance is accessed through a recessed double-storied glass doorway. Inside, long windows bring abundant light to the lofty main sanctuary, with its ornate ceiling further illuminated by a spectacular chandelier. The Torah ark on the rear wall is fronted by tall, graduated pilasters in the form of a menorah. Inside the ark, the minimalist wooden cabinet is adorned with the traditional red velvet parochet framed by wooden panels inscribed with the Ten Commandments. Above, the women's gallery faces the ark.

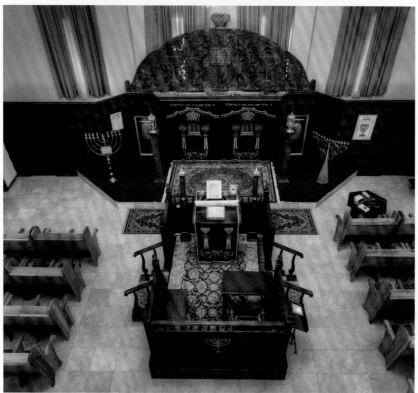

The New Synagogue of the Mountain Jews, Baku, Azerbaijan (2011)

A modern-style synagogue nearby, built of white stone, opened in 2011. This new project, also by Alexander Garber, was fully sponsored by the government of Azerbaijan—a predominantly Muslim country, which is unique for the Caucasus. Its impressive facade features four narrow vertical windows on each side of the main entrance. In the sanctuary for the Mountain Jews, a spacious wooden bimah faces an entire wall covered by a carved wooden screen surrounding the curtained aron ha-kodesh, in turn surmounted by a carved wooden panel with the menorah and scrolls and bracketed by two wooden pillars referencing the glory of the Temple of Jerusalem.

At present, the synagogue is the main center of Jewish life in Baku, housing a learning center, library, and kosher dining room. The synagogue itself reflects Baku's dynamic urban renewal accompanied by the opening of the Heydar Aliyev Cultural Center, designed by the late Zaha Hadid, and the new Olympic Stadium.

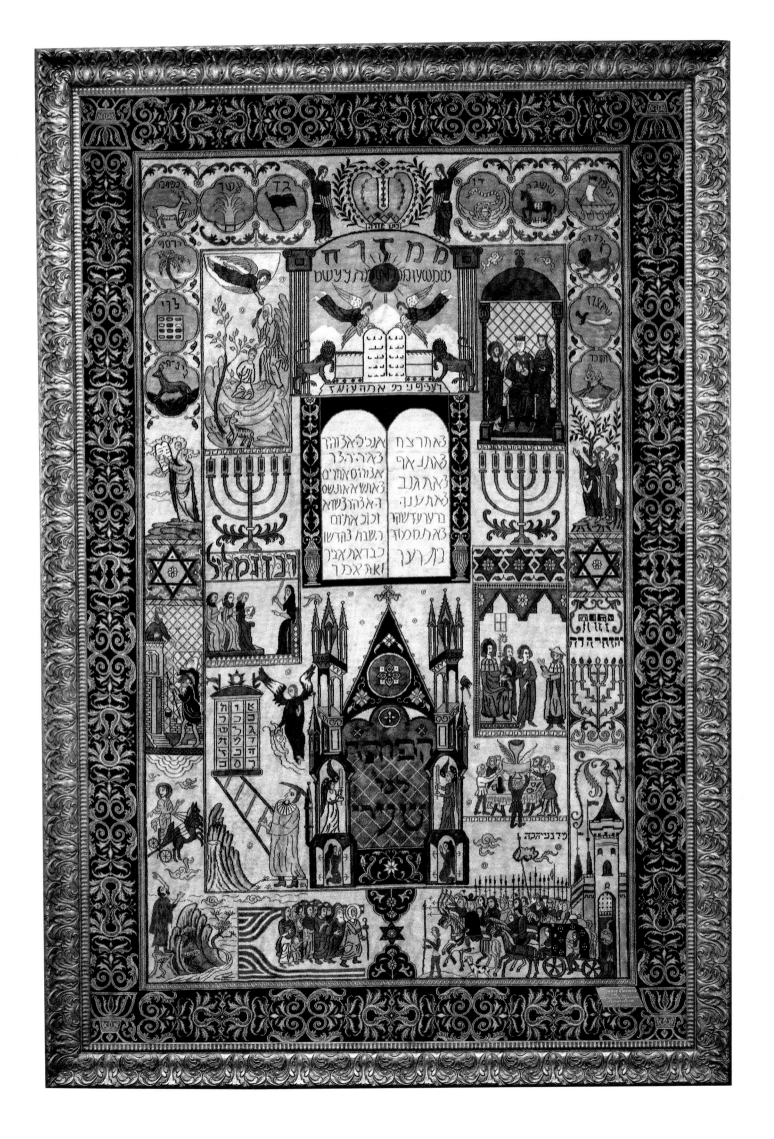

The Jewish Community in Georgia

According to tradition, the Jewish community of Georgia is as ancient as that of the Mountain Jews of Azerbaijan and the Eastern Caucasus, tracing its roots to the Babylonian Exile (586 BCE). Most Jews in Georgia had been serfs until the abolition of serfdom in 1864. Jews then started to settle in large cities, such as Tbilisi and Batumi. Georgian synagogues, built mostly in the nineteenth and early twentieth centuries, reflect a rich mixture of new variations of classical, Renaissance, and Byzantine architecture. Tbilisi is the home of two significant synagogues that point to the former wealth and prestige of this community: the Great Synagogue and the New Synagogue (Second Synagogue), which was destroyed in an earthquake in 2004 and now serves as the David Baazov Museum of Ethnography and History of the Jews of Georgia.

Great Synagogue, Tbilisi, Georgia (1911)

In 1903 the tsar granted the Tbilisi Jews permission to build a new synagogue on a major thoroughfare. The city's *Svet* newspaper lauded its completion in 1911, "The building is broad, spacious, high, built entirely of brick. . . . They have done it solely with their own hard work and using their own modest funds" (*Svet*, 1911, no. 5).

Built in fine redbrick in an eclectic style with Moorish Revival and Byzantine elements and emblazoned with the Star of David, the Great Synagogue of Tbilisi offered everything a modern Jewish community required: both a large and a small sanctuary, a matzo bakery, a mikvah ritual bath, separate facilities for preparing kosher meat and wine, a guardroom, and lavatories, as well as a school and a house for the rabbi.

The large, airy basilica-shaped interior is primarily a vision of white and gold illuminated by large windows. On each of the longer sides, a row of columns with golden capitals supports a U-shaped women's gallery, which is lighted by a clerestory. A huge two-tiered vault with scrolls in green and vermilion on a gold ground spans the entire length of the hall. But the most striking feature is the Torah ark on the far wall facing Jerusalem: a double staircase leads to the aron ha-kodesh with its twin columns and velvet parochet. A great round stained-glass window with the Star of David crowns the ark, highlighting the role of light in this religious tradition. On the second floor, a smaller square sanctuary is spanned by a series of arches that is richly decorated in bright blue and features a central bimah. Recently, the community has installed a large marble menorah outside at the foot of the stairs leading to the synagogue.

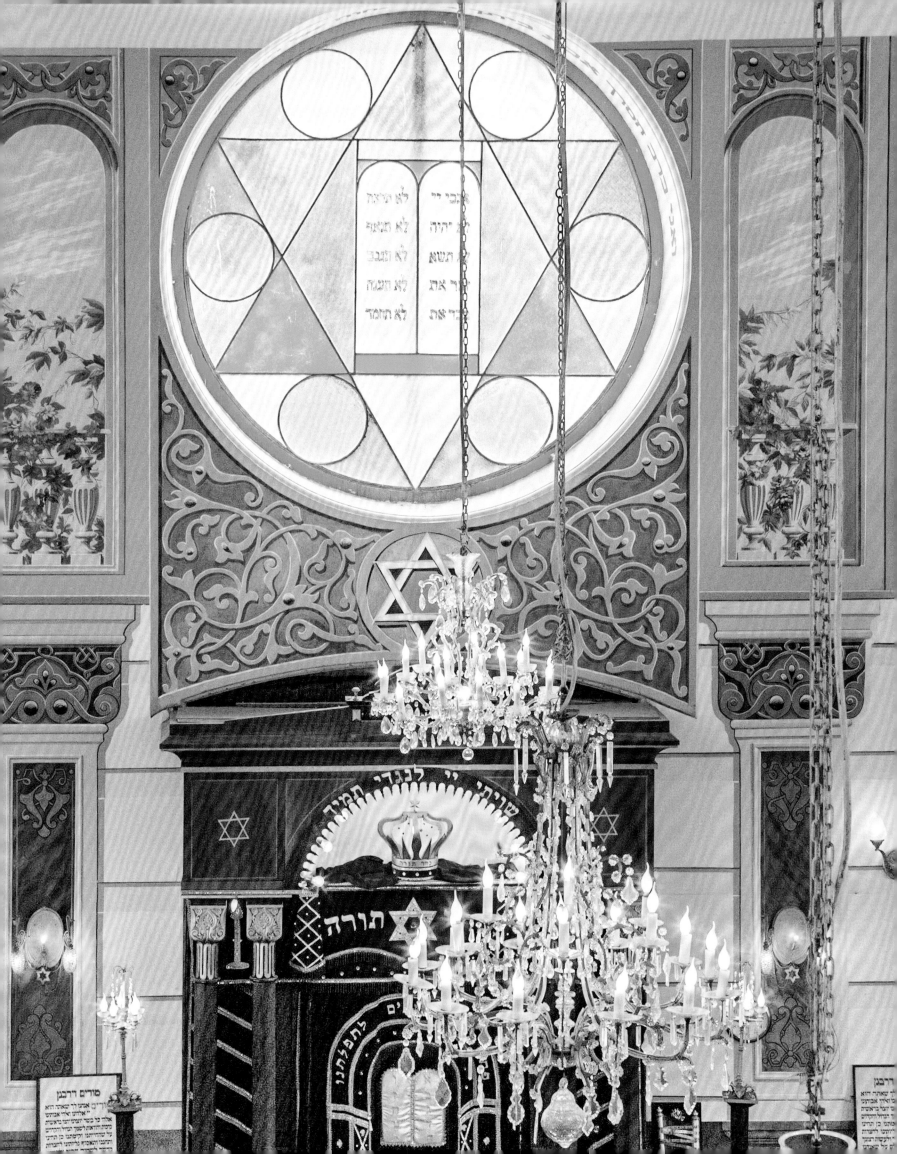

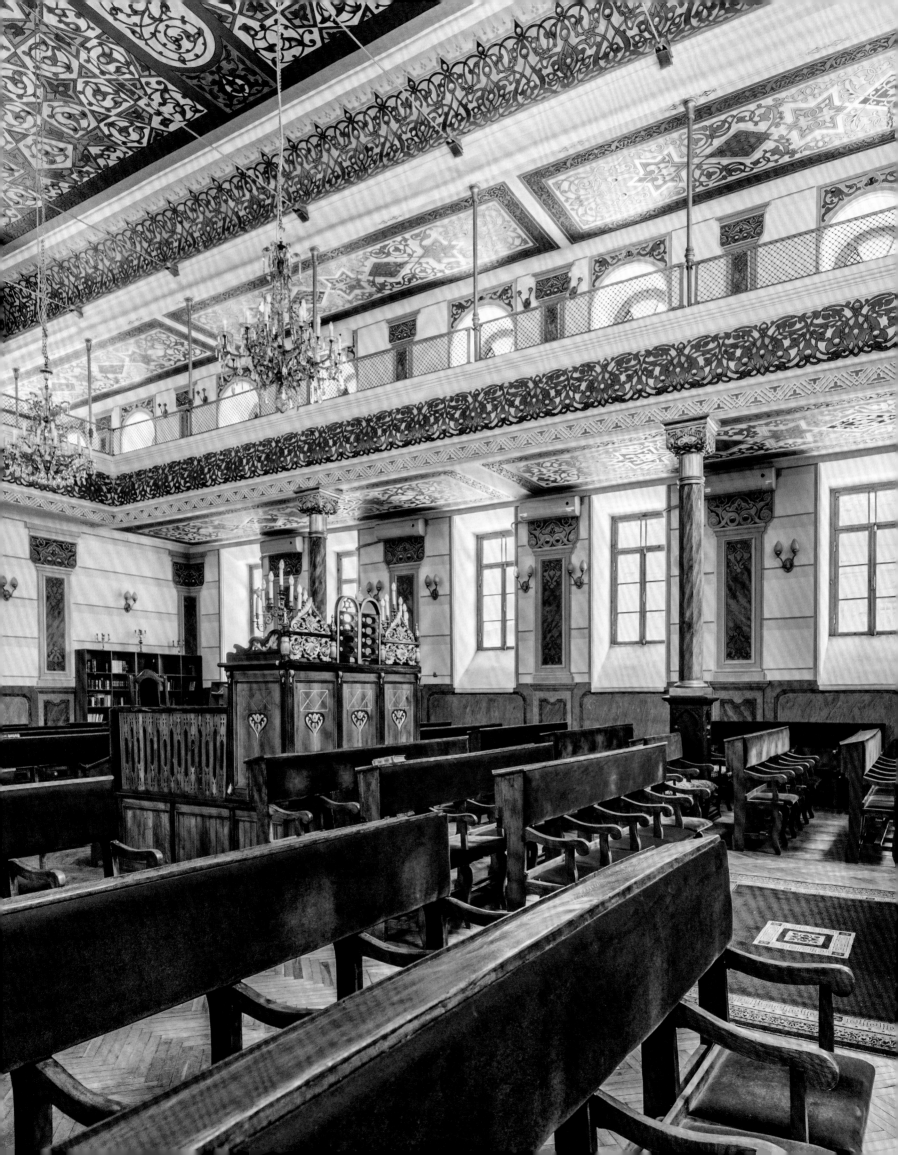

Opposite: View of the women's gallery in the main prayer hall of Tbilisi's Great Synagogue, which is resplendent with painted polychrome designs, murals, stained glass, faux-marble columns, crystal chandeliers, and finely carved wooden benches.

Below: On the story above the main prayer hall of the synagogue, a small sanctuary provides everyday services. Its ceiling, supported by a double row of wide arches, is also lavishly decorated with turquoise-and-gold ornamentation.

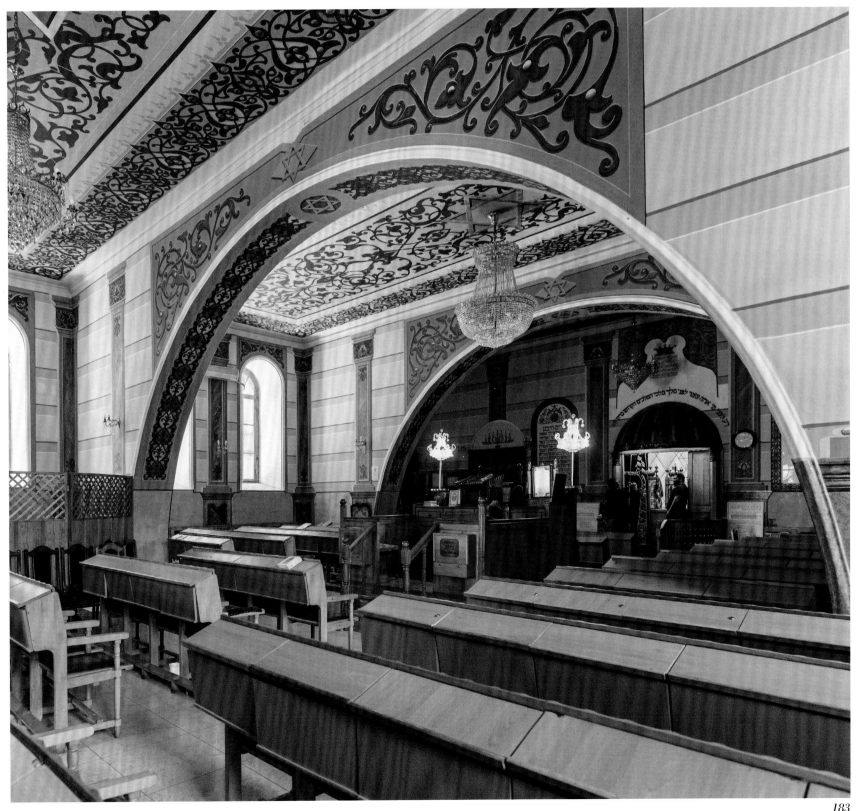

Opposite: Tucked away in the Jewish quarter of Bukhara, Uzbekistan, the Shalom Synagogue was built ca. 1901. Its intimate sanctuary is enlivened by embroidered textiles and handmade rugs, both specialties of the Jews of this region. The plaster shiviti menorahs on the eastern wall recall the importance of the holy texts in Jewish synagogue decoration.

Jews in Uzbekistan

The Uzbekistani Jews also trace their roots to the Babylonian diaspora, specifically as settlers who had previously served in the Persian army in antiquity. The first archaeological evidence of Jews in Central Asia dates to the second century BCE, when the territories were controlled by Greeks and Parthians.

The Bukhara Emirate used to include a considerable Jewish population prior to the Mongol invasion (1220 CE). Like the Mountain Jews and Jews from the East (Mizrahi), Bukharan Jews follow Sephardi practices. There are now only two functioning synagogues in Bukhara as most Jews in this region practice in private homes.

Shalom Synagogue, Bukhara, Uzbekistan (ca. 1901, major restoration 1999)

While local tradition holds that the Shalom Synagogue was originally built in the seventeenth century, the present building consists of two sanctuaries dating to ca. 1901. Typical of the region, one enters through a modest door into a spacious courtyard, where the community gathers for meals, and from there, into the main sanctuary. The tall arched windows in the prayer hall overlook this sheltered open-air space, and a stairway leads to a balcony and women's gallery. The sanctuary features two large wooden columns with stucco carvings and traditional Islamic ornamentation with gold gilding. Rich carpets cover the ark's shelves, which are surmounted by *shiviti* menorahs and the scrolls with the Ten Commandments. A second smaller sanctuary is also accessed through the courtyard.

The Caucasian and Central Asian region where Jews settled for more than two thousand years presents a wide array of synagogue types and styles, some humble—as seen in the mountain villages and the private synagogues of Bukhara—and others with rich carved wood, brilliant tiles, or gorgeous textiles in the major cities. In Tehran, Quba, Baku, and Tbilisi, more sophisticated synagogues were erected, reflecting the greater prosperity and acceptance of the Jewish population, especially in the late nineteenth century. Each community incorporated aspects of the local architecture, whether it be the tiled courtyards of Iran, the domes of Quba, or the neoclassical architecture of Baku. Many Jews emigrated from these regions during the twentieth century. Only with the rise of the independent states in the Caucasus has there been a revitalization of the Jewish communities, especially in Baku and Tbilisi. At times, the most beautiful and moving aspect of these synagogues has been captured in the walls covered with prayers as in Tehran or Bukhara, the exquisite wood carvings as in Derbent or Baku, or the fine brick wall decoration of Hillel ben Haim in Quba.

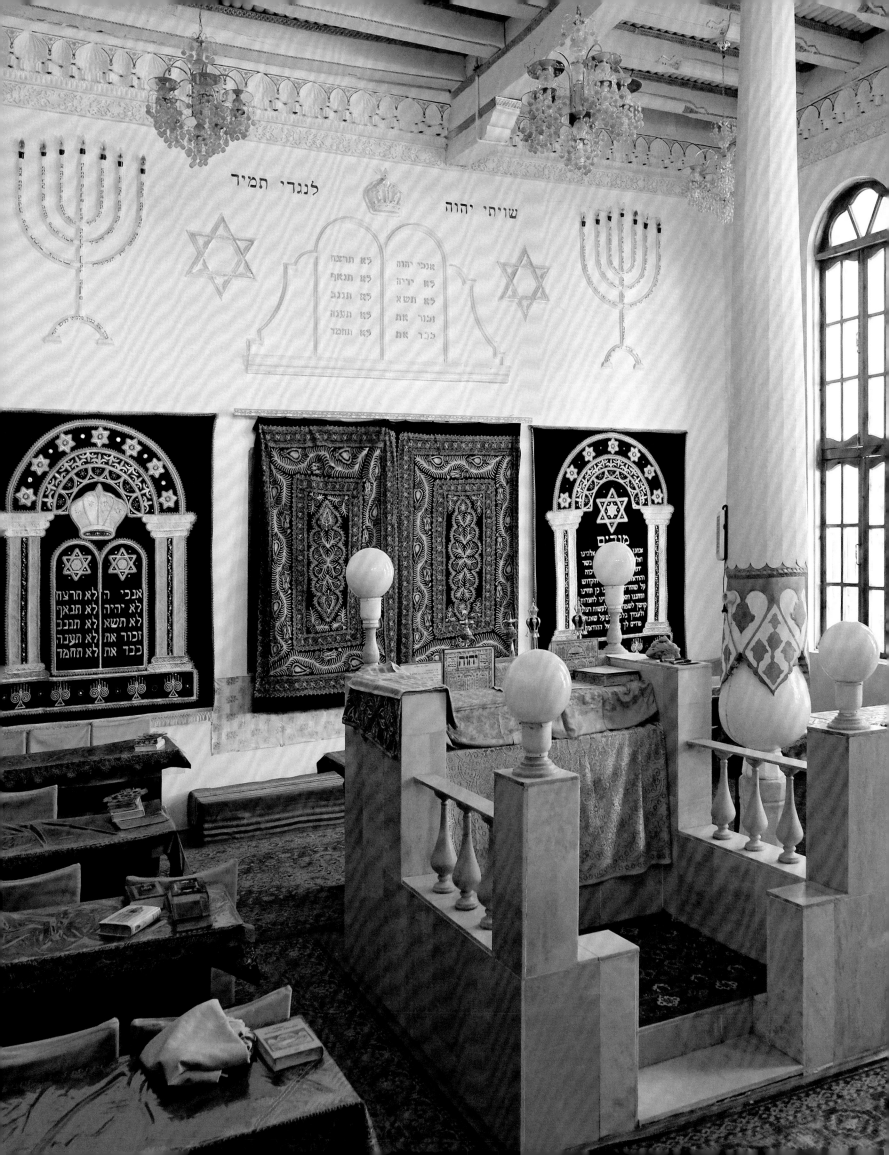

6

6. Synagogues in the New World

Samuel D. Gruber

For more than three hundred years, Jews who settled in the New World have built synagogues that have served as visible symbols of their faith. These houses of worship have been the focus of Jewish identity and culture. Choices in synagogue design speak to Jewish communal realities and aspirations at different times and in different places. This is true throughout the Americas, and especially in the geographically expansive and culturally pluralistic United States.

The first Jewish immigrants to the New World were Spanish and Portuguese Jews, who came by way of Holland. Many arrived in the first quarter of the seventeenth century and settled in Dutch Brazil and in neighboring Suriname. When they were expelled from Brazil in 1654 by the Portuguese, these Jews found refuge in Dutch Suriname and Curaçao, a Caribbean island that became a pivotal Jewish center. At the same time, a small group of Jewish refugees from Brazil settled in New Amsterdam (now New York), where they founded Congregation Shearith Israel (Remnant of Israel). Over the next two centuries, Sephardi Jews settled in other cities along the East Coast of North America and moved steadily into the interior.

In the nineteenth and twentieth centuries, Jews came to the Americas from all parts of Europe, bringing with them their traditions and, at times, the synagogue architecture of their homeland. From the mid-twentieth century, Jewish immigrants from North Africa, the Near East, and Central Asia arrived in the New World, further contributing to diverse expressions of Judaism and synagogue architecture. Though American synagogues continue to be built in contemporary popular styles, they always include an ark and a bimah, and also a variety of Jewish symbols and inscriptions. In the first half of the nineteenth century, Jewish communities commissioned synagogues in a series of historical styles: Greek and Egyptian Revival, Gothic, and Romanesque. When Reform Judaism expanded dramatically after the American Civil War, the Moorish style, already popular in Europe, took off across the United States. From the turn of the twentieth century until World War II, synagogue designers explored variants of classical, Byzantine, and art deco styles. Thereafter, various forms of modernism have become the norm. In this, American innovations in synagogue planning of the 1950s and 1960s have led the way for Jewish communities worldwide, especially in popularizing multipurpose synagogue centers, some spread over large campuses. These more comprehensive spaces allow for a wide variety of community functions (such as teaching, recreational, and day care facilities) and for showcasing the visual arts. Of the thousands of synagogues built in the Americas since the seventeenth century, a number of examples stand out as exceptional representations of Jewish art, culture, and faith.

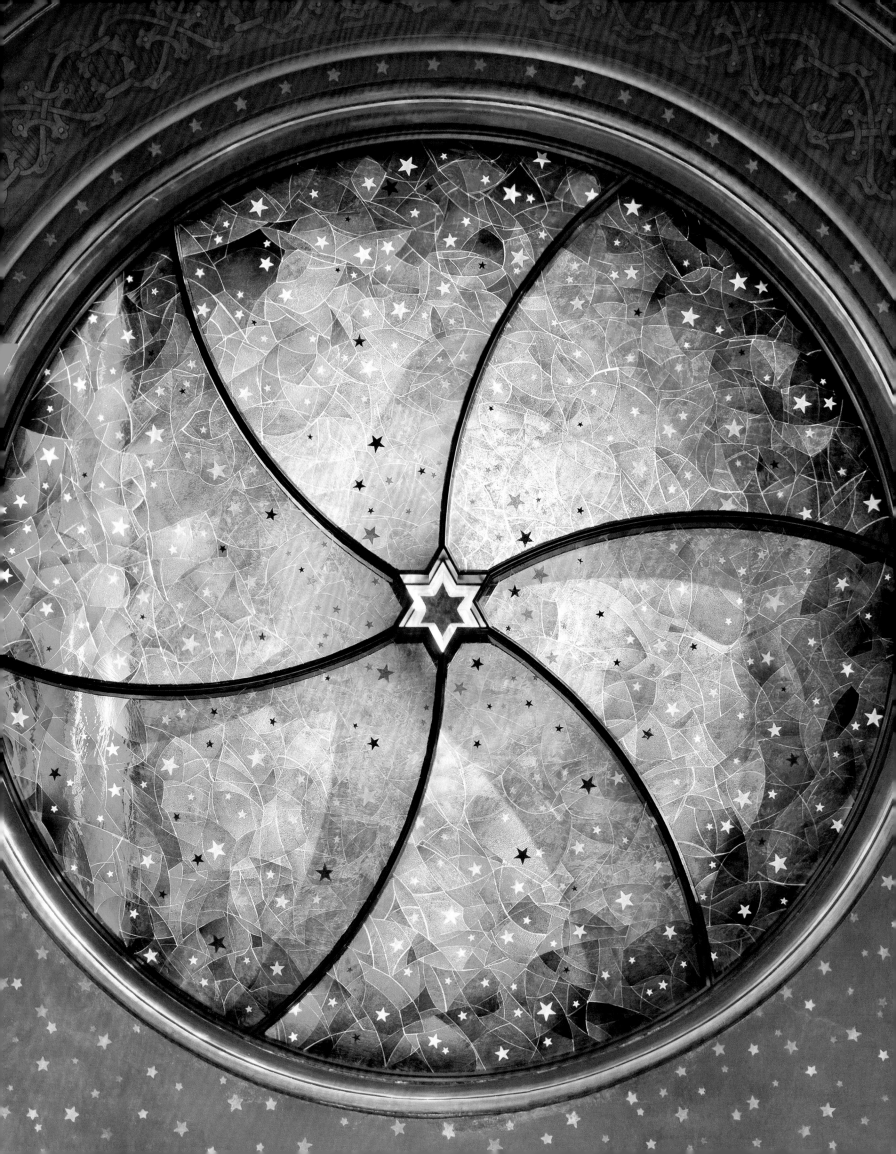

Page 189: *This awe-inspiring rose window, designed in 2010 by Kiki Smith and Deborah Gans, was commissioned by the Museum at Eldridge Street in New York as a "symbol of the continuing life in the building." The museum occupies the former Eldridge Street Synagogue (1887) and completed its restoration in 2007.*

Below: *Mikvé Israel in Willemstad, Curaçao (1732), is the oldest synagogue in continuous use in the western hemisphere. Massive columns support a wooden barrel-vaulted roof—probably built by shipwrights.*

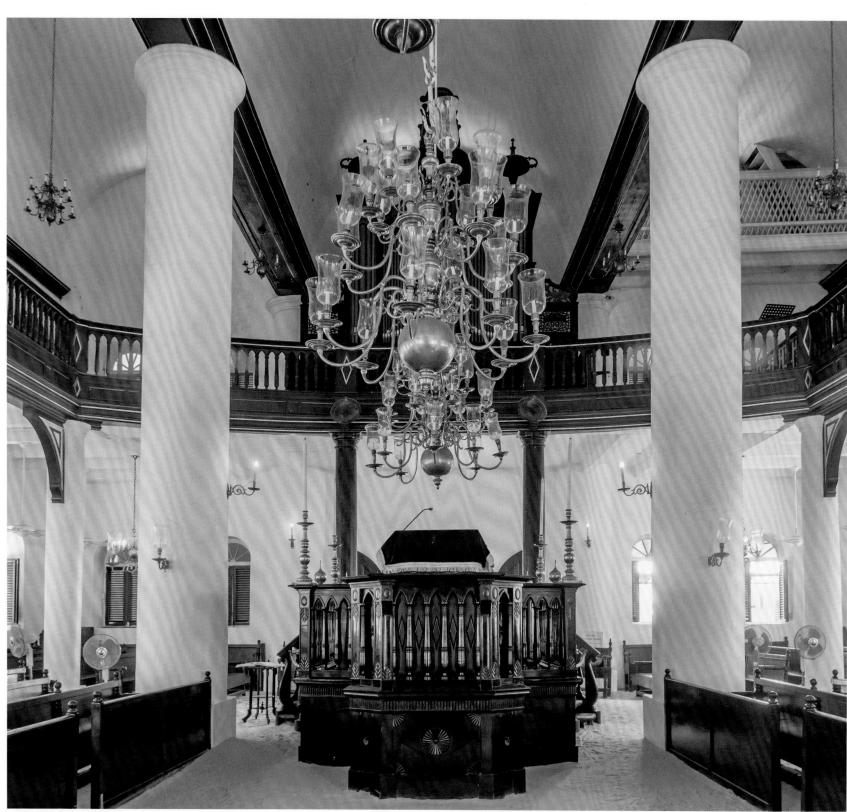

Below: *Inspired by Danish colonial architecture, the Hebrew Congregation of Saint Thomas in the US, Virgin Islands, ranks as the second-oldest extant synagogue in North America. As in Curaçao, the floor of the current edifice (1833) is covered in white sand following the Caribbean tradition.*

Pages 192–93: *The Congregation Shearith Israel in New York is the fourth home of the oldest Jewish congregation in the United States. Designed by Arnold Brunner of Brunner & Tryon (1897) in the classical style, it follows Shearith Israel's Sephardi traditions. Tiffany Studios decorated the interior, which was recently restored.*

Mikvé Israel (Mikvé Israel-Emanuel Synagogue), Willemstad, Curaçao (1732)

The oldest synagogue building in continuous use in the Western Hemisphere, Mikvé Israel, was built in 1732 by the prosperous Jewish mercantile community of Curaçao. In keeping with the colorful Dutch Colonial gabled-roof buildings that line the port of Willemstad, the synagogue occupies a four-story bright yellow edifice set in a tiled courtyard. The sanctuary houses a tall wooden bimah and ark at opposite ends of an open nave. The glorious mahogany woodwork is the creation of a master carpenter from Amsterdam working in the Baroque style of the Spanish-Portuguese synagogue of his native city (see Chapter Three, page 101). Aisles and wooden galleries surround the main hall, offering seating that faces the center in the established Sephardi manner. The ceiling is a long, high barrel vault built in Holland, probably by shipbuilders. White sand covers the floor, typical of many synagogues in the Caribbean, such as the neighboring Hebrew Congregation of Saint Thomas (founded in 1796, 1833). The Curaçao synagogue is still in use by a small but vibrant congregation.

Congregation Shearith Israel, New York, New York (1897)

Congregation Shearith Israel is the oldest congregation in North America, founded by twenty-three Jewish refugees from Dutch Brazil, who arrived in New Amsterdam in 1654. However, their first purpose-built synagogue was not erected until 1732 in Lower Manhattan, at virtually the same time as the rebuilding of the Mikvé Israel synagogue in Curaçao. Shearith Israel now occupies its fourth home on New York's Upper West Side and was designed by Arnold W. Brunner (1857–1925) of Brunner & Tryon, the first American-born Jewish architect to attain national fame. For the exterior of this synagogue dedicated in 1897, Brunner created a robust neoclassical design that subsequently influenced American synagogue architecture for decades. He linked this newly revived version of the classical style with that of the ancient synagogues that had been recently discovered in the Holy Land. At the same time, this form of neoclassicism had become popular across America thanks to the architecture of the World's Columbian Exposition held in Chicago in 1893. However, the interior of Shearith Israel, which

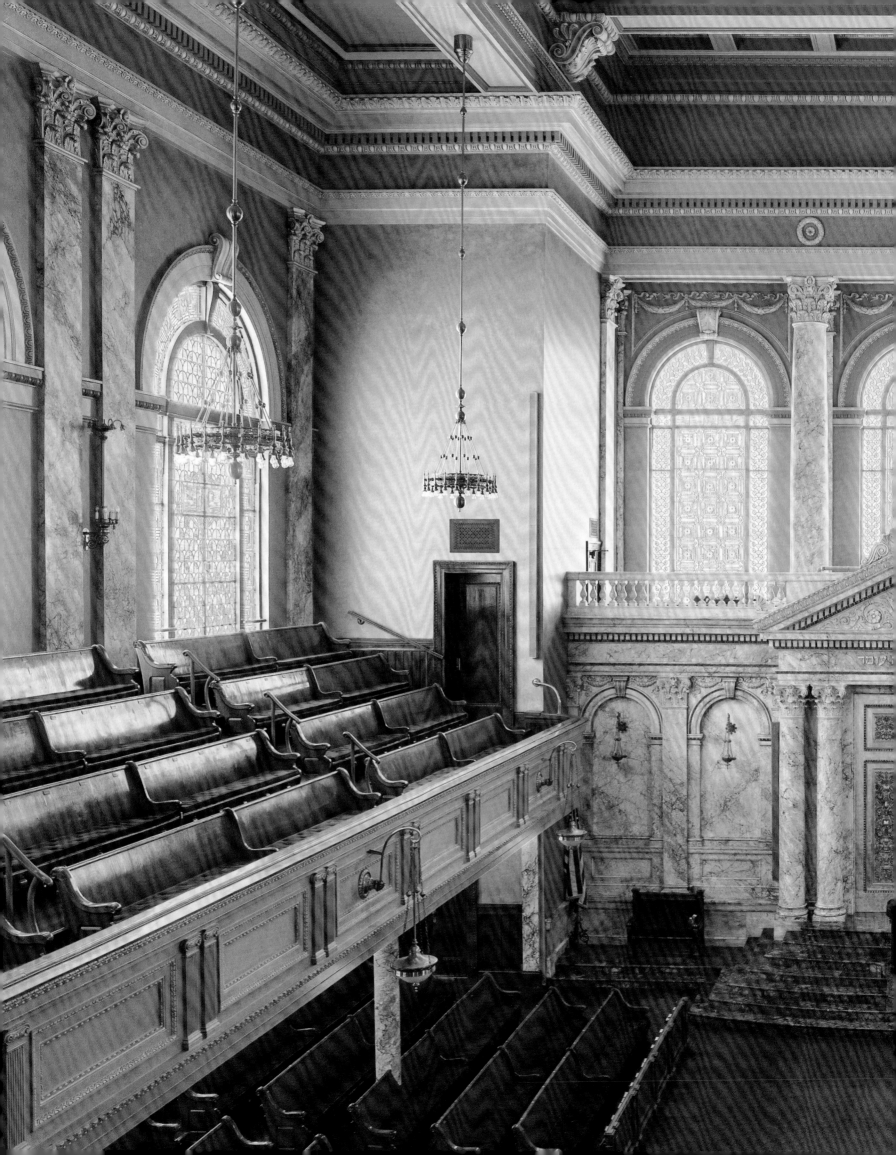

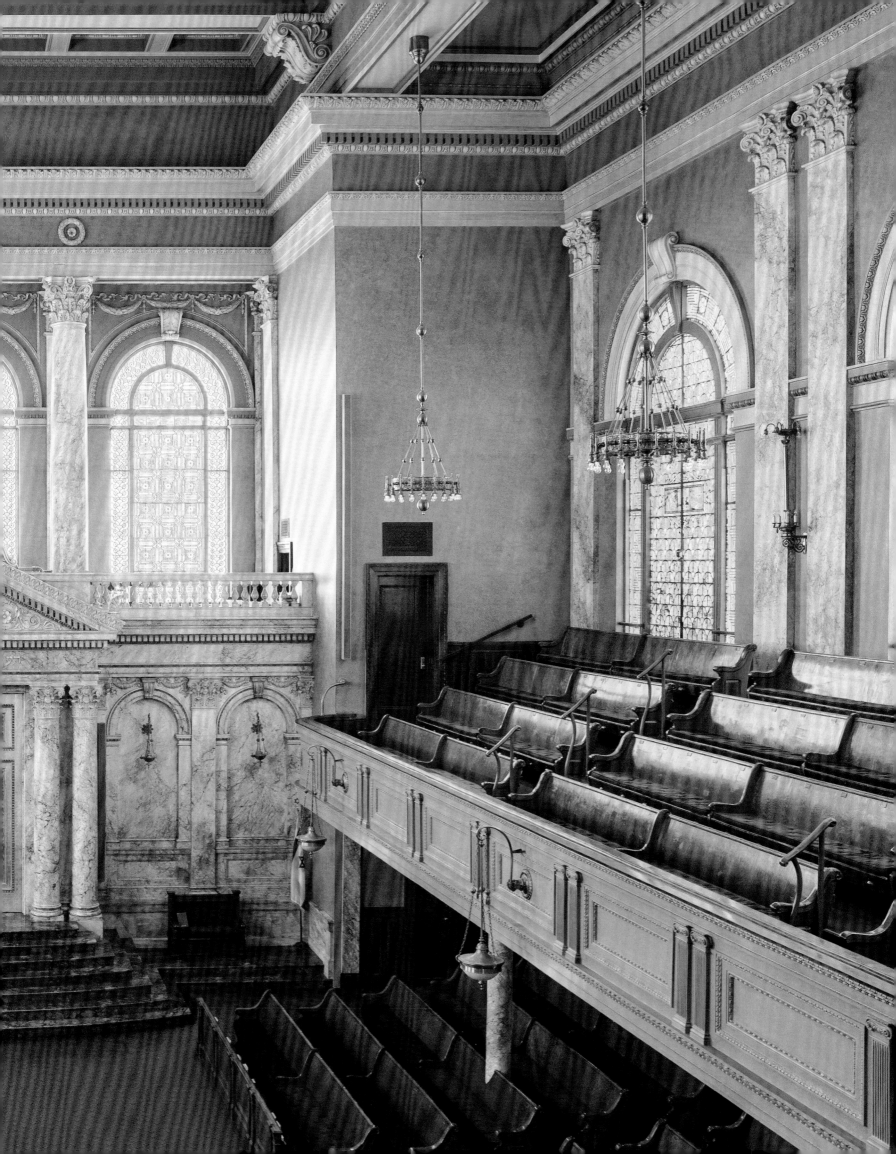

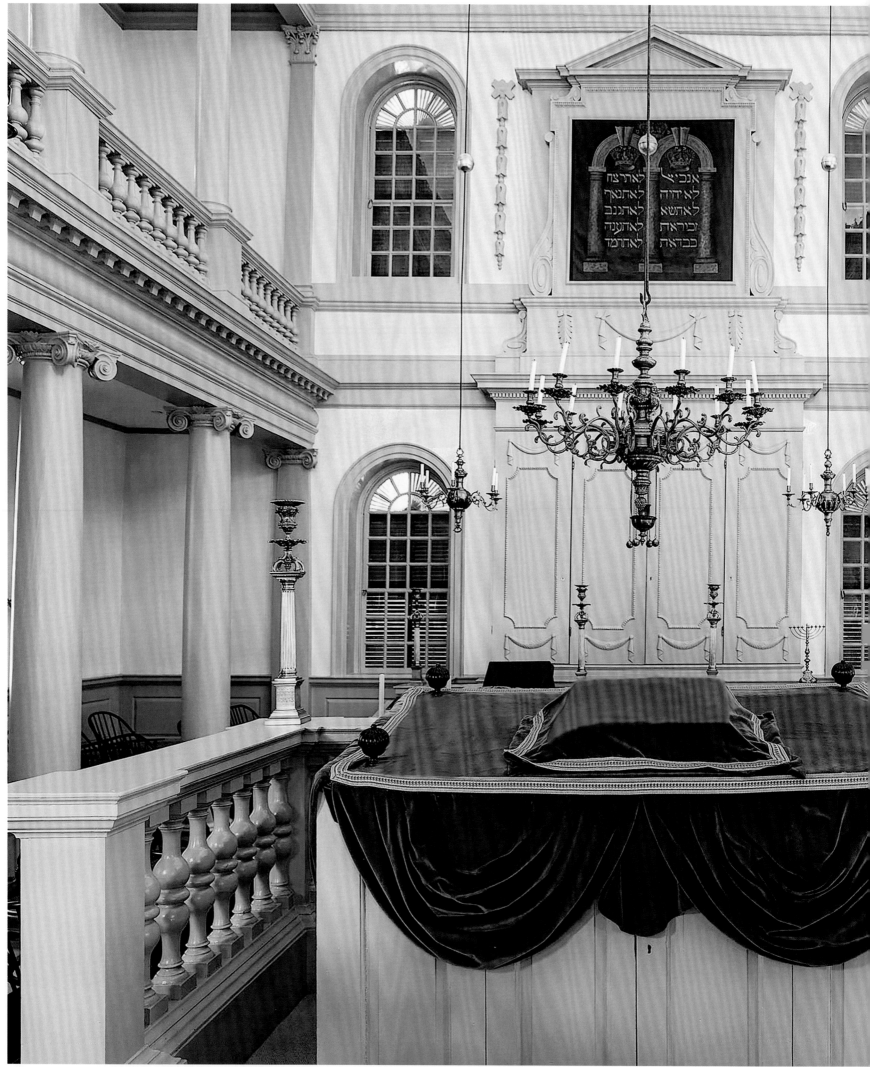

was decorated by Tiffany Studios, retained the traditional Sephardi arrangement of seating for men on the ground floor with a women's gallery above, both facing a large open central space with a reader's platform on one end and the ark on the other.

Touro Synagogue (Congregation Jeshuat Israel), Newport, Rhode Island (1763)

A few decades after the Congregation Shearith Israel was originally founded, the prosperous merchants of the Sephardi congregation of Rhode Island erected one of the earliest synagogues in North America. Built in the Georgian style in 1763, the Touro Synagogue was designed by leading colonial architect Peter Harrison (1716–1775). The austere exterior resembles an eighteenth-century American meeting house—barely hinting at its Jewish religious function; however, its interior plan recalls Amsterdam's Esnoga and contains all of the required liturgical furnishings. The rectangular hall features two tiers of columns, the lower Ionic and the upper Corinthian. These support women's galleries on three sides, with a balustrade rather than a parapet wall to better allow the women to see and be seen. The ark is set against the east wall. Though of modest size, Touro Synagogue is an elegant building equal to any of the finest contemporary civic structures in the Thirteen Colonies. The synagogue's architecture emphasizes to what degree the Jews of Rhode Island saw themselves as an integral part of mainstream colonial life and culture. In fact, the founder of the Touro Synagogue, Aaron Lopez, was a generous supporter of the American Revolution, and several meetings of the Rhode Island General Assembly and the state's supreme court were held in the synagogue.

Below, top: Nothing suggests the Jewish purpose of the Touro Synagogue, which is set back from the street within its own precinct. Like architect Peter Harrison's other public buildings, the synagogue was a civic ornament of colonial Newport.

Below, bottom: The fine neoclassical portico of Kahal Kadosh Beth Elohim in Charleston, South Carolina (1841), faces a small courtyard, while its large southern windows look onto the street. This synagogue replaced an earlier one destroyed by fire, and is the finest adaptation of the Greek Revival architectural style for Jewish worship.

Opposite: An elegant oval dome renders Kahal Kadosh Beth Elohim's interior surprisingly spacious. The synagogue is a founding home of American Reform Judaism, and its small congregation remains active today.

Kahal Kadosh Beth Elohim, Charleston, South Carolina (1841)

Kahal Kadosh Beth Elohim ranks as the second-oldest standing purpose-built synagogue in the United States and is venerated as the birthplace of America's Reform movement. After the devastating Charleston fire of 1838, the congregation rebuilt its synagogue (previously in the Federal style) in the form of a Doric temple, thus linking it to the broader Greek Revival architecture of the time and widely prevalent in the city's new Christian churches. Designed by New York architect Cyrus Warner (1789–1852), it was constructed by David Lopez, a leader of the Charleston congregation and a local builder. The synagogue was consecrated in 1843, but soon after, the congregation was already too large to be contained in the new building and so it was expanded.

Above the door in Hebrew and English an inscription known as the Shema asserts the building's Jewish identity: "Hear, O Israel, the Lord our God is the sole Eternal Being." Inside the large, open rectangular sanctuary on the east wall, a semi-elliptical ark of polished mahogany is housed under a central portico. Inscribed in large gilt letters on the cornice are the words: "Know before whom thou standest." Two black marble tablets bearing the Ten Commandments in gilt letters surmount this structure.

When it was completed, Beth Elohim introduced Reform elements, including an organ and certain liturgical changes. This led to the resignation of the more traditional congregants and the formation of a rival congregation, reflecting a type of schism in Jewish communities that would be repeated elsewhere in the coming years. Today, Beth Elohim maintains an active congregation and the building is designated as a National Historic Landmark.

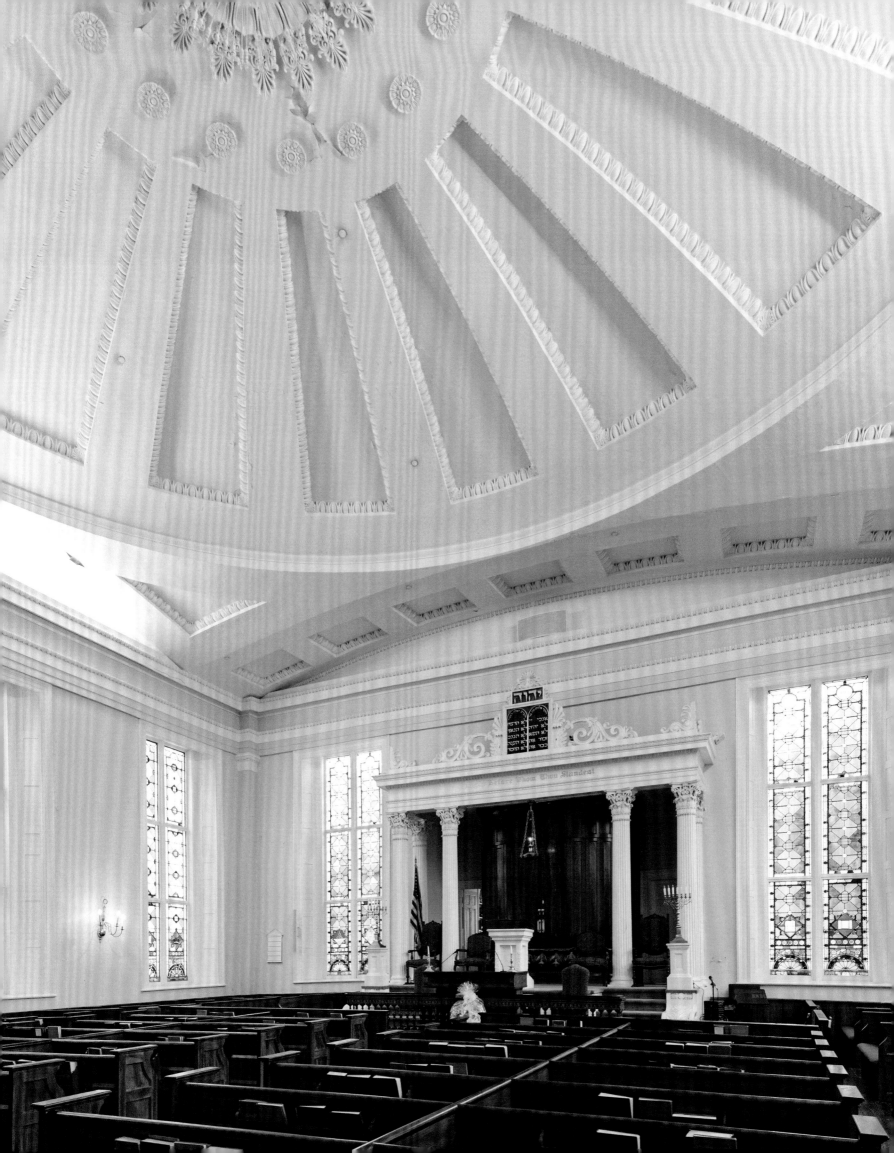

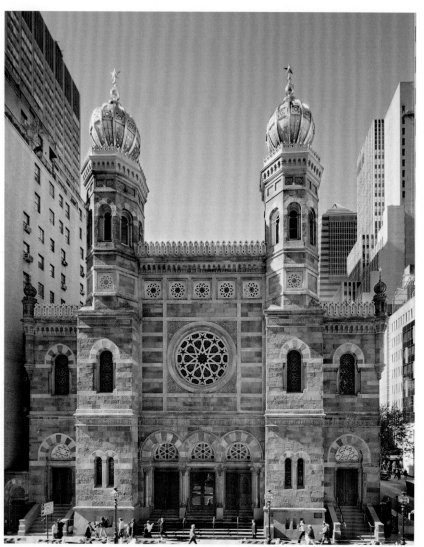

Central Synagogue, New York, New York (1872)

American nineteenth-century congregations favored a variety of historical styles, emulating trends in Europe. Beginning in the 1860s, however, a few congregations commissioned impressive neo-Moorish synagogues—while inspired by Europe, this development offered American Jews something entirely new. The earliest New York example was the prior Temple Emanu-El, the largest synagogue of its time (now replaced), designed in 1868 by two immigrant Jewish architects, Leopold Eidlitz (1823–1908) and Henry Fernbach (1829–1883). (The grand Plum Street Temple in Cincinnati, designed by James Keys Wilson [1828–1894] in 1866, is the oldest Moorish-style synagogue in this country.) Fernbach also built the temple's eastside neighbor, Central Synagogue, which was dedicated in 1872. Constructed in brownstone with two octagonal towers topped by bulbous domes, this synagogue's design pays tribute to the Great Synagogue on Dohány Street in Budapest (see Chapter Three, page 104). A giant rose window over a triple portico dominates the main facade. Below the cornice, a line of arched pendentives and a row of stained-glass roundels adds to the richness of the exterior. The north facade on East 55th Street features six stained-glass windows framed by Moorish arches. Inside Central Synagogue, stenciled Moorish patterns in cobalt, red, and ocher enliven the architecture. Following a terrible fire in 1999, the synagogue was splendidly restored and its historic interior closely replicated. Today, Central Synagogue continues to be used as a place of worship and is especially noted for its fine acoustics and extraordinary musical performances.

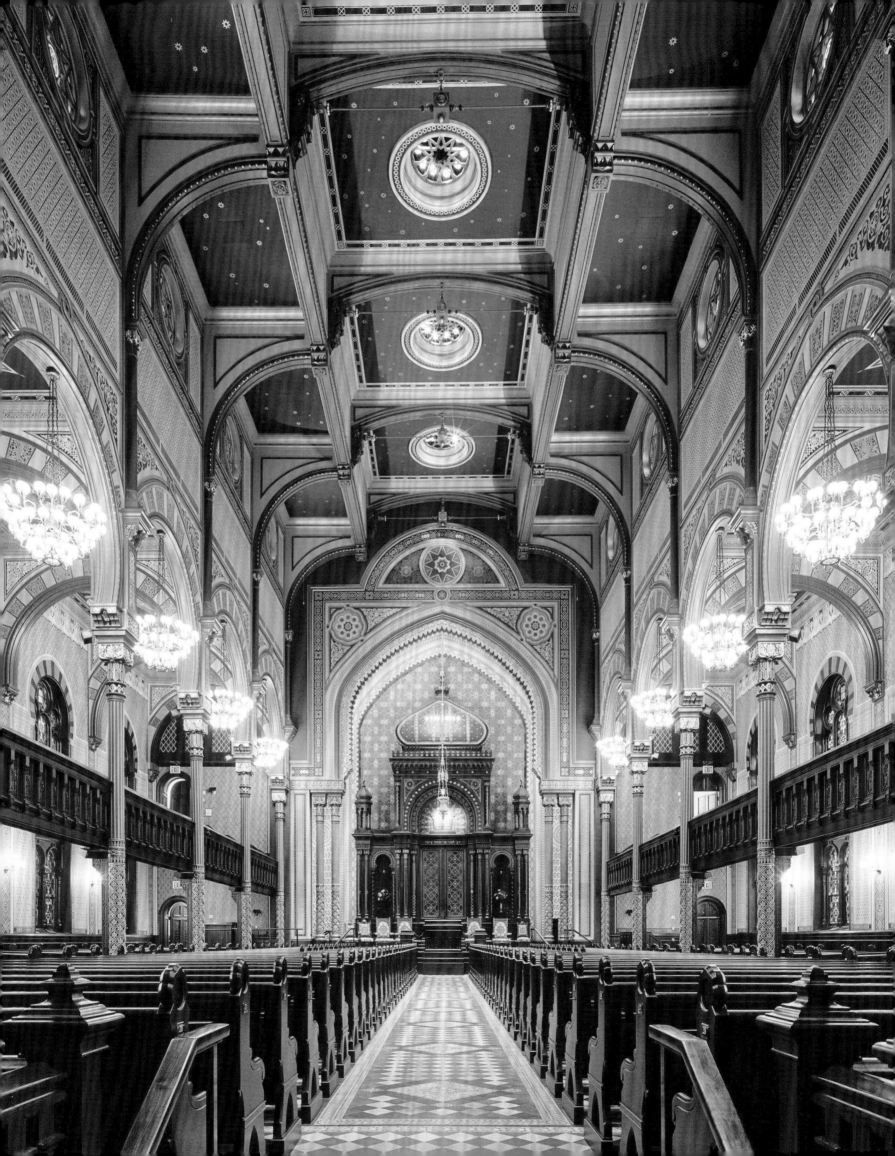

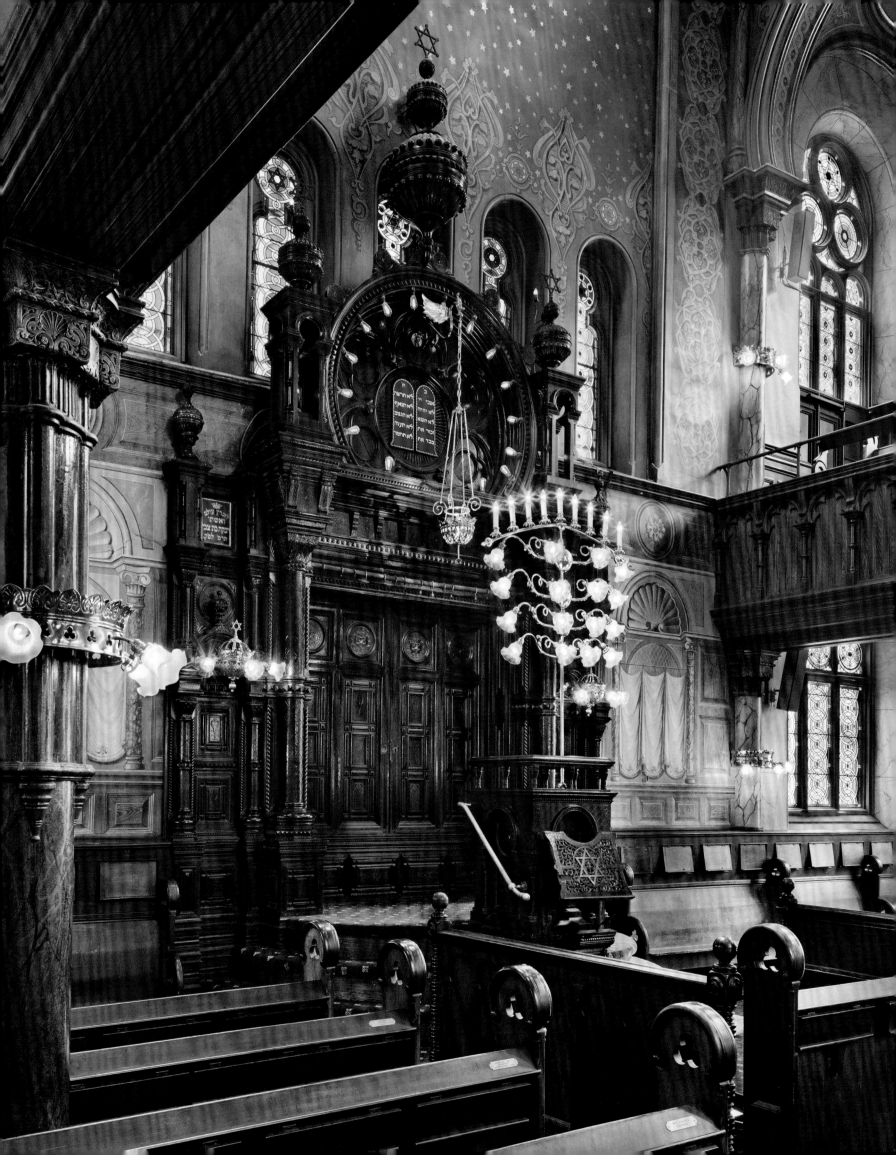

Opposite: The Eldridge Street Synagogue was built for the "downtown" Orthodox Jews in 1887. However, it rivaled the "uptown" synagogues in magnificence. Its finely carved mahogany ark and central bimah reflect the artistry of the eastern European craftsmen of the period.

Pages 203–3: The Herter Brothers designed the upstairs galleries with stepped seating to provide better visibility for both the women above and the men below.

Eldridge Street Synagogue (Kahal Adath Jeshurun, now Museum at Eldridge Street), New York, New York (1887)

On the Lower East Side, the Eldridge Street Synagogue (now the Museum at Eldridge Street) is the first great house of worship built by eastern European Jews in the United States that corresponded with their major initial wave of immigration to America. Designed by Peter and Francis Herter of the architecture firm Herter Brothers and dedicated in 1887, the synagogue provided an elegant sanctuary for Orthodox Jews, competing in grandeur with the uptown Reform temples such as Central Synagogue. The brick and terracotta facade is divided into three vertical bays dominated by a majestic central rose window with Stars of David; Moorish-style horseshoe arches frame the entrances and windows. Inside, the barrel-vaulted and domed sanctuary is surrounded on three sides by a steep and ample balcony, supported by two rows of columns, for female worshippers. The central bimah stands before the ornately carved wooden ark on the east wall. Decorative finishes cover every surface of the sanctuary.

Now a museum, the building was meticulously restored beginning in the 1980s in keeping with its original decor except for the insertion, on the ark wall, of a new rose window designed by contemporary artist Kiki Smith and architect Deborah Gans (the original stained glass bearing an unknown design was destroyed in the 1930s). The great bright blue window with its tiny gold stars lends the entire sanctuary an aura of celestial calm. Like the Eldridge Street Synagogue, but located uptown, the Orthodox Park East Synagogue (Congregation Zichron Ephraim) was also built in the Moorish Revival style with a rose window. It was designed by Ernest Schneider and Henry Herter and dedicated in 1890.

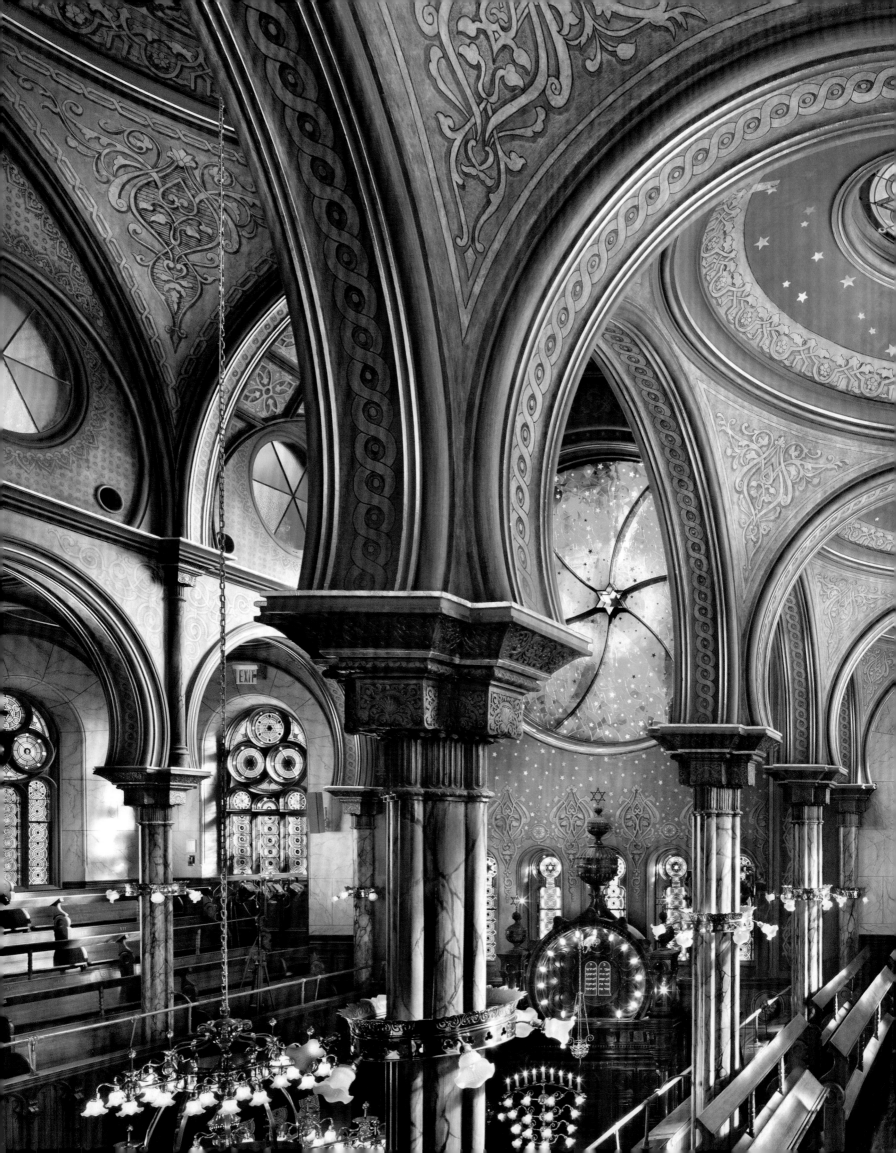

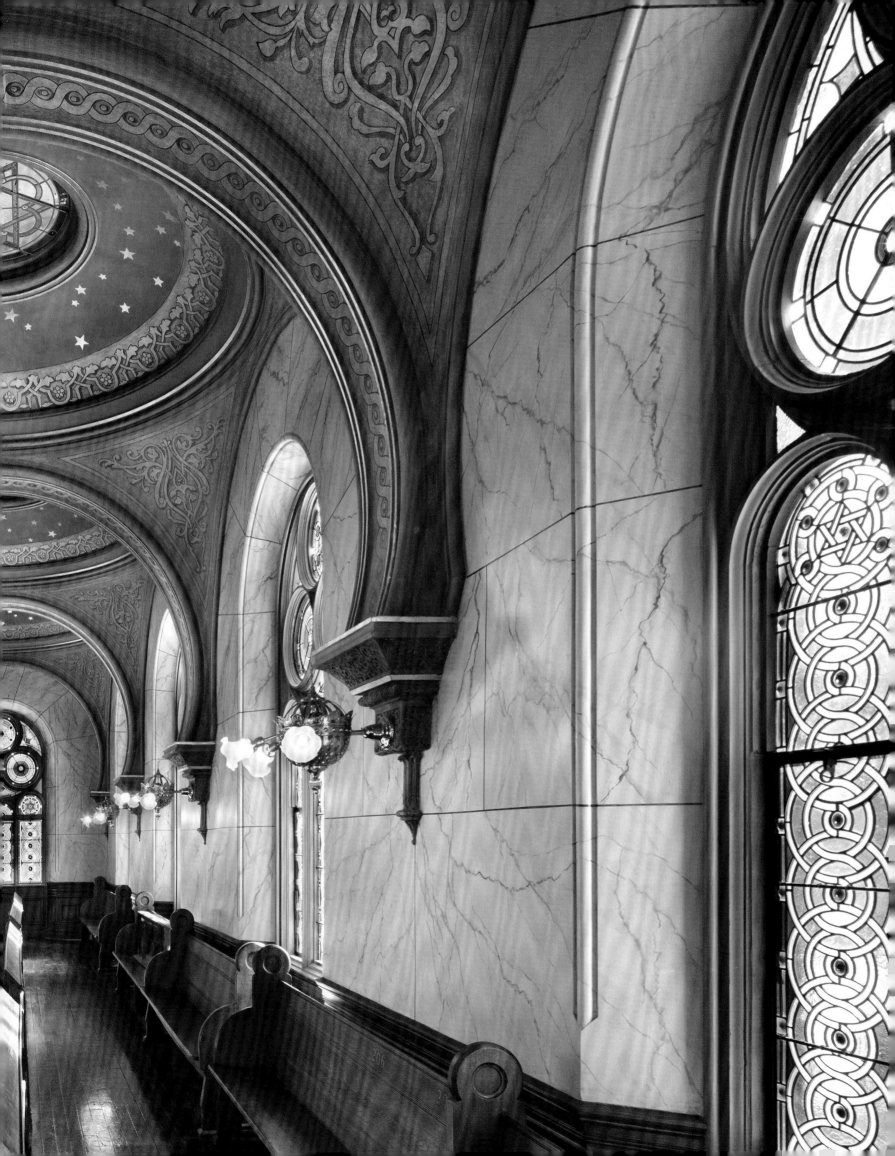

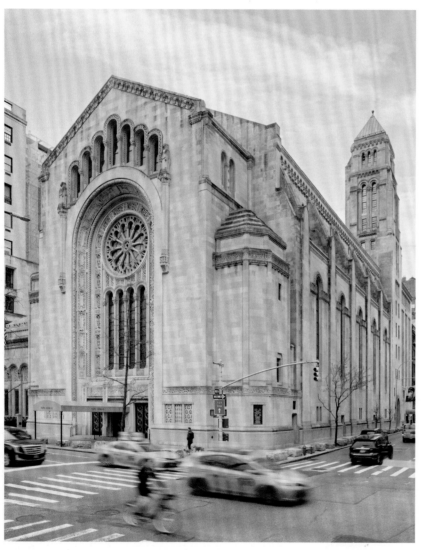

Temple Emanu-El, New York, New York (1930)

Catering to the established community of Jews of uptown Manhattan, Temple Emanu-El is one of the last expressions of architectural optimism and opulence in American synagogue building before the onset of the Great Depression and World War II. Proclaimed the largest synagogue in the world, the current Temple Emanu-El is the fourth home of the congregation that was originally formed in 1845. The size and cost alone should have guaranteed the building, designed by architects Robert B. Kohn (1870–1953), Charles Butler (1871–1953), and Clarence S. Stein (1882–1975), tremendous exposure and influence. However, the temple's dedication on January 10, 1930, just a few months after the Wall Street crash, largely deprived it of such stature. In keeping with New York's premium on space, the architects adopted a ten-story-high vertical plan combining Gothic, Byzantine, and art deco elements. The facade presents an enormous gabled front with a monumental recessed arch enclosing a rose window, lancet windows, and three doorways that reflect medieval church design. On entering, the visitor is inevitably surprised by the enormous uninterrupted interior (103 feet high by 150 feet long and 77 feet wide), built to seat twenty-five hundred people. Huge Romanesque arches that run the length of the sanctuary frame the hall. They culminate in an even bigger arch that defines the eastern ark wall, surrounding the Torah shrine, the choir, and organ lofts. Today, Temple Emanu-El numbers among the city's most prestigious and well-endowed synagogues, famous for commemorating the lives of many great New Yorkers.

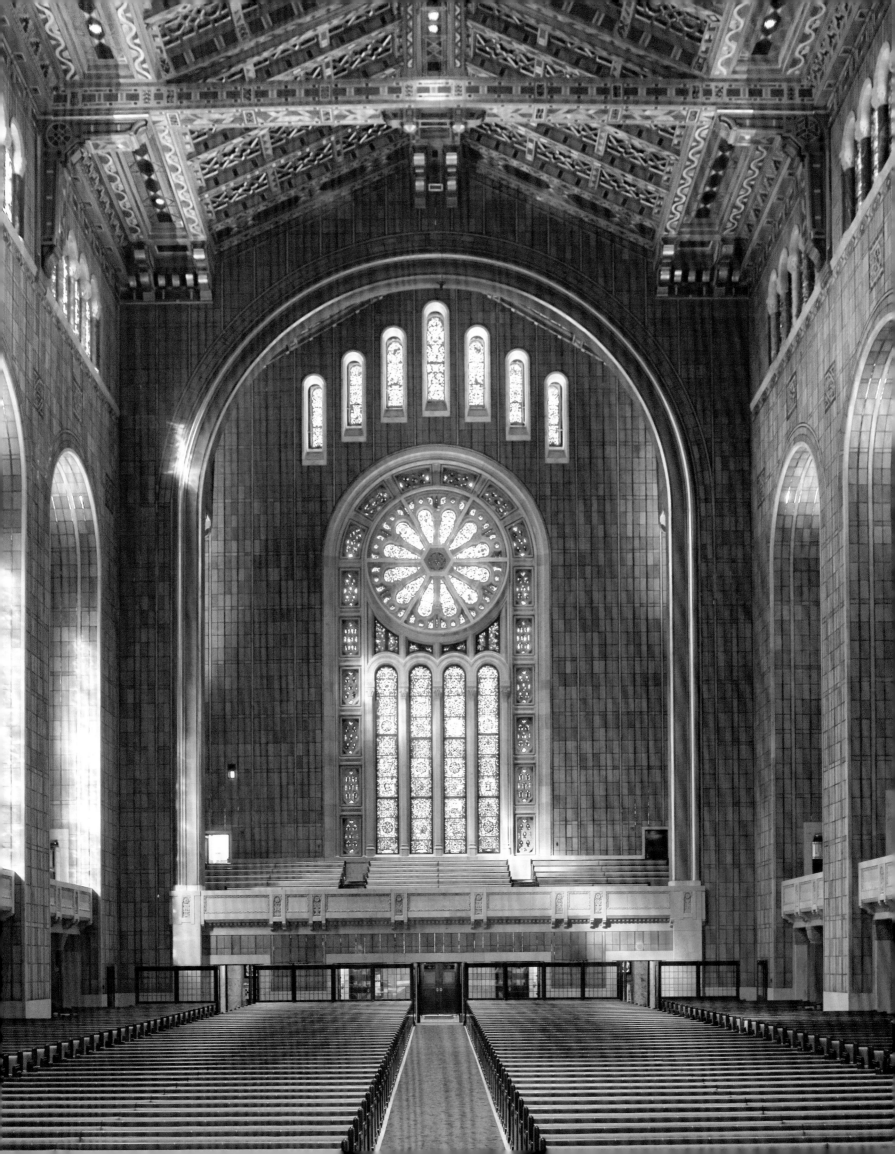

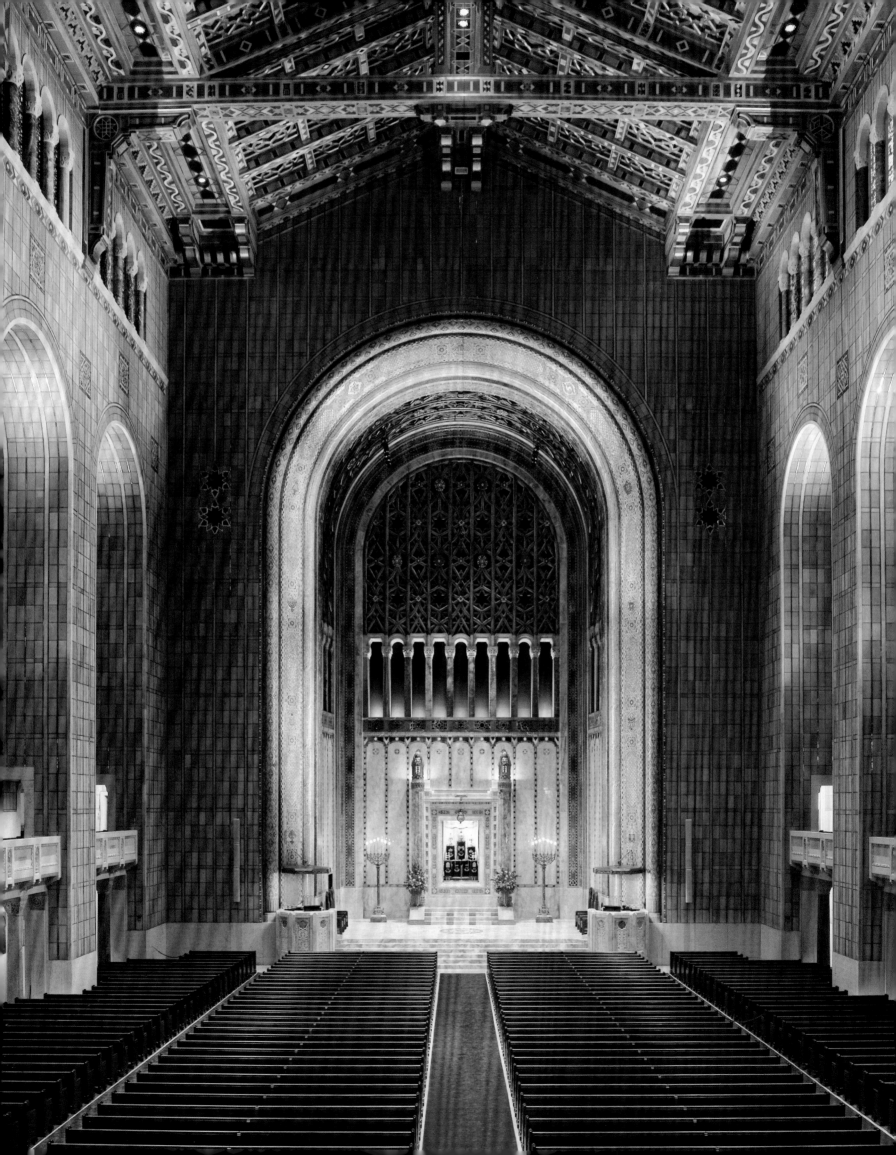

Opposite: Looking down the main sanctuary to the east, the repeated Roman arches and dramatic lighting accentuate the grandeur of the ark and its framing architectural features.

Below, left: In Reform temples, the rabbi's sermon is an important part of the service. Here, the architects adapted the isolated pulpit from earlier Christian and Islamic architecture for this purpose.

Below, right: The gallery level of Temple Emanu-El was not designed specifically for women but rather to accommodate congregational overflow of either sex.

Pages 208–9: The choir loft, composed of a colonnade of rare marble pillars and gilded bronze grillwork with Stars of David, exemplifies the temple's stunning mix of Moorish, Byzantine, and art deco styles.

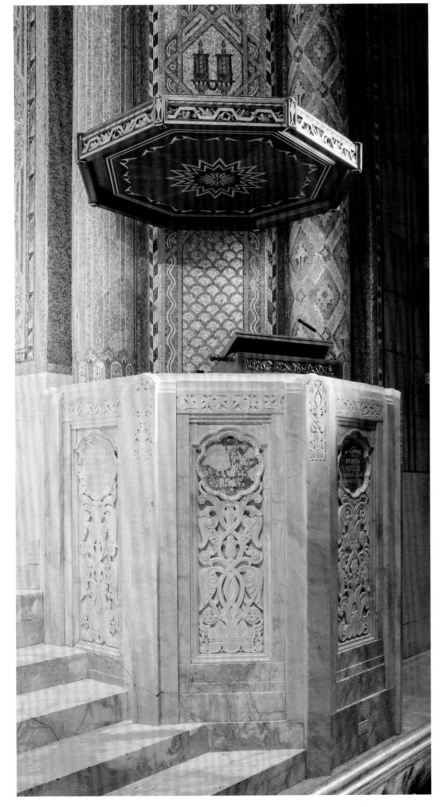

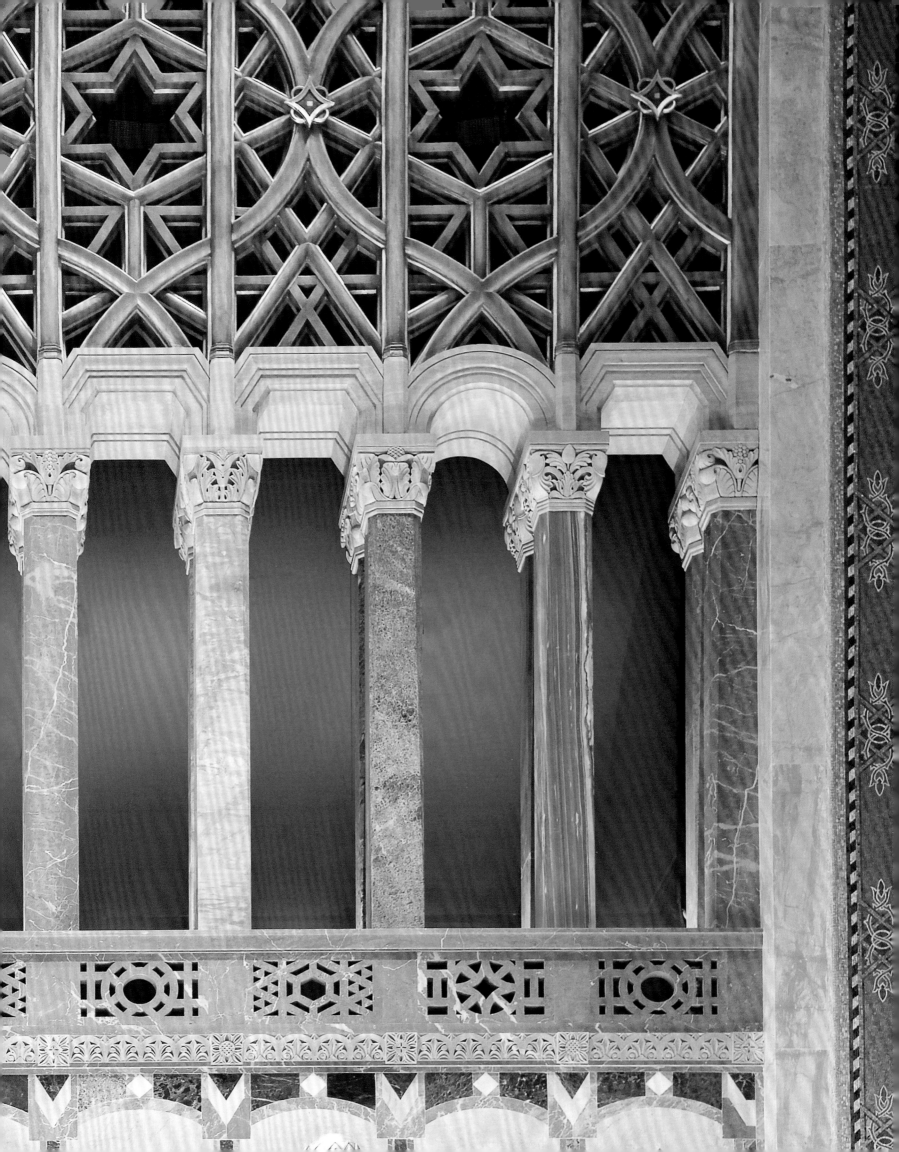

Opposite: This gallery view of Chicago's K.A.M. Isaiah Israel Congregation, formerly Temple Isaiah (1924), shows the harmonious integration of Byzantine-inspired brick-and-stucco decoration with American stained glass. The Guastavino tile work provides structural support and also serves to improve acoustics.

Pages 212–13: In this cohesive synagogue built according to a central plan with a substantial dome, every seat, even those across the gallery, feels close to the ark and bimah.

Temple Isaiah (now K.A.M. Isaiah Israel Congregation), Chicago, Illinois (1924)

In Chicago, Jewish congregations also expressed their identity through striking hybrids of European and Near Eastern architecture. The Byzantine-style Temple Isaiah, situated in Hyde Park and dedicated in 1924, stands as the finest example of the domed synagogue in the Midwest. It replaced early iterations of the synagogue in different locations. At the time of the Hyde Park synagogue's construction, Chicago was home to the largest Jewish population outside of New York. Designed by Alfred S. Alschuler (1876–1940), it was inspired by concurrent excavations in Palestine but architecturally recalls the sixth-century churches of San Vitale in Ravenna and Hagia Sophia in Istanbul. The architect laid out the main sanctuary in the form of an octagonal plan topped by a low dome that rests on eight massive piers. The semicircular balcony increases the seating capacity in proximity to the bimah and ark. The Guastavino interlinking terracotta tiles provide structural support for the sinuous staircases. They also serve to improve the acoustics. The building combines two forms of decoration: The first derives solely from the juxtaposition of earth-toned tiles and bricks; the second from the extensive overlay of explicit Jewish symbols, which crescendo as one progresses through the building. The overall effect is a unique and cohesive structure that is at once grand and surprisingly intimate.

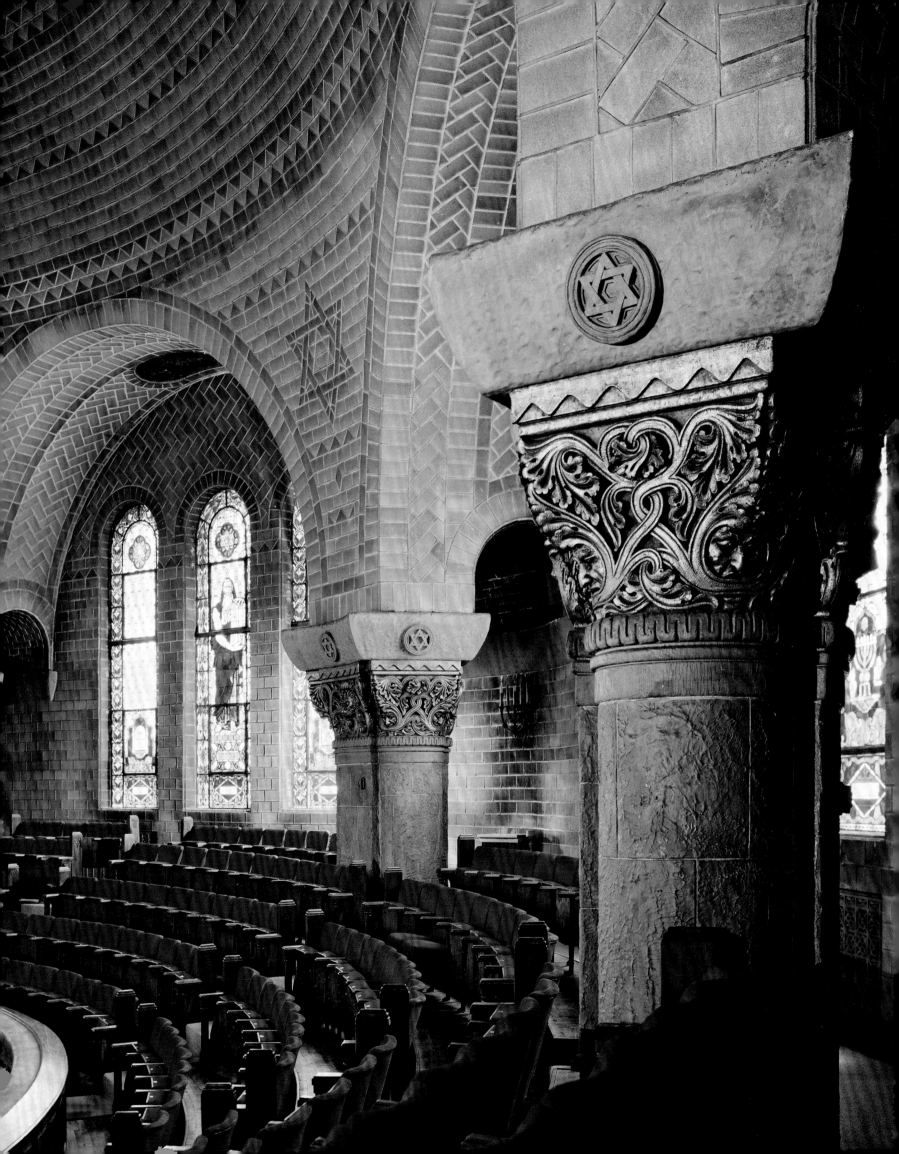

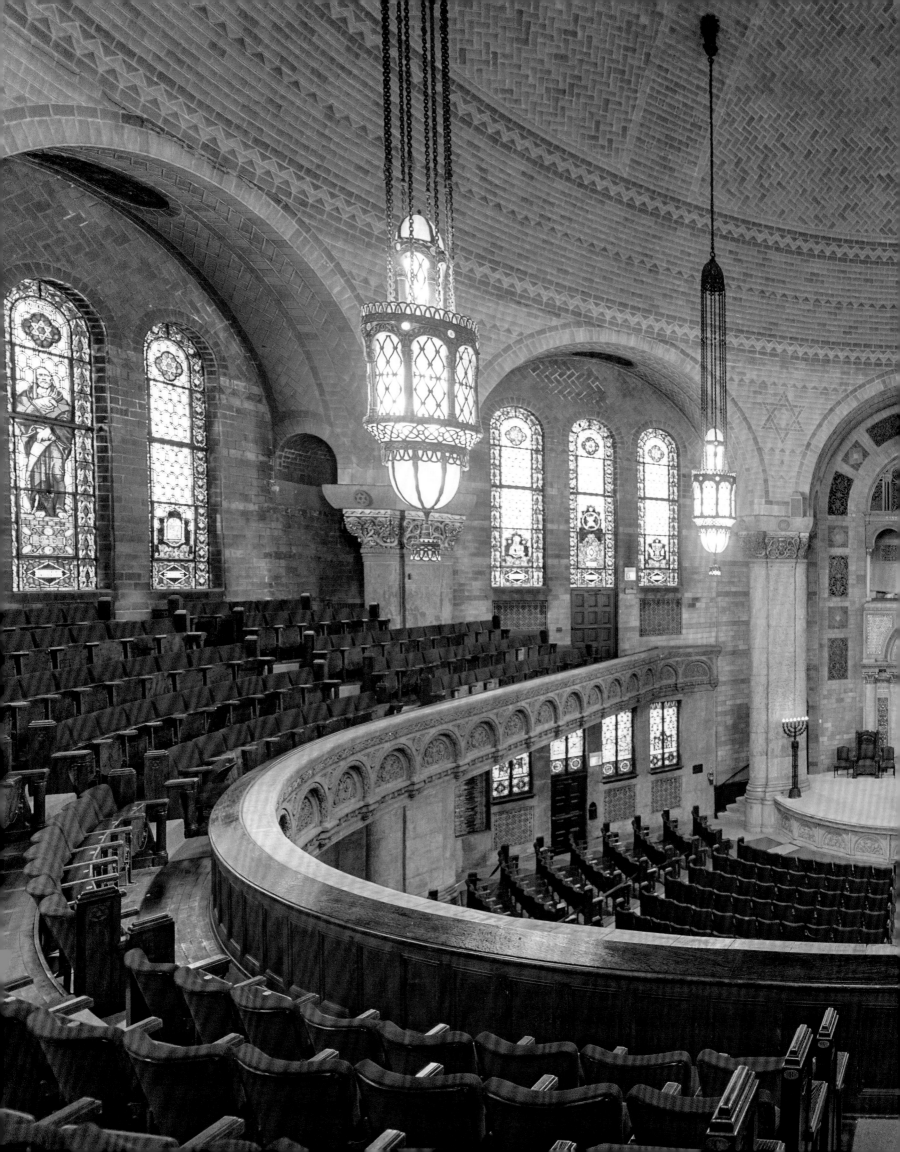

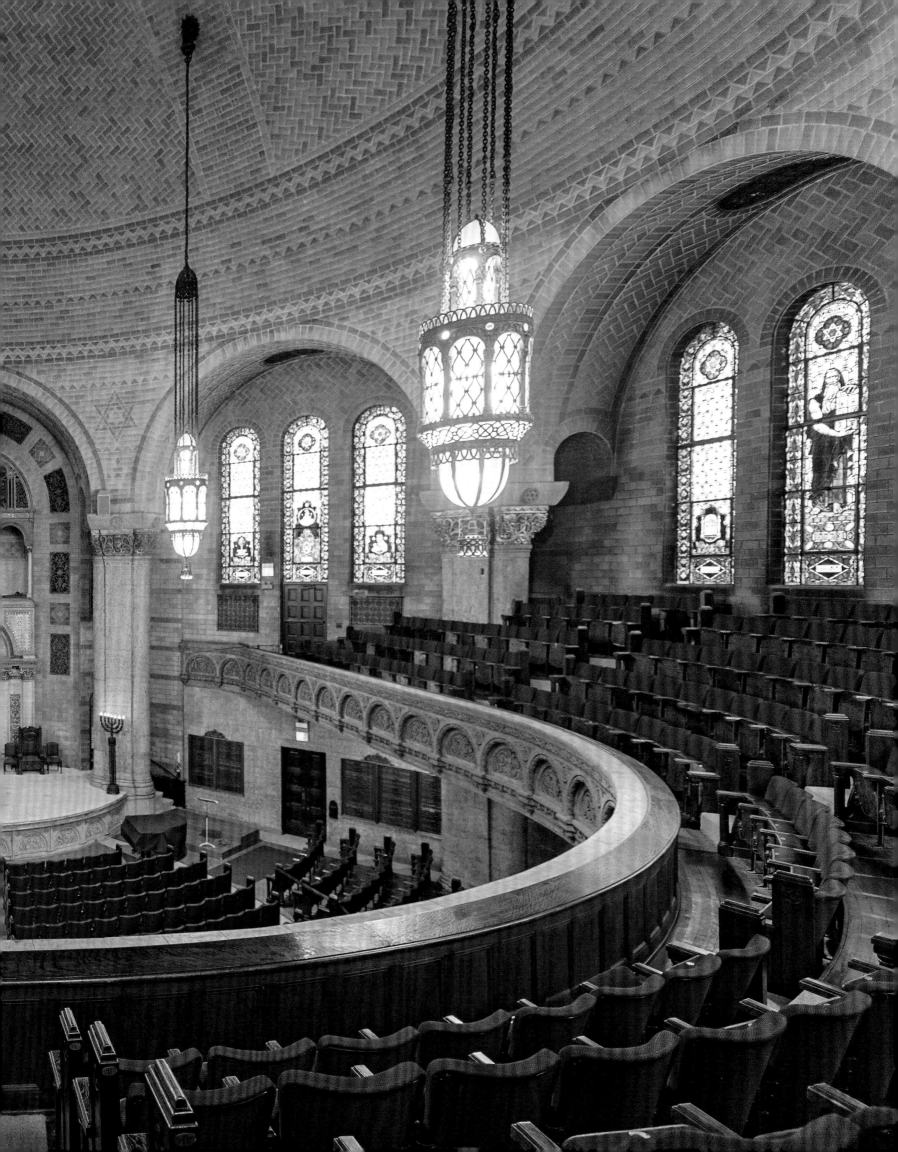

Below: The grand entrance to the Wilshire Boulevard Temple (1929) through a triple arch recalls the narthexes of medieval cathedrals and the round shape of Roman triumphal arches—perhaps an appropriate style for the Hollywood studio heads of 1920s Los Angeles.

Opposite: Inspired by the Roman Pantheon, the temple's hundred-foot-high dome, with its sumptuous decorations, rivaled the most opulent movie palaces of the 1920s.

Pages 216–17: Though similar in plan to Chicago's K.A.M. Isaiah Israel Congregation, the Wilshire Boulevard Temple's coffered dome makes the space appear far more vast. The rim of the oculus is inscribed with the Shema prayer in Hebrew, thus the crowning dome expresses God's oneness.

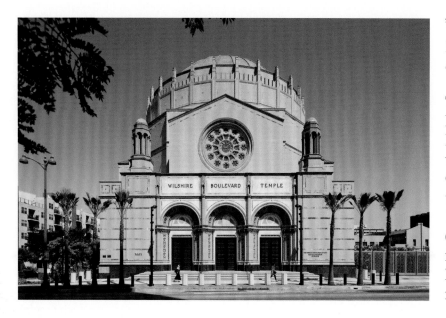

Wilshire Boulevard Temple, (Congregation B'nai B'rith of Los Angeles), Los Angeles, California (founded in 1851, current building dedicated in 1929)

Taking a different approach to Temple Isaiah's Byzantine low-profile dome, the Wilshire Boulevard Temple of Los Angeles was more closely inspired by Rome's Pantheon as well as by a combination of Romanesque and art deco styles. Originally founded in 1851, and now in its third incarnation, the synagogue was designed by Abram M. Edelman (1863–1941), S. Tilden Norton (1877–1959), and David C. Allison (1881–1962) in 1929. Edelman was the son of the congregation's first rabbi and had designed the congregation's previous building, while Norton, a congregation member, was responsible for its first and second iterations.

The new temple was the brainstorm of Rabbi Edgar Magnin, who dreamed of a fresh identity for the Jews of Los Angeles, melding the ideals of its founding community with the power of the Hollywood moguls. Alongside the major movie theaters of Los Angeles on Wilshire Boulevard, the temple boldly holds its own. The main entrance resembles a Romanesque church portal with a foreshortened nave. On entering, the temple's soaring hundred-foot-high dome with its blaze of colors, materials, and opulent textures produces a stunning effect. Black marble columns, teakwood doors, bronze chandeliers, and the golden ark fixtures further enrich the interior. This temple is noted for reintroducing extensive figurative art into synagogue decoration, a controversial concept at the time. The greatly admired artist Hugo Ballin created a representation of Jewish history over three millennia that surrounds the dado of the prayer hall and appears in the great lunettes on the north, east, and west sides of the sanctuary.

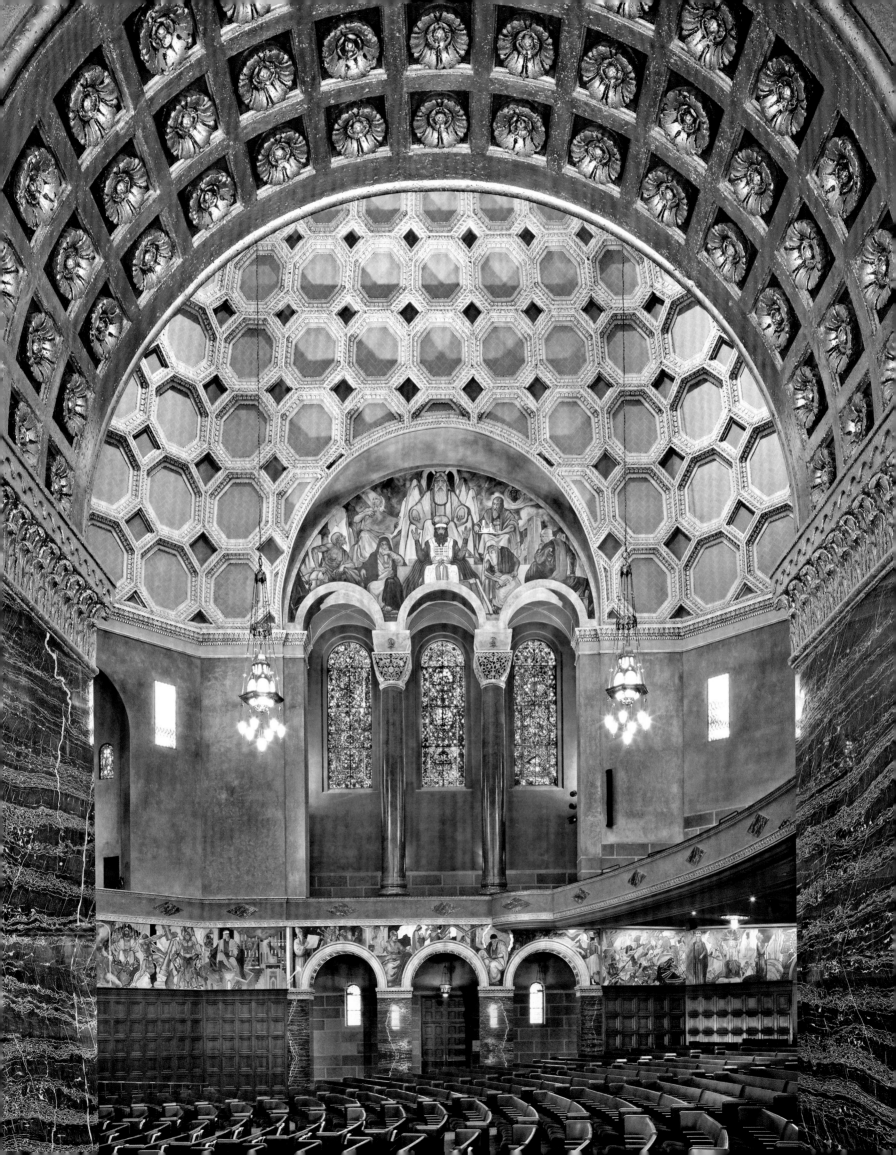

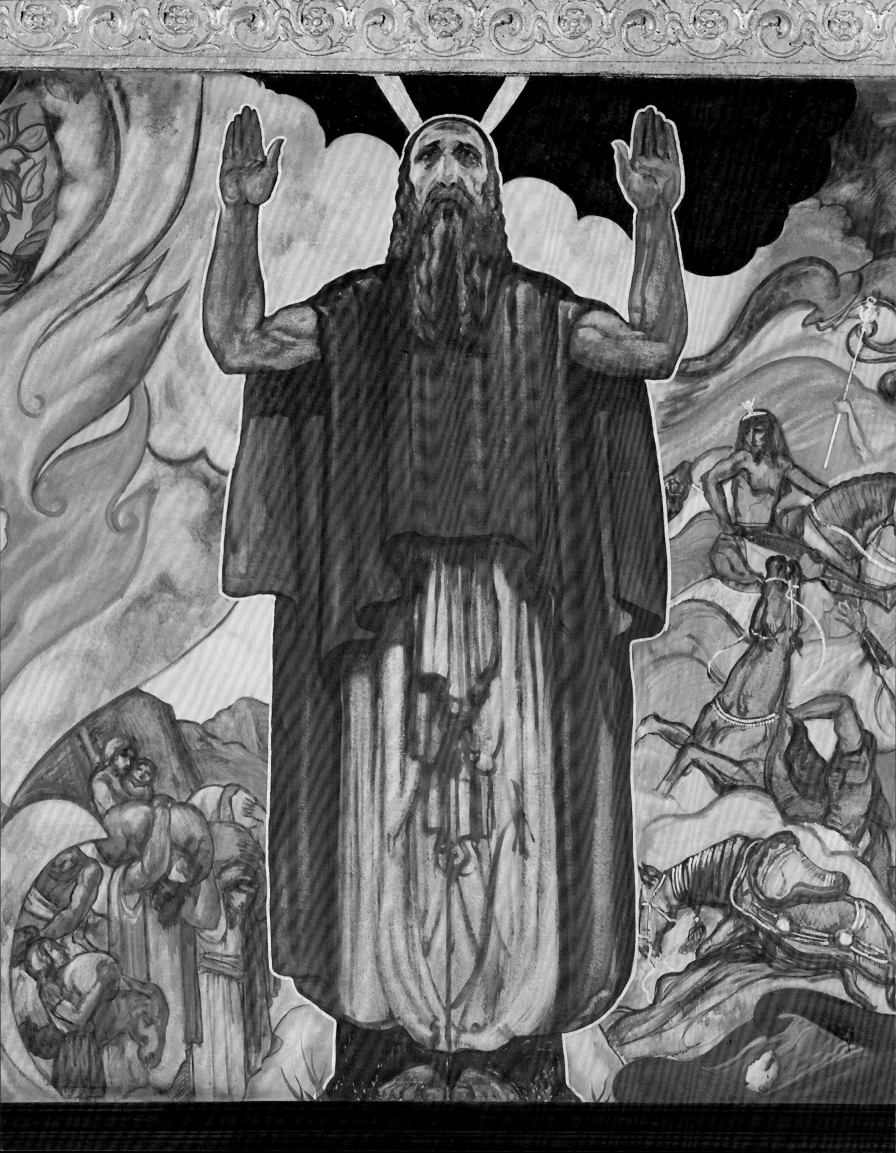

Pages 218–19: Both a renowned artist and a silent film director, Hugo Ballin painted the series of murals depicting the history of the Jewish people on the temple walls and in the giant lunettes. The paintings, sponsored by Warner Brothers, unreel like a Hollywood epic.

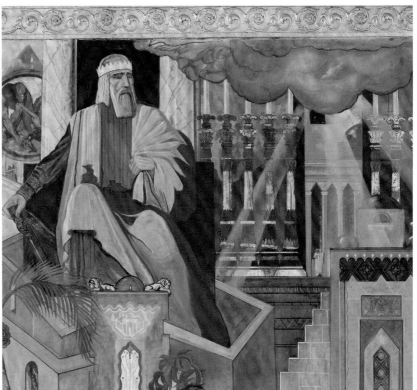

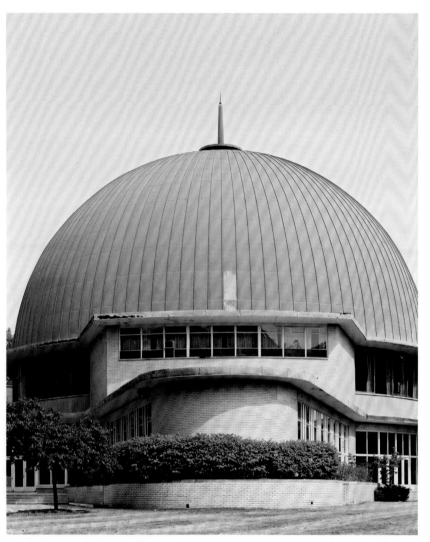

The Park Synagogue (Anshe Emeth Beth Tefilo), Cleveland, Ohio (1953)

As Jews grew more prosperous in the Midwest, many moved to the suburbs and began building synagogues with community centers. In 1946, Rabbi Armond Cohen commissioned the modernist European architect Erich Mendelsohn (1887–1953) to design the Park Synagogue. The topography of the site— thirty acres of densely wooded land cut by a ravine—allowed for considerable freedom in design. Mendelsohn fashioned a wedge-shaped complex: a small daily chapel, like the bow of a ship, intersected by an immense copper-clad dome. From the inside, this hemispheric dome with its low drum appears to float over the congregants—metaphorically emphasizing the connection between earth and heaven.

Normally the sanctuary seats a thousand congregants, but on High Holidays, the foyer and assembly room open to allow for three thousand. The sight lines through the folding partitions permit the vestibule to be more fully incorporated into the main sanctuary experience. This is one of the earliest and best uses of the "flexible plan," and one of Mendelsohn's many brilliant innovations.

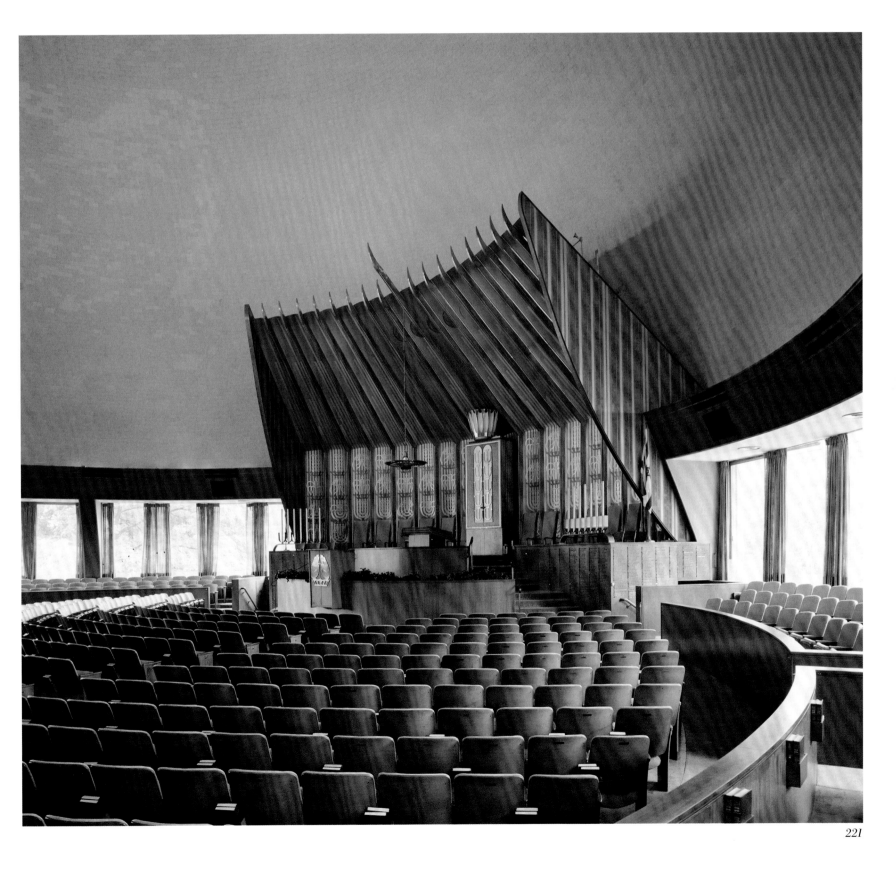

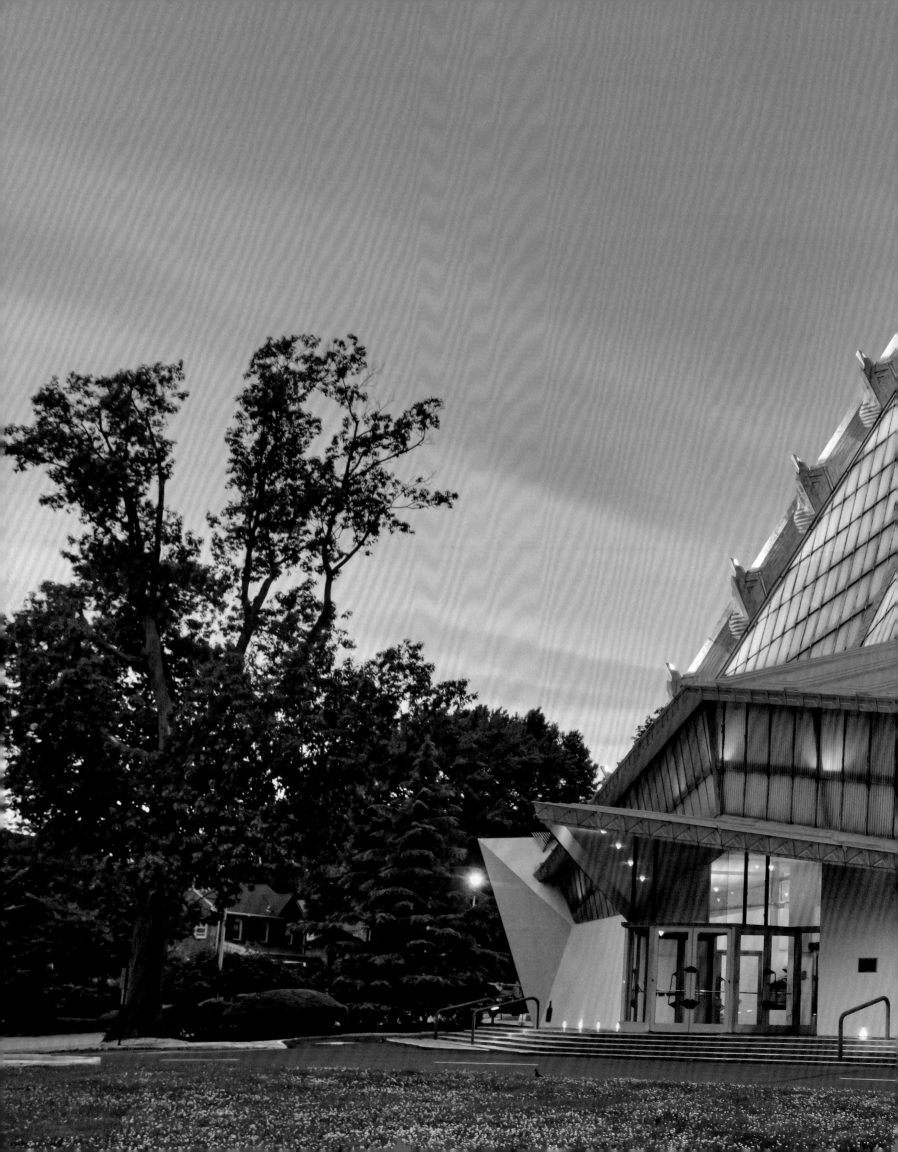

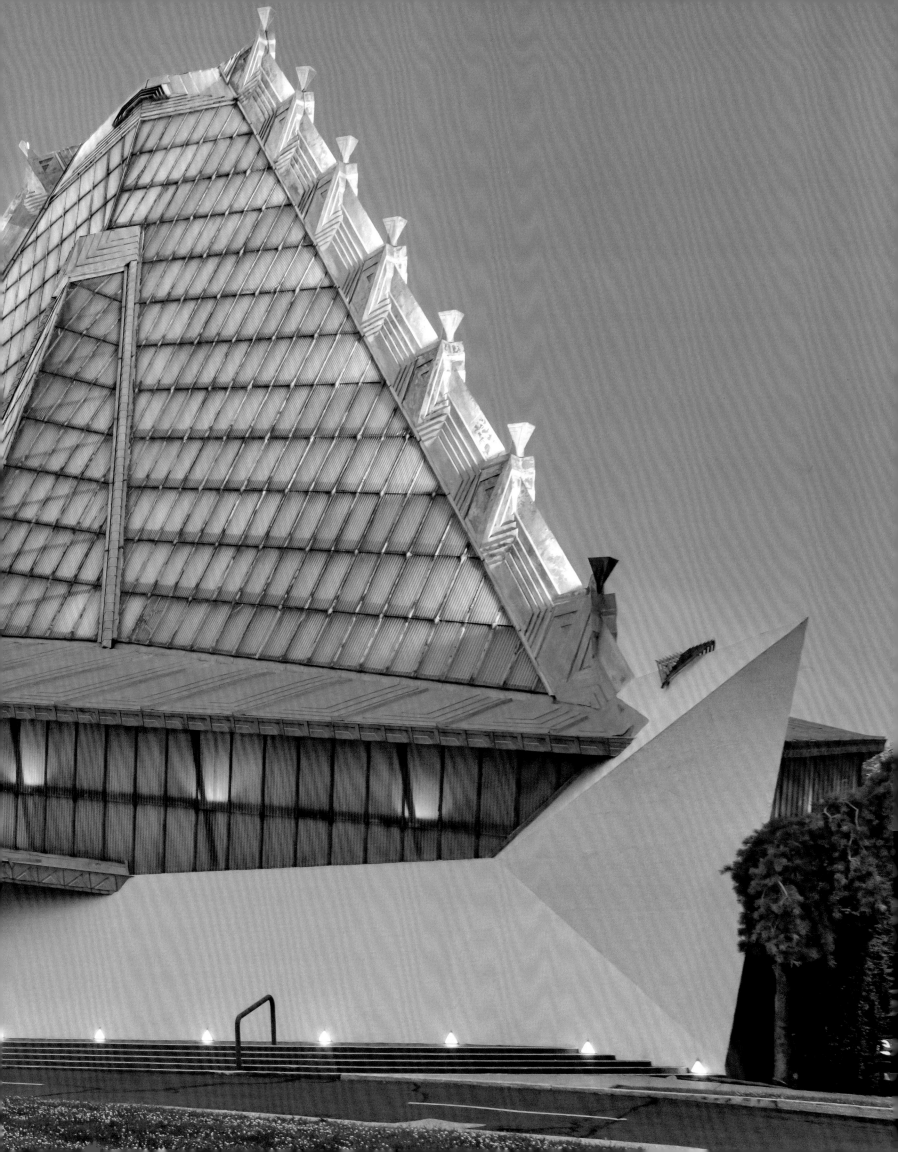

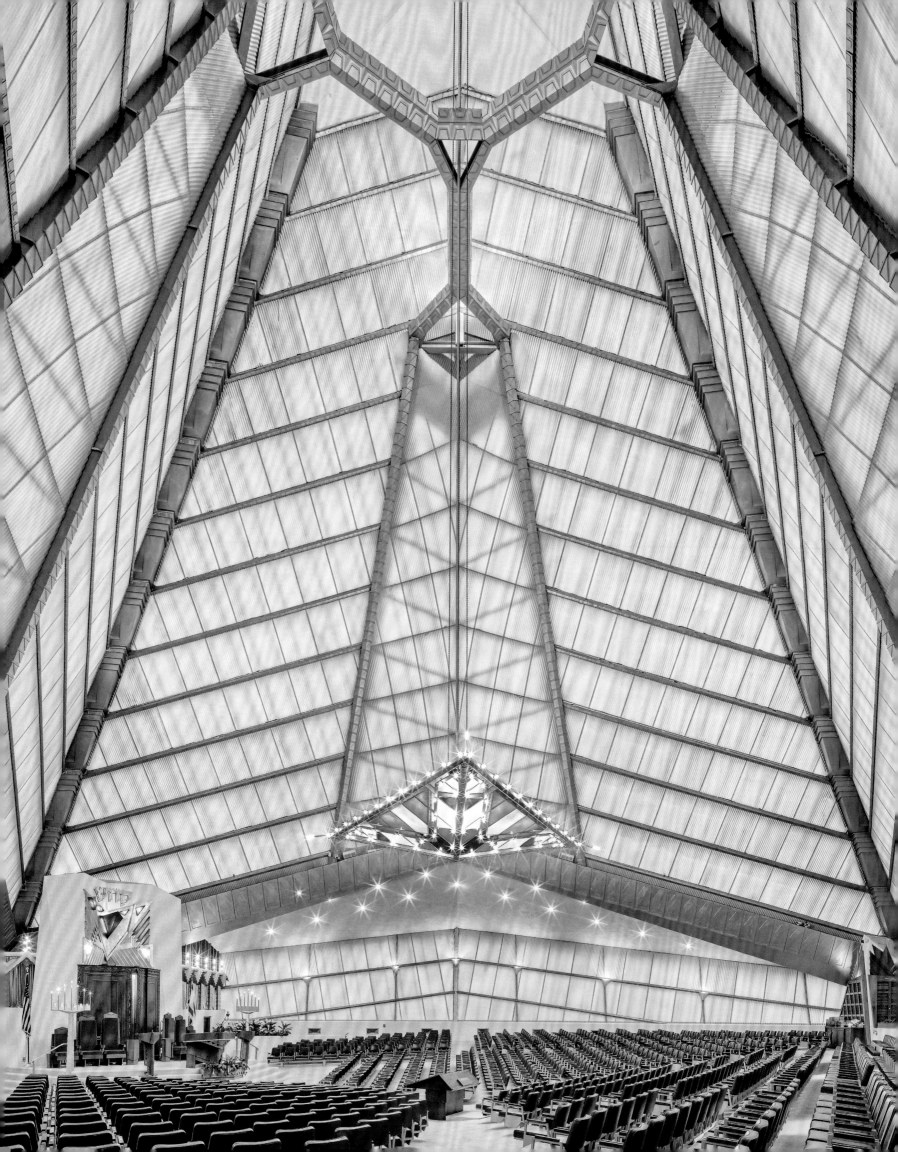

Pages 222–23: The striking exterior of Beth Sholom in Elkins Park, Pennsylvania, has been likened to "a mountain of light." Frank Lloyd Wright's only synagogue, it was completed in 1959, shortly after the architect's death.

Opposite: Inside, the sanctuary appears as a tent of glass. A massive steel tripod supports a glass-and-plastic skin. Throughout every part of the building, furnishings, and decoration, Wright employed triangle variations, which combine to create both tension and stasis.

Below: A huge triangular chandelier hangs in the center of the sanctuary space. Rabbi Mortimer Cohen assigned mystical meanings to the colors, which he saw as manifestations of the divine.

Beth Sholom Congregation, Elkins Park, Pennsylvania (1959)

Influenced by Erich Mendelsohn, architects across America transformed the sanctuary space by developing dynamic forms, often built of concrete and glass. Jewish congregations favored symbolic building profiles, frequently recalling biblical mountains or tents. Beth Sholom's new synagogue in Elkins Park, outside of Philadelphia, was the brainchild of Frank Lloyd Wright (1867–1959) and fully expressed this movement. He designed the synagogue along a hexagonal plan recalling the Star of David, but its height gives it more of a pyramid-like appearance. The central sanctuary is composed of a massive steel tripod supporting an opaque skin of glass and plastic that rises up over a 100 feet. This structure rests on a polygonal concrete base.

Wright, who worked closely with Rabbi Mortimer Cohen to give symbolic and historic meaning to the design, declared, "When you go into a place of worship, you ought to feel as if you were in the hands of God." Sadly, Wright died shortly before the completion of the synagogue in 1959. Soon after, Beth Sholom became the touchstone of American synagogue design, especially for ambitious architects hoping to create iconic sanctuaries.

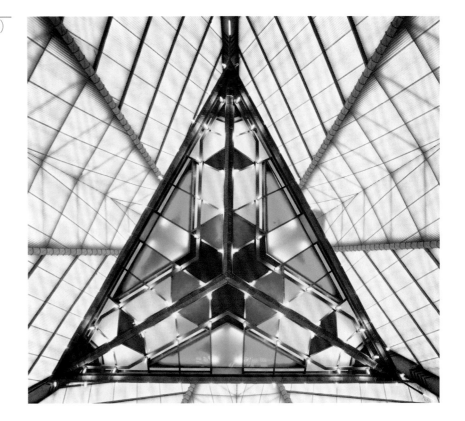

North Shore Congregation Israel, Glencoe, Illinois (1964)

Many monumental synagogues were built in the burgeoning American suburbs, where their expressive forms could be seen from the new network of highways. In 1964, Minoru Yamasaki (1912–1986) created a series of precast concrete arches as a frame for North Shore Congregation Israel in Glencoe, Illinois, leaving large gaps in the structure to be filled with filtered daylight. The interior is vast and the use of light, repeated ogival forms, and white walls with little ornamentation create a cerebral space. The tall, thin gilded ark has been likened to a prayer shawl wrapped around the Torah scrolls but seen from the sanctuary entrance; it also suggests a single flame—a burning bush or eternal light.

Below: The innovative shape of the North Shore Congregation Israel (1964) recalls the modular form of the biblical Tabernacle, only here the components are made of precast concrete supports and panels—in keeping with Minoru Yamasaki's regard for state-of-the art materials. Located in Glencoe, Illinois, the stark white synagogue contrasts with the parklike setting along the lake.

Opposite and pages 228–29: The spaces between the arches create changing patterns of light throughout the day. The lower windows open the space to nature, an early example of the interchange between the sanctuary and the natural world.

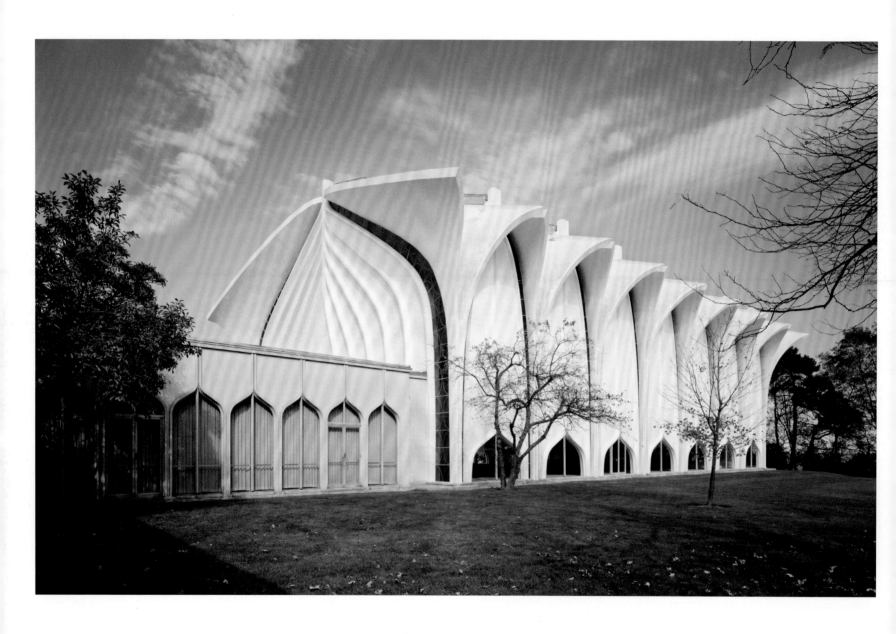

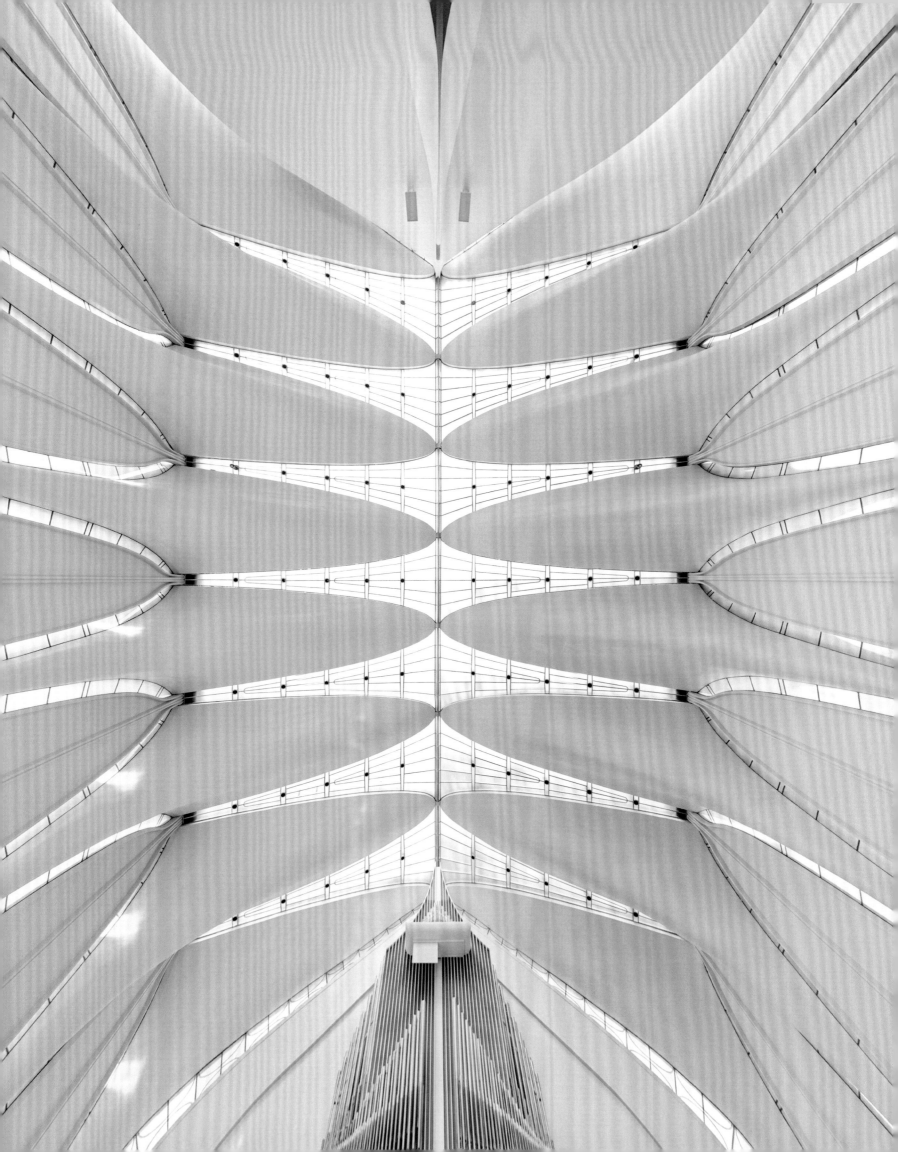

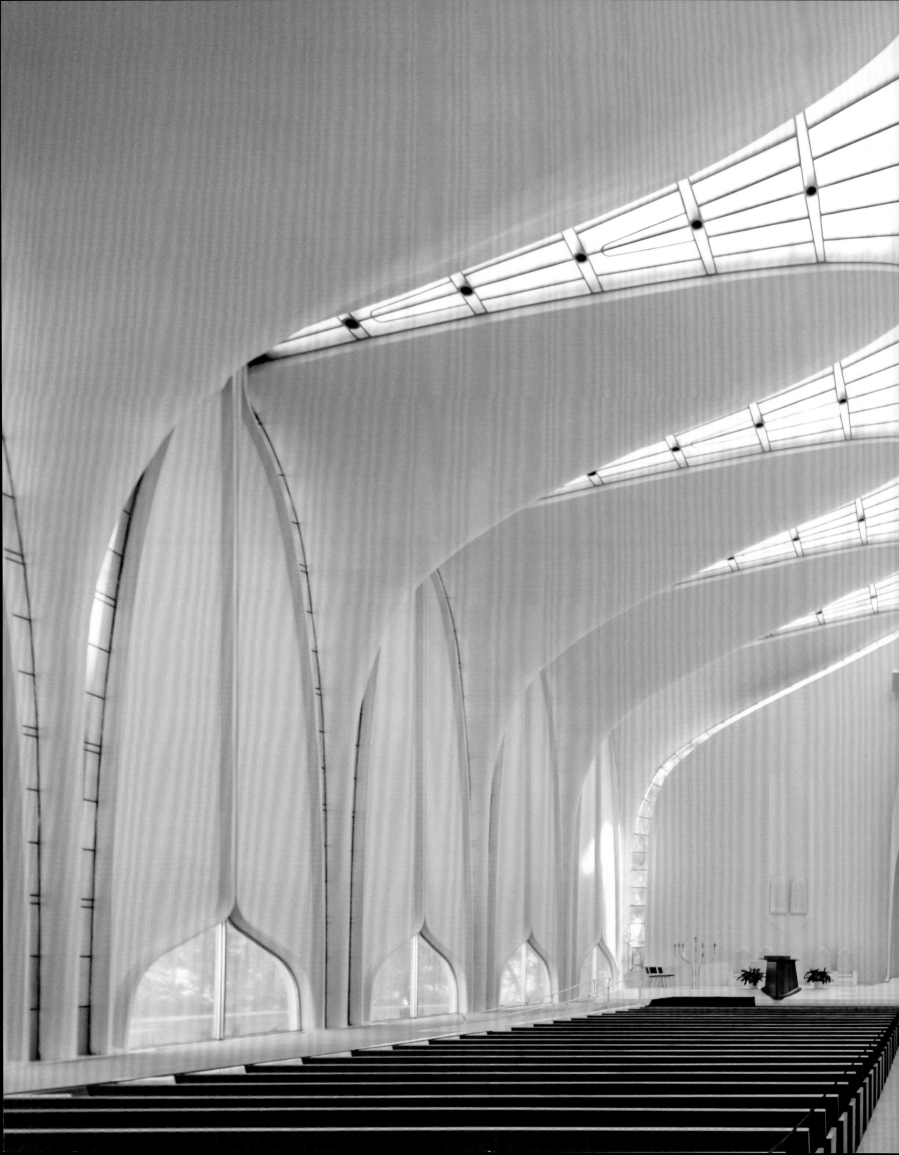

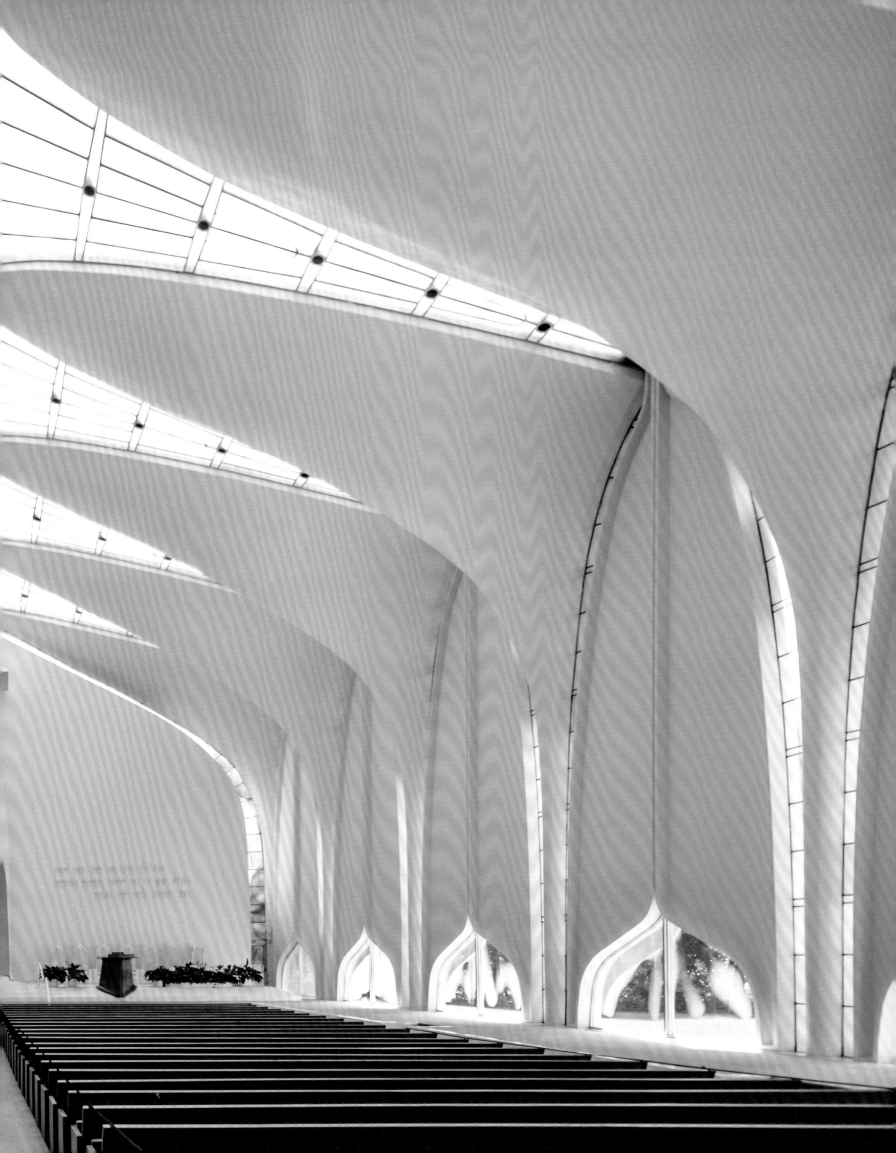

Below, top: The exterior of the Jewish Center of the Hamptons (1989) in East Hampton, New York, is cloaked in wooden shingles in keeping with the local historical style of Long Island.

Below, bottom: This detail of the woodwork exemplifies the superb contemporary craftsmanship of this synagogue, which was designed by Norman Jaffe.

Opposite: According to the architect, the shapes of the wood piers, walls, and boards are designed to evoke the bent profile of a worshipper bowing in prayer. Additionally, the use of wood hearkens back to the great wooden synagogues of eastern Europe, most of which were destroyed in the Holocaust.

Pages 232–33: In a departure from Reform Jewish tradition, the bimah projects into the heart of the congregation to encourage a more participatory form of worship, a design typical of earlier Sephardi synagogues. At the same time, the prayer hall looks out into nature, a thoroughly modern idea.

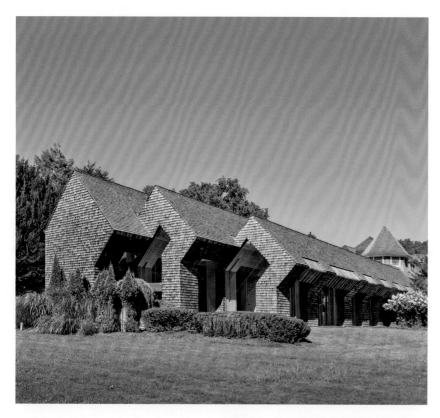

Jewish Center of the Hamptons, Gates of the Grove (Shaarey Pardes), East Hampton, New York (1989)

Set in a grove of indigenous trees visible from the sanctuary and imbued with a wonderful sense of light, the Jewish Center of the Hamptons expresses Judaism as a state of spiritual contemplation. Unlike Yamasaki's approach, this synagogue rejects the developments of suburban architecture by avoiding concrete or hard materials. Nature is ever present. In designing the exterior, architect Norman Jaffe (1932–1993) broke with current architectural precedents by combining the local vernacular of Long Island shingle style with the eastern European Jewish wood synagogue tradition. He adopted the ancient "broad house" synagogue design, wherein the hall is wider than it is long. At first, the sanctuary appears sparsely decorated, suggesting a form of functional modernism. A closer look reveals layers of symbolism in its form, lighting, and materials. The sanctuary's emotional charge comes not from technology, but rather from the carefully crafted details, and the intimacy of its space. Jaffe was deeply inspired by Kabbalistic symbolism and the invocation of the number ten, as in the Ten Commandments. The angling of the woodwork into a series of staggered bent forms, which Jaffe referred to as "arches," is one of its most distinctive features. He compared these to an "an old Jew bent in prayer" and to the shapes of Hebrew letters. Small but easily recognizable stars appear on the exterior, relieving the repetition of the shingles. Within, warm Alaskan cedar benches and woodwork harmonize with the limestone flooring. The view over the bimah through the windows to the greenery beyond presents a shifting panorama, instead of the majestic but static ark wall found in older synagogues.

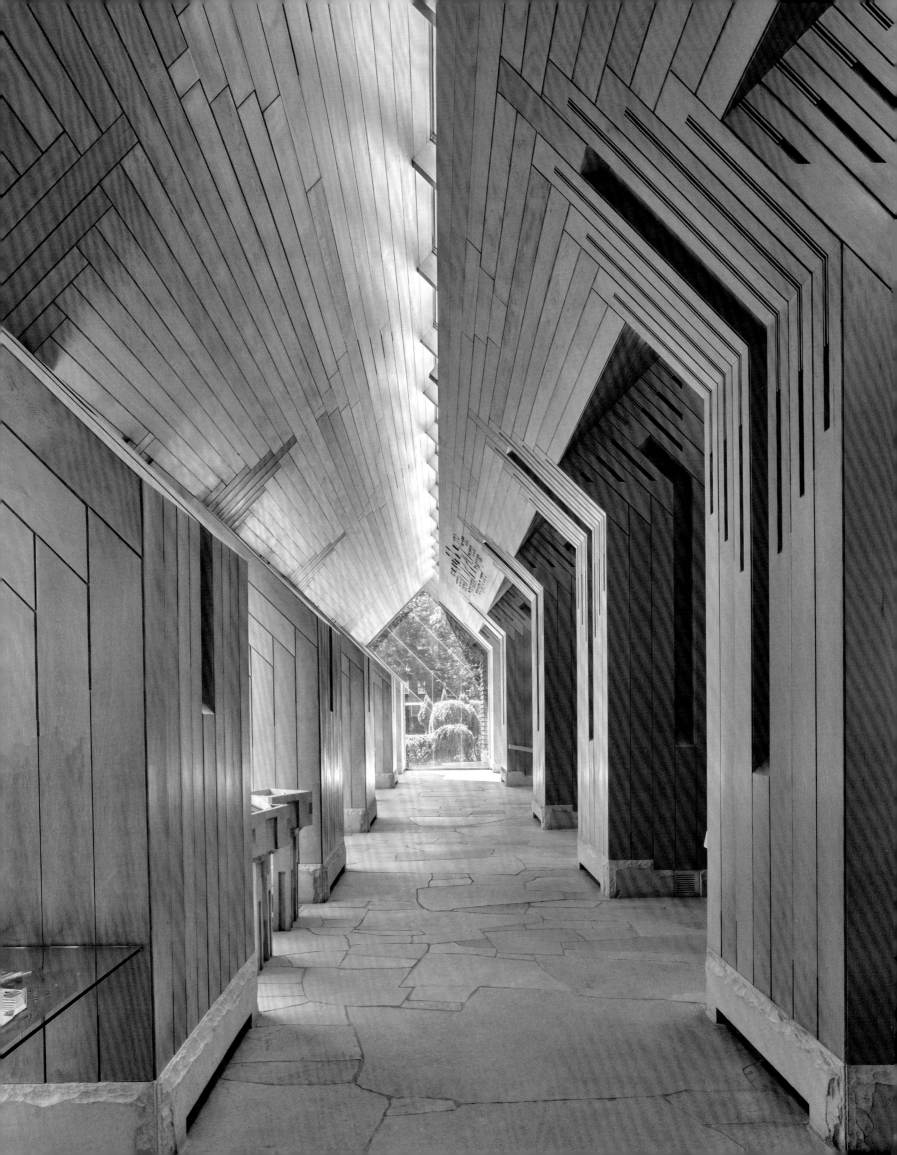

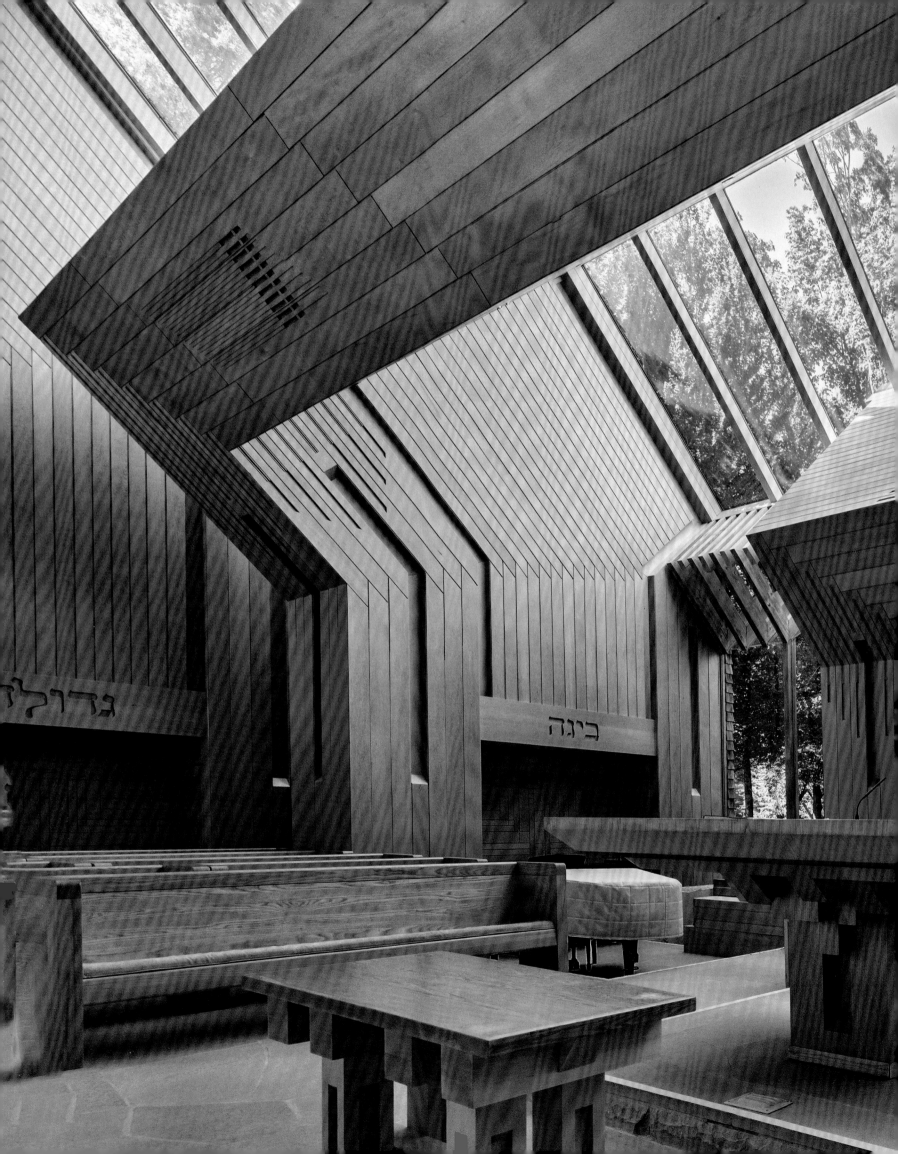

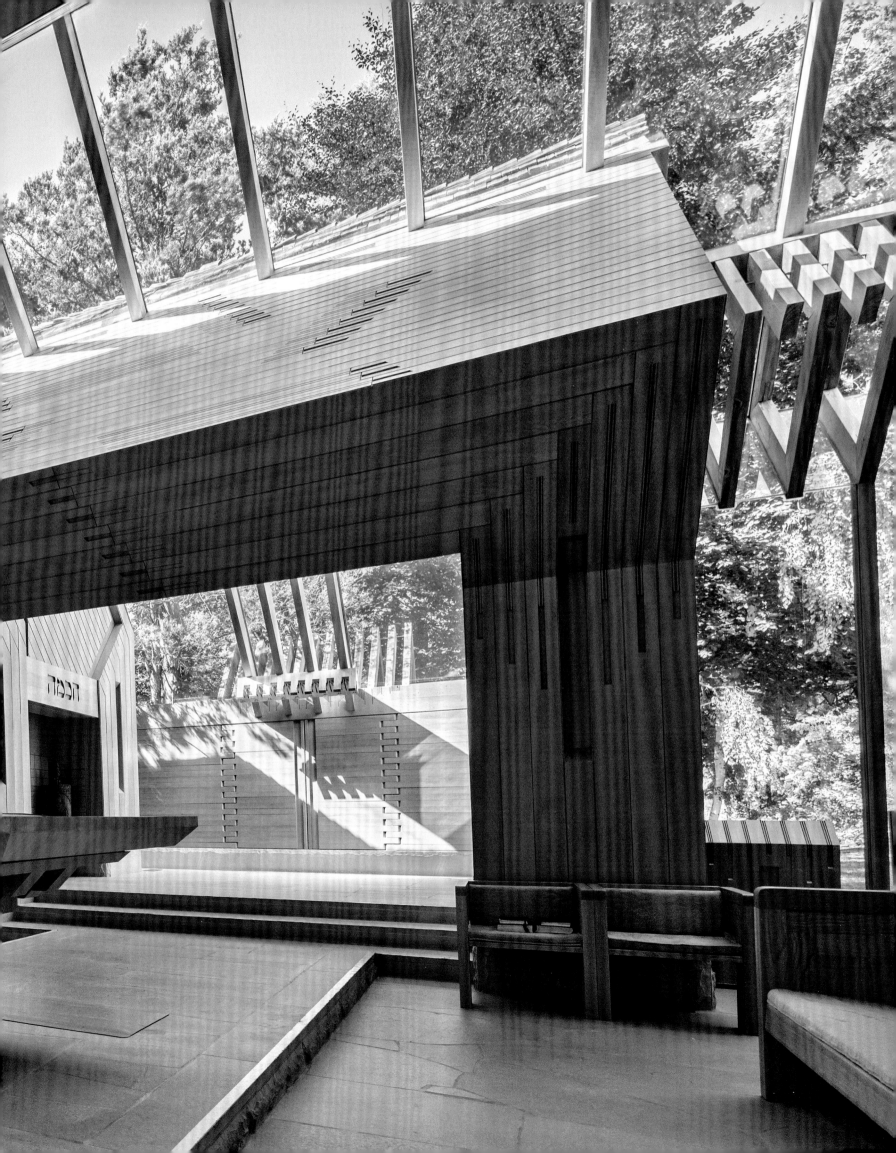

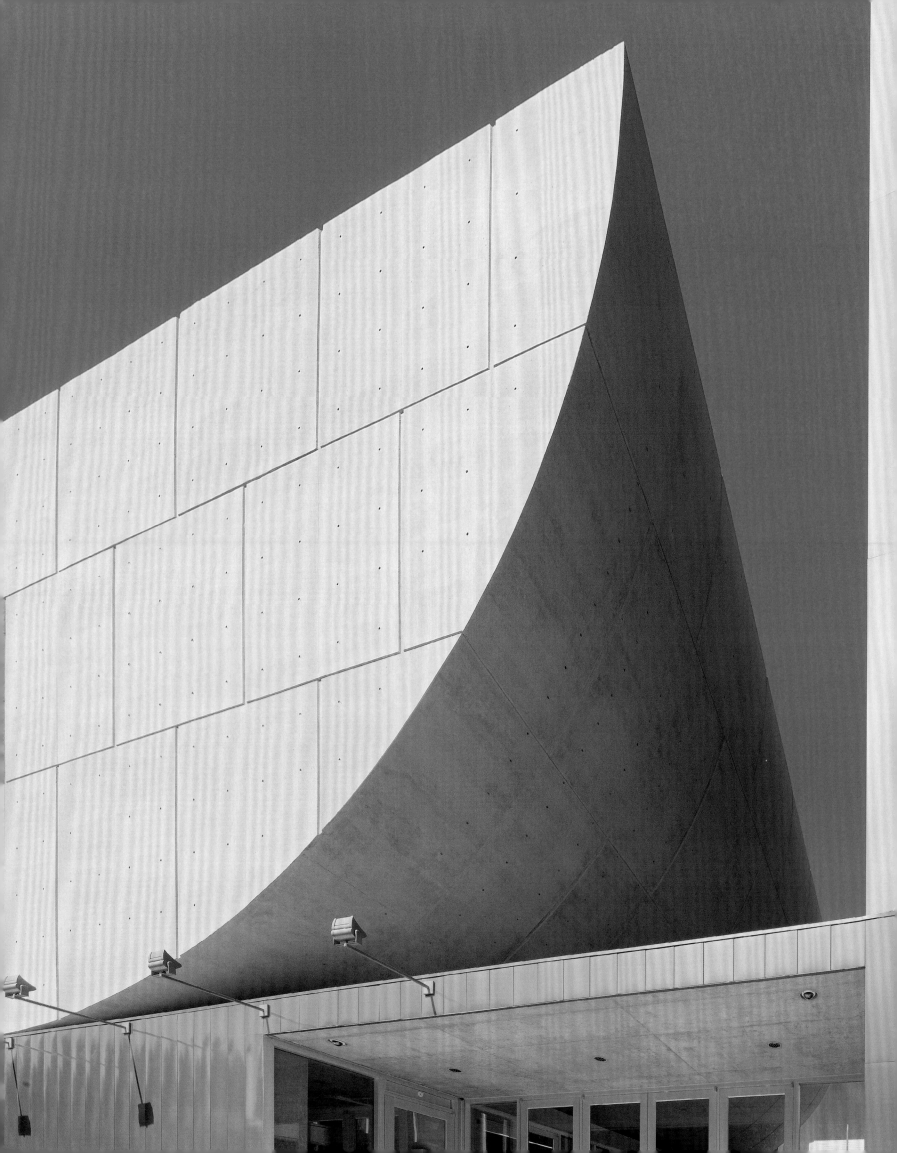

Congregation Beth Sholom, San Francisco, California (2008)

Responding to an urban environment with limited space, architect Stanley Saitowitz (b. 1949) created a bold sculptural form for San Francisco's Congregation Beth Sholom. The synagogue simultaneously respects and disrupts the urban street line, much in the tradition of the Solomon R. Guggenheim Museum and Marcel Breuer's Madison Avenue building that originally housed the Whitney Museum of American Art in New York. Saitowitz created an enormous, seemingly solid masonry "half-pipe" hall for the sanctuary space with a facade that recalls a menorah. The synagogue appears to rest heavily, but precariously, on a one-story base. The architect worked closely with Rabbi Alan Lew to design this spacious sanctuary. In terms of its dramatic form and lighting, the building is indebted to the work of architect Louis Kahn (1901–1974), including his unbuilt synagogue designs.

According to Saitowitz, "The entry sequence establishes the distinction of a sacred place through its passage. It is a circular journey of turning and rising and turning. The point of arrival is the courtyard." Still, the interior of this Conservative synagogue presents a shocking experience with its steep stadium-like seating that follows its curved contours. Worshippers face, or rather overlook, a large open space in the tradition of Sephardi and early American synagogues, rather than the big auditorium-style space typical of many modern synagogues. The unusual light that filters through the arms of the sanctuary's menorah-like shape contributes to a sense of quiet awe.

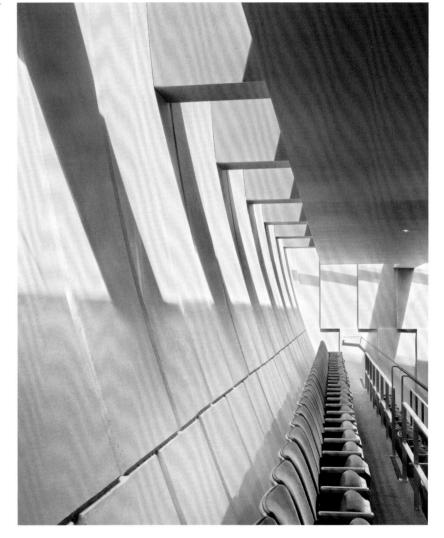

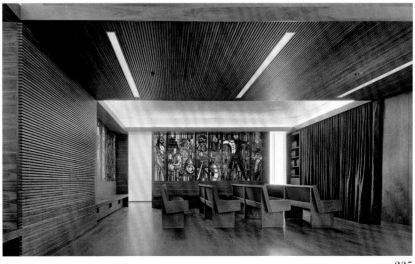

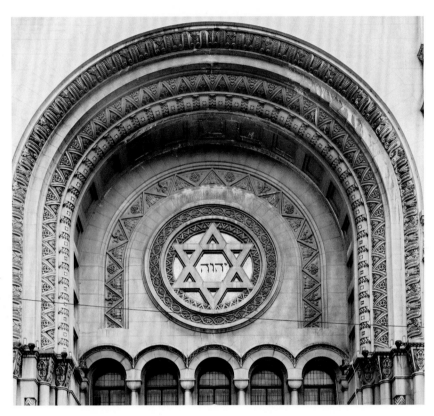

Templo Libertad (Congregación Israelita de la República Argentina), Buenos Aires, Argentina (1932)

Today, Argentina is home to the third-largest population of Jews in the Americas, most of whom are descended from refugees fleeing the Russian Empire and eastern Europe. The cornerstone of Argentina's oldest and largest synagogue, popularly known as Templo Libertad, was laid in 1897, but the building was not dedicated until 1932. The design, especially its long central nave with side aisles culminating in a dazzling apse on the eastern wall, derives from the neo-Romanesque style popular in Europe at the time. However, the facade and many of its details reflect the long elegant lines of art deco. In this, the synagogue recalls Temple Emanu-El in New York, completed just two years earlier. Designed by architects Alejandro Enquin and Eugenio Gantner, the exterior of Templo Libertad is dominated by an enormous arch that frames a Star of David. The sculpted Ten Commandments surmount the facade—a bold public statement of Judaism in a strongly Catholic country. The sanctuary seats a thousand worshippers. The nave, aisles, and galleries all face a rare Walcher organ on the eastern wall. Stained–glass ogival windows surmounted by roundels with Jewish stars located in the apse shed a brilliant light on this majestic hall.

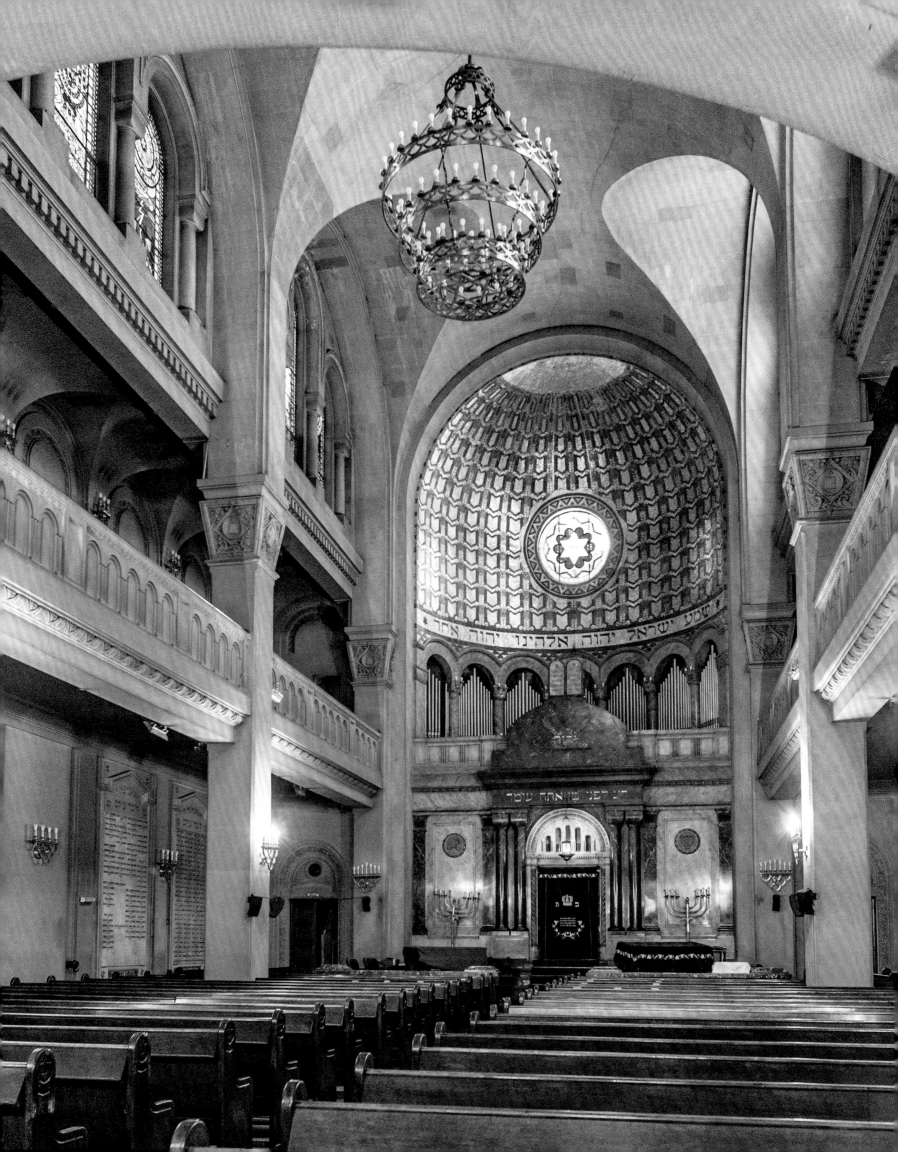

Right: Designed by Carol Ross Barney of Ross Barney Architects in 2008, the Jewish Reconstructionist Synagogue may be the "greenest" synagogue in the United States. It received a LEED Platinum certification for its reuse of 96 percent of the rubble from the previously demolished building and for its high-efficiency mechanical systems. Situated in Evanston, Illinois, the synagogue's deepest connection is to nature itself: trees seen through a glass wall behind the ark appear to bend their boughs in active worship.

In the twenty-first century, changing demographics and settlement patterns of Jewish communities are reshaping the map of active synagogues—leading to new architectural forms and redefining the function of synagogues. Perhaps the most extravagant and visually striking synagogues today are those of relatively recent Jewish immigrants—communities that originated in North Africa, the Middle East, and Central Asia. These new Americans are often drawn to building synagogues that replicate forms and motifs of their former houses of worship left behind in Iran, Iraq, Uzbekistan, or other countries.

For the most part, Jews now favor small, more modest synagogues with flexible spaces. In some cases, American Jews, who were raised in the suburbs but have relocated to newly revived city centers, are choosing to restore older synagogues. Increasingly, many congregations try to incorporate greater environmental sensitivity into their designs, such as the Jewish Reconstructionist Synagogue in Evanston, Illinois. The noted architect Carol Ross Barney (b. 1949) set the synagogue in a grouping of trees and built it with reclaimed wood and energy-saving systems. Some congregations prefer a more direct access to nature, as seen in Temple Emanu-El B'ne Jeshurun, located outside of Milwaukee and designed by Phillip Katz of Phillip Katz Project Development. All of these directions reflect the sensitivity of diverse Jewish communities to the needs of their congregants and, when desired, their ability to tap some of the most innovative architects working today. Despite the recent wave of anti-Semitism in America, these new buildings stand as beacons of hope, bringing to mind the words George Washington first expressed in his 1790 letter directed to the Touro Synagogue of Rhode Island, stating that the government of the United States "gives to bigotry no sanction, to persecution no assistance."

7

7. *Synagogues in Israel*

Michael Levin

A rare surviving image of the Second Temple in Jerusalem appears on a small silver tetradrachm coin from 135 CE (see Introduction, page 15). It features the Temple's facade framed by two pairs of pillars standing before the Ark of the Covenant with its biblical scrolls. Thanks to this and other evidence, archaeologists have succeeded in constructing a model of Herod's destroyed Temple, now on display at the Israel Museum in Jerusalem, thus shedding light on one of the early prototypes of a Jewish house of worship in Israel. From the time of the destruction of the Second Temple in 70 CE to the present, Jews have continued to build remarkable synagogues in the Holy Land. In Israel today, there are more than ten thousand synagogues, not including the classrooms and other spaces where a minyan might meet. However, the country's ever-changing historical and geopolitical situation has led to a wide discontinuity in synagogue design. To date, no single authoritative architectural form, style, or plan based on biblical statutes or archaeological evidence has come down to us.

In the nineteenth century, information on the early synagogues of Israel began to emerge, thanks to the excavations of German and British archaeologists. As most of the ancient synagogues known today have been excavated and studied by Israeli archaeologists starting only in the 1920s, these monuments have not served as inspirational models for new synagogues in Israel. Throughout their history, Israeli synagogues have mostly reflected the architectural styles characterized by their surroundings rather than a unique prototype. Both before and after the State of Israel was established in 1948, new Jewish emigrants in the twentieth century often reproduced synagogues from their former communities, or at times, gathered together in a common building that reflected different traditions. Overall, architects in modern Israel have had greater artistic freedom than their counterparts in designing sanctuaries for non-Jewish communities. This freedom, as we shall see, has led to an extraordinary variety of synagogue designs and some beautiful and daring new buildings. It is interesting to note that when secular public structures are built in Israel with the intention of emphasizing their spiritual content, architects often borrow from the world of synagogues.

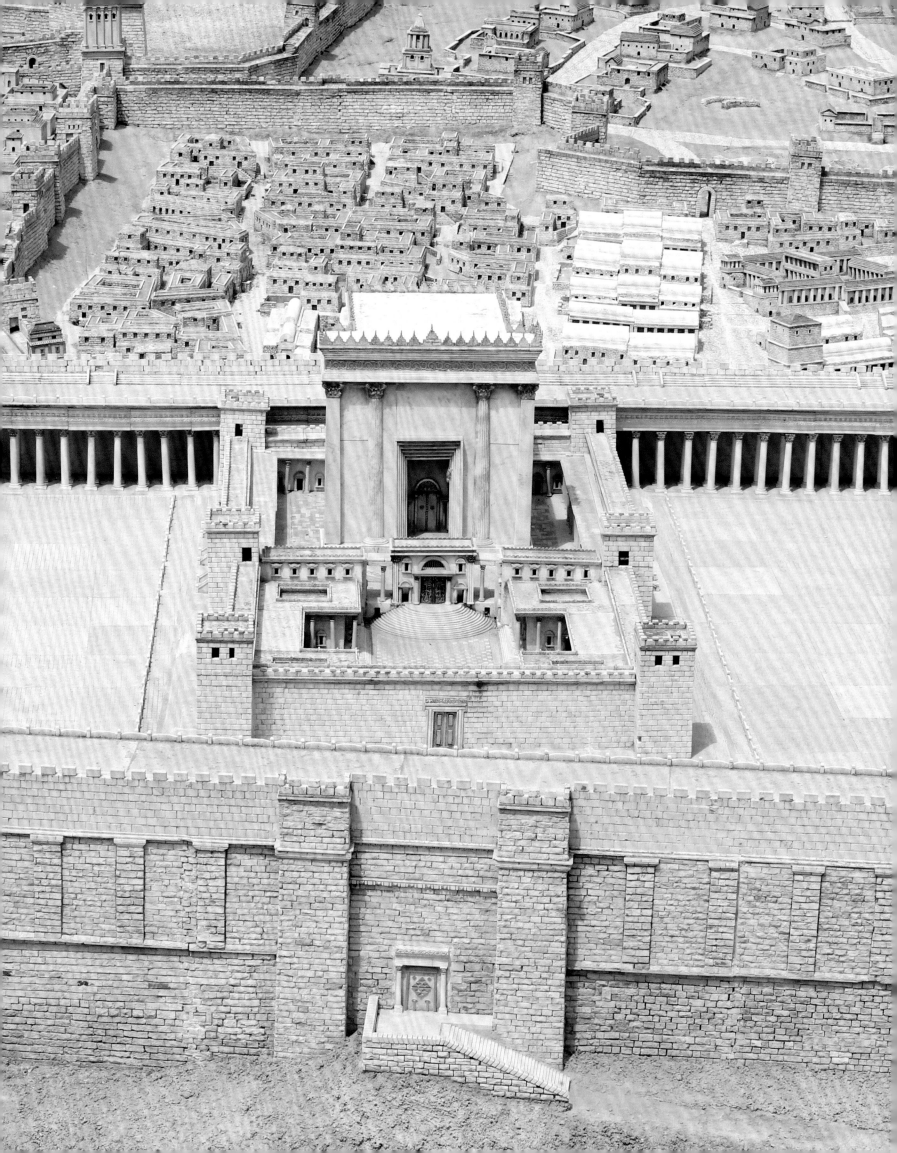

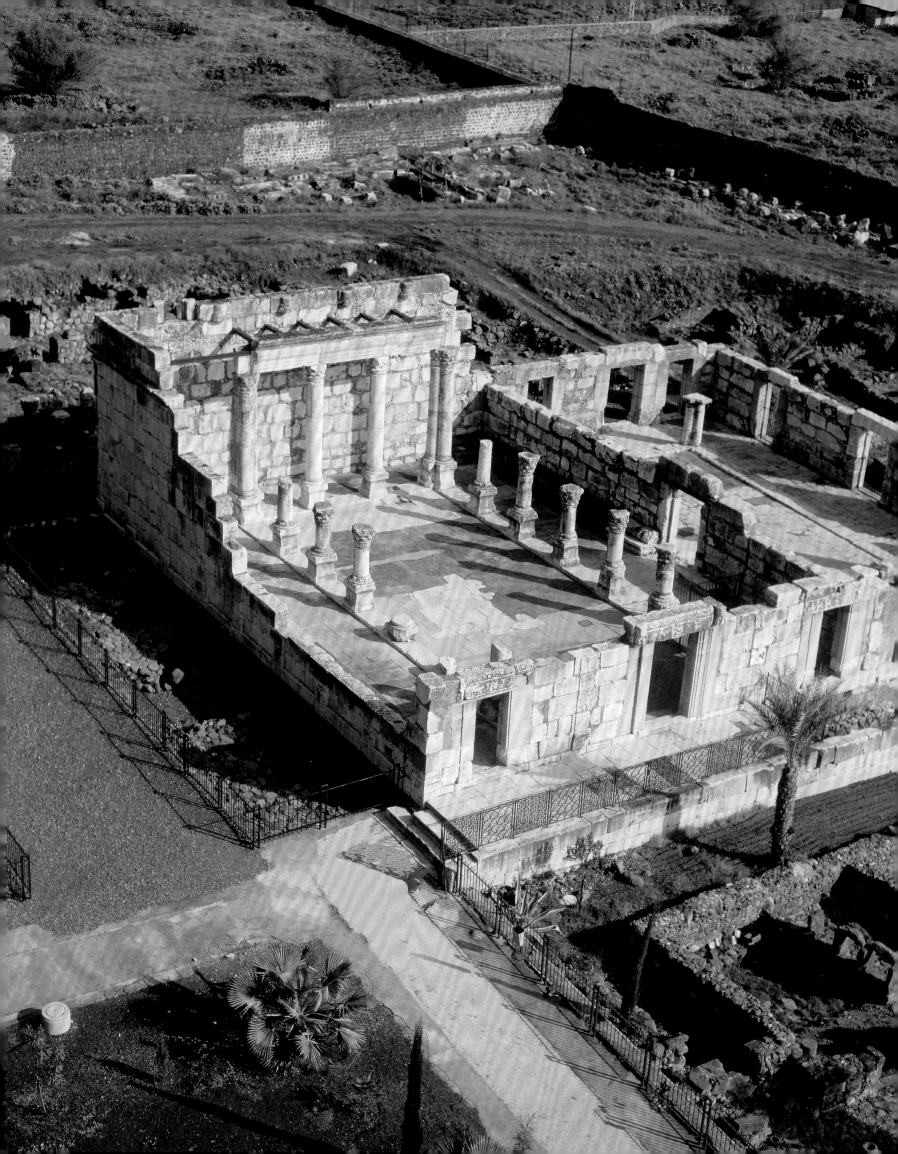

Synagogue Orientation Towards Jerusalem and the Temple Mount

As of the third century CE and to this day, many synagogues both in Israel and abroad have been oriented toward the Temple Mount in Jerusalem, where the Second Temple once stood. Typically, the monumental synagogue in Kfar Nahum (Capernaum) faces east. This basilica-shaped structure, built between the third and fourth centuries CE on a mound overlooking the Sea of Galilee, would direct worshippers to look toward the ark and the landscape beyond, which stretches all the way to Jerusalem (although the distance is too great to allow them to actually see the Temple Mount). One of the reliefs decorating the Kfar Nahum synagogue depicts the Ark of the Covenant, which had served as the focus of prayers from the time the Jews wandered in the desert until the founding of the First Temple ca. 1000 BCE. This synagogue also features a Star of David as a geometric ornament. However, the Magen David was first recognized as a symbol of Jewish faith in the late Middle Ages, and it only became a universal emblem in the nineteenth century. In the Galilean synagogues, there was no fixed place for the Torah scrolls, which were frequently placed on a movable base.

The Karaite Synagogue in the Old City of Jerusalem provides another early example of the importance of orientation toward the Temple Mount. The oldest surviving synagogue in active use in Jerusalem, this small stone building was erected in the ninth century CE by the Karaite community under the Muslim Abbasid dynasty. Destroyed by the Crusaders, it was continuously rebuilt until it was finally restored in 1977 and 1981. Currently below street level, this intimate synagogue just a stone's throw from the Temple Mount follows a medieval square plan with a multi-vaulted ceiling. Today, services are still held by the small but active congregation of the Karaite denomination.

Following the founding of Israel, a number of architects aspired to preserve the Galilean tradition of incorporating the "view" of the Temple Mount as a central motif. In the Reform synagogue at Hebrew Union College (1963), the architect Heinz Rau (1896–1965) installed an external, monumental staircase that provided a splendid view of the Temple Mount, which at that

בית כנסת ע"ש הכט
THE HECHT SYNAGOGUE

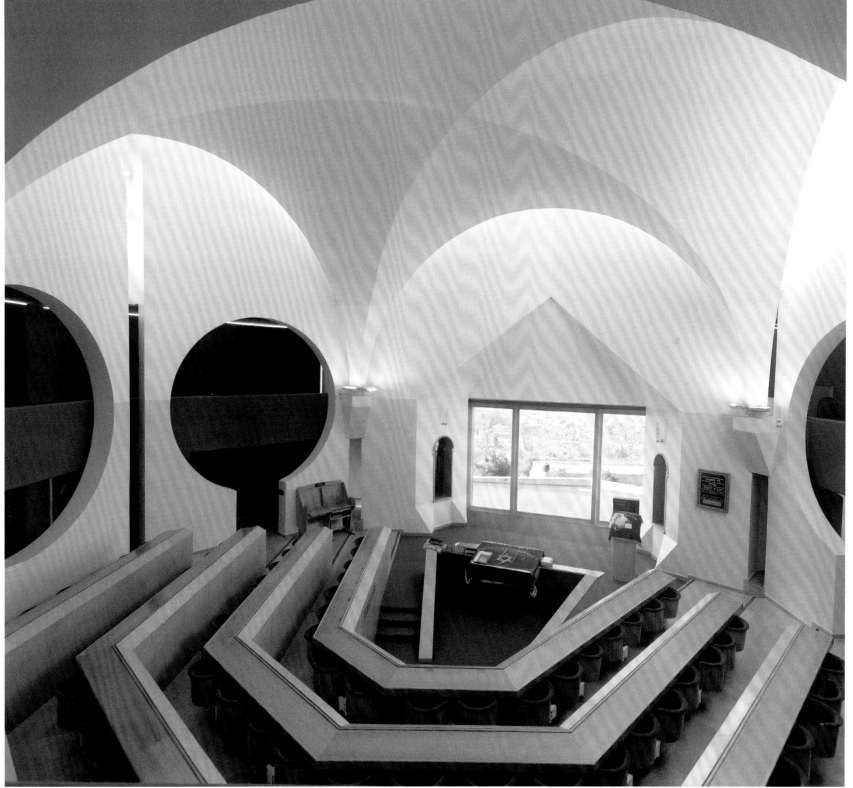

Below: The Hurva Synagogue's massive dome, which is supported by four giant piers, rests on the ruins of the seventeenth-century synagogue and, in turn, on the foundations of two first-century mikvahs.

Opposite: Regarded as "the most beautiful and important synagogue in Palestine in 1864," the Hurva Synagogue in Jerusalem was built for the Ashkenazi community by Assad Effendi, the sultan of Egypt's personal architect, with support from prominent Jews around the world. Destroyed during the Israeli War of Independence, the current reconstruction from 2010 reflects its earlier famed neo-Byzantine iteration.

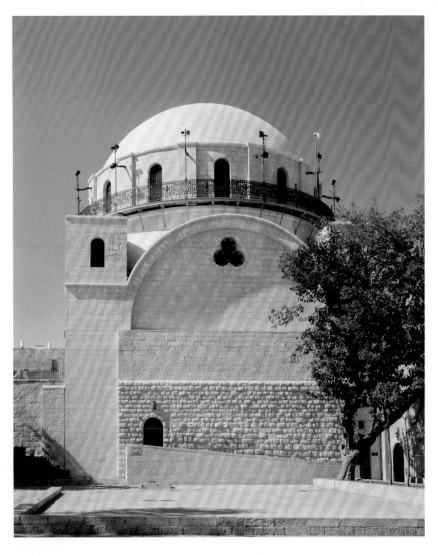

time was inaccessible but still visible. In the Hecht Synagogue (1981) on the Mount Scopus campus of the Hebrew University, architect Ram Karmi (1931–2013) centered his design on an immense window that faces the magnificent sight of the Old City, dominated by the Temple Mount. He placed the holy arks on either side of the great window, framing the Mount to provide what he deemed as the key spiritual experience for worshippers. For the rebuilding of the historic Hurva Synagogue in Jerusalem, the American architect Louis Kahn (1901–1974) proposed not only a monumental structure overlooking the Temple Mount but also an architectural pathway to the Western Wall in plans drawn up between 1968 and 1974 that were unfortunately never realized. However, for many years, Kahn's plan was a focal point for debates on how a contemporary synagogue should look.

Defining the Sacred: The Hill and the Dome

Synagogues in Israel typically lacked external characteristics that marked them as places of worship, such as bell towers or minarets, but a number were situated on high places so that they would preside over the skyline. In other cases, synagogues were deliberately nestled among nearby buildings to keep a relatively low profile. Frequently, it was the attitude of the powers ruling the Holy Land at any given time that determined the prominence of a synagogue's site. In certain periods, such as the late Roman Empire at Capernaum, Kefar Baram, and Chorazim, and occasionally under the Ottoman Empire, these governments permitted synagogues greater visibility, although at other times, they did not allow synagogues to be higher than the surrounding buildings, especially their own houses of worship. In the Ramban Synagogue, built in the eleventh century and inaugurated in 1267—the most important of the four synagogues of Jerusalem's Jewish quarter—the floor was lowered to accentuate the height of the ceiling without increasing the building's overall stature. The windows faced only the inner court, which was surrounded by the other three synagogues with lowered floors. For the same reason, the bell tower of the Church of the Holy Sepulchre in Jerusalem was reduced in height by the Muslim rulers. In our time, however, the location and shape of each synagogue is determined, of course, by the unique needs of the communities, the environment, and Israeli construction laws.

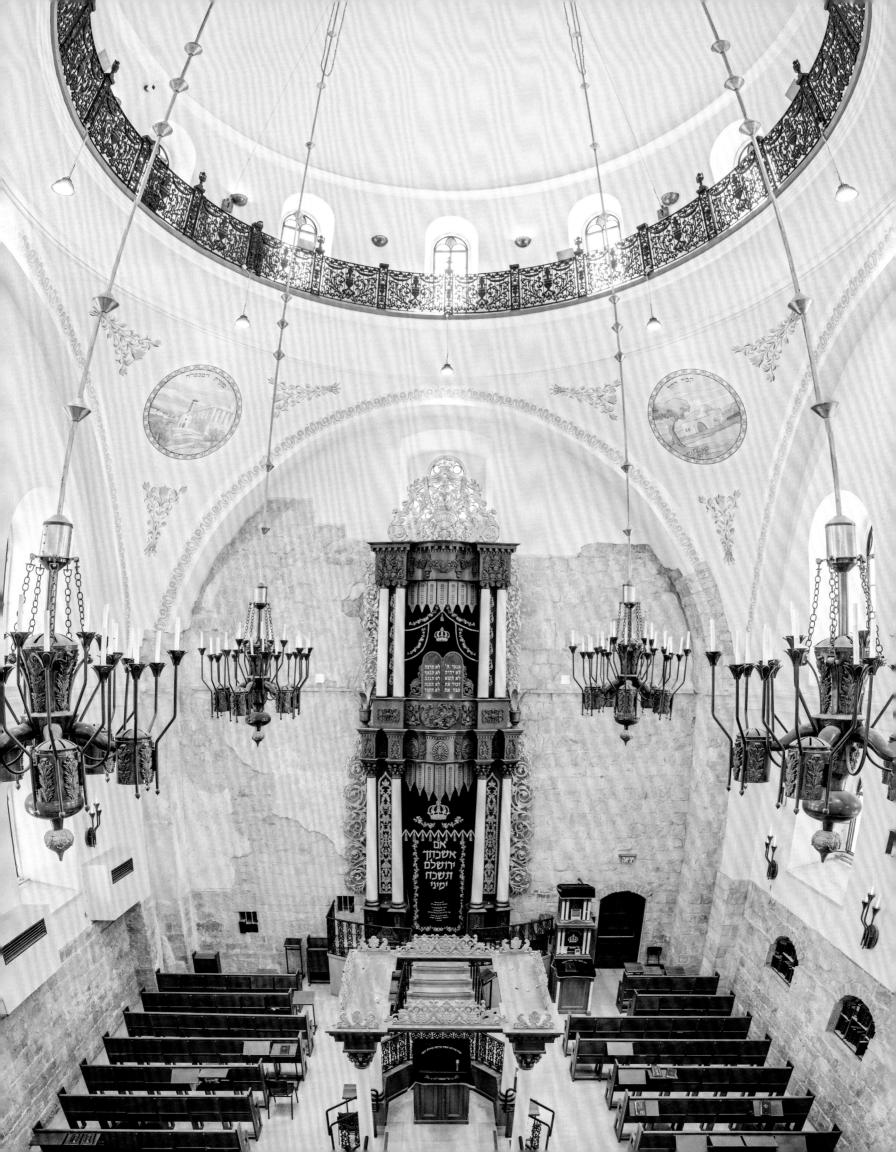

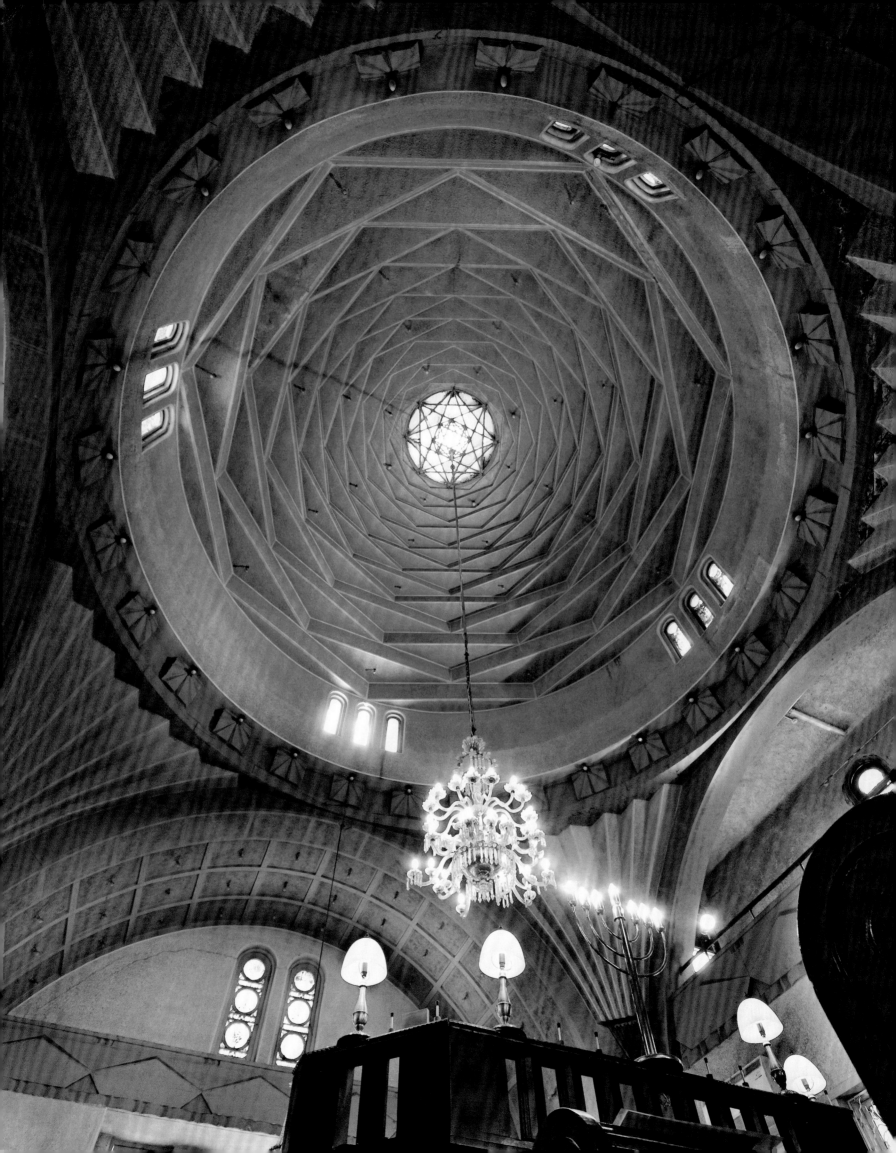

Although few original synagogue domes built before 1948 have survived in Israel to this day, they are a key feature of many synagogues both in Israel and around the world. Beautiful and complex structures, domes have long served to draw attention to a building's eminence and sacred function in Judaism, Islam, Christianity, and Buddhism. Thanks to powerful backing, the Tiferet Israel Synagogue (1858, destroyed in 1948) and the second iteration of the Hurva Synagogue (replaced in 1864, destroyed in 1948) were built in Jerusalem in the nineteenth-century Ottoman style with large domes that stood out in the skyline alongside the Dome of the Rock and the Church of the Holy Sepulchre. Supported by powerful pendentives in four corners, these domes took their inspiration from ancient Byzantine and Turkish structures in Istanbul. After the second Hurva Synagogue was destroyed during the War of Independence in 1948, as mentioned earlier, Louis Kahn drew up elaborate plans for a new building that included shifting patterns of light based on his idea that "no space, architecturally, is a space unless it has natural light." Following Kahn's concept, the British architect Sir Denys Lasdun (1913–2001) proposed to combine the remains of the old structure with a new building to enhance its authenticity, but that plan was also sadly rejected. Eventually in 2010, the Hurva Synagogue was restored based on old photographs and models, presenting an immense central dome that serves as a beacon in the cityscape. Within, it is ringed by a small wrought-iron balcony and a row of windows that floods the sanctuary with bright daylight.

Today, many synagogue domes have been modified and modernized by altering their shapes or employing novel construction materials. Sir Patrick Geddes (1854–1932) had originally planned that the main structure of the Mount Scopus Hebrew University Synagogue would feature a huge hexagonal dome serving as the spiritual heart of the campus. However, this was never constructed; instead his son-in-law Sir Frank Charles Mears (1880–1953) and Benjamin Chaikin (1885–1950) capped the university's National Library with a smaller dome in 1925–30, following a plan by Geddes.

Joseph Berlin (1877–1952) and Richard Pacovsky (1887–1981) designed an unusual dome for the Sephardi synagogue of Ohel Moed on Tel Aviv's Shadal Street in 1927. From the outside, the dome appears round, yet from inside, the concrete ribs stacked one over the other in a weblike fashion create a unique visual experience. Its Byzantine-style pendentives connect the circular hemisphere to its square base. The exterior of this building has been clad with stone—an unusual practice in Tel Aviv—perhaps as an allusion to ancient Jerusalem. Erich Mendelsohn (1887–1953), one of the most important Jewish architects in the first half of the twentieth century, planned many domes both in Israel and abroad. In Cleveland, Mendelsohn created a monumental dome for Park Synagogue (dedicated in 1950, see Chapter Six, page 220) to highlight its significance as an important Jewish structure. The new campus of the Hebrew University in Givat Ram, designed by Heinz Rau and David Reznik (1924–2012) in 1957, presents a modern example of the use of two traditional elements: the dome and the ark. In addition, going against the city codes that required the use of stone cladding, the architects chose white-washed reinforced concrete for this striking university synagogue dome.

For the innovative Shrine of the Book (inaugurated in 1965) on the Israel Museum campus, Frederick Kiesler (1890–1965) and Armand Bartos (1910–2005) designed another unusual dome. While this building is not a synagogue per se, it was built to display the Dead Sea Scrolls and the Book of Isaiah, the oldest extant biblical books. The low, flattened dome shape with articulated ribs mimics the form of the vessel in which the scrolls were originally found.

Alternative Synagogue Forms

While synagogues in Israel generally follow a specific orientation, and occasionally feature a dome, their overall form developed with great freedom and invention—whether the square shape as seen at Masada and Gamla or the basilic building in the early sanctuaries of Chorazim, Baram, and Capernaum (see Chapter One), the circular design of Hebrew University's synagogue in Givat Ram, or even the semicircular plan of the Yeshurun Synagogue in Jerusalem. During the 1960s in the city of Be'er Sheva, architect Nahum Zolotov (1926–2014) went so far as to build a synagogue in the shape of the Star of David made from reinforced concrete. Knafo Klimor Architects surpassed many of these designs in their daring creation of the gemlike Scroll of Light Synagogue in Caesarea (2007). Its spiral design reflects the architects' view of the cyclical nature of Judaism through time. According to their statement, "The hub of the scroll's junction forms the prayer hall, isolated from its surroundings by the lack of direct visual contact with anything else. The isolation transforms the place into a microcosm where the strongest force is that of the light penetrating the building through openings in the ceiling. This hidden light washes over the curved walls that come together towards the Holy Ark. The ark hovers over a pool of water and is lit by a soft indirect light that is reflected in the pool. The place's symbolism as a 'Scroll of Light' aims to emphasize the meaning of the creation of light as the foundation of life and as a symbol of truth, knowledge, and hope."

Light as a Means to Induce Sanctity and Spirituality

Light has always served as an important means to create an atmosphere of spirituality in synagogues. Today, along with natural light, traditional oil lamps, chandeliers, and translucid materials, new forms of artificial light have become a major design feature in synagogue architecture.

In the tradition of Christianity and Islam, some synagogues have also adopted the splendor of stained glass. Hadassah Hospital Synagogue, in Jerusalem's Ein Karem neighborhood, commissioned artist Marc Chagall in 1962 to create a series of large stained-glass windows executed by expert artisans as the main element of its design. The artist chose the Twelve Tribes of Israel as his central motif, placing them inside concrete arcs. The brilliant hues change as the sun moves along its path, lighting alternating windows at different times of the day. Chagall was disappointed that the windows were installed in such a small, low building, which was designed by Joseph Neufeld (1899–1980) at the center of the Hadassah campus. Twenty years later, the large synagogue of Hechal Shlomo commissioned windows by the Swiss artist Régine Heim, who created dazzling abstract patterns of fuchsia, vermilion, purple, and flame colors that are set in a more conventional installation, similar to the placement of stained glass in churches.

The Cymbalista Synagogue and Jewish Heritage Center at Tel Aviv University (built between 1996 and 1998) also uses light and materials to produce exceptional effects. This cutting-edge Swiss architect Mario Botta (b. 1943) designed two massive towers shaped like binoculars made from golden Verona ashlar blocks. The severe cone-shaped towers are narrow at the base and flare out gradually. They are linked by a lower, stark rectangular building that houses a lobby and prayer halls. Around each tower, Botta set a ring of tiny cubic apertures providing a minimalist form of decoration, and above them, a series of semicircular windows at the roofline. An interior canopy projecting from the ceiling serves to diffuse and mute the sunlight, creating a fascinating play of light and shadow. Whereas daylight enters from the outside to illuminate the building, at nighttime, the light from inside pours out, turning the towers into huge lanterns. In the very minimalist prayer halls, the use of expensive and rare materials, such as alabaster and blond wood, enhances the sense of sanctity. One tower houses an Orthodox synagogue, and the other can be used by Conservative and Reform Jews for prayer in their preferred style. This space also serves as a meeting place for discussions and lectures on religious as well as secular issues.

In the tiny hundred-seat synagogue at the Hebrew University in Givat Ram (1957), light enters from below the mushroom-shaped concrete dome. In the Shrine of the Book mentioned earlier, visitors walk along a dark corridor leading to the main hall, which is then lit like the Roman Pantheon through its oculus.

Below: An icon of modernist architecture, the lid-shaped dome of the Shrine of the Book embodies the caps of the clay jars that sealed the Dead Sea Scrolls. Designed by Frederick Kiesler and Armand Bartos and inaugurated in 1965, this shrine houses some of the oldest records of the Hebrew Bible, which were discovered at Qumran in 1947 (Israel Museum, Jerusalem).

Pages 256–57: The interior of the shrine centers on the seven original papyri displayed in a roller-shaped case and topped by a finial, suggestive of a Torah scroll. Natural light from the dome's oculus creates an aura of sanctity.

Pages 258–59: Marc Chagall designed twelve windows for the Abbell Synagogue, which is in Jerusalem's Hadassah Hospital, each depicting one of the tribes descended from Jacob. On their completion in 1962, he declared, "All the time I was working, I felt my mother and father looking over my shoulder; and behind them were Jews, millions of other vanished Jews. . . ." For the windows, his team developed a new polychrome process that avoided lead strips between colors.

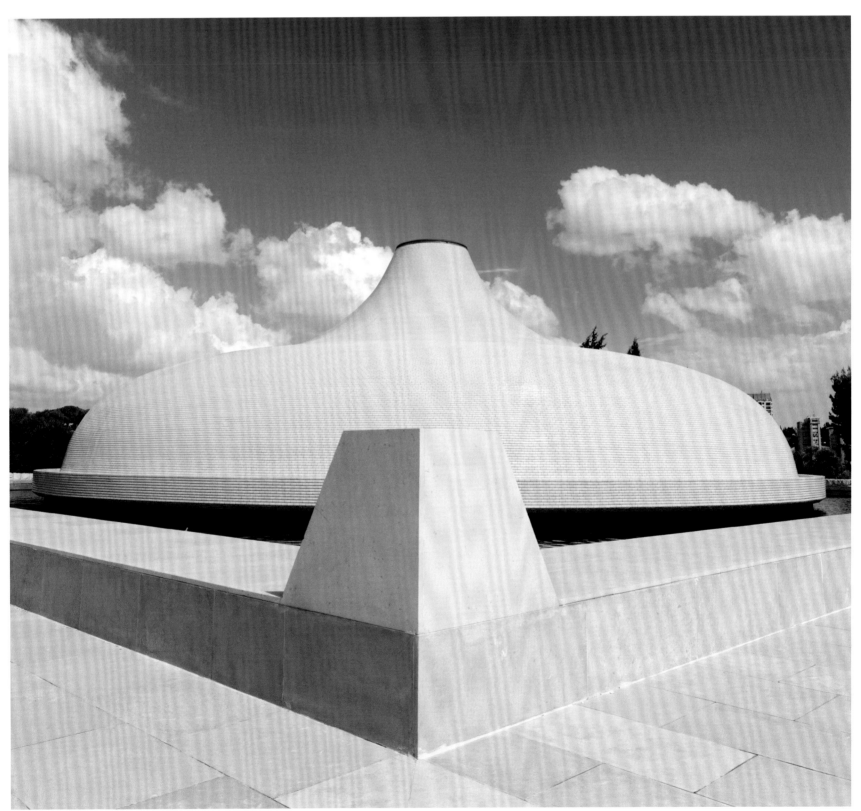

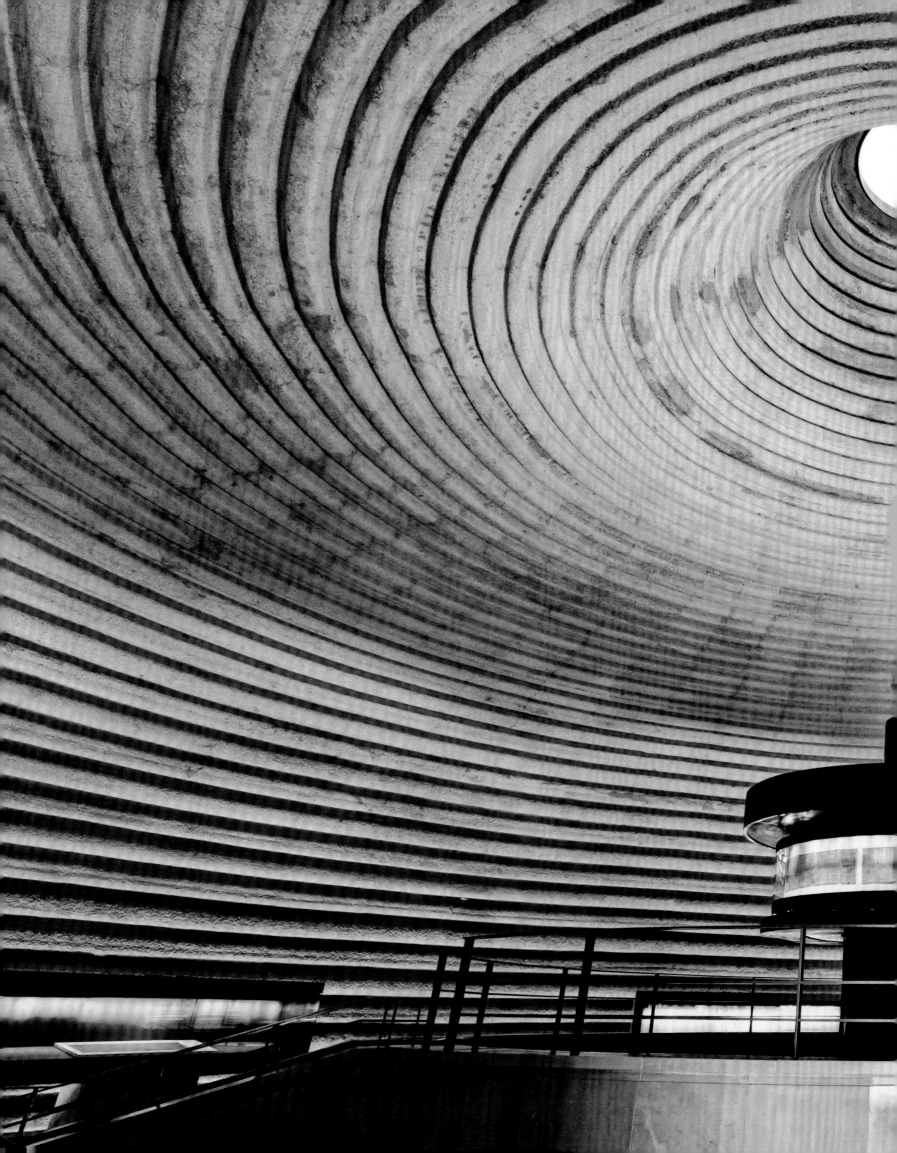

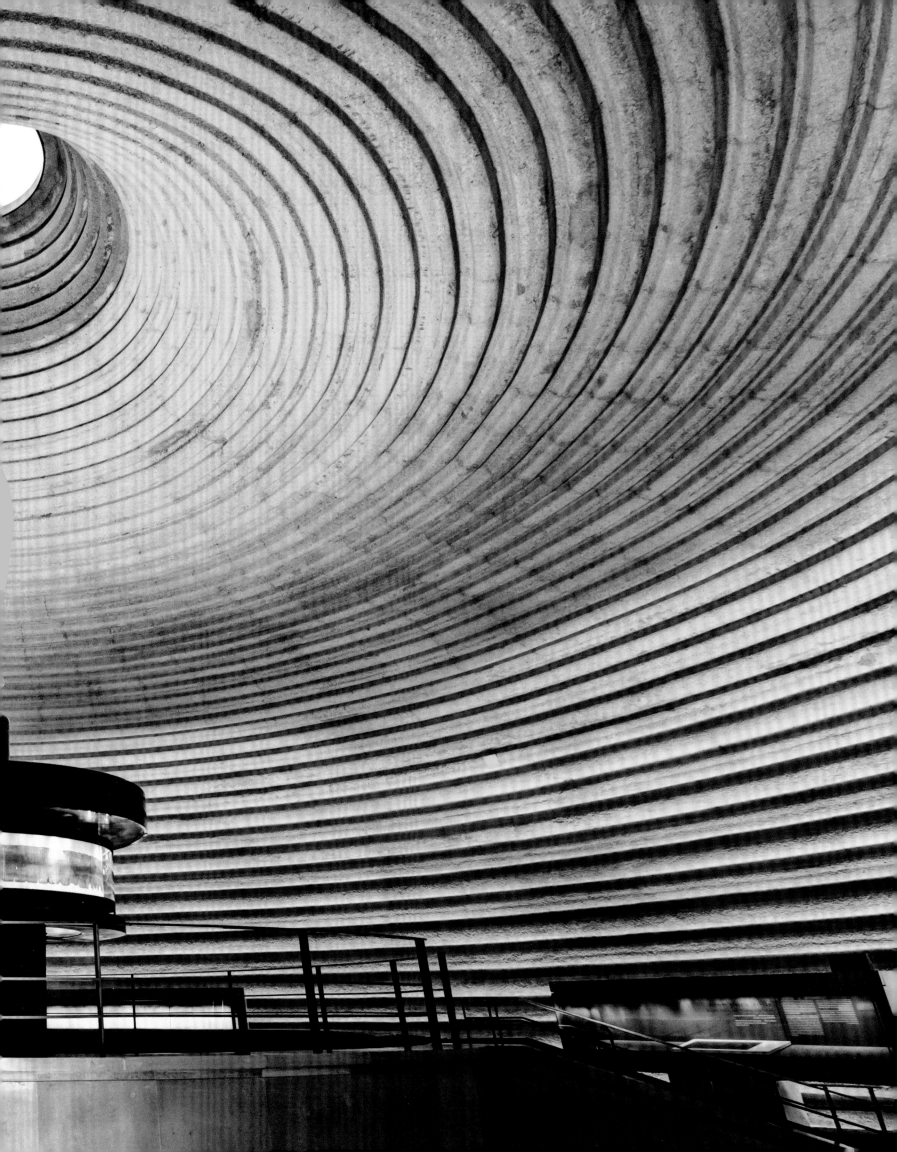

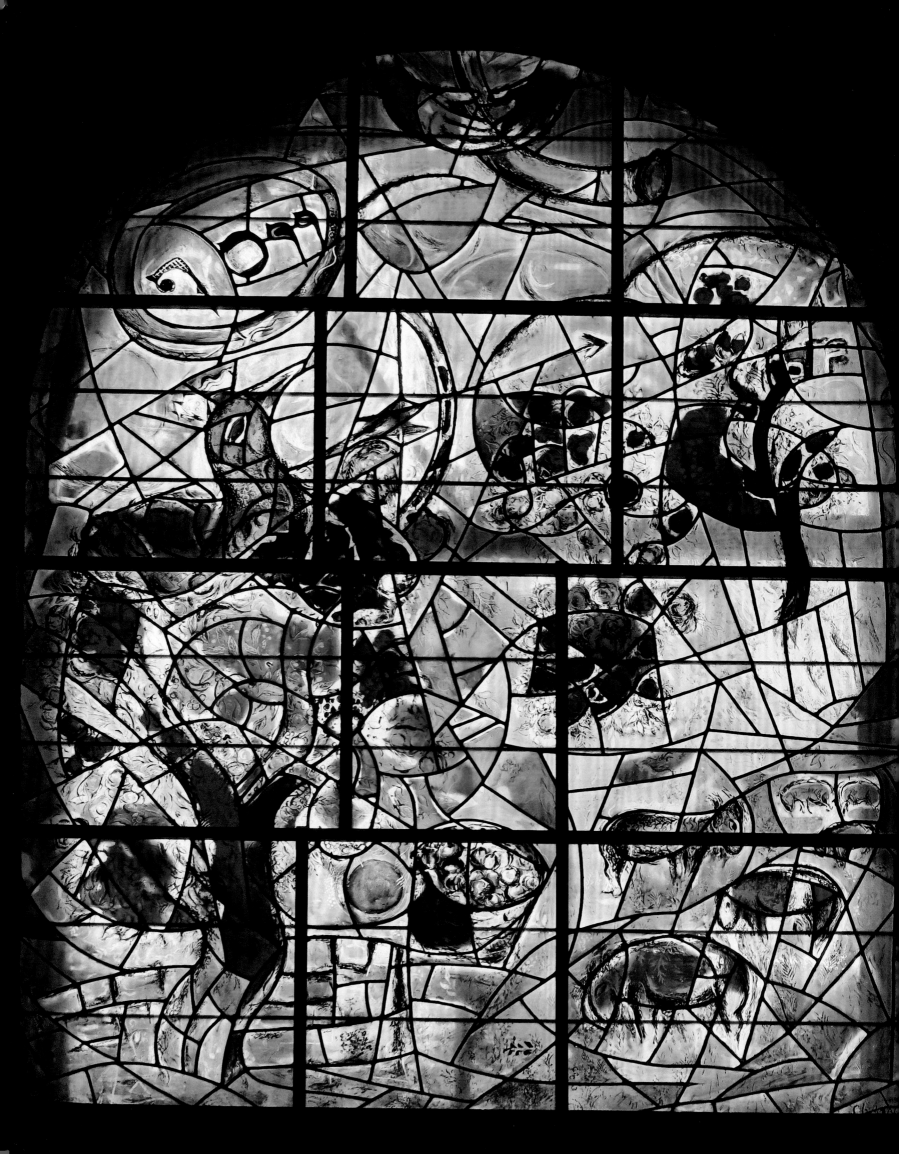

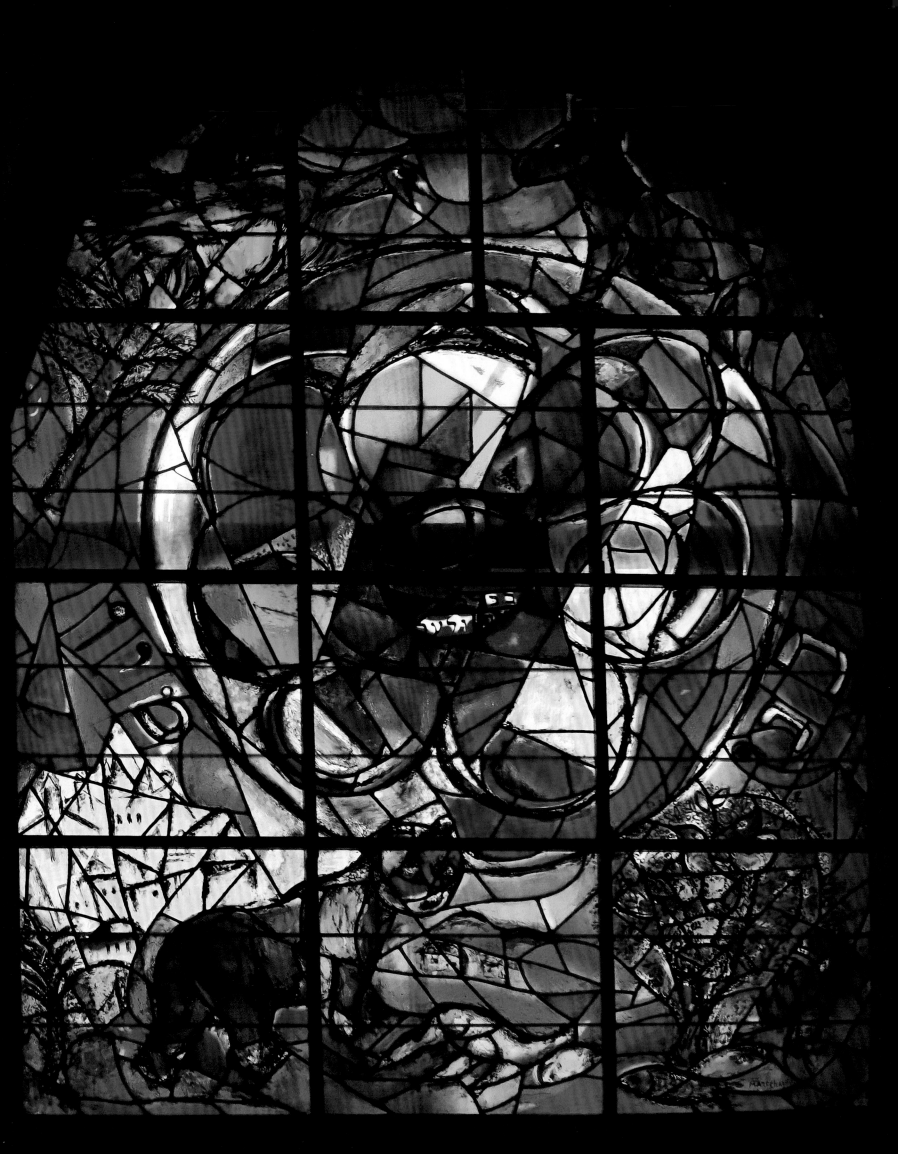

Below and opposite: Earth, water, and sky provide a minimalist setting for the Scroll of Light Synagogue, designed by Knafo Klimor Architects (2007). Its elegant white spiral form wraps around an olive tree and pool, which serve as focal points for the spare interior of this small sanctuary.

Opposite: The stark interior of the Cymbalista Synagogue (1998) designed by Mario Botta at Tel Aviv University, deploys a hung ceiling to mediate the flow of daylight. The austerity of the sanctuary contrasts with the high-end wood furnishings and the opaque alabaster Torah ark.

Pages 264–65: The dramatic twin towers of the Cymbalista Synagogue house two distinct sanctuaries united by a common entry with reception halls. The massive redbrick towers rise from the ground on a square base and gradually transform into a textured circular form that has a bold, chimney-like physicality.

Zvi Hecker (b. 1931) and Alfred Neumann (1900–1968) designed a radically different form of synagogue at the IDF Officer School in Mitzpe Ramon in 1969–71. They proved that it is possible to create a sense of sanctity even inside an exposed concrete structure built of modular, prefabricated units, which were placed on-site. The rigorous concrete shapes were painted green, yellow, and gray to contrast with the more monochrome desert landscape. Light penetrates the building through three small openings in the walls and in the roof. The windows do not allow direct sunlight inside, but occasionally the rays that enter diverge to form a colorful spectrum. An alcove that protrudes from the outside wall indicates the position of the holy ark on the side closest to Jerusalem.

The interior design of synagogues has long functioned as an important means of proclaiming Jewish identity and adding additional layers of meaning to the religious experience. In many ancient synagogues in Israel, mosaic floors depict human figures in the zodiac and the seasons of the year. A surprising archaeological find in the 1930s was the sixth-century mosaic floor in the Beit Alpha Synagogue with depictions of an ark presented as an architectural front with columns supporting a gabled roof (which some people believe represents the front of the Second Temple), holy vessels, two menorahs, a shofar, a firepan (also known as a *machta* for sweeping away ashes or spreading incense), birds, lions, and an illustration of the zodiac as well as a representation of the sacrifice of Isaac. At first, the Beit Alpha mosaic imagery was believed to be the rare expression of a marginal Jewish sect. Today, archaeologists mostly agree that these images reflect mainstream Jewish beliefs regarding representation at that time. Moreover, verses from the Talmud confirm that during this period, some rabbinic leaders did not prohibit the use of human imagery. This is at variance with the strict interpretation that prevailed at other times concerning the prohibition of making of any "graven image," in accordance with the Second Commandment. It appears that not only was the representation of biblical scenes and objects in synagogues permitted for several hundred years but also that stepping on them when featured within mosaics was allowed as well—unlike in churches of the period, where figural decoration appears primarily on the walls.

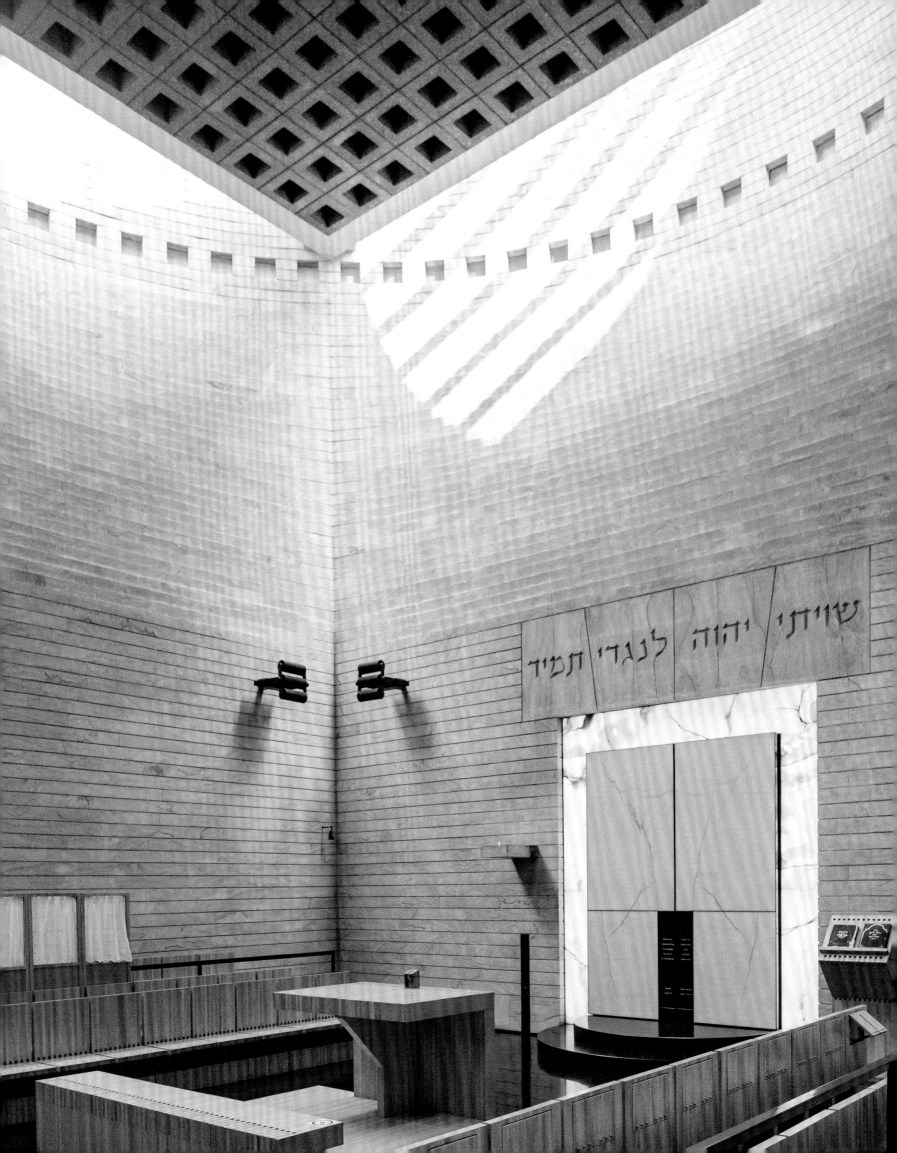

THE CYMBALISTA

While it is not common practice to represent human images in synagogues today, the menorah, the Twelve Tribes of Israel, and the Seven Species of plants and fruits (Deuteronomy 8:8) do appear on such liturgical objects as ark coverings and wall ornamentation—as seen in the colorful murals of the Abuhav Synagogue in Safed. Rabbi Abuhav was a Spanish Kabbalist in Toledo who had never actually visited Safed. In the sixteenth century, exiles from Spain brought a scroll inscribed by the rabbi to a synagogue in Safed, which later became known as the Abuhav Synagogue. In accordance with the Kabbalah tradition, the design of the synagogue has numerical significance. The first six steps of the bimah represent the working days of the week, while the seventh and highest stands for the Sabbath. The earthquakes of 1759 and 1837 damaged the building. The new dome of the synagogue was redecorated in the nineteenth and twentieth centuries with musical instruments (alluding to music played by the Levites in the Temple) as well as symbols of the Twelve Tribes of Israel. It also features the five crowns, which reference in turn: kingship, priesthood, the Torah, good standing, and the forthcoming redemption (this last crown, which does not appear in the Talmud, represents a dominant belief of the sixteenth-century Safed). A painting of the golden Dome of the Rock adorns the synagogue entrance referring to "the site of King Solomon's Temple." The secular artist Siona Tagger, born in Jaffa in 1900, contributed several paintings to the synagogue.

At the Ades Synagogue (established by Syrian immigrants in 1901 in Jerusalem's Nachlaot quarter), the large ark made of walnut and covered with intricate geometric motifs inlaid with mother-of-pearl reflects the design and heritage of its founders. The mural representations of the Twelve Tribes of Israel along the upper part of the wall were painted several years after the founding of the synagogue by students of Ya'acob Stark, a teacher at the Bezalel Academy of Arts and Design, who specialized in designing the Hebrew letters as a source of decoration. The murals faded and were restored in 2015. The Heichal Shlomo Synagogue in Jerusalem (constructed between 1958 and 1963) prominently features the Tablets of Stone representing Judaic law in the form of two abstract stone rectangles on the top of its 1960s modern facade.

Below: View of the modest exterior of the Abuhav Synagogue, founded by the followers of a Kabbalist rabbi from Toledo in the fifteenth century.

Opposite: The current late-nineteenth-century restoration of the Abuhav Synagogue in Safed surprises with its painted murals, which are alive with Jewish symbols that reference the Kabbalist rabbi's teachings.

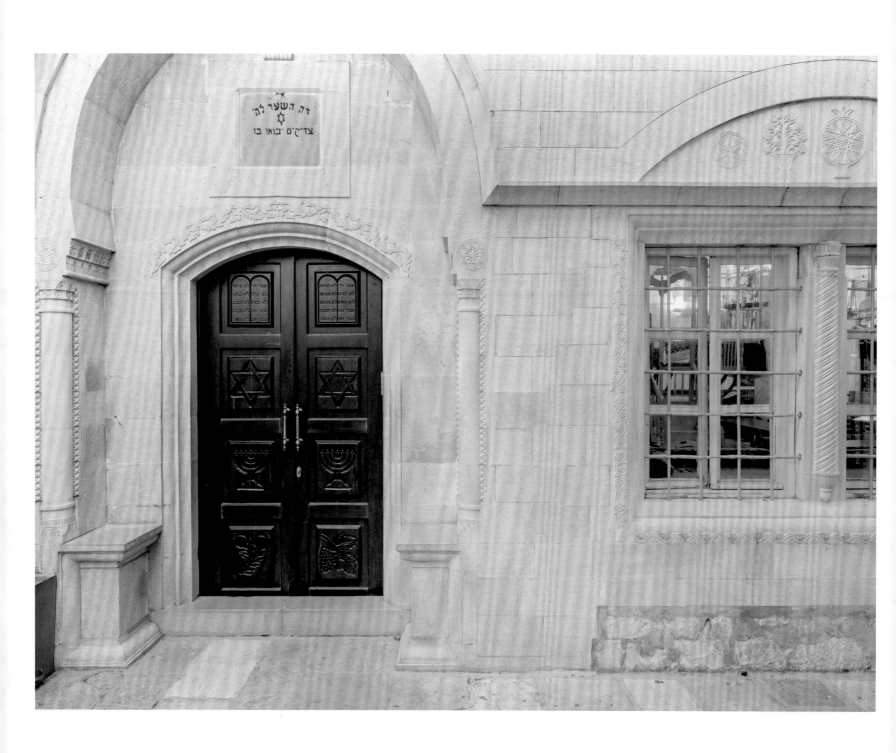

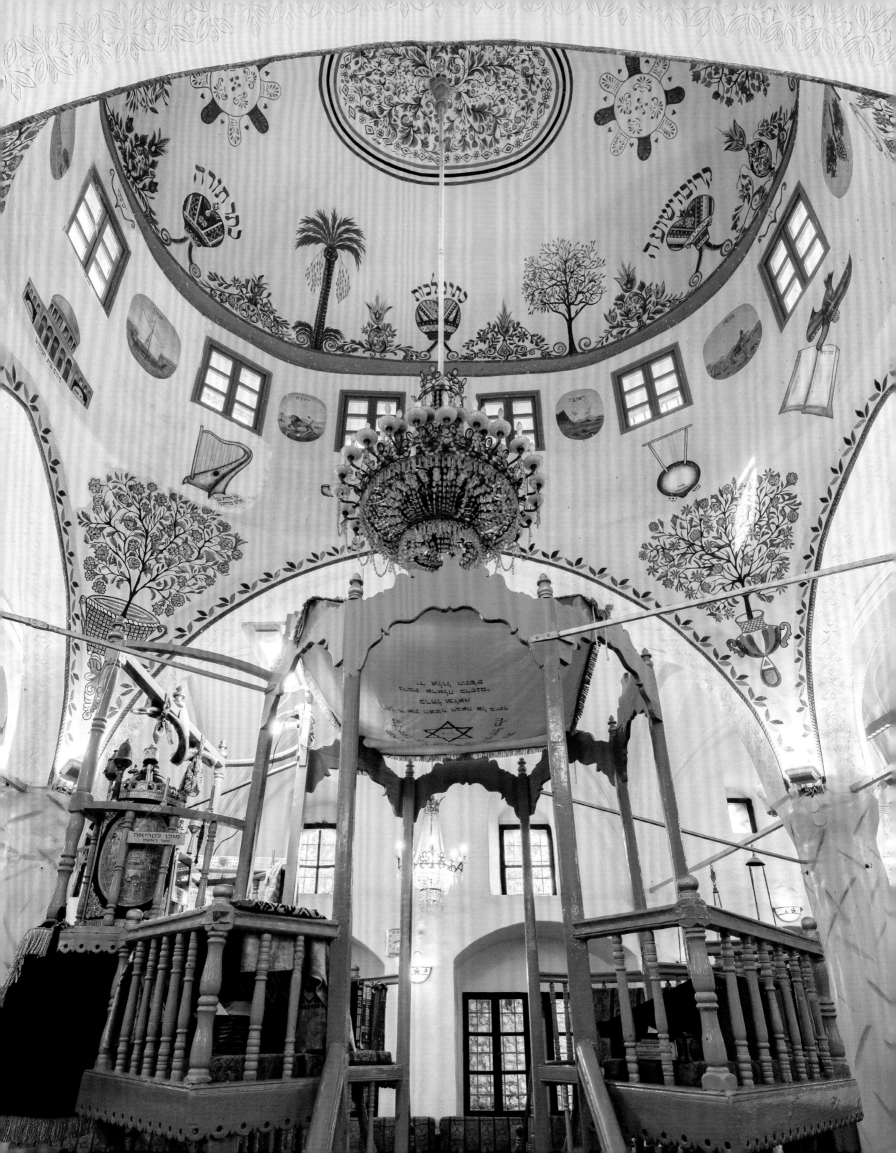

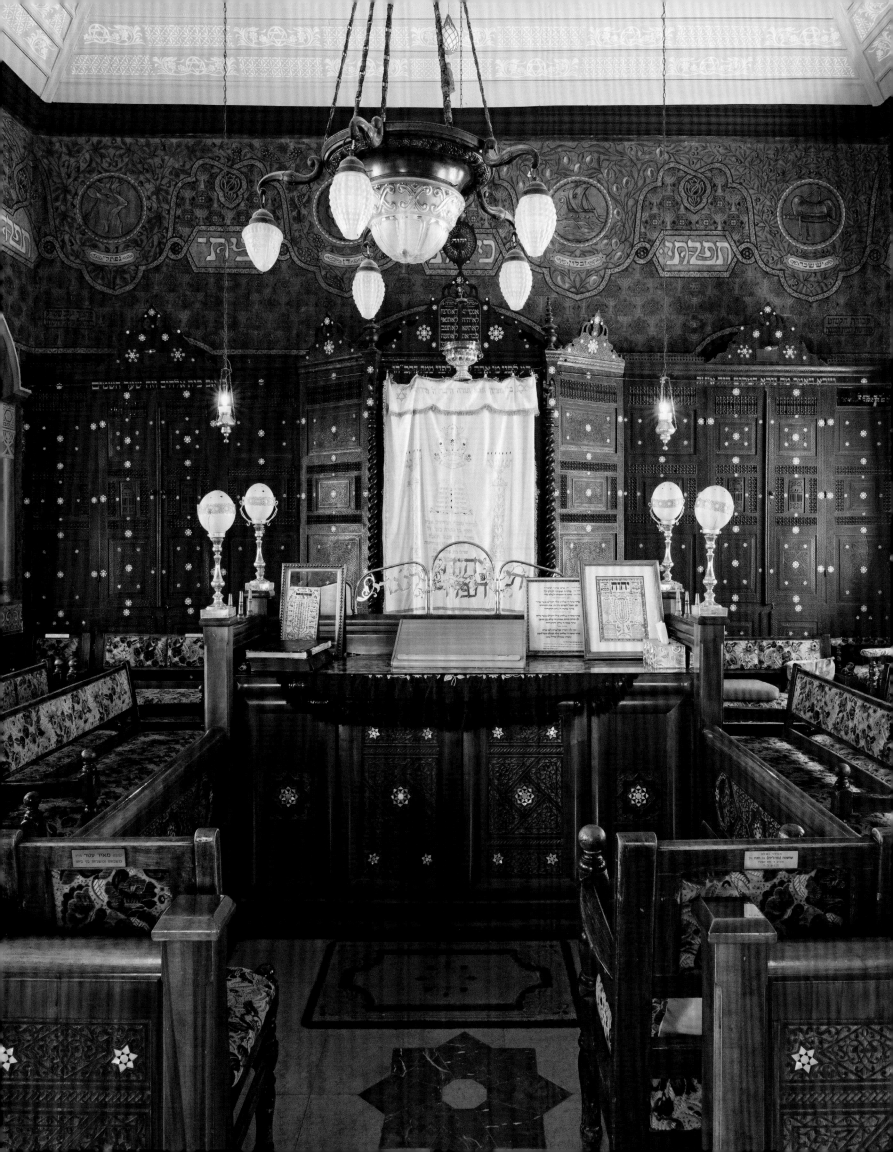

Opposite: The Syrian Jews who established the Ades Synagogue in Jerusalem in 1901 brought with them their tradition of intricate wood carving inlaid with mother-of-pearl.

Below: This Syrian tradition favors dense carpet-like surface designs in geometric patterns enriched with inscriptions and symbols.

יפ‏א

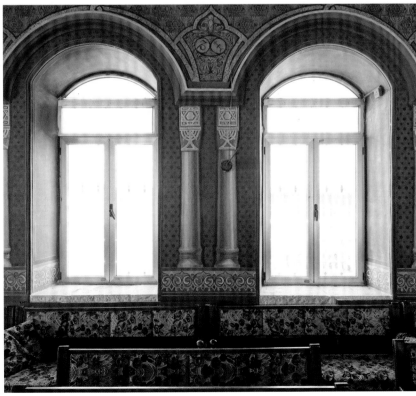

However, when architect Y. Tabachnik wanted to combine the image of the tablets in Beit HaDekel, an apartment house built in the eclectic style of Tel Aviv in the 1920s, the municipality forbade the use of this motif on a residential building.

After 1948, the entire interiors of several Italian synagogues were transported to Israel, introducing the gorgeous vocabulary of European decoration to the new state. Elaborate holy arks, podiums, bimahs made of rare wood, bronze lighting fixtures, and other decorations served as inspiration for both synagogues and even the Knesset (Parliament) building. The restoration in 1965 of the Baroque Vittorio Veneto Synagogue, transported from a town near Venice to the Israel Museum, Jerusalem, provides visitors with a view of its splendid decorations as well as an opportunity to experience the intimate nature of its space, especially the balcony for the women's section. In subsequent years, other examples of synagogues from different countries were added to the museum's Judaica wing. In Beit Hatfutsot (Museum of the Jewish People) in Tel Aviv, visitors can now view exquisite models of synagogues from around the world.

According to the architectural historian Sir Nikolaus Pevsner, the function of religious buildings is to convert visitors into worshippers. English architect Sir Denys Lasdun commented that most of the architect's work involves solving functional requirements, as in the case of hospitals or theaters, but when you design synagogues, you are dealing with the essence of architecture: space, light, and materials. The true nature of the synagogue is the gathering of people for a sublime purpose, and nowhere is this more keenly felt than in Israel.

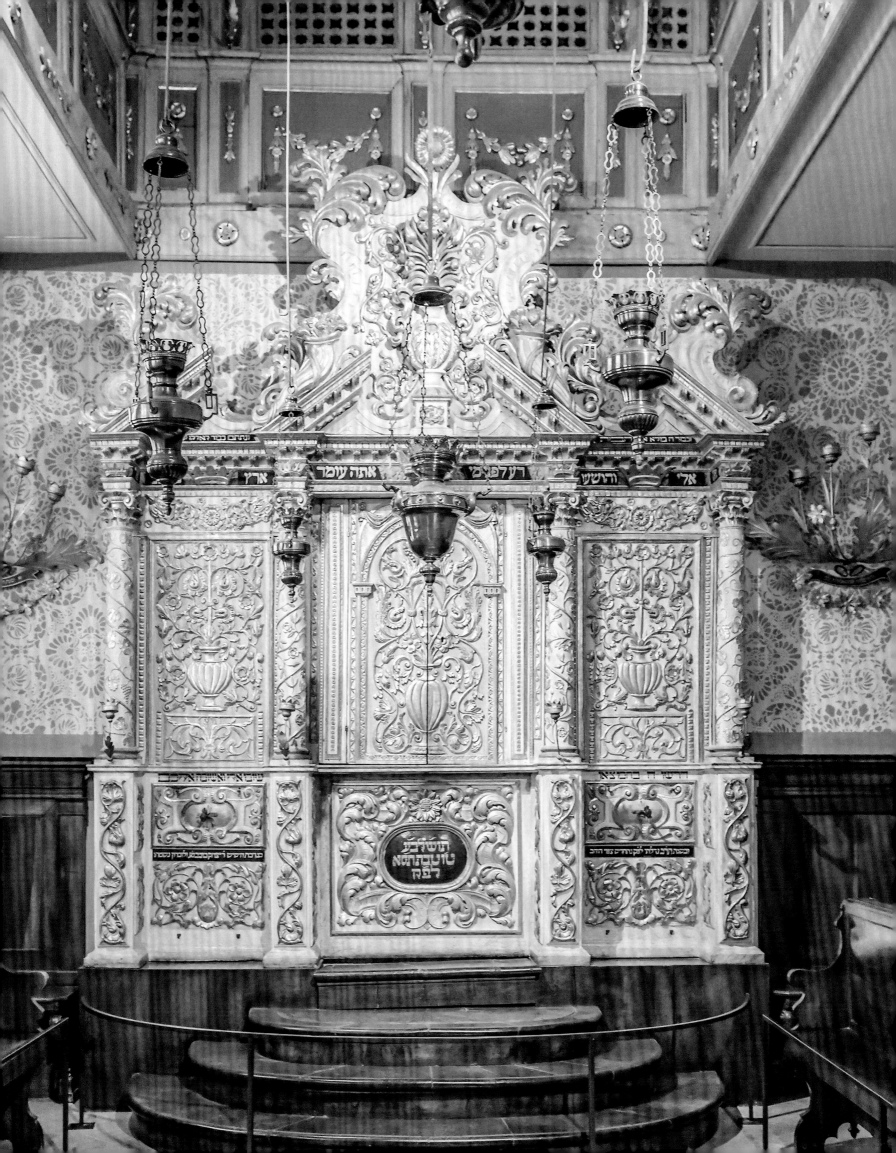

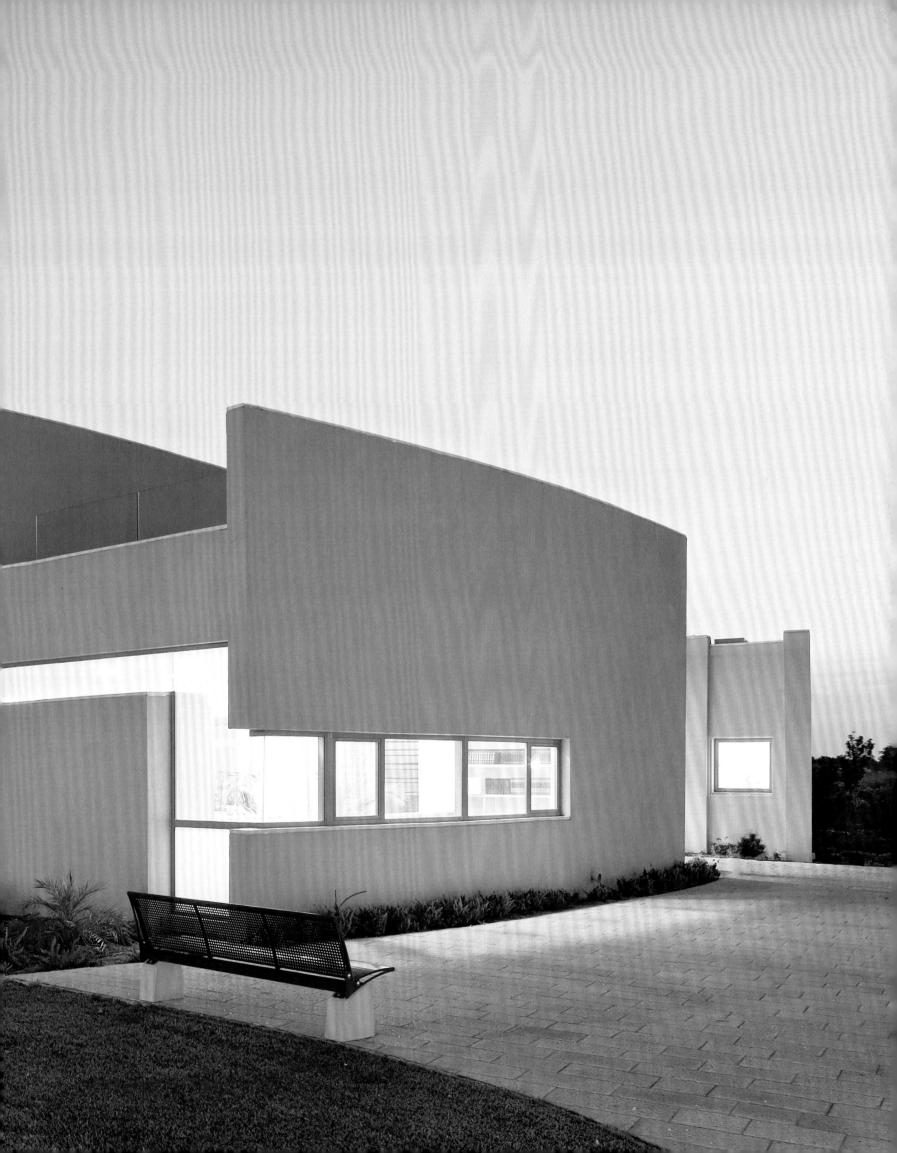

Aggadot (Hebrew): Stories in rabbinic literature that are based on Jewish traditions, legends, and parables.

Amidah (Hebrew): The "standing" prayer conducted in silent recitation that is a core part of the Jewish statutory prayer.

Ark (Hebrew: *aron ha-kodesh* or *heikhal*): A repository for storing the Torah scrolls within the synagogue. The ark is usually situated in a niche or apse that faces Jerusalem.

Ashkenazi (pl. Ashkenazim): Term used to describe Jews living along the Rhine River during the time of the Holy Roman Empire. Now commonly used to refer to Jews in western, central, and eastern Europe, and in Russia, and their descendants.

Bar mitzvah: Literally "son of the commandment," a coming-of-age ceremony that is celebrated when a boy reaches thirteen years of age and is considered an adult for religious purposes, according to the Mishnah (Avot 5:21) and the Talmud (BM 96a).

Bat mitzvah: Literally "daughter of the commandment," a coming-of-age ceremony for girls. In liberal communities, it is performed when a girl reaches thirteen years of age and virtually identical to the bar mitzvah ceremony. In Orthodox communities, where women traditionally do not lead prayers or read from the Torah, it is performed when a girl reaches twelve years of age and celebrated according to the customs of the community.

Beit ha-knesset (Hebrew): *see* Synagogue.

Beit ha-midrash (Hebrew): *see* Study house.

Bimah (Hebrew): A raised platform or podium for congregational leaders, the rabbi, and the cantor, or a table, from which the Torah scrolls are read in a synagogue.

Cantor (Hebrew: *chazan*): The chanter who, in a synagogue, sings liturgical music and leads prayers.

Conservative Judaism: A denomination that seeks to chart a middle ground between the strict observance of Orthodoxy and the more liberal attitude toward the Ten Commandments found in Reform Judaism.

Convivencia (Spanish): A time of relative peace between Jews, Christians, and Muslims in al-Andalus (Muslim Spain). Popularized as a symbol of Jewish identity in the 1800s, it propelled the creation of the neo-Moorish style.

Decalogue: The Ten Commandments given by God to Moses on Mount Sinai.

Derashah (Hebrew): The weekly sermon usually given by the rabbi on the Sabbath.

Diaspora: The dispersion of the Jews from the Holy Land and their subsequent settlement around the world.

Eternal light (Hebrew: *ner tamid*): A continuously burning lamp customarily suspended before the ark in a synagogue to remind worshippers of the omnipresence of God.

Gallery: An interior balcony that projects over or surrounds a section of the main sanctuary within the synagogue.

Galut (Hebrew): Exile, *see* Diaspora.

Gemara (Hebrew): A commentary on the Mishnah, which forms the core of the oral law recorded in the Talmud.

Gemilut hasadim (Hebrew): Acts of loving-kindness prescribed in the Talmud.

Haggadah (Hebrew): The text that is read during the Passover Seder on the first two nights.

Halakhah (Hebrew): Jewish law.

Haredi (Hebrew: pl. Haredim): An ultra-Orthodox Jew who adheres strictly to the observance of the Ten Commandments.

Hasid (Hebrew: pl. Hasidim): A member of a subgroup within the ultra-Orthodox or Haredi Jewish communities.

High Holidays or Holy Days (Hebrew: *yamim noraim*): A series of holy days starting in the Hebrew month of Elul with Rosh Hashanah (the Jewish New Year) and and that culminates with Yom Kippur (the Day of Atonement).

Jewish Enlightenment: A series of social and religious reforms adopted by some Jewish communities following the French Revolution.

Magen David (Hebrew: The Star or Shield of David): The six-pointed Star of David, formed by two interposed equilateral triangles, is commonly seen as a symbol of Judaism. First associated with Jewish synagogues in the third century CE, it became especially popular in the late nineteenth century and continues to be used today to represent Judaism throughout the world, including in the State of Israel.

Matzo (Hebrew): Baked unleavened bread that is traditionally eaten during Passover,

referencing the haste in which the Jews left Egypt.

Mechitzah (Hebrew): A divider separating the men's and women's sections of the synagogue. Reform and most Conservative synagogues omit this divider.

Menorah (Hebrew): A seven-branched candelabrum that was originally described in the First Temple, which commonly adorns synagogues around the world. An eight-branched candelabrum is used during the Hanukkah festival.

Mezuzah (Hebrew): A piece of parchment in a decorative case containing verses from the Torah (Deuteronomy 6:4–9; 11:13–21) that is posted at entrances to Jewish homes and rooms, and occasionally on synagogues.

Mikvah (Hebrew): A ritual bath with fresh-flowing water for men and women used for cleansing prior to attending synagogue.

Minyan (Hebrew, pl. minyanim): A quorum of ten adults (in Orthodox practice, ten men) required for the recital of certain prayers.

Mishnah (Hebrew): The core of the Talmud, a record of the oral laws, *see* Talmud.

Mitpahot (Hebrew): Cloth that covers the Torah prior to storage in the ark cabinet.

Mitzvah (Hebrew): A holy commandment.

Mizrach (Hebrew): Literally "east," a marker within Jewish homes or synagogues west of the Holy Land that indicates the direction of Jerusalem, toward which prayers are traditionally addressed.

Orthodox Judaism: A denomination of Judaism that originated in nineteenth-century Germany. It seeks to adhere strictly to traditional doctrine as embodied in the Torah, Talmud, and legal codes.

Parochet (Hebrew and Aramaic): A curtain placed in front of the ark in a synagogue, recalling the covering placed before the Ark of the Covenant according to Exodus 40:21.

Pinkasei ha-kehilot (Hebrew): Books that record historical information and demographic data on Jewish communities in eastern Europe, from their origins through the Holocaust.

Rabbi (Hebrew): Traditionally a term of respect used for religious teachers or those who conducted services in the synagogue. Today, "rabbi" refers to ordained Jewish leaders who have completed rabbinic school or the equivalent. They perform many

functions, such as leading prayers, teaching, administrating the synagogue, and carrying out services for the community and outreach programs.

Reader's desk (Hebrew: *shulchan*): The desk on which the Torah is placed for reading, often found on the bimah.

Rebbe (Hebrew): A Hasidic rabbi and spiritual leader.

Reform Judaism: A movement in Judaism that, originating in nineteenth-century Germany, puts primary emphasis on progressive values and less on ritual and personal observance.

Rimmonim (Hebrew): Ornaments that adorn the Torah scrolls.

Rosh Hashanah (Hebrew): Jewish New Year.

Seder (Hebrew): The ceremonial dinner that celebrates the first two nights of Passover.

Sephardi (Hebrew, pl. Sephardim): Jews and Jewish traditions originating in Muslim Spain and spreading throughout the Mediterranean and Arab worlds and beyond after the expulsion of the Jews in 1492.

Shema (Hebrew): A central prayer and affirmation of faith derived from the Torah (Deuteronomy 6:4–9). It begins: "Hear, O Israel! The Lord is our God, the Lord is One."

Shiviti (Hebrew): Image of a menorah composed of rows of Hebrew letters invoking the contemplation of God's name.

Shoah (Hebrew): Also known as the Holocaust, the mass murder of Jews and others perpetrated by German Nazis and their sympathizers during the period 1941–45.

Shofar (Hebrew): A trumpet made from a ram's horn that is used for religious purposes, notably during the High Holidays.

Shtetl (Yiddish): Small, mostly Jewish towns in eastern Europe and Russia that were largely wiped out during the Holocaust.

Shul (Yiddish): Term used for a synagogue (primarily in Orthodox circles).

Siddur (Hebrew): Jewish prayer book.

Sifrei *Torah* (Hebrew): Torah scrolls.

Study house: Also known as *shtibl* and *kloyz* in Yiddish, or *beit ha-midrash* in Hebrew. Traditionally a religious school and discussion hall for Jewish male adults, either near or attached to a synagogue. It

may contain an ark and a bimah for prayer. Except for Orthodox synagogues, the study house has been largely replaced by religious schools designed for younger students.

Synagogue: A consecrated Jewish space for congregation and prayer.

Talmud (Hebrew): The record of legal decisions and discussions of ancient Jewish sages pertaining to the Torah.

Tamid (Hebrew): Daily sacrifices proscribed by the Torah (Exodus 29:38–42) within the Temple, and that largely ceased after its destruction in 70 CE by the Romans.

Tefillah (Hebrew): Prayer proscribed in Deuteronomy 11:3.

Teva (Hebrew): A movable chest containing the holy scriptures, usually housed within the synagogue, often present in early synagogues.

The Temple: The main Jewish sanctuary in Jerusalem originally built by King Solomon in the tenth century and destroyed in 587/6 BCE (referred to as the First Temple Period). Subsequently rebuilt in 516 BCE and destroyed by the Romans in 70 CE (Second Temple Period). Since the nineteenth century, the term temple has been increasingly applied to synagogues, especially to those of the Reform and Conservative movements.

Tikkun olam (Hebrew): A concept of cosmic repair derived from Lurianic Kabbalah. In more liberal denominations, it is used to refer to social justice.

Torah (Hebrew): Five Books of Moses (also called Pentateuch or Chumash). Can also refer to subsequent legal traditions (Mishnah, Talmud, and biblical commentaries), known as the Oral Torah.

Yad (Hebrew): Literally, a "hand," referring to a ritual pointer used for reading the Torah scrolls.

Yeshivah (Hebrew): House of study or seminary.

Yom Kippur (Hebrew): Day of Atonement, marked by a twenty-five-hour period of fasting and atonement.

Anisimov, Ilya Sherbatovich. *The Mountain Jews of Caucasus*. Moscow: Nauka Publishing House, 2002. First published in 1888.

Branca, Marzia, ed. *Mario Botta: The Cymbalista Synagogue and Jewish Heritage Center*. Corte Madera, CA: Gingko Press, 2001.

Chakovskaya, Lidia. *The Memory of the Temple Incarnate: The Artistic Realm of the Holy Land Synagogues of the III–VI AD*. Moscow: Indrik, 2011.

Cohen-Mushlin, Aliza, and Harmen H. Thies, eds. *Jewish Architecture in Europe*. Petersberg, Germany: Imhof, 2010.

Fine, Steven. *Art and Judaism in the Greco-Roman World: Toward a New "Jewish Archaeology."* New York: Cambridge University Press, 2010.

——————. *The Menorah: From the Bible to Modern Israel*. Cambridge, MA: Harvard University Press, 2016.

——————, ed. *Jewish Religious Architecture: From Biblical to Modern Judaism*. Boston: Brill, 2020.

Gharipour, Mohammad. *Synagogues in the Islamic World: Architecture, Design, and Identity*. Edinburgh: Edinburgh University Press, 2017.

Gruber, Samuel D. *American Synagogues: A Century of Architecture and Jewish Community*. New York: Rizzoli International Publications, Inc., 2003.

——————. *Synagogues*. New York: Metro Books, 1999.

Hubka, Thomas C. *Resplendent Synagogue: Architecture and Worship in an Eighteenth-Century Polish Community*. Hanover, NH: Brandeis University Press and University Press of New England, 2003.

Hughes, Aaron W. *Rethinking Jewish Philosophy: Beyond Particularism and Universalism*. Oxford: Oxford University Press, 2014.

Kee, Howard Clark, and Lynn H. Cohick, eds. *Evolution of the Synagogue*. Harrisburg, PA: Trinity Press International, 1999.

Klein, Rudolf. *Synagogues in Hungary 1782–1918: Genealogy, Typology, and Architectural Significance*. Budapest: Terc Press, 2017.

Kravtsov, Sergey R. *In the Shadow of Empires: Synagogue Architecture in East Central Europe*. Weimar: Grunberg Verlag, 2018.

Krinsky, Carol Herselle. *Synagogues of Europe: Architecture, History, Meaning*.

Rev. ed. Mineola, NY: Dover Publications, 1996.

Levin, Michael. "Modern Architecture in Jerusalem: Tradition and Innovation." *Israel Museum Journal* 1 (Spring 1982): 63–73.

Meek, Harold Alan. *The Synagogue*. London: Phaidon, 1995.

Nazarova, Eugenia M., ed. *History and Culture of the Mountain Jews*. Jerusalem: Israel World Congress of Mountain Jews, 2018.

Piechotka, Maria, and Kazimierz Piechotka. *Heaven's Gates: Masonry Synagogues in the Territories of the Former Polish-Lithuanian Commonwealth*. Warsaw: Polish Institute of World Art Studies: Polin Museum of the History of Polish Jews and London: Polish Institute and Sikorski Museum, 2017.

Piechotka, Maria, and Kazimierz Piechotka. *Heaven's Gates: Wooden Synagogues in the Territories of the Former Polish-Lithuanian Commonwealth*. Warsaw: Polish Institute of World Art Studies: /POLIN Museum of the History of Polish Jews; London: Polish Institute and Sikorski Museum, 2015.

Rodov, Ilia M. *The Torah Ark in Renaissance Poland: A Jewish Revival of Classical Antiquity*. Leiden: Brill, 2013.

Sacerdoti, Annie. *A Guide to Jewish Italy*. New York: Rizzoli International Publications, Inc., 2004.

Sachs, Angeli, and Edward van Voolen, eds. *Jewish Identity in Contemporary Architecture*. New York: Prestel, 2004.

Schorsch, Ismar. *From Text to Context: The Turn to History in Modern Judaism*. Waltham, MA: Brandeis University Press, 2003.

Skolnik, Fred, and Michael Berenbaum, eds. *Encyclopaedia Judaica*, 22 vols. Detroit and Jerusalem/New York: Macmillan Reference and Keter, 2007.

Stolzman, Henry, and Daniel Stolzman. *Synagogue Architecture in America: Faith, Spirit and Identity*. Victoria, Australia: Images Publishing, 2004.

van Voolen, Edward. *My Grandparents, My Parents and I: Jewish Art and Culture*. New York: Prestel, 2006.

Wigoder, Geoffrey. *The Story of the Synagogue*. London: Weidenfeld & Nicolson, 1986.

Wischnitzer, Rachel. *The Architecture of the European Synagogue*. Philadelphia: Jewish Publication Society of America, 1964.

Jewish Sloboda: My Heritage

God Nisanov

This book is a tribute to the culture in which I grew up and that remains my world to this day. In the Middle Ages, my distant ancestors lived in Persia and later moved to the northeastern slopes of the Caucasus Mountains, now modern Azerbaijan. The village where I was born was called Jewish Sloboda ("Jewish Town") because its entire population consisted of Mountain Jews. Before the Russian Revolution of 1917, there were eleven synagogues and two yeshivas in our village. When the Soviets closed most of the synagogues and renamed our town Krasnaya Sloboda (Red Town), we still managed to preserve our traditions.

First under pressure from the Turkic and Persian cultures, and later, the giant atheistic Soviet empire, our community was only able to maintain its integrity and identity thanks to the religious traditions of our ancestors. Every Thursday we baked bread in a tandoor oven, and on Fridays we went to the bathhouse and then prepared a table for Shabbat. Before the holidays, we dressed in new clothes, and on the eve of Passover, we repainted our houses and fences.

It was a world in which the question "why?" did not arise. We accepted our traditions and lived our lives accordingly. I went to the synagogue for the first time as a child of four or five, on the anniversary of my grandfather's death. My dad read the prayer in Hebrew. I had not heard this language before as we spoke Juhuri, a Judaic-Persian dialect. The sound of the unfamiliar words was funny to me, which is probably why this event is imprinted in my mind. To this day, we go to the synagogue on the anniversary of my grandfather's death to honor his life. It is our way of life.

To one degree or another, this historically conditioned independence, characteristic of many Jews, never prevented us from living in the world at large. Existing in harmony with others and cooperating for our common prosperity is a major feature of Jewish culture. When readers of this book become acquainted with these gorgeous synagogues spanning different eras and traditions, I hope they will gain a deeper understanding of the Jewish faith as well as a fresh appreciation of its heritage and openness toward the greater world.

Lidia Chakovskaya, PhD, senior research fellow at the State Institute of Art Studies, Moscow, and professor of art history, Lomonosov Moscow State University. Her main field of research is Jewish art.

Steven Fine, Dean Pinkhos Churgin Professor of Jewish History and founding director of the Center of Israel Studies, Yeshiva University, New York. He is co-editor of *Images: A Journal of Jewish Art and Visual Culture,* and author of *Art and Judaism in the Greco-Roman World: Toward a New Jewish Archaeology* (rev. ed. 2010).

Max Fineblum (ARCH), Morgan State University, Baltimore.

Mohammad Gharipour, PhD, is professor and director of the Graduate Program in Architecture, School of Architecture and Planning, Morgan State University, Baltimore. An author and editor of twelve books, he serves as the director and founding editor of the *International Journal of Islamic Architecture,* co-editor of the book series *Critical Studies in Architecture of the Middle East,* and editor of the book series *Health and Built Environment.*

Samuel D. Gruber, PhD, is an architectural historian and historic preservationist based in Syracuse, New York, where he teaches at Syracuse University and Cornell University. He is president of the International Survey of Jewish Monuments.

Aaron W. Hughes is Philip S. Bernstein Chair of Jewish Studies, Department of Religion and Classics, University of Rochester, Rochester, New York. A prolific writer, he is also editor in chief of *Method and Theory in the Study of Religions.*

Sergey R. Kravtsov, PhD, is a research fellow at the Center for Jewish Art at the Hebrew University of Jerusalem. Trained as an architect and city planner in Lviv, Ukraine, he later received his doctoral degree in architectural history from the Institute for the Theory and History of Architecture in Moscow, Russia. He is widely published in the areas of urban planning and synagogue architecture.

Professor Michael Levin is the lecturer on the History of Modern Art and Contemporary Art and Architecture and founder of the multidisciplinary art department at Shenkar College of Engineering, Design and Art, Ramat-Gan, Israel. His publications include *White City, International Style Architecture in Israel, Santiago Calatrava: Artworks*, and *The Modern Museum Temple or Showroom.*

Rabbi drs. Edward van Voolen is an art historian and curator as well as rabbinic director of the Abraham Geiger College, University of Potsdam, Germany. He holds degrees in art history and history from Amsterdam University, and he received rabbinic ordination from the Leo Baeck College in London. For thirty-five years, he was curator at the Jewish Historical Museum, Amsterdam, and responsible for numerous exhibitions, ranging from medieval to modern art, design, and architecture. He is widely published in the fields of Jewish cultural history, Jewish art, and architecture.

Note from **Judy Glickman Lauder**: A special thank-you to my family for their loving support and invaluable input in writing these words: Leonard Lauder, Rabbis Brenner Glickman and Elaine Rose Glickman, and Rabbi Jeffrey Glickman and Mindy Radler Glickman.

Acknowledgments

*Opposite: The dome of the Spanish
Synagogue in Prague (1868, interior
redecorated in 1882–83) reflects the
multiple variations of the Star of David
in stained glass and in the complex
jewel-like stenciled designs that cover
the spandrels and adjoining vaults.*

*Pages 286–87: The transparent curtains
with tiny Stars of David surrounding
the inner sanctuary of the Neue
Synagoge in Dresden (2001) create a
zone of private contemplation for the
congregants while integrating them
into the communal space.*

Synagogues: Marvels of Judaism is the collaborative effort
of a group of brilliant intellectuals, creative designers, and
outstanding people from around the world.

First, I would like to thank all of the essay writers and scholars
who have contributed to the volume, notably our consulting
editor and essayist Aaron W. Hughes, Philip S. Bernstein
Chair of Jewish Studies, Department of Religion and Classics,
University of Rochester, Rochester, New York. I am also grateful
to Lidia Chakovskaya, PhD, senior research fellow at the State
Institute of Art Studies, Moscow, and professor of art history,
Lomonosov Moscow State University; Steven Fine, Dean
Pinkhos Churgin Professor of Jewish History and founding
director of the Center for Israel Studies, Yeshiva University,
New York; Max Fineblum (ARCH), Morgan State University,
Baltimore; PhD, Mohammad Gharipour, PhD, professor and
director of the Graduate Program in Architecture, Morgan State
University, Baltimore; Samuel D. Gruber, PhD, president of the
International Survey of Jewish Monuments; Sergey R. Kravtsov,
PhD, research fellow at the Center for Jewish Art at the Hebrew
University of Jerusalem; Professor Michael Levin, lecturer on
the History of Modern and Contemporary Art and Architecture,
Shenkar College of Engineering, Design, and Art, Ramat-Gan,
Israel; and Edward van Voolen, art historian, curator, and
rabbinic director of the Abraham Geiger College, University of
Potsdam, Germany.

I also wish to express my deep gratitude to Judy Glickman
Lauder for her moving and thoughtful foreword, and for her
many contributions to the preservation of synagogues and
Judaism around the world.

I thank the publisher Charles Miers, Rizzoli International
Publications, Inc. A very special thanks to senior editor Sandy
Gilbert Freidus, who stewarded every aspect of this book
and went far beyond the role of most editors. Special thanks
to general editor Jai Imbrey, PhD, who oversaw the book's
creation and contributed to the captions, glossary, bibliography,
and research. Thanks also to Beatriz Cifuentes of Waterhouse
Cifuentes Design for her glorious design of the book, and to
Victoria Marmur for her contribution to the research and

preparation of the photographs. Thanks to copyeditor Kelli Rae
Patton, proofreader Susan Homer, and indexer Marilyn Flaig.

A great thank-you to all the photographers who took part
in the project and provided their inspired work: Giampiero
Alessandrini, Tom Bonner, Javier Callejas Sevilla, Jakub
Certowicz, Louis Davidson, Pieter Estersohn, Shamil
Gadzhidadaev, Mohammad Reza Domiri Ganji, Amit Geron,
Erez Haim, Steve Hall, Piotr Jamski, Stephan Julliard, Alan
Keohane, Farid Khayrulin, Massimo Listri, Andrew Meredith,
Norbert Miguletz, Rainer Mirau, Samuel Morgan, Yuri Palmin,
Andrew Pielage, Rien van Rijthoven, Paul Rocheleau,
Mikhail Rozanov, and Luc Stranders.

I would like to express my gratitude to the team of producers
who made this book so special: Nikolay Uskov, a prominent
medieval historian and editorial director of *Forbes* Russia for
his superb organization and insightful ideas for its successful
implementation, and Ekaterina Karelina, PhD, Institute of
Philosophy of the Russian Academy of Science, who holds a
master's degree from Oxford University, for her vision, ideas,
and all-around support of our project.

My most heartfelt words of gratitude go to God Nisanov, the
vice-president of the World Jewish Congress and philanthropist,
whose vision, participation, and generosity brought this
project to life.

And, of course, above all, to my family. To my dear husband,
Kamran, whose unending support and assistance have always
been invaluable.

—Leyla Uluhanli

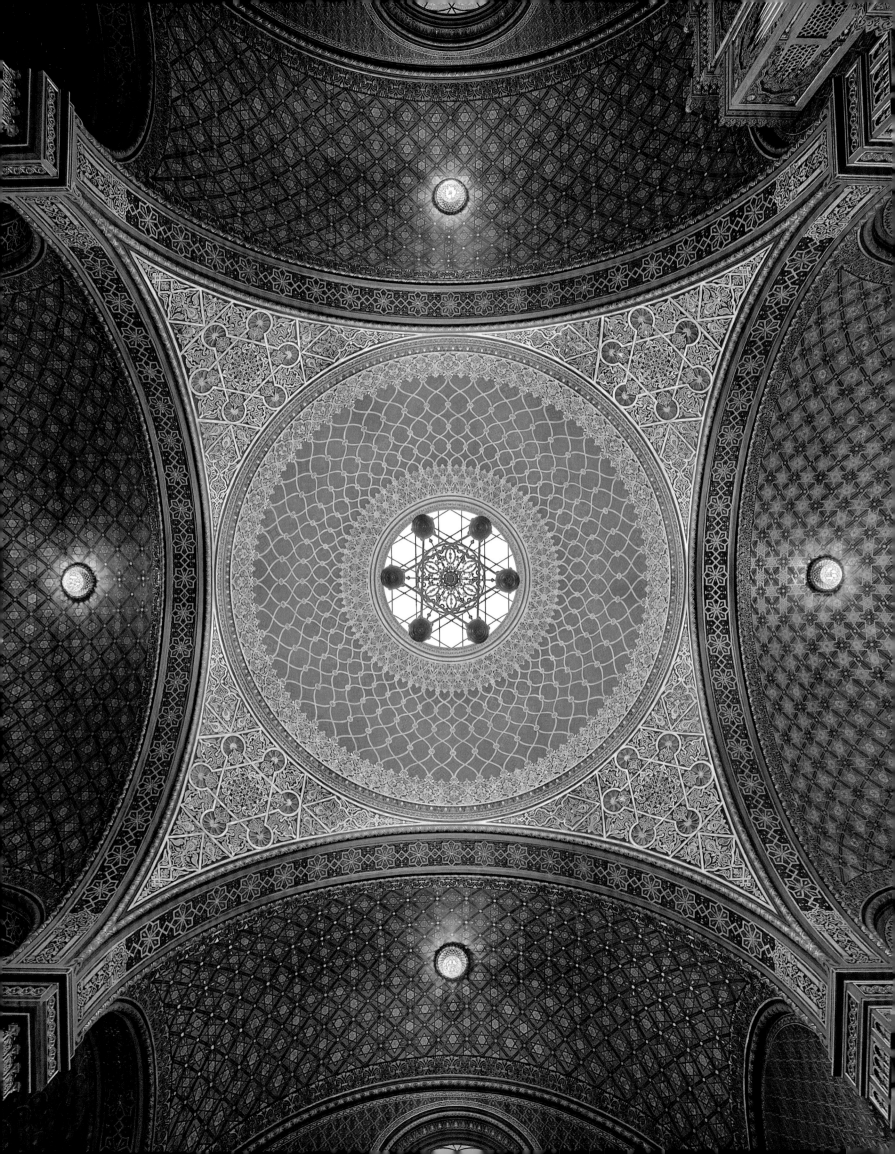

First published in the United States of America in 2021 by
Rizzoli International Publications, Inc.
300 Park Avenue South
New York, NY 10010
www.rizzoliusa.com

Publisher: Charles Miers
Project Editor: Sandra Gilbert Freidus
General Editor: Jai Imbrey
Editorial Assistants: Kelli Rae Patton, Susan Homer, Marilyn Flaig
International Producer: Ekaterina Karelina
Design: Beatriz Cifuentes-Caballero of Waterhouse Cifuentes Design
Design Coordinator: Olivia Russin
Photography Editor: Victoria Marmur
Production Manager: Barbara Sadick
Managing Editor: Lynn Scrabis

Printed in China

2021 2022 2023 2024 / 10 9 8 7 6 5 4 3 2 1

ISBN: 978-0-8478-6650-2
Library of Congress Control Number: 2021937247

Visit us online:
Facebook.com/RizzoliNewYork
instagram.com/rizzolibooks
twitter.com/Rizzoli_Books
pinterest.com/rizzolibooks
youtube.com/user/RizzoliNY
issuu.com/Rizzoli